Paul Signac and Color in Neo-Impressionism

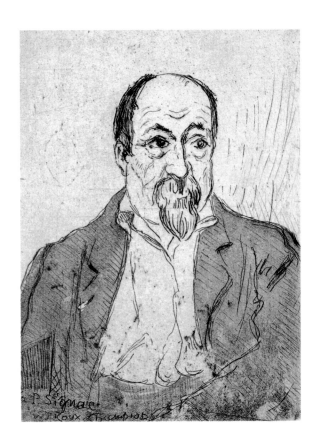

Frontispiece *Portrait of Paul Signac*
by Joseph Victor Roux-Champion
(1871–1935). ca. 1910. Etching, 19
× 13.5 cm. Collection of Floyd Rat-
liff, Santa Fe, New Mexico.

Paul Signac and Color in Neo-Impressionism

by Floyd Ratliff

including the first English edition of

From Eugène Delacroix to Neo-Impressionism

by Paul Signac

translated from the third French edition
(H. Floury, Paris, 1921) by Willa Silverman

Dedication

In Memory
of my comrades in
The United States Army
and in
The French Forces of the Interior
who fell in
France

1944–1945

The Rockefeller University Press, New York 10021

© 1992 by The Rockefeller University Press.
All rights reserved
Printed in Japan

Library of Congress Cataloging-in-Publication Data

Ratliff, Floyd.
 Paul Signac and Color in Neo-Impressionism / by Floyd
Ratliff ; including the first English edition of *From Eugène
Delacroix to Neo-Impressionism* by Paul Signac ; translated
from the third French edition (H. Floury, Paris, 1921) by
Willa Silverman.
 p. cm.
 Includes translation of: *D'Eugène Delacroix au Néo-
Impressionnisme.*
 Includes bibliographical references and index.
 ISBN 0-87470-050-7
 1. Neo-Impressionism (Art). 2. Color in art. 3. Signac,
Paul, 1863–1935 — Philosophy. 4. Art, modern — 19th
century. I. Signac, Paul, 1863–1935. *D'Eugène Delacroix
au Néo-Impressionnisme.* English. 1992. II. Title. III. Title:
From Eugène Delacroix to Neo-Impressionism.
N6465.N44R38 1992
759.05'5 — dc20
 91-66383
 CIP

Library of Congress Catalog Number 91-066383
ISBN 0-87470-050-7

Contents

Preface

This book is about an artist, a technique of painting that he fostered, and the role of that technique in a major movement of art. The artist is Paul Signac (1863–1935)—the noted French oil painter, water-colorist, and writer on art. The technique is division-ism, a variation of and an improvement on pointil-lism. The movement in art is the "new" Impressionism that was founded by the innovative Georges Seurat in the 1880s, with Signac as its princi-pal adherent and chief spokesman.

Signac once wrote, "The Neo-Impressionist does not paint with *dots*, he *divides*." And the main conclusion of this work is that a strict pointillism (with its small closely juxtaposed dots) is a rather ineffective technique, whereas a more lenient divi-sionism (with its larger, more loosely arranged touches) is a very effective technique. This compari-son and conclusion is based on the theory of color, on the empirical findings of the Neo-Impressionist painters themselves, and on the writings of several critics and scholars.

The study outlined above provides an extended introduction to a translation of Signac's book *D'Eugène Delacroix au Néo-Impressionnisme*. This treatise on color and on technique is widely recog-nized as the basic document of Neo-Impressionism. Since the first publication of the whole work in 1899, it has gone through several editions in the original French (the latest in 1978) and has been translated into German and Danish. But despite its great impor-tance in the history of modern art, this most funda-mental of all works on Neo-Impressionism by one of its most renowned exponents has never before been translated into English. The translation presented here is of the 1921 edition—the last of the three French editions published during Signac's life and under his supervision.

Also included are *A Select List of Works in En-glish on Signac, Neo-Impressionism, and Color*, and a *Glossary of Technical and Art Terms*.

Acknowledgments

Over the years I have been greatly aided and much encouraged in this study by many friends and colleagues. I thank them all. I am most grateful to the late Helene Jordan and to Vivian Shelanski (both formerly with The Rockefeller University Press) for early advice and assistance. Special thanks go to my colleagues in vision research Robert Shapley, James Gordon, and Ehud Kaplan for technical assistance in the preparation of several of the illustrations, and to my friends Victor Wilson, Israel Abramov, and William Miller for their critical and helpful reading of early drafts of the manuscript.

I also wish to thank Sonya Mirsky, Rockefeller University Librarian, for her assistance in locating many hard-to-find books and elusive references.

Willa Silverman first undertook the translation of Signac's book while still a beginner in the study of French in high school. She continued her studies of French at Harvard, and later studied and taught in France on a Fulbright Foundation Fellowship and on a Bourse Chateaubriand grant and other support from the French government. In 1983 she received her M.A., and in 1988 her doctorate in French Studies at New York University. All the while Ms. Silverman willingly helped with the work whenever and wherever I called upon her. She deserves much credit for her patience. I thank Noel Gates, a professional translator, for a careful reading and polishing of the translation of Signac's book and for a thorough comparison with the original French text for accuracy.

Maria Lipski typed (and retyped) the manuscript many, many times as it passed through its innumerable revisions. Merry Muraskin read, and made numerous corrections in, a preliminary version of the text. Lisa Croner and Wendy Eisner also read this preliminary draft and made many helpful comments and offered much constructive criticism. I thank Wendy

Eisner especially for the many leads she provided to important events in the history of art which were previously unknown to me and which I was able to incorporate into the work.

A near-final draft of the manuscript was read by Dorothea Jameson, a color scientist and Professor of Psychology at the University of Pennsylvania; Sanford Wurmfeld, an artist and a Professor of Art at Hunter College in New York City; Robert Boynton, a color scientist and Professor of Psychology at the University of California, San Diego; and Lee Fargo, a graduate student at San Diego with interests in art, design, and color science. They made many helpful comments and their candid and constructive criticism, for which I am very grateful, led to many significant improvements throughout the whole work.

When at long last the time came to publish the book, Bradley Hundley, Director of The Rockefeller University Press, supervised the editing and production. Marie-Christine Lawrence designed the book and the layout of illustrations. Steve Baeck edited the final draft of the manuscript. All original line illustrations were prepared by Carol Leigh Gribble. Original color work was done by Robert Shapley. They all have my thanks for their efforts on this project. Their commitment to excellence is evident throughout the work.

Concerning the illustrations of paintings, I am deeply indebted to a number of individuals and institutions for permission to reproduce works of art in their possession. Very special thanks go to Colin Anson, Director of the Gallery of David Carritt Limited, London, who kindly made all arrangements for publication of an important painting in a private collection, and I offer my thanks here to the anonymous owner for his generosity. I also wish to thank Susan Witherow, Hirschl and Adler Galleries, New York;

Richard Thomson, The University of Manchester, England; and Thomas G. Grischkowsky, The Museum of Modern Art, New York, for their assistance in locating some of the paintings reproduced in the book.

During my research and writing on *Paul Signac and Color in Neo-Impressionism* I received generous grants-in-aid for various aspects of the work, and for closely related scientific investigations, from Florene Schoenborn, the National Science Foundation, the National Eye Institute, the Esther A. and Joseph Klingenstein Fund, and the Harry Frank Guggenheim Foundation. I am grateful to them all for their support.

I also owe much to The Rockefeller University, where I did this research. The University has long provided me with excellent facilities and has always allowed me complete freedom to pursue my various interests in the relations between the visual arts and visual sciences along with my regular experimental and theoretical studies on the neural mechanisms of vision. The benefits to me, in terms of enhanced personal pleasure, and to my work, in terms of deeper critical insight, of the broad perspective thus gained are incalculable.

My greatest debt is to the many scholars whose works on Color and on Neo-Impressionism informed me on every topic discussed in this study. This work of mine, which owes so much to theirs, is a tribute to them all.

Floyd Ratliff
Santa Fe,
New Mexico

Introduction

In 1968, the Solomon R. Guggenheim Museum mounted an exhibition of over one hundred Neo-Impressionist paintings, selected from nearly as many collections throughout the world. Among the many remarkable works in this extraordinary assembly (see Herbert's catalogue *Neo-Impressionism*) was one of Paul Signac's masterpieces, *Le Petit déjeuner* (Breakfast), which I saw there for the first time. This book grew out of that exhibition and the strong impression that painting made on me. At that time I had been engaged for more than two decades in the scientific study of the basic mechanisms of visual perception—especially the neurophysiological and psychophysiological processes underlying the integrative action of the eye and the brain. As a specialist in vision research, I was struck by Signac's broad grasp of some of the most fundamental principles of the interaction of color and by his masterly use of those principles, particularly as evidenced in this one painting.

A few weeks after my visit to the Guggenheim exhibition, while browsing through Weyhe's art book store and gallery on Lexington Avenue in Manhattan, I came across a copy of Signac's book *D'Eugène Delacroix au Néo-Impressionnisme*. I was already much interested in the relations between the visual arts and the visual sciences in general, and this treatise, which I had not seen before, intensified my interest in Signac and in Neo-Impressionism. I resolved then and there to examine in some depth the relation between the scientific theory of color and the practice of Neo-Impressionist painting, touched on by Signac in his book. Since this was an avocation of mine rather than a vocation, the work progressed slowly and sporadically, and it has taken more than twenty years to gather all the materials needed and to complete this book. The delay was fortunate. During

that time the science of color advanced very rapidly, and many conflicts and contradictions among competing theories have been resolved. A more comprehensive and more unified theory of color is beginning to emerge, and Color in Neo-Impressionism can now be seen in much better perspective than ever before.

A principal aim of this book is to present these advances in color theory, and their bearing on Color in Neo-Impressionism, in a form accessible to all. Scientific material is therefore set forth in brief outline only and explained in nontechnical everyday language. Also, examples of relevant visual phenomena are either fully described or actually illustrated so that the bases for most major conclusions drawn will be self-evident in the reader's own visual experience. Overall, both the theory of color and the Neo-Impressionist movement are treated from a quasi-historical point of view so as to unfold gradually and make clear by degrees the origin and evolution of principal ideas and practices.

The book is arranged so that each topic furnishes background for and leads into the next. First, a biographical sketch of Paul Signac provides both an outline of his role in the development of Neo-Impressionism and a glimpse of the turn-of-the-century France in which the movement took place. Next, an historical note is presented to show, in a broader context, the place of Neo-Impressionism in the evolution of modern painting. With the biographical sketch and the historical note as background, the five-part essay *Color in Neo-Impressionism* begins with the central issue of the whole work: the distinction between two color phenomena—optical mixture of color and interaction of color—and their importance in the two artistic techniques of pointillism and divisionism, respectively. The next section outlines the origin and evolution of two seemingly con-

tradictory and long competitive color theories. One theory, the trichromatic, is derived largely from observations of optical mixture of color and is presented here as the scientific rationale for pointillism. The other theory, opponent-color, is derived largely from observations of the interaction of color and is presented here as the scientific rationale for divisionism. This is followed by a discussion of the modern trend toward a unification of these two theories of color, which turn out now to be complementary rather than contradictory. The essay then turns to the influence of the theory of color on the practice of the artist, with special attention to clarification of several issues concerning optical mixture of color, interaction of color, and the distinction between additive and subtractive mixtures of color. Finally, the essay concludes with a treatment of the relation between technique and temperament in art as exemplified by the work of three major figures in the Neo-Impressionist movement: Georges Seurat, Henri

Matisse, and Paul Signac. The translation of Signac's *D'Eugène Delacroix au Néo-Impressionnisme,* which follows, may then be viewed from a new art-historical standpoint, informed by the foregoing developmental account of the slow but inexorable scientific advances in color theory, and their relation to the actual practices of the colorist.

The principal thesis of this study, which is strongly supported by Signac's own writings, is that the Neo-Impressionist painters actually relied more on the technique of divisionism (with its interaction of color) than on the technique of pointillism (with its optical mixture of color). This new perspective on the hundred-year-old technique of Color in Neo-Impressionism, based on the more advanced and more unified color theory of today, forms a companion piece to other "revisionist" approaches to Neo-Impressionism, such as those that emphasize the social sources and cultural implications of the artists' work.

Paul Signac and Color in Neo-Impressionism

Paul Signac
A Biographical Sketch

Paul Signac was born 11 November 1863, in Paris, at 33 rue Vivienne, near the Bourse. (1863 was also the year of the death of Eugène Delacroix, the painter whom Signac later came to admire so much.) The Signacs were a bourgeois family in quite comfortable circumstances; Paul's father owned a saddler's shop in the Passage de Panoramas and was fairly well-to-do. Thrifty ways and prudent investments secured the family fortune and ensured that Signac would have a steady and substantial income throughout his entire life. Thus, he was able to travel widely and, in his middle age, to maintain a home in Saint-Tropez on the French Riviera and a home and studio in Paris. This affluence was in stark contrast to the meager means of most of his fellow artists. But Signac was generous and hospitable, and always shared his good fortune with his many friends.

During Signac's boyhood years the family kept two homes—one always in Paris itself, in Montmartre, and the other just outside the city, in Asnières, within the great loop of the Seine just below the Ile de la Grande-Jatte. In his teens, Signac studied at the College Rollin on the boulevard de Clichy. But chance played a greater role than formal education in the selection of his career. At that time he lived near the College (on the avenue Frochot) and on his way to and from his classes he walked through the bustling Montmartre art students' quarter and passed by the sidewalk displays and shops of the numerous art dealers in that section. This daily encounter with the

Paris art world set the course of his long and productive life. It first stimulated his interest in painting and then reinforced it at every turn. Soon Signac was well on the way to becoming an Impressionist. He visited the Impressionist Exhibition of 1879 on the avenue de l'Opéra (from which he was thrown out by Gauguin for making unauthorized sketches of Degas's work). He also attended the Claude Monet exhibition, held in June 1880 on the premises occupied by the publishers of the review journal *La Vie moderne* .

That same year Signac's father died, and it was at about this time that the sixteen-year-old Paul began to settle definitely on his own future. His lifelong career as an artist was chosen, firmly and irrevocably, just a little more than a year later. At that time, he withdrew from his studies for the baccalaureate at the College Rollin (although he was said to be a good student) and declared his intention to take up Impressionist painting. Signac's parents had wanted him to become an architect, and according to one account, he did enter the Ecole Nationale Supérieure des Arts Décoratifs in 1882, but evidently for only a short stay. The art of painting soon became his one and only objective in life.

Signac wasted no time. He immediately began painting in the open air—both in Montmartre and on the Seine riverside at Asnières. Almost at once he became a serious and truly dedicated artist, already much under the influence of the Impressionists. His favorites in that movement were Claude Monet, Camille Pissarro, Pierre Auguste Renoir, and Armand Guillaumin. That he and they were kindred souls is evident in their paintings: the soft blue shadows in Monet's *Vue des Tuileries* (View of the Tuileries) (1876) and in Pissarro's *Hoar Frost* (1873); the scattered splashes of various hues in Renoir's *Torse de femme au soleil* (Torso of a Woman in the Sun)

Principal sources of information for this biographical sketch were the works by Bock (1981), Broude (1974, 1978), Cachin (1968, 1971), Callen (1982), Halperin (1988), Hammacher (1962), Herbert (1958, 1965, 1968), Homer (1964), Lee (1983), Nochlin (1966), Rewald (1948, 1956, [1946] 1961, [1943] 1972, [1958] 1978), Szabo (1977), and Thomson (1985).

Books consulted for background on turn-of-the-century France include Bernier (1983), Milner (1988), Rearick (1985), and Weber (1986).

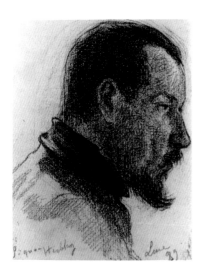

Figure 1 *Portrait of Paul Signac* by Maximilien Luce (1858–1941). 1889. Charcoal on paper, 19 × 15.9 cm. Collection of Mr. and Mrs. Arthur G. Altschul, New York (No. 251). Signed lower right: Luce 89; inscribed lower left: Signac-Herblay. Luce spent some time together with Signac at Herblay, on the Seine, during the summer of 1889. In this work he appropriately portrays the 26-year-old artist and seaman in the rough clothing of a sailor. There are numerous portraits and photographs of the gregarious, outgoing Signac at all stages of his career. All show him, except as a very young man, with the neatly trimmed and pointed beard which was almost a badge of membership in the intimate circle of Neo-Impressionist artists and Symbolist writers in which he moved.

(1876); and the Turneresque "frenzy" of color in Guillaumin's *Sunset at Ivry* (1873) all emphasized the effects of light and color rather than specific characteristics of the subject—as Signac and the other Neo-Impressionists were soon to do in their work.

Signac actually met Guillaumin when both were painting on the quays of the Seine at Asnières and was much encouraged by him. He soon followed the river to the sea in his painting and he executed his first seascapes at Port-en-Bessin, Brittany. Ever after Signac was drawn to the sea. He loved sailing and by the time he was grown he was a proficient sailor. He was proud of this accomplishment, and at one time he even went so far as to have the title "Captain in the Merchant Marine" printed under his name on his calling cards. In 1883 he bought his first sailboat. (He was to own a total of thirty-two during his lifetime!) On that first boat he painted the names of three innovators in art, literature, and music whom he greatly admired: Manet, Zola, and Wagner. (Names of some of the boats he owned later were more whimsical—The Epileptic Red Herring; The Tub; The Detachable Collar.)

Signac was largely self-taught. The only formal art training he ever received was for a short period in 1883 at the *atelier libre* of M. Jean Baptiste Philippe Emile Bin, a winner in 1842 of the prestigious Prix de Rome in art and a former mayor of Montmartre. But Signac received much informal training and inspiration from his early association with like-minded artists and critics of that time. He was in close touch both socially and professionally with several painters and writers who met regularly in Rodolphe Salis's Chat Noir cafe, and in 1882, at the age of nineteen, he contributed two articles to Salis's magazine, *Le Chat noir*. One of these articles, *Une Trouvaille*, was a clever imitation of the work of Emile Zola. Signac

also engaged in a certain amount of tomfoolery at the Chat Noir. In a fake funeral there he came dressed as and played the role of a nun.

Signac was always very serious about the new movement in art, however. He participated in the founding of the Société des Artistes Indépendants in 1884. And at a meeting of the Société on 9 June of that year he became acquainted with Georges Seurat. This acquaintance soon ripened into a close and enduring friendship. Now a full-fledged artist, mature in technique although not yet twenty-one in years, Paul Signac exhibited some of his paintings, along with Seurat, at the first Salon des Indépendants.

Among all the members of the Société, Seurat exerted the strongest influence on Signac; it was he who introduced the young painter to the scientific laws of physiological optics and who encouraged him to study the technical works of Charles Blanc, Michel-Eugène Chevreul, Ogden Rood, David Sutter, and Hermann von Helmholtz. At the same time, however, it was Signac who called the more experienced Seurat's attention to the effectiveness of the Impressionists' use of "pure" color. Signac's great admiration for the Impressionists and for their technique is further revealed in his written correspondence with Monet and in the record of a personal interview with him in 1885. Incidentally, it was the title of one of Monet's paintings, *Impression, soleil levant* (Impression, Sunrise), that led the critic Louis Leroy to coin the term *Impressioniste* in a sarcastic and derisive review of the 1874 exhibition of the *Société anonyme des artistes peintres, sculpteurs, et graveurs etc.* (the first Impressionist exhibition).

Signac spent the summer months of 1885 at the port of Saint-Briac where he painted seascapes. One of them was *La Croix des marins* (The Sailor's Cross), painted in a style best characterized as inter-

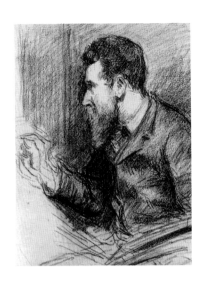

Figure 2 *Portrait of Georges Seurat* by Maximilien Luce. 1890. Charcoal on paper, 29.9 × 22.9 cm. Collection of Mr. and Mrs. Arthur G. Altschul, New York (No. 272). Inscribed lower left: Seurat par Luce (in uncertain hand). Portraits and photographs of the rather shy and withdrawn Seurat are rare. This one, a study of the artist at work, was drawn the year before his death at age 31, and appeared on the cover of an 1890 issue of *Les Hommes d'aujourd'hui* devoted to Seurat. The text on Seurat for this issue was written by Jules Christophe. Monographs on many of the Neo-Impressionists were published in this small biographical weekly, wherein artists supplied portraits of one another, and accompanying texts were provided by their Symbolist literary friends. For more on Luce and these two portraits, see Herbert (1965).

Figure 3 *Boulevard de Clichy* by Paul Signac (1863–1935). 1886. Oil on canvas, 45.7 × 64.1 cm. Collection of The Minneapolis Institute of Arts, Minnesota, bequest of Putnam Dana McMillan. Signed lower left: P. Signac. Signac's studio was near the place de Clichy, and the College Rollin he had attended in his youth was on the boulevard de Clichy itself. This view of the boulevard was painted at about the time when his systematic divisionist manner was just beginning to emerge (see Cachin 1971). Intimations of the transition from one style to another can be seen in this one painting. The white and bluish tones of the formless swirling snow in the boulevard and in and among the trees aligning it are almost purely Impressionistic. The detailed treatment of the more substantial buildings on either side, however, is definitely in the Neo-Impressionist style (see Courthion 1972).

mediate between Impressionism and Neo-Impressionism. That same year Seurat painted his monumental *Un Dimanche après-midi à l'Ile de la Grande-Jatte* (Sunday Afternoon on the Island of the Grand Jatte), using his new "scientific" technique. The effect on Signac of this extraordinary painting and of this revolutionary technique was profound and long lasting. From that time onward until the end of his life he was a steadfast Neo-Impressionist. But Signac emphasized that Seurat and he, and the other leading Neo-Impressionists, were "divisionists," not "pointillists." That is to say, they painted with small touches of pigment, each separate and visually distinct, rather than with minute points, each separate but visually indistinct. As Signac was later to write:

> There is a widely held, erroneous belief that the Neo-Impressionists are painters who cover their canvases with multicolored *petits points* (dots). We shall later prove what we affirm at the outset, namely that the trivial procedure of *dotting* has nothing in common with the aesthetic of the painters defended in these pages, or with the technique of *division* used by them.
>
> The Neo-Impressionist does not paint with *dots*, he *divides*.

Signac practiced what he preached. By the winter of 1885–86 he was painting entirely in the prescribed divided manner. One of the first of his major Neo-Impressionist works, *Les Modistes* (The Milliners) (1885–86), was completed at that time. In the spring of 1886, Signac showed *Les Modistes* at the eighth and last Impressionist exhibition. The work was in very good company there, along with paintings by Camille Pissarro, Lucien Pissarro, and Georges Seurat. And it was the work of these four artists, at this final Impressionist exhibition, to which

the Symbolist critic Félix Fénéon first applied the term *Néo-Impressionnisme.* (Seurat's own more descriptive but less felicitous terms, *Peinture optique* and *Chromo-luminarisme,* were never widely adopted.)

The Symbolist writers and the Neo-Impressionist painters who had met here and there from time to time began to meet more regularly, along with others of the avant-garde, in Signac's studio on the boulevard de Clichy. As Gustave Kahn wrote: "Seurat, Luce, Dubois-Pillet, Cross, and Van Rysselberghe rubbed shoulders with Paul Adam, Félix Fénéon, and myself. Henri de Regnier was seen there. A musician, Gabriel Fauré, and Paul Alexis used to come, and Camille Pissarro . . . who had joined the pointillists."

Another distinguished (and somewhat eccentric) member of this mixed group was the inventor Charles Henry, a librarian at the Sorbonne and a former laboratory assistant to the world-famous physiologist Claude Bernard. (Later, Henry was to become director of the Laboratory of Sensory Physiology at the Sorbonne.) Through Fénéon, the Symbolist editor, publisher, and critic, Henry became acquainted with Seurat and Signac in the spring of 1886, the same year in which he published his *Introduction à une esthétique scientifique.* Seurat was strongly influenced by Henry, whose "scientific" rules of aesthetics he attempted to apply in his paintings.

Signac did not follow Seurat here, however, even though he did collaborate closely with Henry and produced several drawings and color samples for some of Henry's writings. Notable among Signac's many works for Henry is his well-known color lithograph *Application du cercle chromatique de M. Ch. Henry* (Application of Monsieur Ch. Henry's Chromatic Circle) (1888–89), on the back of the program

of Antoine's Symbolist Théâtre libre. The lithograph was an ingenious artistic "review" of Henry's book *Le Cercle chromatique*, as well as an advertisement of Antoine's theater. Although Signac supported Henry in his studies on aesthetics, it appears that he regarded Henry's rules more as aids for teaching the appreciation of beauty to the layman than as a guide for the practicing artist. Nevertheless, Signac did seem to believe in some form of "logic" in art, for he frequently quoted Delacroix's remark:

> The art of the colorist is obviously similar in some ways to mathematics and music.

This is an oft recurring theme in the history of color; even the ancient Greeks spoke of the relationships among and transitions between colors as harmonious. But a direct and literal analogy between the harmony in a series of prismatic colors and the harmony in a series of musical tones is strained. Prismatic colors are not related to one another mathematically or psychologically in the same way that musical tones are. *Harmony* has many meanings, however. And the harmony sought by Signac was more in the accord of the contrast of diametric pairs of complementary colors than in the consonance of a series of prismatic colors.

In the winter of 1886–87, Signac painted *Le Petit déjeuner* (Breakfast), which is regarded by many as one of the greatest—if not *the* greatest—of all his paintings in the Neo-Impressionist style. In this work Signac's harmony of contrast rules supreme. The painting was exhibited in the Salon des Indépendants in the spring of 1887 and is now in the Rijksmuseum "Kröller-Müller" in Otterlo, The Netherlands. Also in 1887, Signac painted more seascapes, this time at Collioure. In 1888, both he and Henri de Toulouse-Lautrec exhibited with the Belgian avant-garde group Les XX (Les Vingt, or The Group of Twenty) in Brussels. In the following year, he painted at Portrieux in the north of Brittany, and ever afterwards he returned often to that region of France, which holds such an attraction for artists.

The sociable Signac was a natural leader and soon became widely recognized as the principal spokesman for and chief publicist of Neo-Impressionism. He was largely responsible for introducing Vincent van Gogh to the new movement and explaining some of its technical "secrets" to him. He also established a close relationship with Théo van Rysselberghe, the principal Belgian Neo-Impressionist and a founding member of the antiacademic Les XX, and with Henri van de Velde, who made important contributions to the development of Neo-Impressionism in Holland, Germany, and Belgium. Signac exhibited with Les XX again in 1890, and in 1891 he was elected a foreign member of that society.

Neo-Impressionist painting was strongly affected by the interaction of diverse artistic influences and by the friendly relationships and interchange of ideas among men of greatly differing backgrounds. This interplay of techniques and ideas manifested itself in a striking way in Signac's portrait of Félix Fénéon, which was first exhibited at the Salon des Indépendants in 1890. It is a most unorthodox painting—a remarkable combination of Neo-Impressionist technique, Japanese influences, and Charles Henry's theories of color and line. The humor and subtlety of the many serio-comic references in the painting to various persons, ideas, and events of that period are reflected in the whimsical title of the work: *Sur l'émail d'un fond rhythmique de mesures et d'angles de tons et de teintes, portrait de M. Félix Fénéon en 1890* (Against the Enamel of a Background Rhythmical with Beats and Angles, Tones and Col-

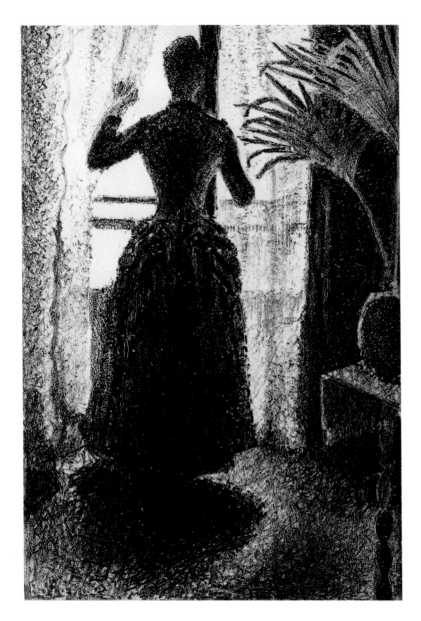

Figure 4 *Femme regardant à la fenêtre* (A Parisian Sunday) by Paul Signac. 1887–88. Lithograph on paper, 17.4 × 11.8 cm. All rights reserved, The Metropolitan Museum of Art, New York, Harris Brisbane Dick Fund 1928 (28.80.9). Written in pencil on the back: Femme Regardant à la Fenêtre. This lithograph, published in *La Revue indépendant de litterature et arte,* January 1888, portrays the reversed figure of the woman in Signac's oil painting (1888–90) of the same title (see Szabo 1977). It is also almost a perfect mirror image of Signac's earlier charcoal study (1886) for that same painting. (For some unknown reason, the design on the stone for this lithograph was given the same orientation as that of the finished earlier works, so it printed in reverse with regard to them.) The style of *Femme regardant à la fenêtre* and the manner in which it is executed give it the appearance of a typical Neo-Impressionist charcoal drawing. The rather stiff figure and the very strong forced contrast of light and shade, especially at the boundary of the woman's shadow on the floor, show the influence of Seurat. The theme of the work is almost certainly based on an earlier (1880) painting by Signac's friend Gustave Caillebotte (1848–1894), entitled *Interieur, femme à la fenêtre* (see Varnedoe 1987).

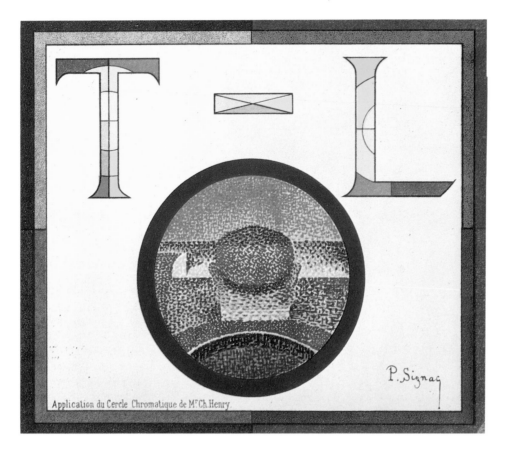

Application du Cercle Chromatique de M.ᵉCh.Henry.

P. Signac

Figure 5 *Application du cercle chromatique de M. Ch. Henry* (Application of Monsieur Ch. Henry's Chromatic Circle) by Paul Signac. 1888–89. Color lithograph, 16.2 × 18.7 cm. Collection of The Museum of Fine Arts, Boston, gift of Peter A. Wick 1955. Signed on the stone: P. Signac. The original of this color lithograph was intended to serve two purposes simultaneously: to advertise Charles Henry's book *Le Cercle chromatique* (as indicated by the several circular designs) and to promote the Théâtre libre (as indicated by the initials *T-L*). Signac also made a poster in watercolors to advertise the book. The later version of the lithograph shown here was used as a program cover for a play written by one of Signac's friends which was presented at the Théâtre libre in 1889. The program is printed on the back. An analysis of this work by Herbert (1968), summarized below, shows how the arrangement of the colors illustrates some aspects of Henry's color circle and some general principles of the contrast of colors. The *T* and the *L* appear as sections cut out of Henry's color wheel—rightside up in the *T* and upside down in the *L*. The dash between the *T* and the *L* is composed of the two pairs of opponent colors: red versus green, and yellow versus blue. The tondo is filled with contrasting colors. At the top, the orange-red of the stage is opposed by the bluish green of the spectator's hair; in the middle, the yellow of the footlights sets off the purple hair; and lower down the hair is bluish green again to oppose the ruddy flesh tones. The border of the lithograph mirrors contrasting pairs of colors diagonally, from one corner to another. An outer red and an inner green in the lower left reverse to inner red and outer green in the upper right. The contrasting yellows and blues on the other diagonal are similarly reversed. The interest of artists and aestheticians in opponent colors, as evidenced in this lithograph, was completely independent of concurrent developments in the scientific opponent-color theory.

ors, Portrait of Monsieur Félix Fénéon in 1890). Fénéon reciprocated with a monograph on Signac for an issue of *Hommes d'aujourd'hui*. Seurat also made a contribution to that same issue. His magnificent portrait of Signac, in charcoal, entitled *Paul Signac, 1890*, was reproduced on the cover.

Signac and Seurat were very closely attached to one another, and the death of Seurat at the early age of 31 in March 1891 was a severe trauma for Signac. After some months of mourning and depression, he recovered from the loss, resumed his painting, and soon his life took a new direction. In December 1892 he married Berthe Robles, a relative of his friends the Pissarros. Signac painted one portrait of her, *La Femme à l'ombrelle* (Woman with Parasol) (1893), evidently from a photograph, rather than from life.

The anarchist–communist painter Henri-Edmond Cross (née Delacroix), who was to become a very close friend, encouraged Signac to leave Paris. Signac's love of the sea attracted him to the Mediterranean port of Saint-Tropez. In the spring of 1892 he made the break and sailed there in his boat *Olympia*. His marriage was not successful, and later on in Saint-Tropez he established a home with his mistress, Jeanne Selmersheim-Desgrange, in a small villa called La Hune. They never married, but lived together for the remainder of Signac's life as man and wife. They had one child—a daughter, Ginette. Selmersheim-Desgrange was a jewelry designer and a painter in the Neo-Impressionist style. Her mosaic-like *Jardin de La Hune* (Garden at La Hune, Saint-Tropez) (1909) shows the influence of Signac's teaching in almost every broad stroke of the brush. La Hune and Saint-Tropez soon became home rather than a second home to Signac. He stayed there for the greater part of each year until 1911. His friend and fellow artist Cross also settled in Saint-Tropez. Signac's ample means enabled him (and Cross) to be generous hosts, season after season, to their many friends and colleagues from Paris.

In 1895, Signac completed a study in oils for a commissioned mural, *Au Temps d'harmonie* (In Time of Harmony), which at first he intended to call *Au Temps d'anarchie* (In Time of Anarchy). The finished work was painted in the town hall of Montreuil and was his one and only large mural. This work was a reflection on and statement of Signac's idealistic views on the "golden age" which was envisioned but yet to come. At that time Signac's involvement with avowedly anarchist intellectuals (who saw both art and science as progressive forces) was quite sincere and very strong. In fact, the full title of the mural, *In the Time of Harmony. The Golden Age Is Not in the Past, It Is in the Future*, was actually derived from the writings of the anarchist leader Charles Malato (author of *Philosophie de l'anarchie*).

For the most part, Signac and his anarchist companions were more concerned with the idea of anarchy than with the deed. But even so, many of them were dedicated activists rather than mere advocates, and were well known as such to the authorities. Indeed, two of Signac's best friends, Félix Fénéon and Maximilien Luce, who were deeply involved in the militant branch of the anarchist movement, were imprisoned for a short time after the assassination of M. Marie François Sadi Carnot, the President of France, in 1894. Luce was never brought to trial. But on the basis of indisputable evidence, Fénéon was charged with possession of explosives. A skillful defense resulted in a tie vote of the jury and a mandatory acquittal. The acquittal was not deserved. Much later, in his old age, Fénéon confessed to a friend that it was he who had set the bomb that exploded in the restaurant of the Hotel Foyot.

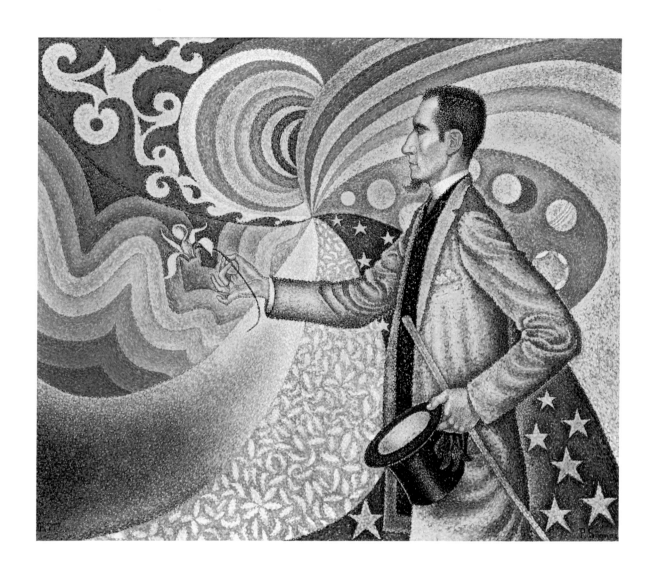

14

Figure 6 *Sur l'email d'un fond rhythmique de mesures et d'angles de tons et de teintes, portrait de M. Félix Fénéon en 1890* (Against the Enamel of a Background Rhythmical with Beats and Angles, Tones and Colors, Portrait of Monsieur Félix Fénéon in 1890) by Paul Signac. Oil on canvas, 74 × 95 cm. Private collection, New York. Photo: Malcolm Varon, NYC. © M. Varon. Signed and dated lower right: P. Signac 90; marked lower left: Op. 217. This remarkable portrait, bordering on the bizarre, was not only extraordinary in Neo-Impressionist work, it was also in a style most unusual for any type of painting of its time and place. Such a theatrical pose against such a flat and stylized background is probably without parallel in late nineteenth-century French art. It was most appropriate for Signac to recognize Fénéon and to pay tribute to him in this dramatic Neo-Impressionist painting, for it was Fénéon, the brilliant Symbolist art and literary critic, who gave the name *Néo-Impressionnisme* to the new movement. Furthermore, he was one of its principal champions. He followed the work of the Neo-Impressionists closely over the years, and wrote numerous informative articles about the artists and many favorable reviews of their exhibitions. For a biography of Fénéon, see Halperin (1988). The painting is both a serious portrait of Fénéon and a collection of humorous references to persons and ideas influential in Neo-Impressionism. Art historians have many and diverse opinions about the specific influences that shaped this portrait and that gave rise to the several ideas represented in it (e.g., see Cachin 1971; Halperin 1988; Herbert 1968). It is generally agreed that Japanese prints and textiles and Henry's *Cercle chromatique* contributed to the composition of the background. It has been suggested that the stars might be symbolic of the United States—Fénéon's resemblance to Uncle Sam was an "in" joke among his friends. The graded bands of color at the left may have been an adaptation of Chevreul's Illusion (see Figure 28), in which uniform steps take on a fluted appearance. Fénéon's pose, along with the English top hat and cane, and the lily he holds, have been taken as a reference to Oscar Wilde. But these and other interpretations are highly speculative. The many allusions to persons and events of that time were quite subtle—meaningful only to a few members of a select circle, even then. And now, a hundred years later, they have all the mystery of the symbols of an ancient secret society. Lacking a detailed written explanation by the artist or by the model, it is unlikely that the intended meaning of this extraordinary painting can ever be fully deciphered.

By this time, Signac's views on the Neo-Impressionist technique were beginning to change, and these changes appeared both in his writing and his painting. In 1895 he started work on his study of the origin, evolution, and technique of Neo-Impressionism. His painting began to depart more and more from a strict adherence to Seurat's "scientific" rules—especially noticeable in the broadening of his brushstrokes. The influence of Charles Henry's aesthetics, never very strong and already on the wane, diminished still further. But Signac's agile mind was never still; as these early influences weakened, others soon took their place. For example, he gradually developed a greater interest in the work of other artists, both classical and contemporary. In 1896, Signac took his first trip to Holland, and in 1897 he traveled to London to see Joseph Mallord William Turner's work. He saw there not mere pictures but, in his words, "polychromes" and "jewelry." For Signac, Turner's works were "the most useful lesson in painting ever to be gotten."

Signac's treatise on color, *D'Eugène Delacroix au Néo-Impressionnisme,* was first published serially in 1898 and then in book form in 1899. The publication of this book on the history and fundamental principles of Neo-Impressionism set forth Signac's own views and signaled his release from Seurat's formal rules of the early movement. Signac had come into his own as leader of the second phase of Neo-Impressionism. His own techniques were now paramount. Broader strokes of the brush—a true divisionism, distinct from pointillism—characterized all of his later work. He paid less and less attention to mathematical aesthetics, and more and more to the freer and more spontaneous medium of watercolors. But these gradual changes over the years were neither an abandonment nor a repudiation of established

Neo-Impressionist technique. They were merely a further development in the natural evolution of that technique which Signac still regarded as "guided by tradition and science."

Henri Matisse came to Saint-Tropez in the summer of 1905 and both Signac and Cross thoroughly indoctrinated him in the aims of Neo-Impressionism and tutored him in its methods. Matisse was still exploring, still searching for his own way. He would paint at one time in a nicely stippled, almost pointillist manner and at another time in broad, divisionist strokes. But for Matisse this excursion into Neo-Impressionism was all a diversion, an experiment, a mere "flirtation" with a technique; and he soon turned back to his own emerging style, in which he was guided more by his own instinct and intuition than by laws or rules, whether of art or of science.

Signac's interests continued to broaden and he traveled more and more. In 1904 he made a trip to Venice, and in 1906 a second trip to Holland; in 1907 he visited Constantinople, and in 1908 returned to Venice. Everywhere he painted watercolors *sur le motif,* many of which are now recognized as great works of art, but which he himself regarded then only as notes for the larger oil paintings to be done later in his studio. Travel to new places enlarged the artist's perspective on the old. For example, the splendor of the unfamiliar Venice contrasted with and enhanced the ruggedness of the familiar Provence. As Signac's close friend Henri-Edmond Cross wrote in a letter to Pierre Angrand in 1904:

> The admiration and the taste one has for the coast of Provence is an excellent preparation for the sensual joys of Venice. Their beauties, so different, are reunited in an equal amiability: the one is rough and exposed, the other is light and decorated with the most precious jewels. And, as in "Sacred and Profane Love" by Titian, they look at their reflections in the same water.

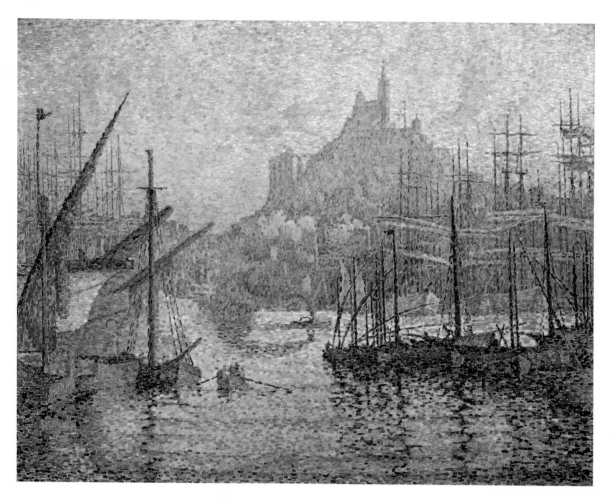

Figure 7 *View of the Port of Marseilles 1905* by Paul Signac. 1905. Oil on canvas, 88.9 × 116.2 cm. © 1979 The Metropolitan Museum of Art, New York, gift of Robert Lehman 1955 (55.220.1). Signed and dated lower right: P. Signac 1905. Signac's love of the sea and of sailing is manifested in his numerous paintings of French ports. This view of the Port of Marseilles is from the north bank of the old port. Looking south across the water one sees the basilica of Notre Dame de la Garde on a steep limestone peak. Rising from the top of the church is a thirty-foot gilded statue of the virgin, once known locally as *La Bonne Mère* (The Good Mother), a title formerly given to this painting (see Szabo 1977). The tendency toward gray, a danger inherent in the divisionist technique, is put to good use here (along with a judicious use of white) to envelop the distant peak and the far reaches of the harbor in a cold and misty haze.

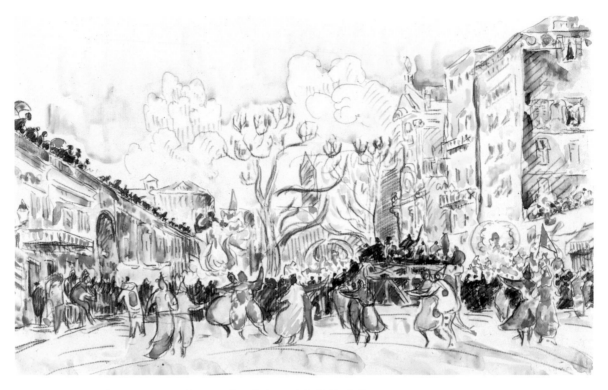

Figure 8 *Carnival at Nice* by Paul Signac. ca. 1920–21. Watercolor over preliminary drawing in black chalk on paper, 24.4 × 44 cm. Collection of The Yale University Art Gallery, gift of Mr. and Mrs. Arthur G. Altschul, B.A. 1943. Signed lower right: Paul Signac. This watercolor is one of a series of five which depicts the Marche de Ponchettes in Nice during its annual carnival. All are undated. Two were published by Signac's close friend, follower, and biographer Lucie Cousterier in 1922, establishing a likely date for the series of about 1920 or 1921 (see Herbert 1968). The dynamic manner in which the human figures are represented in this watercolor is rare in Signac's work in other media. In contrast to the cold, stiff, and formal isolation of individual figures, characteristic of so many of Signac's meticulous divisionist paintings, slowly and carefully executed in oil, the engaged activity and gaiety of the dancers in the *Carnival at Nice* share the liveliness inherent in the watercolor medium in which the work is rapidly executed. Although best known for his work in oils, Signac turned again and again to watercolor in which he was equally proficient. And, according to authorities, his finest watercolors, painted in the last decades of his life, place him in the first rank of watercolorists in the French school. Information on this painting is from Herbert (1968). For other watercolors by Signac, see Szabo (1977).

The death of Cross in 1910 was as great a shock to Signac as had been the death of Seurat many years before. It marked the close of another major period in Signac's life.

In 1914, in Antibes, Signac published anonymously a miniature work on Stendhal—a so-called *mini Stendhal par lui-meme,* once described by an admirer as the "smallest great book in the world." This "book" was only a thin pamphlet entitled *Aide-mémoire Stendhal-Beyle,* a four-page "autobiography" of the French writer Marie-Henri Beyle (1783–1842), who wrote under the name Stendhal and whose libertarian and internationalist views greatly influenced Signac. World War I, which broke out then, was another great trauma for Signac, who was himself a true libertarian and a pacifist, and who was international in his outlook on both art and society. He could not understand how some of his foreign friends could so suddenly become his enemies.

During the war years, from 1913 to 1919, Signac lived at Antibes with his mistress. From 1920 to 1930, they lived and worked in Paris, Brittany, and Vendee. In these later years Signac painted finished works in watercolors, rather than mere notes or sketches. Among these works were paintings of more than 200 French ports and harbors! Several of Signac's finest watercolors joined some of those of Eugène Delacroix, Jules Cheret, Eugène Boudin, Constantin Guys, and Johan-Barthold Jongkind in the private collection of Claude Monet—one of Signac's boyhood idols and the nominal founder of Impressionism. In 1927, at the age of 64, Signac published his book on Jongkind, whom he greatly admired as a precursor of both Impressionism and Neo-Impressionism and whose watercolors he also collected. Signac's widely acclaimed discourse on watercolor forms a major chapter of the book under the title, *Traite de l'aquarelle.*

Signac was an active and thoroughly dedicated Neo-Impressionist until the very end. He became president of the Société des Indépendants in 1908 and remained in that office until his death. In 1930, a retrospective exhibition of his paintings was held at the Galerie Bernheim-Jeune, Paris. And in 1931 an exhibition of his work was held at the Carnegie Institute in Pittsburgh. Although Signac was now in his late 60s, he continued to work both in his studio in Paris and in the open air along the coast of Brittany, painting more and more watercolors of ports. He seemed to be fixed on this one particular subject, but in fact his choice was probably more a reflection of his love of the sea than a belief that it was a superior motif for art. In 1935, the year of his death at age 72, he prepared an essay on *Le Sujet en peinture* for *L'Encyclopédie francaise,* in which he discussed the relative merits of subject and composition. He wrote:

> It is through the harmonies of lines and of colors, which he can govern according to his needs and his will, and not through the subject, that the painter ought to stir the emotions.

The whole of Signac's life was devoted to a search for those harmonies—in particular, for the way "to give color the greatest possible brilliance." In this search he combined painterly practice and scholarly study in a unique manner and thereby made important contributions to both the development and the elucidation of the theory of Color in Neo-Impressionism.

An Historical Note

The place of Neo-Impressionism in the evolution of modern art

Neo-Impressionism was but one short link, across *la belle époque*, in a long chain of events leading up to the art of today. The preceding biographical sketch of Signac emphasizes the contributions of that one man to Neo-Impressionism, and the appended translation of Signac's book gives his personal turn-of-the-century view of the movement—its origins, its technique, and its contributions. But Color in Neo-Impressionism needs to be placed in a much larger art-historical context in order to see more clearly the major role it has played in the evolution of modern painting. To serve that purpose, a simple chronology of some of the most significant movements and an identification of some of the most notable colorists in the direct line of that evolution are presented here below.

Romanticism

In the late eighteenth and early nineteenth century, there was a quickening of an ongoing and widespread but irresolute revolt in art, literature, and music against the formalism of Neo-Classicism. In art, ancient Greek and Roman examples provided the classical sources, and the accepted style was characterized by appeal to reason and intellect, with a demand for a well-disciplined order and restraint in the work. The decisive Romantic movement away from this formality emphasized the individual's right of self-expression in which imagination and emotion were given free rein. The Romanticists stressed color (and the emotions it could express) rather than line (and the rational). Their style was painterly rather than linear; color offered them a freedom that line denied.

Also, subjects of the Romantic artists were more timely, often derived from contemporary Romantic writing rather than from the classical sources of antiquity.

Among the Romanticists who had a strong influence on Impressionism were, in Britain, Joseph Mallord William Turner (1776–1837); in Germany, Caspar David Friedrich (1774–1840); and in France, Eugène Delacroix (1798–1863). Turner, in whose works sumptuous color took precedence over the realistic portrayal of form, had a direct influence on both the Impressionists and the Neo-Impressionists, some of whom traveled to London for the sole purpose of seeing his works. Friedrich's magnificent natural landscapes presaged the naturalism that was to come in both the Barbizon School and Impressionism. And Delacroix, the master colorist, led the way for the Impressionists to use pure unmixed hues—both on the palette and on the canvas. "It is well," he wrote, "if the brush-strokes are not actually fused. They fuse naturally at a certain distance by the law of sympathy that has associated them. The colour thus gains in energy and freshness."

Delacroix's style was similar to that of the Neo-Classicists in that it was monumental and often dealt with heroic events or with great human tragedies. His *Le 28 juillet, La Liberté conduisant le peuple aux barricades* (Liberty Guiding the People), painted in 1830 at the age of 32, is a good example of the heroic. This female figure of freedom, leading the people in revolt on the barricades, is one of Delacroix's most famous and most popular paintings. *La Liberté,* herself portrayed as a woman of the oppressed people, has since become *the* symbol of a free France. Delacroix's *Mort de Sardanapalus* (The Death of Sardanapalus) of 1827 is a typical Romantic subject in a tragic vein. In this colorful painting there is a melo-

dramatic representation of the all-powerful satrap on his deathbed, cruelly, yet calmly, ordering his eunuchs to slay and to send into the afterworld with him all the dearest members of his household. *Mort de Sardanapalus* was inspired by a work of Byron (as were many of Delacroix's themes).

Although Delacroix's works were similar in some respects to the Neo-Classicists', they differed significantly in others. The dynamic action and vitality of Delacroix in comparison with the more restrained and statuesque work of Jacques Louis David, for example, is striking (see Friedlaender 1971). But most important for this study on Color in Neo-Impressionism, and more revolutionary than any other aspect of his painting, was Delacroix's attention to and emphasis on color itself (see Pach's 1937 translation of Delacroix's journal). Indeed, this alone was sufficient to lay the groundwork for the Impressionism and Neo-Impressionism that was to come.

Delacroix's *Femmes d'Alger dans leur appartement* (Women of Algiers in Their Apartment), painted in 1834 after an extended trip to Morocco where he was almost overwhelmed by the light and color there, was a virtual textbook on "eloquent color" and "lyrical harmony" for Signac. In *D'Eugène Delacroix au Néo-Impressionnisme* (Chapter 2, section 10) Signac analyzed Delacroix's color in this painting as follows:

> The orange-red bodice of the woman reclining at the left has a blue-green lining: these areas, in complementary hues, enhance one another in mutual harmony, and this favorable contrast gives the fabrics an intense brilliance and luster.
>
> The negress's red turban stands out against a door-curtain striped in varied colors, but it meets only the greenish stripe, the very one that creates the most satisfying harmony with this red.

Red and green alternate on the paneling of the wardrobe, providing another example of binary harmony: the violet and green of the floor tiles, the blue of the negress's skirt and the red of its stripes offer harmonies which are no longer those of complementary but more closely related colors.

After these examples of the analogy of opposites, we would have to cite almost every part of the painting as an application of the harmony of like colors. Each part quivers and vibrates, because of touches of tone upon tone, or of almost identical hues, for which the subtle master has hammered, dabbed, caressed, and hatched the various colors, having first laid them flat and then worked them over again by means of his ingenious method of gradation.

The outstanding brilliance and the glowing charm of this work are due not just to this use of tone on tone and of small intervals, but also to the creation of artificial hues resulting from the optical mixture of more remote elements.

The green trousers of the woman at the right are flecked with little yellow designs; this green and this yellow mix optically and create a local yellow-green which is really the soft, shining color of a silken fabric. An orange bodice is enhanced by the yellow of its embroideries; a yellow scarf, rendered more intense by red stripes, blazes out in the middle of the painting, and the blue and yellow ceramic tiles of the background merge in an indefinably green hue of rare freshness.

We will also mention the examples of gray hues obtained by the optical mixture of pure opposed elements: the white of the blouse worn by the woman at the right is interrupted by a soft, imprecise hue, created by the juxtaposition of little flowers in pink and green; the soft, shimmering hue of the cushion on which the woman at the left is reclining is produced by the mingling of little red and greenish embroideries which, being adjacent, are reconstituted as an optical gray.

As will become evident later on, almost every aspect of the Neo-Impressionist technique that was to follow in half a century, except the use of the

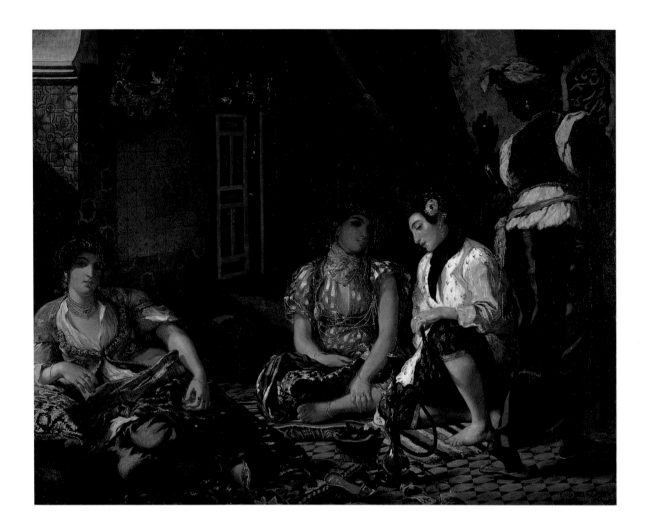

Figure 9 *Femmes d'Alger dans leur appartement* (Women of Algiers in Their Apartment) by Eugène Delacroix (1798–1863). 1834. Oil on canvas, 1.80 × 2.29 m. Collection of The Louvre, Paris. Photo: © Réunion des Musées Nationaux. This work shows the beginnings of the strong and long-lasting influence of Delacroix's journey to Morocco in 1832. The brilliance and the harmony and contrast of the Oriental color he saw there was very much in accord with and readily adaptable to his own emerging style. Of all of Delacroix's work, this one painting probably had the greatest influence on Signac.

divided touch throughout, was anticipated somewhere in this one magnificent work by Delacroix.

The Barbizon School

The transition between Romanticism and Impressionism was provided by a small group of painters (mostly French) who lived and worked in the village of Barbizon near the Forest of Fontainebleau about 1830–1870 (see Bouret 1973). Their naturalistic style was empirical, based almost entirely upon the direct observation and painting of nature in the open air. And in their typical depictions of rural genre and natural landscape subjects, they paid careful attention to the colorful expression of light and atmosphere. For them, color was as important as composition; and this free and visual approach, with its appeal to emotion, gradually displaced the more studied and formal, with its appeal to reason. (Charles Baudelaire once described this departure from accepted ways as a "silly cult of nature unpurified, unexplained by imagination.") The school was founded by Théodore Rousseau (1812–1867) and included, among others, Jean Baptiste Camille Corot (1796–1875), Jean François Millet (1814–1875), and Charles François Daubigny (1817–1878). Corot, especially, was important in the transition from Romanticism to Impressionism. He had great influence on his successors, and was much admired by them. The young Monet, one of the founders of Impressionism, once wrote: "The Corots are absolute wonders."

Impressionism

This movement grew out of and followed immediately after the Barbizon School (see Pool 1967). A distinguishing feature of the work of the Impressionists was the application of the paint in touches of mostly pure color rather than in blended color, which made their pictures appear much more luminous and colorful even than the work of Delacroix, from whom they had learned the rudiments of the technique. To the modern eye, the accepted paintings of the salon artists of that day seem pale and dull, almost drab and lackluster, by comparison. But still more could be achieved. As Signac wrote, "The brilliance of this result is lessened by soiled pigmentary mixtures and its harmony is limited by an intermittent and irregular application of the laws governing color." Like the painters of the Barbizon School, much of their painting was done out of doors, and they attempted to capture the ephemeral, fleeting impression of the play of light at a given moment. Technique was most important, but other factors in their lives and in that time helped to shape the movement, too. For an account of the many and diverse social and cultural influences on Impressionism, see Herbert 1988.

The first Impressionist Exhibition was held in 1874. Prominent among the Impressionists were Claude Monet (1840–1926), Pierre Auguste Renoir (1841–1919), Alfred Sisley (1839–1899), Camille Pissarro (1830–1903), Paul Cézanne (1839–1906), Eugène Boudin (1824–1898), Berthe Morisot (1841–1895), Armand Guillaumin (1841–1927), and Gustave Caillebotte (1848–1894). All these and many others contributed much to Impressionism. But the work of Monet and Renoir was especially significant. Monet (whose comma-like brushstrokes were once called "tongue lickings" by an irate critic) and Renoir (who extended the Impressionist technique to figure painting) painted together for a time at La Grenouillère, the popular public bathing place and

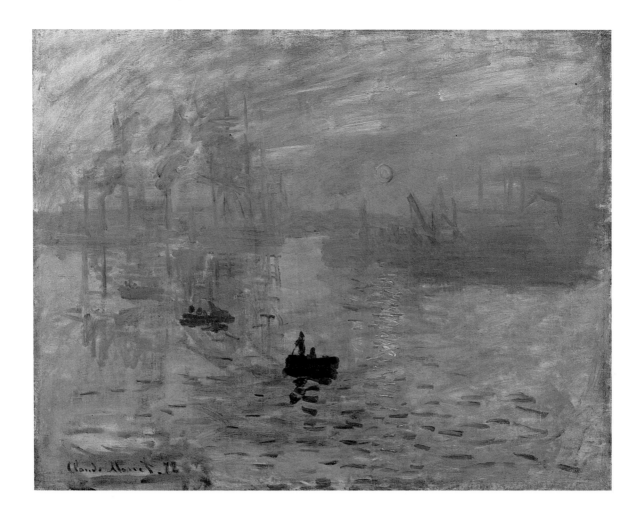

Figure 10 *Impression, soleil levant* (Impression, Sunrise) by Claude Monet (1840–1926). 1872. Oil on canvas, 50.4 × 65.4 cm. Collection of the Académie des Beaux-Arts, Musée Marmottan, Paris, bequest of Donop de Monchy. Inv. 4014. Signed and dated lower left. In this work Monet focused his attention almost exclusively on his immediate overall impression of light and color rather than upon a studied view of the details of the landscape itself, much in the manner of Turner. The critic Louis Leroy coined the term "Impressionist" in a scornful review of the work. Thus Monet unintentionally named the whole Impressionist movement when he gave the title *Impression* to this one painting. For further discussion of the origin and acceptance of the term *Impressionism,* as applied to this movement, see Dayez (1974).

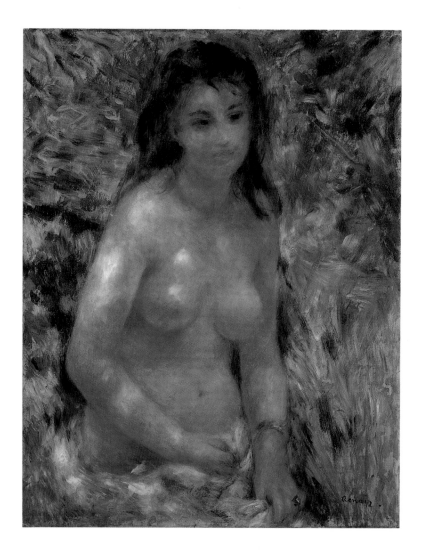

Figure 11 *Torse de femme au soleil* (Torso of a Woman in the Sun) by Pierre Auguste Renoir (1841–1919) ca. 1875–76. Oil on canvas, 81 × 65 cm. Caillebotte Bequest, 1894, to the Musée du Luxembourg, Paris, 1896 to the Musée du Louvre, 1929 Photo: © Réunion des Musées Nationaux. Signed, lower right. Renoir almost alone among the Impressionists, concentrated on portraiture and the human figure, rather than on the usual landscapes. This painting, included in the second Impressionist exhibition, was badly received by the critics (see Dayez 1974). The color without sharp contour, the greenish cast given to the figure by reflected light from the surrounding yellow green foliage, the mottled appearance of the skin in the patchy light filtered through the overhanging trees, led to this sarcastic remark by Albert Wolff in Le Figaro: "Try to explain to M. Renoir that a woman's torso is not a head of decomposing flesh covered with green and purple patches, which are the sign of advanced putrification of a corpse." Wolff's review was typical of most of the critics of that day. Few were ready for the Impressionists' emphasis on light and color rather than on an accurate portrayal of the features of the model.

social center at Bougival on the Seine. This close co-operation between Renoir and Monet at Bougival, where some of their best-known works were painted, was instrumental in bringing about a better defined and more coherent Impressionism. A distinct movement gradually emerged, and finally set the stage for the inevitable new movement that was soon to follow.

Neo-Impressionism

This "new" Impressionism was more of an extension and further development of the old Impressionism than a direct revolt against it. Indeed, there were Impressionists in the new movement, and the first Neo-Impressionist exhibition was actually an integral part of the Eighth (and last) Impressionist Exhibition of 1886. Pissarro, who was one of the holdovers, referred to some of his old friends and colleagues as "Romantic Impressionists" to distinguish them from the members of the new "Scientific" movement.

Neo-Impressionism was, in fact, greatly influenced by the rapidly developing science and technology of the mid- and late nineteenth century. Especially important were the many advances in physical and physiological optics, in the psychology of color, in photography, and in photomechanical color printing. Also significant were the heightened public acceptance of and intense interest in the rational approaches of science and technology to everyday problems. Against this scientific and technical background, Neo-Impressionism thoroughly analyzed and significantly revised the technique of Impressionism (see Homer 1964; Thomson 1985). The new technique which emerged was characterized (as was Impressionism itself) by the use of pure colors. The major difference between the technique of the Neo-Impressionists and that of their immediate predeces-

sors was in their use of relatively small and sometimes nearly uniform touches of color. This modified Impressionism with its finer "grain" offered two advantages: it provided a more meticulous means of defining form and permitted a more measured and more careful control of the "dosage" of color (and thereby of the harmony and contrast of color) throughout the painting. The procedure was painstaking and, for some, tedious. Brushstrokes ranged from small (pointillist) points or dots to somewhat larger more rectangular (divisionist) touches, with the smallest points resulting in optical mixture of color and the largest touches interaction of color, with a whole host of vibrant phenomena in between which are characteristic of the Neo-Impressionist technique (see Herbert 1968).

Georges Pierre Seurat (1859–1891), the founder and leader of the movement, Paul Signac (1863–1935), principal disciple, and Camille Pissarro (1830–1903), a convert from Impressionism, along with his son Lucien Pissarro (1863–1944), were the original Neo-Impressionists. They were soon joined by many others including Albert Dubois-Pillet (1846–1890), Maximilien Luce (1858–1941), Louis Hayet (1864–1940) and Charles Angrand (1854–1926). Later on Henri-Edmond Cross (1856–1910), Théo van Rysselberghe (1862–1926), and Hippolyte Petitjean (1854–1929) also joined the movement.

The first and most productive phase of Neo-Impressionism was short-lived (ca. 1885–95). Many probable causes for the early decline have been cited. Among the most important of these were the sudden death of Seurat, the founder and leader of the movement; the death of Dubois-Pillet, an early follower; Camille Pissarro's much-publicized defection from the movement and return to painting in his earlier Impressionist style; the unexpected turning away of Louis Hayet from the art world; and the significant

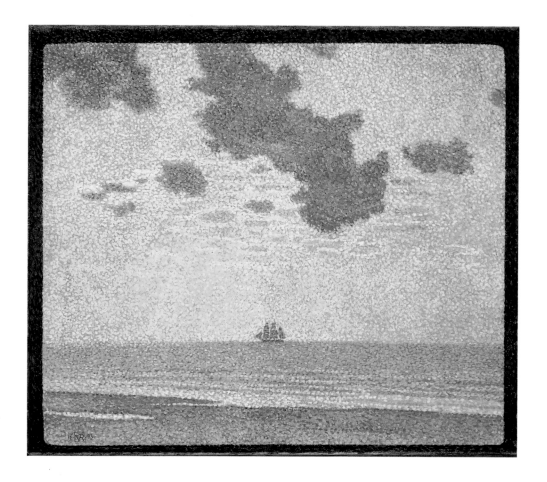

Figure 12 *Gros nuages* (Big Clouds) by Théo van Rysselberghe (1862–1926). 1893. Oil on canvas, 49.5 × 59.7 cm. © 1989 Indianapolis Museum of Art, Indianapolis, Indiana, The Holliday Collection (79.287). Signed and dated with monogram lower left: 18VR93. Inscribed on central horizontal stretcher bar: gros nuages. Colorman stamp on reverse: Mommen, Bruxelles. In this painting van Rysselberghe has followed the advice of Signac to broaden the brushstrokes. The rectangular divisionist touches are quite large and almost uniform throughout. It is characteristic of the gradual transition into the second phase of Neo-Impressionism, under the influence of Signac. The harmony and contrast of color is expressed in the usual Neo-Impressionist manner with opposing complementaries, but with a very limited palette. The emphasis here on the contrast of only those colors close to the opponent pair yellow-blue is most unusual. But the luminous scene itself is most unusual, too—the red-green pair is not needed to portray such a light. The painted "frame" on the canvas (following Seurat) further emphasizes harmony and contrast. It is deep blue, with minute flecks of color (barely visible in this reduced size) complementary to the main passages of color in the immediately adjacent parts of the painting. Overall, this work is devoted more to a study of the interplay of color than to the depiction of the actual seascape itself. For more on van Rysselberghe and on this painting, see Lee (1983).

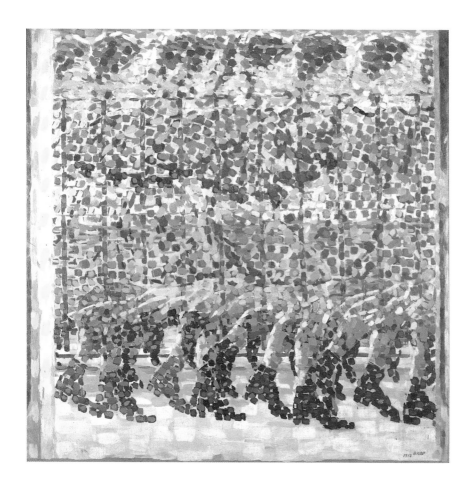

Figure 13 *Bambina che corre sul balcone* (Girl Running on a Balcony) by Giacomo Balla (1878–1958). 1912. Oil on canvas, 125 × 125 cm. Collection of Civica Galleria d'Arte Moderna, Raccolta Grassi, Milano (Archivi del Futurismo 37). Signed and dated lower right: 1912 Balla. The Neo-Impressionist technique from Balla's earlier days as a divisionist is very much evident in this stroboscopic Futurist painting. The enormous touches are almost ultra-divisionist, and contour gives way almost completely to color. The col-ored bands at the edges of the canvas are similar to and undoubtedly derived from Seurat's painted frames. This painting (along with many others from the same period which led into Cubism) was included in the Guggenheim exhibition *Neo-Impressionism* (see Herbert 1968). The similarity of the treatment of motion in this work and in Marcel Duchamp's famous stroboscopic *Nude Descending a Staircase* of the same date is striking.

changes in the interests and directions of Lucien Pissarro and Charles Angrand. Furthermore, many painters who were attracted to Neo-Impressionism briefly, including Vincent van Gogh (1853–1890), Henri Matisse (1869–1954), André Derain (1880–1954), Henri van de Velde (1863–1957), and Giacomo Balla (1878–1958) either went on shortly to develop their own styles or to become a part of one of the many new movements.

van Gogh took up Neo-Impressionism almost as soon as he became acquainted with it and then put it down almost as quickly to follow his own distinctive style (see Hammacher 1962). Matisse was attracted to the new technique for a few years, but soon rebelled and (along with Derain) led the way to Fauvism. These and other influences eventually coalesced into a "pure" Matisse, which can be recognized in almost any of the various media in which he later worked (see Barnes and De Mazia 1933; Elderfield 1978). van de Velde painted (quite successfully) in the Neo-Impressionist style, but only for a year or two. Then, after experimenting briefly with a divisionism involving long sinuous parallel strokes adapted from van Gogh, he turned to the decorative objects and the architecture of Art Nouveau, in which he quickly gained wide acclaim. Balla adapted a variant of the Neo-Impressionist technique to the depiction of motion in his "stroboscopic" Futurism. The somewhat more tangential work of Jean Metzinger (1883–1956) and Robert Delaunay (1885–1941) went in still another direction and formed a direct link between divisionist Neo-Impressionism and analytic Cubism (see Herbert 1968).

Indeed, Neo-Impressionism spread into almost every one of the new *isms* in art that followed it. At the same time, however, a refined version of Signac's personal and original contribution to the movement (a stronger emphasis on pure color in somewhat larger brushstrokes) gradually took form as a new phase of Neo-Impressionism in the work of a small close-knit group under the direct influence of Signac and Cross at Saint-Tropez, and is still thriving here and there today. The most prominent among these early followers of Signac's divisionist style of Neo-Impressionism were Lucie Cousterier (1876–1925), Jeanne Selmersheim-Desgrange (1877–1958), Henri Person (1876–1926), and Eduard Fer (1887–1959). A description of one of Fer's paintings by Guillaume Apollinaire in the 1 June 1912 issue of the *Mercure de France* is an almost perfect characterization of the direction taken by Signac and his followers in this second phase of Neo-Impressionism: "It was not at all one of those pointillist pictures where the artist streaks the canvas in order to give it a hazy, poetic appearance; it was a veritable divisionist painting where the colors kept all their force and all their purity."

Précis

Throughout the nineteenth century there was a gradual shift in emphasis in the many successive movements in painting. Light and color, rather than a faithful representation of the subject itself, were used more and more to "stir the emotions"—as Signac once put it. Neo-Impressionism accelerated this trend and carried it into the next century at which time it spread out widely and led ultimately to the glorification of color in modern painting. In some schools of twentieth-century art the trend has now been carried to its logical conclusion: Color has become an end in itself rather than a means to another end.

Color in Neo-Impressionism

Signac dedicated the first edition of *D'Eugène Delacroix au Néo-Impressionnisme* (published by Revue Blanche 1899) "à la mémoire de Georges Seurat." After the death of his friend Henri-Edmond Cross, in 1910, he changed the dedication in the second and third editions (published by Floury 1911, 1921) to read "à la mémoire des peintres Georges Seurat, Henri-Edmond Cross. Et pour la couleur." In essence, Signac's book is a treatise on color and in praise of color. Indeed, the Symbolist writer and art critic Félix Fénéon (who first called Seurat and his followers "Neo-Impressionists") had, on reading the manuscript, suggested that it be entitled *Color in Neo-Impressionism*. Under this title, the following five-part essay examines both the theory and the use of color in Neo-Impressionism from the perspective of what is known about color today.

I. The optical mixture of color and the interaction of color

Pointillism and divisionism

Any mention of color in Neo-Impressionism generally brings to mind the notion of separate, small points or dots of differently colored pure pigments meticulously applied on the canvas in such a way that the eye may blend closely neighboring ones into a single luminous color. This technique of applying colors has been given the name *pointillism*; the blending by the eye is called *optical mixture of color*. Contrary to common belief, however, pointillism does not actually achieve all that some of its proponents have claimed. In fact, as this essay aims to show, the most important technique in Neo-Impressionism is *divisionism*, and the most important visual effect is the *interaction of color*. In divisionism, the canvas is covered with separate touches or patches of various pure

pigments, each applied with a relatively broad stroke of the brush. The different colors of the neighboring touches rarely blend entirely into one but, even though usually seen as completely separate and distinct, they may nevertheless interact with and greatly modify one another. Divisionism, with its interaction of color, rather than pointillism, with its optical mixture of color, was the great technical achievement of Neo-Impressionism.

The Neo-Impressionists' view

What did the Neo-Impressionists themselves have to say on this matter? In a letter to Maurice Beaubourg (quoted in full by Lee 1983), Georges Seurat, the founder of the movement, described the Neo-Impressionist technique, in part, as follows:

> Granting the phenomena of the duration of the light-impression on the retina, synthesis necessarily follows as a resultant. The means of expression is the optical mixture of tones, of colors (of the local color and the color of the illuminating light: sun, oil lamp, gas, etc.), that is to say, of the lights and their reactions (shadows), in accordance with the laws of *contrast*, gradation, and irradiation.

Paul Signac, in his *D'Eugène Delacroix au Néo-Impressionnisme,* described the technique and its merits, in part, in these words:

> In the Neo-Impressionist technique . . . the touch may have any form . . . its dimensions are proportional to the size of the painting and uniform for that painting, so that, at a normal distance, the optical mixture of dissociated colors occurs easily and reconstitutes the hue.
>
> How can one otherwise note with precision the interplay and encounter of opposed elements: the quantity of red that tinges the shadow of a green, for example; the effect of an orange light on a blue local color or, inversely, of a blue shadow on an orange local color?

These summary statements by the two most prominent members of the new movement both emphasize optical mixture and thereby appear to contradict the central thesis of this whole essay, and—when taken uncritically at face value—they do. But this apparent contradiction is largely a matter of loose terminology. The Neo-Impressionists (and some sympathetic critics) improperly extended the term *optical mixture of color* to include other visual phenomena, such as the interaction of color, in which the colors are not truly mixed. (Note that in the two statements cited above, both optical mixture *and* contrast are essential.) Therein lies the beginning of one hundred years of confusion about the role of optical mixture of color in the technique of Neo-Impressionism.

The major source of this confusion (there are others) is that the constituents of the Neo-Impressionists' so-called optical mixtures only rarely completely fuse with one another and produce a new color. Most often, the colors either cooperate or contend with one another in some way, and in that "interplay and encounter," as Signac called it, produce a new visual result without completely losing their own identities in the process. Through the Neo-Impressionists' imprecise extension of the term *optical mixture* to include these results, they unintentionally misled the critics, the public, and, to some extent, themselves. The resulting confusion still persists, even today.

To be fully informed about the technique of the Neo-Impressionists, it is necessary to look at their paintings as well as to read their writings. According to the Neo-Impressionists' own accounts, their technique was originally based on the scientific theory of the optical mixture of color. But their paintings show that certain necessary modifications of the technique

when it was put into actual practice—in particular, the enlargement of the touch so strongly advocated by Signac—resulted in the interaction of color. The Neo-Impressionists appear to have extended the term *optical mixture,* occasionally, to include those results, too. This is understandable, for as the size of the touch exceeds the critical dimension at which closely neighboring touches fuse in the eye, optical mixture of color merges subtly into interaction of color. In their extremes, these two phenomena are very different processes, but the point at which one becomes the other depends upon both the size of the touch and the viewing distance and therefore the distinction between them is not sharp and distinct. Thus, it is not surprising that the boundary of the appropriate terminology is also blurred.

This essay will demonstrate that whereas a true optical mixture does set the lower bounds of the far-ranging and many-faceted technique of Neo-Impressionism, such optical mixture, in itself, plays only a negligible role in that technique overall. The interaction of color, in all of its many guises, is far more important.

To succeed in this endeavor it is necessary to make a clear distinction, at the very outset, between the optical mixture of color and the interaction of color. As will be shown later on, there are sound psychophysiological and theoretical reasons for doing so. When examined on those experimental and analytical grounds, the apparent contradiction between the view presented here and that espoused by the Neo-Impressionists will vanish. Terms and phrases that Signac used, such as *reconstitute the hue* and *interplay and encounter of opposed elements,* will fall naturally into place under the rubrics "optical mixture of color," in the modern Young-Helmholtz trichromatic theory, and "interaction of color," in

the modern Hering opponent-color theory, respectively. Indeed, as we shall see, the Neo-Impressionist technique stands in a somewhat ambiguous position at the interface between these two theories, which were once thought to be contradictory, but which are now regarded as complementary.

Some definitions

For clarity, the term *optical mixture* will be used here, when in direct reference to painting, only to mean the visual fusion of separate differently colored touches into one new color because of their close juxtaposition, as described above. In such an optical mixture the individual touches lose their own identities and can no longer be seen as separate and distinct. Some colorists, even today, do not accept this narrow definition, but it is standard and well-established. It is the meaning of the term as used in both physical optics and physiological optics, the fields from which its use in Neo-Impressionism was derived. It is the meaning of the term as defined by Signac himself in his book *D'Eugène Delacroix au Néo-Impressionnisme.* Furthermore, it is the meaning of *optical mixture* as defined in modern dictionaries of art terms. The broader term *interaction of color* will refer to the interplay among separate and more or less distinct and unfused touches of color. (See *Glossary of Technical and Art Terms.*)

A few further words of explanation and definition are in order here. The terms *pointillism* and *divisionism* are sometimes regarded as synonymous and occasionally are used interchangeably in writings about Neo-Impressionism. Strictly speaking, however, pointillism refers only to the use, by the painter, of small *points* or dots of pigment. Divisionism, on the other hand, is a more general term: it refers to the

practice of *dividing* the paint on the canvas by means of separate, unmixed strokes of different pigments, whatever their size. Thus, in principle, divisionism includes, but is not limited to, pointillism.

Currently, however, the term *divisionism* is most frequently used in a more restricted sense to mean only a brushwork of rather broad and distinct touches of paint. (Exactly where one technique ends and the other begins on an absolute scale of size is somewhat arbitrary; effective visual size for the spectator depends on viewing distance.) There is ample precedent for this restriction of the meaning of divisionism. Signac himself adopted this usage in his writing: "The Neo-Impressionist does not paint with *dots, he divides.*" And he adopted the technique that usage implies (rather than a strict pointillism) in his painting: "We did quite right to broaden our brush work!" he said. We shall use the term *divisionism* here in that same limited sense; that is, with reference only to the practice of dividing the composition into rather broad, distinguishable, and usually nonoverlapping strokes.

Color terminology

The terms used to describe color vary greatly from one field to the next. For clarity and consistency I have adopted four terms that are in the common language and that are generally used in discussions of the psychology of color. These four terms are *color* itself, and its three principal dimensions: *hue, saturation,* and *brightness.*

Color is a general term that includes both the chromatic colors: red, yellow, green, blue, and all their intermediates and derivatives; and the achromatic colors: black, white, and all intermediate shades of gray. *Hue* is the chromatic quality of a color. The red of an apple, the yellow of a lemon, the green of grass, and the blue of the sky are different hues. *Saturation* is the chromatic purity of color, ranging from the grayest color to the most vivid. The vivid red of a full-blown poppy is more saturated (more reddish) than the pale red of a faded ash rose. *Brightness* is the lightness or darkness of a color as compared with a neutral gray scale ranging from the darkest black to the brightest white. The black print on this page is very dark; the white of the page itself is very bright.

There is general agreement among artists, artisans, and scientists on the use of the term *hue,* although *color* and *hue* are often used interchangeably (and will sometimes be here). The term *saturation* is not accepted by all; *intensity, purity,* and *chroma* are common alternatives. Also, artists often use the term *value* in place of *brightness. Brightness* and *lightness* are generally interchangeable, but in some technical works the former is reserved for self-luminous objects only. That distinction is not significant in this essay, so *brightness* will be used here to conform with common usage, as in the term *brightness contrast.*

Everyday examples of optical mixture of color and interaction of color

The fundamental phenomena of optical mixture of color and of interaction of color that are used in painting are not something out of the ordinary, known only to the practiced painter or to the color scientist. Rather, they are commonly observed in our everyday experience, both in our natural surroundings and in man-made objects.

At the near edge of a meadow in full bloom, individual flowers and grasses are seen separately and distinctly: each has its own color and is often strongly contrasting with its background. But in the

far distance, all fuse, by optical mixture, into one single hue—a uniform hue, characteristic of that particular mix of vegetation. In the middle distance, there are flecks of various colors, neither separate and distinct nor completely fused—a soft heathery appearance. There are numerous such variegated displays in nature which at short distances lead to division into separate colors, at far distances to mixture of all into a single color, and at middle distances to a partial blend in which neither division nor mixture clearly dominates.

The same phenomena are commonly observed in man-made objects. The clothing we wear provides many illustrative examples. When the fabric of a tweed coat is viewed close up, the colors are divided. That is, the interwoven yarns, each of a different color, may easily be seen as separate and distinct, and the fabric appears multicolored. At a somewhat greater distance, the various colors are neither clearly distinct nor completely fused. Instead, one color may appear to be tinged or mottled with another. But when seen at a very great distance, the separate colors of the individual yarns of the same weave cannot be resolved and are indistinguishable from one another. By optical mixture, all fuse into one, and the fabric then appears to be of a single, uniform hue.

Another common experience, illustrating an important aspect of the interaction of divided color, is that some colors go well with certain others, and some do not. For example, depending on one's natural complexion, a scarf of a poorly chosen color may make one's skin appear sallow and sickly, whereas a well-chosen color may make it appear radiant and robust. Such harmony and contrast of color, resulting from juxtaposition of colors that are either agreeable or contentious, are familiar to everyone. And the more observant among us are struck by the lively

and delightful interplay of colors in the most ordinary things. What wonder there is in this simple event described by Isak Dinesen in her book *Out of Africa*:

> Up at Meru I saw a young Native girl with a bracelet on a leather strap two inches wide, and embroidered all over with very small turquoise-coloured beads which varied a little in colour and played in green, light blue and ultra-marine. It was an extraordinarily live thing; it seemed to draw breath on her arm, so that I wanted it for myself, and made Farah buy it from her. No sooner had it come upon my own arm than it gave up the ghost. It was nothing now, a small, cheap, purchased article of finery. It had been the play of colours, the duet between the turquoise and the "nègre,"—that quick, sweet, brownish black, like peat and black pottery, of the Native's skin,—that had created the life of the bracelet.

Many other color phenomena also depend upon interactions resulting from particular spatial arrangements of color. For example, a textile pattern of thin alternating stripes of contrasting colors, of small spots scattered on a contrasting background, or of spots surrounded by contrasting rings, may appear to shimmer or to vibrate. The same is true of certain strongly contrasting black and white patterns. Indeed, it is of considerable interest that much of what is true about optical mixture and interaction of the chromatic colors red, green, yellow, blue, et cetera, is also true, in some respects, of the achromatic colors black, gray, and white. The same laws of fusion apply, and the opposition and interaction of black and white is much like that of complementary pairs of chromatic colors, such as red-green and yellow-blue. This is most important for both the practice of the colorist and the theory of the scientist.

Thus the fundamental facts about the mixture of color and the interaction of color are directly ac-

cessible to us all in our common everyday visual experience. But how best to make effective practical use of these phenomena in painting and how best to incorporate them into a unified theory of color in science are not so readily apparent. Systematic study is required. Let us begin with a closer examination of optical mixture of color and of interaction of color.

Optical mixture of color in pointillism

So-called optical mixture (*mélange optique*) in the technique of a true pointillism results from the close packing of the differently colored small points or dots of pigment on the canvas. When viewed from a distance, the eye cannot resolve the closely neighboring points of color and distinguish one from another, and they appear to blend—that is, to "optically mix" —into a single color.

Optical mixture by close juxtaposition of points is illustrated in two ways in Figure 14. On the left, the basic principle of this type of optical mixture is demonstrated by using the achromatic colors black, white, and gray. The intermediate gray is a distinct color, neither black nor white. Yet when viewed very close up or under a magnifying glass there is no gray color at all; there are only approximately equal areas of black and white, formed by a multitude of small black spots distributed uniformly on the white paper. The separate black spots are so small and so closely packed on the white background that, when viewed from a distance, black and white appear to fuse into a single, uniform gray. The whole scale of gray can be produced in this way. For example, all of the many different gray tones here and there in Luce's portraits of Signac and Seurat (see Figures 1 and 2) are given by the corresponding different proportions of black to white—the various amounts of

black charcoal picked up by the grainy tooth of the white paper as the artist varied the pressure on and angle of the crayon.

Similarly, as illustrated on the right in Figure 14, an optical mixture of chromatic colors, red and green, yields a new color. Small spots of red and green, which can only be resolved and seen separately and distinctly when magnified or viewed very close up, appear to fuse into a yellow when viewed from some distance. Thus the optical mixture of color is a local, rather than an extended, visual effect. That is, to be fused in the eye, the points or dots must be very close together—so close that images of next neighbors are almost superimposed when they are focused on the retina and therefore cannot be resolved and distinguished from one another. (A note of caution: The fidelity of printed reproductions of works of art and of scientific demonstrations of visual phenomena is severely limited by each of the several procedures involved in the copying and printing. Great care was taken in the preparation and printing of all shaded and colored illustrations in this book. But the reader must always keep in mind that the illustrations are *reproductions,* several steps removed from the originals.)

The term *optical mixture,* in reference to Neo-Impressionist painting in this essay, means only the fusion, by the eye, of small spots (points) of color that are very close together but not overlapping. But optical mixture is not restricted to painting, nor to fusion of neighboring points alone. Such mixture may be obtained by many other means such as the actual superposition, one directly upon another, of differently colored beams of light (as with two overlapping colored spotlights on a stage), or the rapid succession, in the same place, of differently colored patches of light (as with a rapidly rotating color disk

Figure 14 The optical mixture of achromatic and chromatic colors. The illustration on the left is printed with only two achromatic colors: the white of the paper and the black of the ink. The top panel shows the solid black of the ink; the bottom panel, the white of the page. The third achromatic color, gray, in the center panel, is produced by optical mixture of the same black and white: very small dots of black ink on the white of the paper. Viewed from the proper distance, the black and white cannot be resolved from one another, and fuse into a new intermediate color: gray. The illustration on the right is printed with only two chromatic colors: red and green. The top panel is printed with a uniform red; the bottom panel with a uniform green. The third chromatic color, a dull yellow, in the center panel, is produced by optical mixture of the same red and green: both are displayed in very small, closely juxtaposed, but nonoverlapping separate spots, each printed with the same mix of inks used in the corresponding red and green panels. At the proper viewing distance, the red and green spots fuse in the eye and optically mix into a new color—neither red nor green, but yellowish. (For best results, view under a strong light.)

41

in a classroom demonstration). The term *optical* (that is, *visual*) is fitting and proper in all such instances because the combination of the two or more colors into one actually takes place by means of integrative processes *within* the visual system, not by some kind of physical addition externally to it.

A characteristic feature of any optical mixture, whether it results from the fusion of closely juxtaposed small points of differently colored pigments, or from the actual superposition of differently colored beams of light, or from the rapid succession of differently colored patches of light, is that the identity of each of the component colors is lost in the mixture. When different colors are optically mixed, all become one. Furthermore, as will be shown later, the combination required to produce any one particular color is not unique. Innumerable different mixtures can produce the same color. (Identical colors with different constituents are called *metamers*.) Therefore, the component colors in an optical mixture cannot be deduced from the color of the mixture itself. Separate colors once combined into one by the eye and the brain cannot be sorted out again.

Interaction of color in divisionism

Unlike the optical mixture by local fusion of closely packed points that is the basis of true pointillism, the interaction of broad strokes of color that is crucial to the technique of divisionism is a more far-reaching visual effect, and each of the separate unmixed colors involved usually retains at least some of its own identity. That is to say, the different colors of broad, adjacent strokes or touches of various pigments applied in the divisionist manner may reciprocally interact with and mutually influence the appearance of one another over considerable distances, but each of the interacting touches of color is still recognizable as a separate, albeit possibly somewhat modified, color.

Brightness contrast effects resulting from such reciprocal interactions among achromatic colors may be created easily and seen at once simply by cutting out two identical pieces of gray paper and placing them on different backgrounds for comparison: one on white paper, the other on black. The gray piece on the black background appears light, the piece on the light background appears dark. If the positions of the two gray pieces are interchanged, the brightness contrast exerted on each changes accordingly. The one that was light now appears dark; the one that was dark now appears light. Thus apparent brightness is not altogether an intrinsic property of a patch of color; it depends partly on the surrounds.

A poetic description and a psychological explanation of such phenomena were offered by Shakespeare in *The Merchant of Venice*. As Portia and Nerissa return to Portia's villa at night after the triumph over Shylock in Venice, they speak about visual perception:

> PORTIA: That light we see is burning in my hall.
> How far that little candle throws his beams,
> So shines a good deed in a naughty world.
>
> NERISSA: When the moon shone we did not
> see the candle.

This interchange between Portia and Nerissa is about Weber's law: that the small increment of light required to be just noticeably different from the background increases as the background light increases. But Portia goes on to extend the basic idea of the perceptual relation of one thing to another to

the more interesting case of brightness contrast itself, and explains:

> So doth the greater glory dim the less.
> A substitute shines brightly as a king
> Until a king be by, and then his state
> Empties itself, as doth an inland brook
> Into the main of waters.

<div align="right">(5.1.97–105)</div>

Portia's "So doth the greater glory dim the less" is a penetrating insight into one of the most fundamental characteristics of visual perception: the appearance of any color is in relation to its surrounds; colors interact with and reciprocally influence one another.

An example of such interaction of achromatic colors is shown in Figure 15. The familiar Taoist yin and yang pattern shown here does double duty because this form of the pattern has the interesting property that it is at the same time a symbol of the interaction and integration of opposed, but nonetheless complementary, influences in general (dark versus light, feminine versus masculine, negative versus positive) and a specific example of this particular phenomenon of interaction itself. Note that the gray disk on the white background appears much darker than the physically identical gray disk on the black background. That they are actually identical can be demonstrated, as shown in the inset, by covering the pattern with a blank sheet of white paper in which two identical small holes are cut to form a homemade reduction screen. The apertures expose equal portions of the gray disks, and the white paper furnishes identical surrounds. Under the same conditions thus provided, the two disks appear the same.

There is no scientific reason to believe that equalizing the surrounds of the gray disks in such a

Figure 15 The interaction of achromatic color: simultaneous brightness contrast. The two small gray disks are identical physically; that is, both are printed in the same halftone (small spots of black on white) as the gray space surrounding the whole symbol. Yet they appear to be different. The gray disk on the black background appears brighter and the gray disk on the white background appears darker than the physically identical gray surround. (*Inset*) A reduction screen, consisting of a sheet of paper with two holes cut out to expose equal portions of the two gray disks, shows that with the same surrounds the two disks appear to be the same shade of gray. The apparent difference, without the mask, is an example of the phenomenon of simultaneous brightness contrast.

Figure 16 Simultaneous brightness contrast. The two vertical bands have the same gray level. The background gray level varies sinusoidally. A physical measure of the gray level across the figure is shown directly below. Note that the two upward and downward displacements of the curve, representing the bright and dark bars, respectively, are of the same amplitude. Courtesy Patrick Colas-Baudelaire.

manner should affect, in any way, the physical absorbance or reflection of light by the multitude of small black spots of ink that are printed on the white paper to give the appearance of gray. Indeed, scientific demonstrations of brightness contrast, as in Figure 16 in which the display is computer generated and the gray levels are known exactly, show the same phenomena. The changes in brightness that are seen in these simple but compelling demonstrations are determined by the action of light on a living eye and by the active interplay of opposing psychophysiological forces within the eye and the brain, not by the action of light on lifeless matter and by the passive interplay of physical forces external to the eye. The interaction of color is a manifestation of psychophysiological aspects of *sight* rather than of physical aspects of light.

Thus the universal principle of opposites expressed by the symbol of the interaction and integration of opposed influences shown here not only represents certain fundamental characteristics of nature

Figure 17 Cover of a thesis on chromatic induction. The words are all printed with the same purplish ink but, by contrast with the bluish and reddish bands and with the white of the paper, they all appear quite different. On the blue the letters appear more reddish, on the red they appear more bluish, and on the white they appear darker. Courtesy Jan Walraven.

itself, but also certain fundamental characteristics of the way in which the mind perceives nature. And an understanding of the role of such reciprocal interactions among opposing influences in the visual perception of color is central to an understanding of the technique of divisionism advocated by Signac.

The interaction of chromatic colors is similar, in many respects, to the interaction of achromatic colors. The color of any region is generally influenced by the color of its surrounds, much in the same way

as the brightness of a region is affected by the brightness of its surrounds. An example of such chromatic induction, or color contrast, is shown in Figure 17. This illustration is a reproduction of the cover of a thesis on chromatic induction by Jan Walraven. The author's name and the words *chromatic* and *induction* are all printed with the same ink. They appear differently colored because of contrast with their differently colored surrounds.

Additional examples of the interaction of chro-

matic colors—the familiar simultaneous color contrast—are shown in Figure 18. For comparison, red, green, yellow, and blue spots are printed on a gray palette to provide a standard with no chromatic contrast between color and background. To provide different chromatic backgrounds, the surface of each of the four remaining palettes is printed with a different one of the four spot colors. The spots on each of the colored palettes are printed with the same colors of ink and with halftone dots of the same size as are the corresponding spots on the standard gray palette. (Because a spot of the same color as a palette would not stand out against the identical background, all such spots are omitted and replaced with the standard gray in each case.) The spots on the colored palettes appear quite different than those on the gray palette. The differences are due to contrast. This is easy to demonstrate. All corresponding spots on the five palettes will appear to be the same color if viewed in isolation through a reduction screen provided by identical small holes in a uniform sheet of paper laid over the page. Thus, the striking differences in the appearance of the colored spots (and of the achromatic gray spots) when viewed normally, without a reduction screen, are due entirely to the differences in their surrounds.

Often, as in the examples illustrated, the interacting colors are not all equally bright. Therefore brightness contrast, as well as color contrast, may affect their appearance. (It is difficult to tell how much the change in appearance depends upon brightness contrast and how much upon color contrast per se without making careful psychophysical measurements in which other colors, adjustable in hue and brightness, but not subjected to contrast themselves, are matched with the contrasting colors.) Although

Figure 18 The interaction of chromatic color: simultaneous color contrast. The red, yellow, green, and blue spots on the gray palette provide a standard, with no chromatic contrast. Corresponding spots on the other four palettes are printed with the same colors of ink and the same sizes of dots as in the standard. Also, the grays, both spots and palette, are all the same. The differences in the appearance of the physically identical spots result from contrast with the different colors and different brightnesses of the four palettes.

both the brightness and the hue of large patches of color may be greatly modified in this way by interaction with other patches, each and every one can still be seen as a separate and distinct patch of color. No blending of neighboring colors takes place, but they do nonetheless interact with and influence the appearance of one another.

Graded and differential contrast effects

The strength and range of the interaction of color can best be illustrated by viewing identical patches of color on a background that varies continuously from one extreme to another. In Figure 19, an array of identical gray disks is superimposed upon a "wedge" of gray that covers almost the whole range from white to black. (The central disk in the middle of the wedge is barely visible because overall it and the very center of the wedge are the same gray.) The disks farther into the dark end of the wedge appear lighter, and those farther into the light end appear darker. Yet they are all the same, physically, as can be demonstrated without use of physical instruments. Viewing each through a reduction screen so that each has the same surrounds is sufficient to convince one of their identity. The apparent differences are clearly the effects of the interaction of achromatic color: so-called simultaneous brightness contrast.

Similarly, an array of identical yellowish disks placed on a background of color that varies smoothly from red through yellow to green appears to be made up of differently colored disks. The one located on the central yellow background appears yellow itself and is difficult to distinguish from its immediate surrounds. The disks farther into the red appear greenish, and those farther into the green appear reddish. Yet all are physically the same as can be

demonstrated by viewing them through identical apertures in a reduction screen. This is truly an interaction of chromatic color: so-called simultaneous contrast of color. It can be produced, as it is here, with little or no difference in the brightnesses of the interacting colors.

With small disks on gradually changing backgrounds, as in these two illustrations, the induction of color appears to be more or less the same over the whole extent of each disk. But by adjusting the strength of the induction on different parts of a particular disk, either by steepening the background wedge of color or by enlarging the disk so that it extends farther into the different background colors, differential effects can be produced within one and the same disk.

Indeed, under such conditions, different parts of the same patch of color may be affected quite differently through interactions with closely neighboring areas that are differently colored. This is shown dramatically, for both chromatic and achromatic colors, in Figure 20. At the top, a large, physically uniform gray disk is centered on a background of gray shaded gradually from dark to light. The disk, through achromatic interaction with its immediate surrounds, appears shaded from light to dark in the opposite direction. In addition, because of this differential shading, the disk takes on a convex, almost spherical, moonlike appearance. The disk is actually uniform over its whole extent as can easily be demonstrated by masking the surrounds with a homemade reduction screen laid over the figure.

Below, in the same figure, is a comparable example of differential chromatic interaction. There, the large disk is a uniform yellowish color and is on a background that shades gradually from red at one side to green at the other. Through chromatic induc-

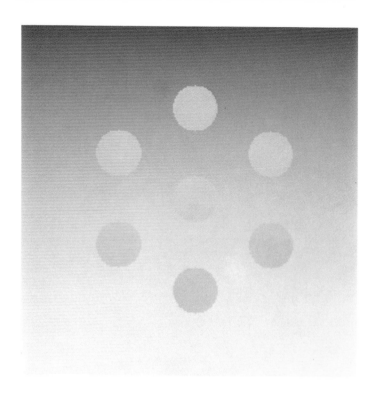

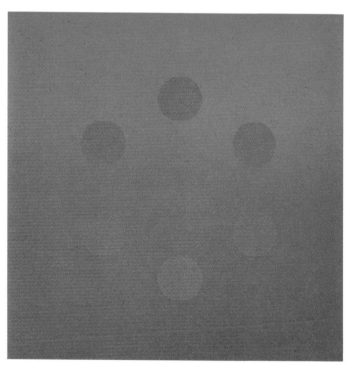

Figure 19 Graded brightness contrast and color contrast. (*Top*) The background of the panel is made up of a uniformly graded gray. The array of gray disks superimposed upon the wedge of gray are physically identical but appear to be shaded in steps of gray opposite to the graded gray of the background. (*Bottom*) The background of the panel varies from red to yellow to green. The array of disks, viewed in isolation, are all the same yellowish color. Against the red end of the background the disks appear to be greenish; against the green end of the background they appear reddish. Note that both achromatic and chromatic contrast are important in the formation and enhancement of contours. The central disks, in both panels, are barely visible because of the low contrast with their backgrounds. Based on experiments and demonstrations by Shapley (1985). Photo: Robert Shapley.

49

Figure 20 Differential brightness and color contrast. (*Top*) A large uniform gray disk superimposed on a graded gray background appears, by contrast, to be shaded in the opposite direction. This induced shading gives the disk a slight three-dimensional moonlike appearance. (*Bottom*) A large uniform yellow disk superimposed on a background that varies from red to yellow to green appears, by contrast, to vary from green to yellow to red—in the opposite direction. As above, the disk appears slightly three-dimensional. Based on experiments and demonstrations by Shapley (1985). Photo: Robert Shapley.

tion, the disk appears greenish yellow near the red side of the background and reddish yellow near the green side. Because of the induced graded coloration, this disk also takes on a three-dimensional, almost spherical appearance.

Thus, as these examples show, in laying down a uniform patch of color on a nonuniform background, the scale of the patch with respect to the background is significant, for it may affect the amount of contrast between them and, accordingly, the amount and extent of chromatic induction. Scale is all-important, both in the optical mixture of color and in the interaction of color.

Scale and viewing distance

The distinction between the technique of pointillism (which uses optical mixture of color) and that of divisionism (which uses interaction of color) is largely a matter of scale. Small, densely packed points of color fuse with one another; large, loosely arranged touches of color interact with one another. But there is a continuum between small and large, and, in practice, one technique may merge into the other—perhaps inadvertently, because the artist's control over the brush is imperfect; perhaps intentionally, because the artist wishes to use both techniques in the same painting. In either event, the painter does not have complete control over the final outcome. Since the distinction between the two techniques is a matter of scale, the distance from the spectator to the painting —the viewing distance—is also a determinant. Indeed, almost as much depends upon the viewing distance as upon the actual size of the points or touches of color, for it is the size of these points or touches imaged in the viewer's eye that is significant, and image size varies with distance.

In the gallery, scale must always be considered. For example, a pointillist painting in which the artist has intended an optical mixture to take place should not be hung at the side of a narrow corridor for then, when the spectator is forced to view the small points close up, the scale is enlarged and the points will be seen separately and distinctly. Under those conditions, optical mixture cannot take place effectively; an unintended interaction of the distinct points of color may occur instead. On the other hand, when large touches of color in a divisionist painting are viewed from a great distance (as at the end of a long corridor), they may appear to be point sized and closely packed (or not be distinguishable from one another at all). The decrease, at a great distance, in the apparent size of the separate touches and their resulting fusion then precludes the intended interaction among them, but an unintended optical mixture may occur instead.

Between these two extremes, where the apparent sizes of neighboring points or patches of color are such that they are neither completely fused with one another nor completely separate and distinct, the visual phenomena are more ephemeral: at times, first one color may seem to dominate and then another. This uncertainty enables the viewer to participate actively in the selection and production of either fusion or interaction, or even to produce an unresolved tension between the two that may actually serve to enliven the painting.

Both the artist at work in the studio and the viewer of the finished painting in the gallery must have room to maneuver. For example, some of the apparent technical defects in scale and perspective in the left half of Seurat's very large (225-×-340-cm) *Un Dimanche après-midi à l'Ile de la Grande-Jatte* (Sunday Afternoon on the Island of the Grand Jatte) (see

Figure 78) may have resulted from constraints on viewing distance at the time when the work was painted. As Signac wrote to Pissarro, "One senses that this large canvas was executed in a small room without space to stand back." The viewer must also have "space to stand back" from a painting of this size. Evidently, sufficient space was not provided when *La Grande-Jatte* was first shown at the Eighth Impressionist Exhibition, for Emile Verhaeren, the Belgian Symbolist writer and critic, complained then that the painting was hung in a room much too narrow for its size. The Art Institute of Chicago, where the painting now hangs, has given the scale of this majestic work proper consideration, and has provided ample room for the viewer.

It is evident that the appearance of colors in Neo-Impressionist painting (or in any style of painting, for that matter) depends not only on the actual scale of the artist's technique itself, but also on the visually effective scale of the image in the eye that results from the viewing distance. And that scale is not fixed. Indeed, Leonardo's rule that the proper distance for viewing a painting is twice the diagonal of the work is seldom strictly observed. (The same is true for Pissarro's rule of three times the diagonal for a Neo-Impressionist painting.) The size of the gallery,

the press of the crowd, the whim of the spectator, the lighting of the work, and many other factors all serve to determine the distance at which a painting is seen. Thus the appearance, and especially the vitality, of any painting may be much affected by the conditions under which it is viewed and by the very nature of the responsive eye itself.

Motion

Change, of any kind, is a most important aspect of any stimulus to vision. As Shakespeare's Ulysses remarked, when upbraiding Achilles for his inaction in *Troilus and Cressida*:

>things in motion sooner catch
> the eye than what not stirs.

> (3.3.182–183)

Paintings themselves do not move. But motion is relative. And as the eye moves here and there during the viewing of a painting, the image of the painting moves with respect to the retina. Thereby the dynamics of the living eye can give life to a static painting. Indeed, the Neo-Impressionists were very much aware that the successive contrast brought

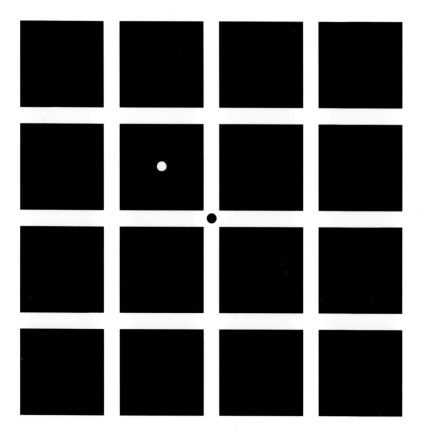

Figure 21 Involuntary eye movements. A Verheijen grid for the demonstration of small involuntary eye movements by means of afterimages. Steady fixation on the black dot in the center of the grid for about thirty seconds will produce a strong negative afterimage of the grid which becomes visible when fixation is transferred to the white dot. The unsteadiness of the afterimage results from small involuntary movements of the eye. Redrawn after Verheijen (1961).

about as the eye scans the painting and moves from one touch of color to another plays an important role in the enhancement of contours and in the contrast of colors. By means of the successive contrast produced by such voluntary eye movements, the viewer can actually participate, to some extent, in the definition of contour and contrast in a painting.

Involuntary eye movements are also important. Such movements are ever present. Even when one attempts to fixate steadily on a point, there is a residual, minute, involuntary tremor of the eyes. To experience the effects of involuntary movements, fixate steadily on the black dot at the center of Figure 21 for thirty seconds or so. Then fixate steadily on the white dot in the center of the black square; the nega-

tive afterimage of the entire figure will soon be seen distinctly. "Steady" fixation is not truly steady: the afterimage of the grid cannot be kept still. Because of the continual small involuntary tremor of the eyes, the afterimage will seem to move considerably with respect to the stationary background provided by the real grid. (Note also an interesting contrast phenomenon in the grid. Shadowy dark patches appear at the intersections of the white bars.) Experiments in which the effects of these small involuntary eye movements are reduced or eliminated by means of a simple optical device show that they are essential for the maintenance of vision. An image that is stabilized on the retina quickly fades from view (see Ratliff 1965).

The importance of minute eye movements in the perception of paintings can be demonstrated even with small-scale reproductions on the pages of this book. Periodic patterns of unrelieved black and white, used in a masterly manner as in Bridget Riley's *Current* shown here in Figure 22, can be startling in their intensity and vitality. When viewed under strong light at the proper distance, the slightest movement of the eyes (or slight oscillations of the reproduction of the painting itself) will yield vivid, pulsating impressions of brightness and of shimmering pale colors—usually transverse to the black and white striations. The painting appears vibrant, restless, and under great tension. And, try as one will, it cannot be constrained in any rigid "cage of form" constructed by the eye and the brain. These extreme tensions are common characteristics of interactions among the elements of many different repetitive patterns, both natural and man-made, but they are used here by the artist in a most uncommon way. Similar, but less dramatic, effects are at play in the everyday visual examination of any pattern of light, shade, and color.

Assimilation of color

The achromatic colors white and black have other strong and sometimes unexpected effects on neighboring colors. The lightness of white and the darkness of black, for example, may sometimes appear to "spread" into or be assimilated by adjacent areas of color, both achromatic and chromatic. (For this reason, the phenomenon of assimilation is sometimes called the spreading effect.) These phenomena may well have been known to Signac and to Seurat, for they were described in Chevreul's book on the harmony and contrast of colors, which they consulted.

Figure 22 *Current* by Bridget Riley (1931–). 1964. Synthetic polymer paint on composition board, 58⅜ × 58⅞ inches. Collection of The Museum of Modern Art, New York, Philip C. Johnson Fund. Slight scanning movements of the eyes across the reproduction of the painting or slight oscillations of the page on which it is printed produce a variety of transient pulsating impressions of brightness and color.

(The spreading effect was given a much more detailed treatment by Wilhelm von Bezold in his 1874 book in German on the theory of color. Bezold's work was not translated into French, however, and probably was not readily available to the Neo-Impressionists.) It seems unlikely that the Neo-Impressionists made any deliberate use of the spreading effect, based directly on scientific knowledge of the phenomenon. It is possible, however, that they made some unintentional use of it, particularly in instances where large touches of pigment were spaced rather widely on the the canvas, leaving substantial gaps of the white ground exposed between them.

Assimilation can be seen in a variety of patterns, as is shown in Figure 23. The pattern at the top of the figure consists of periodic arrays of parallel evenly spaced white and black lines placed vertically on a uniform gray area. The gray interspaces between the parallel white lines on the left appear brighter than the uniform gray background, and those between the parallel black lines on the right appear darker, although the gray background is physically uniform throughout. This reduction of differences—a sort of reverse contrast—is assimilation.

A repetitive pattern of identical gray lozenges, the right half of which is marked off by black lines and the left half by white lines, also shows strong effects of assimilation (Figure 23, *center*). The black and white lines seem to "run" or "bleed" into the lozenges that they surround and impart some of their darkness or lightness to the gray interiors. This induced darkness and lightness forms a ghostly subjective contour in the middle of the gray background where the black lines turn to white.

Assimilation does not require a periodic pattern. A more or less random arrangement of white dots and black dots on a uniform gray background, such as an artist might lay out by stippling freehand, also produces a dramatic assimilation of brightness and darkness (Figure 23, *bottom*). The gray background is physically uniform everywhere. That is, the same halftone screen was used to print the gray areas throughout the entire figure. The assimilation of brightness from the black and white spots by the surrounding gray is quite pronounced. The gray between the white spots appears significantly lighter than the surrounding uniform gray, and the physically identical gray between the black ones signifi-

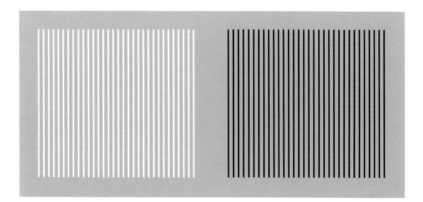

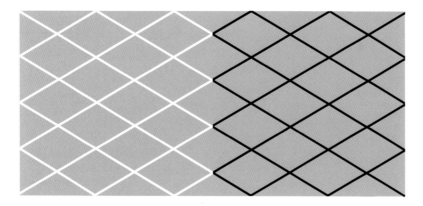

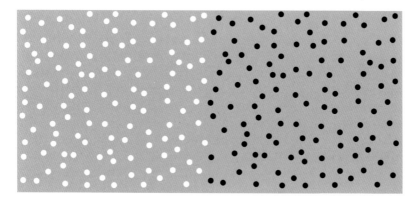

Figure 23 Assimilation of brightness. (*Top*) The gray background of the striated pattern is physically the same everywhere. But between the parallel white lines the gray appears lighter and between the parallel dark lines it appears darker. This change in apparent brightness is called assimilation. Redrawn after Day and Jory (1978). (*Center*) The gray lozenges are physically the same throughout the pattern. By assimilation, the dark lines appear to darken the lozenges that they surround and the white lines appear to lighten the ones that they surround. Where the two opposite effects meet at the middle of the pattern, a subjective contour forms a distinct midline. (*Bottom*) The gray background on which the black and white dots are scattered more or less randomly is physically uniform. Surprisingly, the gray between the white dots is lighter than elsewhere, and the gray between the black dots is darker than elsewhere. Note that this difference in brightness induced by assimilation leads to the formation of a subjective contour in the gray background where the transition from black to white spots occurs. Based on a demonstration by D. M. Mackay.

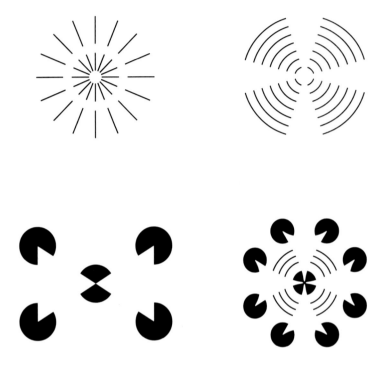

Figure 24 Patterns formed by subjective contours. (*Top*) The annulus in the radial array of lines and the cross in the circular array of lines appear brighter, by contrast, than the white of the page elsewhere. The annulus and the cross appear to be bounded by continuous contours that extend from the end of one line to the next, but these contours are subjective. (*Bottom*) Kanizsa triangles are formed by subjective contours. The triangles on the left appear to be brighter than the white of the page and the subjective contours extend over great distances between the cutout sections of the circular black disks at the corners. The subjective contours of the Maltese cross at the right appear curved, even at the outer ends where there are no interrupted lines to serve as a guide. Redrawn after Wade (1982).

cantly darker. As a result, there appears to be a fairly distinct contour between the two apparently different gray areas.

Subjective contours often form surprisingly distinct patterns. For example, in the space formed by the interruptions in the concentric circles shown at the top of Figure 24, one sees an expanding Maltese-like cross that appears to be significantly brighter than the white surrounds provided by the bare paper elsewhere. Similarly, interruptions in the pattern of radial lines shown in the same figure produce an apparent annulus perceptually brighter than the surrounds, although physically the same.

The patterns formed by subjective contours can extend far beyond the elements that induce the brightness differences. Some patterns based on ones first developed by Gaetano Kanizsa are especially striking (Figure 24, *bottom*). In the examples shown, complete figures are seen even though they are only partially bounded by real contours. Note that the

Figure 25 *Dobkö* by Victor Vasarely (1908–). 1957–59. Oil on canvas, 76¾ × 44⅞ inches. Reproduced from *Victor Vasarely* by W. Spiess (1971), Harry N. Abrams Inc., New York. © Artists Rights Society, Inc., New York/SPADEM 1988.

subjective contours are visually interpolated as smooth curves, rather than as straight lines, where such curves are suggested by the partial boundaries.

These and related phenomena have been widely used by modern artists. In Vasarely's *Dobkö,* shown here in Figure 25, many rectangles appear to be suspended in the horizontal array of black and white lines and bars. The subjective contours that help to form these rectangles are induced mainly by the alignment of the sharp edges of some of the trun-

cated lines and bars, somewhat in the manner of the Kanizsa triangles.

All of the effects of assimilation shown thus far have been achromatic. Similar effects on chromatic colors are shown in Figure 26. These designs consist of only three nonoverlapping colors in addition to the white of the paper: a red, a blue, and a black.

Nevertheless, the appearance of the red and blue colors varies considerably from one part of the pattern to another. Where the blue is surrounded by

Figure 26 The assimilation of color. The three printed colors (red, blue, and black) and the white of the page on which they are printed are each the same everywhere. Yet each varies significantly in appearance depending on its immediate surrounds. In general, the shift in appearance of a given color is as if the surrounding color had spread into it—thus the common descriptive term *spreading effect*. Note that the effects are the reverse of those expected from the usual brightness contrast and color contrast. Based on original 1874 figures by von Bezold (see Wurmfeld 1985). From *Human Color Vision* by Robert M. Boynton, © 1979 by Holt, Rinehart & Winston, reprinted by permission of the publisher. After Evans 1948.

black it appears darker and more saturated than where it is surrounded by white. Similarly, where the red is surrounded by black it appears darker and more saturated than where it is surrounded by white. The chromatic colors red and blue appear to soak up and to become permeated by the surrounding black or white. Where one chromatic color is surrounded by the other there is also a noticeable difference in hue compared with where it is surrounded by white. (That all of these phenomena are the result of inter-

actions may easily be verified, as before, with the use of a simple homemade reduction screen.) There is always some uncertainty, however, about whether one chromatic color actually spreads into another in such a demonstration pattern as this one; changes in brightness can easily be mistaken for changes in hue. Nevertheless, careful scientific experiments in which brightness is controlled show that under the proper conditions a true assimilation of color can and does occur. In any event, various configurations of inter-

Figure 27 *All Things Do Live in the Three* by Richard Anuszkiewicz (1930–). 1963. Acrylic on masonite, 21⅞ × 35⅞ in. Private collection, New York. Photo: Geoffrey Clements.

laced and interacting colors have long been used to good effect by artists and artisans.

A recent example of an artist's use of assimilation is Richard Anuszkiewicz's painting *All Things Do Live in the Three* (Figure 27). The reddish background is physically the same throughout the entire painting. The differences in brightness and hue of the background result entirely from the differences in the brightness and hue of the small dots. By assimilation, their brightness and hue is imparted to the neighboring surround. Illusory contours are also formed at the boundaries between the various patterns of differently colored dots.

Edge effects

Finally, the appearance of a touch of color, particularly the contrast with the surrounds, is markedly affected by the sharpness of its edge. The influence of any discontinuity in nature is strong; a marked

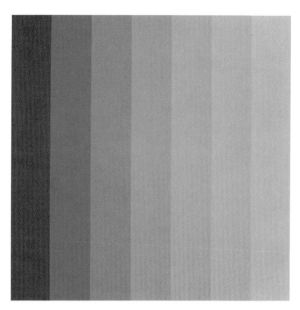

Figure 28 The Chevreul Illusion. This illusion was described by Chevreul in his great work in 1839 on the harmony and contrast of colors. Each gray band in the series appears fluted, but each is physically uniform across its whole extent. Based on Chevreul's original figure (for a recent English edition see Chevreul 1967). Photo: Robert Shapley.

sensitivity to sudden, abrupt change is inherent in our biological and psychological makeup. As Yukio Mishima wrote in his novel *Spring Snow:*

> Be it the edge of space or time,
> there is nothing so awe-inspiring as a border.

The so-called Chevreul Illusion is a striking example of border contrast—sensitivity to and perceptual exaggeration of sudden changes in brightness. Each vertical band in the graded series shown in Figure 28 is physically uniform across its whole extent. That is, all of any one particular band is printed with the same halftone screen. Nevertheless, the bands all appear fluted—each somewhat lighter near its darker neighbor and somewhat darker near its lighter neighbor. The uniformity of each band can be demonstrated by masking all but any one of them with two sheets of paper.

The Chevreul Illusion depends strongly on the number of bands. If the pattern is covered again with the same two sheets of paper so that only one pair of bands is exposed, leaving only a single step visible,

the fluting is much reduced in comparison with that produced by the whole series of steps. Indeed, the contrast at a single border is relatively weak, and often is not at all noticeable. The fluting also changes to some degree with changes in the dimensions of the pattern itself or with viewing distance, indicating a further dependence upon spatial extent. Thus, this striking border contrast shows, in still another way, the importance of extended spatial interactions in visual perception. This illusion must have been known to Signac and Seurat through their studies of Chevreul's work. And Signac may have made some intentional use of an adaptation of it in the Japanese textile background of his famous portrait of Félix Fénéon (see Figure 6).

Edges are significant in other ways, also. As shown in Figure 29, the hard-edged disk of black appears noticeably darker and somewhat more dense over its whole extent than does the same black disk with a soft edge. Similarly, most observers report that the hard-edged disk of color appears noticeably darker and somewhat more saturated over its whole extent than does the same color with a soft edge. (As

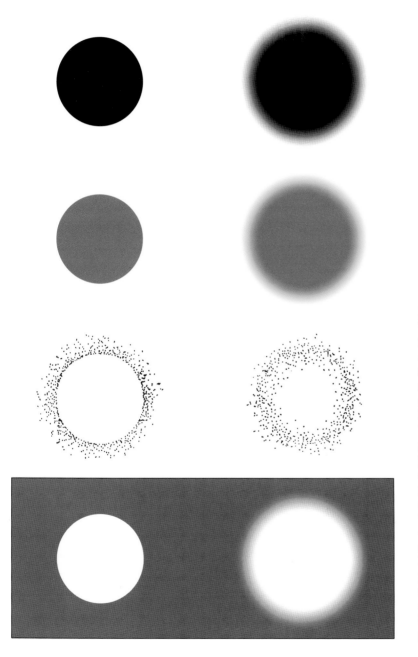

Figure 29 Edge effects. (*Top pair*) The two disks printed with the same black appear different because of the different edges. The hard-edged disk appears to be a deeper black than the soft-edged one. Viewed through a reduction screen that masks the edges, both appear the same. (*Second pair*) The different appearance of the two physically identical colored disks depends upon the differences in their edges. (*Third pair*) The white of the page surrounded by a sharp-edged annulus of stippling appears brighter than that surrounded by an annulus of stippling graded equally on both sides. (*Bottom pair*) The disk on the left, with a sharp-edged contour, appears brighter than the disk on the right, which is formed by vignetting —a gradual shading off of the gray background into the white of the page.

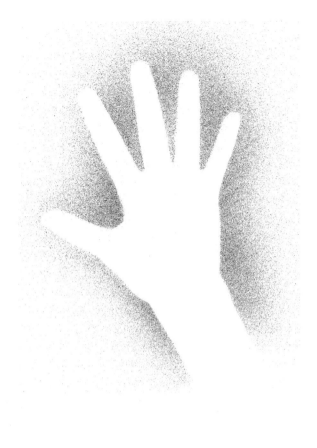

Figure 30 Negative of human hand (ice age art). There is evidence that the cave painters produced graded spattering with a sharp edge by blowing wet pigment through a hollow bone tube against a mask—in this case the artist's own hand. The gradient of the spattering could be controlled by the flow of air and by moving the tube back and forth, as with a modern artist's airbrush. Redrawn after an "airbrush" painting in the caves at Pech-Merle (Cabrerets), France.

before, the identity of the two blacks and of the two colors can be demonstrated by viewing each pair through two identical properly spaced small holes in a blank sheet of white paper laid over the illustration.) Thus, as is well known to artists and to artisans, the appearance of both achromatic and chromatic colors is markedly affected by the manner in which one touch is graded into the next. These edge effects are commonly used in the printing of textiles: the hard edge for a bold and more vibrant pattern, the soft edge for a subdued and more muted design.

Another closely related technique is also shown in Figure 29: the use of graded stippling or spattering up to a sharp border. This method of accentuating borders is ancient, perhaps as old as art itself. Rudiments of the technique may be seen in the art of the cave painters, who blew wet pigment through a tube against the edge of a movable supple mask to outline objects. Often one of their own hands served as a mask, perhaps to form a "signature." When the mask was removed, the diffuse pigment remaining terminated in a sharp border outlining the signature hand (Figure 30). Such a distribution of pigment not only enhances the sharpness of the border itself, but also the apparent brightness of the enclosed area adjacent to the border.

A wide variety of these techniques was also used long ago in oriental art, some as early as the Song Dynasty (ca. A.D.1000) in China (see Ratliff 1985). Among them were gradients of ink applied on silk or

paper with a broad brush; graded grooves incised in soft clay of unfired ceramics and later filled with glaze to be fired; and gradients of glaze pigments stippled on unfired ceramics and then partially fused in the firing. As shown in the third pair in Figure 29, both the border itself and the brightness of the area enclosed by it are enhanced by graded stippling that is cut off sharply, but not by stippling graded on both sides of the border. Thus, as all these several examples show, the edge or contour itself, as well as the more extended surrounds, is an important determinant of both color and contrast.

Paul Signac made good use of this ancient technique in his drawing of Maximilian Luce for the cover of the issue of *Les Hommes d'aujourd'hui* that was dedicated to Luce (Figure 31). Note the graded shading with a sharp edge surrounding the sun (or lamp-globe?) in the light of which Luce is reading. The technique makes that area of the page appear much brighter than it would otherwise. The brightness would have been enhanced even more if that corner of the drawing had not been cropped and had instead been completely surrounded by the sharp edge.

Some interactions of color are obvious, some are subtle; some interactions lend themselves to use in a particular style of painting, some do not. Many modern artists, such as Bridget Riley, Victor Vasarely, Richard Anuszkiewicz, and Josef Albers, intentionally make use of some of these now well-known optical phenomena, and to good effect: thus the term

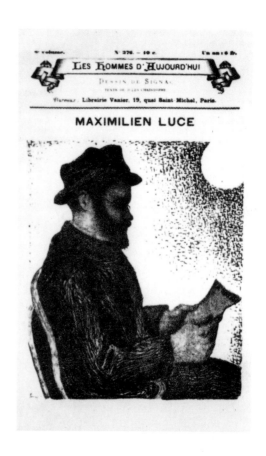

Figure 31 *Maximilien Luce* by Paul Signac. 1890. Charcoal drawing reproduced on cover of *Les Hommes d'aujourd'hui*. Bibliothèque d'Art et d'Archéologie, Paris.

optical art (see Seitz 1965). On the other hand, it is most unlikely that Suzanne Valadon (1867–1938) or Henri Matisse (1869–1954), who were contemporaries of the Neo-Impressionists, used the heavy black contours that often appear in their work for the assimilation of color that they might produce. But whether a painter makes deliberate use of the interaction of color or not, it is nonetheless just as fundamental a process in visual perception as is the optical mixture of color. The Neo-Impressionists clearly recognized the importance of the interaction of color and fully exploited it in their technique of divisionism.

Color on the canvas—a summary

It is evident from the foregoing discussion that the hue, saturation, and brightness of any color on the finished canvas depend on many factors. To begin with, the appearance of any single touch of color, seen alone on a neutral ground, is determined largely by the mix of pigments on the palette from which that particular touch of color was lifted and transferred to the canvas. But once other touches of color are placed on the canvas too, other factors immediately come into play.

One important factor is the optical mixture of color—a blending or fusion by the eye of two (or more) colors into one, as in Figure 14. In the severely systematic technique of a true pointillism (which rarely, if ever, is adhered to strictly and completely) the separate points or dots of color lose their own identity and are blended into one because of their small size and close juxtaposition.

Another more important factor is the interaction of color—the induction, at a distance, of a change in one colored area by the presence of a neighboring area of a different color, as in Figure 17. In the rather lenient technique of divisionism the separate touches or patches of color are relatively large and, although they may influence the appearance of one another, each retains something of its own identity because of its large size and visible separateness.

An important modifying factor is the position of the viewer with respect to the painting. The choice of small point or large patch is up to the painter. But since the distinction between small points and large patches is primarily a matter of scale, the viewing distance, which adjusts scale of the image on the retina, is almost as important as the absolute size of the points and patches of color on the canvas. Whether optical mixture of color, interaction of color, or some tension between the two takes place, is at least partly under the control of the viewer of a painting, who can adjust this distance at will.

In brief, color, and the harmony and contrast of color, are not intrinsic to the physical properties of light nor to the physical properties of objects illuminated by light. Rather, color—in all its manifestations—is imposed by the act of vision itself upon the patterns of light and shade that reach the eye. Much was already known about this process by the time of the Impressionists' glorification of color. Indeed, how vision takes place had, by that time, already been the subject of intense inquiry for centuries. The resulting late nineteenth century theory of color—as it was understood by Seurat and Signac, particularly in its bearing on optical mixture of color and interaction of color—was basic to the development of Neo-Impressionism. A knowledge of the origins of that color theory and of the subsequent evolution of the theory are essential for a full understanding of the whole movement of Neo-Impressionism.

II. The origin and the evolution of the theory of color

Optical mixture of color and interaction of color are familiar phenomena: easy to illustrate, easy to see, and easy to describe in general terms. But both phenomena are very complex technically, and each is quite different from the other. Therefore, it is difficult to encompass the two of them (and other lesser color phenomena, as well) within a single, comprehensive scientific theory. Indeed, in the heyday of Neo-Impressionism, near the end of the nineteenth century, color theory was marked by many contradictions and much confusion. And, as will be evident later, some of the same contradictions and confusion appeared in the theories of the Neo-Impressionists and in the writings of their proponents and of their detractors. Furthermore, some of the problems they encountered then are still unsolved today.

At the time Signac was writing his book on Neo-Impressionism, just before the turn of the century, there were two principal scientific lines of thought about color. One was the well-developed, well-known, and widely accepted trichromatic theory (with three primaries: red, green, and blue). This theory was based largely on practical everyday experience with and scientific observations of the optical mixture of color. The other was the less well developed, less well known, and less widely accepted opponent-color theory (with two opponent pairs of basic colors: red versus green and yellow versus blue). This theory was based largely on practical everyday experience with and scientific observations of the interaction of color. The trichromatic theory seemed to provide a scientific basis for pointillism, and the opponent-color theory a scientific basis for divisionism.

To understand fully the principles and practices of the Neo-Impressionist technique, one must understand the theories on which the technique was based. Furthermore, these theories must ultimately be interpreted in practical terms of technique itself: the pigments and mixtures of pigments actually used, and how those pigments were applied to the canvas by the artist. Although the only relevant theories for the Neo-Impressionists themselves were those which were current (and known to them) during the last quarter of the nineteenth century, they can be understood better when viewed in terms of what we now know about color, a hundred years later, in the last quarter of the twentieth century. Therefore, let us first consider—in outline—the origin and the evolution of the trichromatic and opponent-color theories up to and throughout the Neo-Impressionist period. The subsequent chapter will then show how some of the apparent contradictions between these two theories have since been resolved, leading toward a unification of them in modern times. The reasons for some of the long-standing confusion about both the theory and the practice of Neo-Impressionist painting will then be more apparent.[1]

The analytic approach— trichromatic theory

The three-color (trichromatic) theory is the outgrowth of an analytic, or reductionistic, approach to the study of color vision. That is, theory and experiment focused on an analysis of the component colors in white light and upon an analysis of the component

1. Modern works on color and on color vision consulted for this section of the essay include Boynton (1979), Carpenter (1974), Chamberlin and Chamberlin (1980), Evans (1974), Falk, Brill, and Stork (1986), Gerstner (1986), Halbertsma (1949), Hurvich (1981), Kuehni (1983), Marx (1973), Nassau (1983), Osborne (1980), Rossotti (1983), Wade (1982), Williamson and Cummins (1983), and Wright (1968).

parts of the retina that respond selectively to those colors. The foundation for the trichromatic theory was laid in the late 1600s when Sir Isaac Newton first analyzed a single narrow beam of white sunlight into a broad array of many different colors—the solar spectrum—by passing the beam through a glass prism.

Newton's first principles The display of these spectral colors is a common natural occurrence. The very same array is seen in the rainbow, and similar but less pure arrays appear in the interference colors reflected from an oil slick in the street after a rain and in the colors of various iridescent and opalescent objects, to give only a few examples (see Nassau 1983). But Newton went far beyond mere observation of the separated colors: he discovered basic principles. First of all, he found that there was an orderly progression of the colors—the prism deviated each distinguishable color of light by a different angle from all the others. In this continuous spectrum (Figure 32), Newton identified seven principal colors: red (deviated the least), orange, yellow, green, blue, indigo (each deviated more than the previous one), and violet (deviated the most). Today, this differential deviation of the different colors of light is attributed to their different wavelengths in the continuous electromagnetic spectrum: red, the longest; violet, the shortest.

Newton also demonstrated that this decomposition of a narrow beam of white light into a broad spectrum of colors could be reversed. If the dispersed rays of spectral colors were brought together by a lens so that they entered a second prism at the same angles at which they left the first, then the mixture emerged from the second prism as a single white beam again. By occluding one color or another, or several, from such a recombination, Newton was able to study the optical mixture of color. He found that such additive mixtures of two colors not far removed from one another in the solar spectrum would produce a fairly well saturated intermediate spectral color. If the two colors mixed were somewhat farther apart in the spectrum, they would still produce an intermediate spectral color, but usually somewhat desaturated; that is, as if toned down with white, or even almost completely white at particular separations. Surprisingly, a mixture of the most widely separated spectral colors, red and violet, produced a completely new color, purple, which is not found separately in the solar spectrum at all. No matter how little or how much a ray in a beam of sunlight was deviated by Newton's prism, it never appeared purple by itself. It may be, as Shakespeare put it, that to "add another hue unto the rainbow" is "to gild refinéd gold, to paint the lily," but that is essentially what the eye does when it creates nonspectral purple out of spectral red and violet. This nonspectral purple was to provide one of the principal links between the physics of color and the psychology of color.

The differential deviation and resulting dispersion of differently colored rays of light, which could be measured and expressed in terms of angles and distances, were the significant physical findings in Newton's experiments. The visual appearance of the rays and of their mixtures, which could only be expressed in terms of color sensations, were the significant psychological findings. It is important to keep in mind this distinction between the physical and psychological aspects of light and color. Strictly speaking, as Newton himself observed, "the rays are not colored." It is the action of light on the eye that leads to the sensation of color. We now understand this action in considerable detail, and Newton laid the groundwork for that understanding.

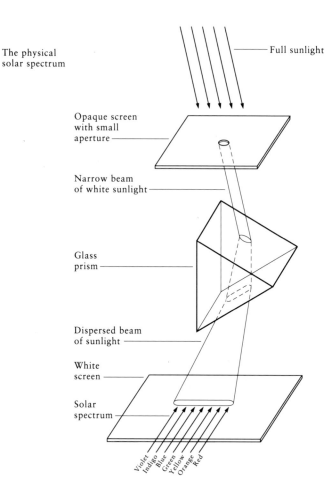

The physical
solar spectrum

Full sunlight

Opaque screen
with small
aperture

Narrow beam
of white sunlight

Glass
prism

Dispersed beam
of sunlight

White
screen

Solar
spectrum

Violet
Indigo
Blue
Green
Yellow
Orange
Red

The psychological
color circle

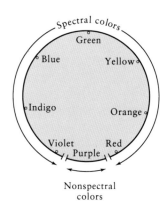

Spectral colors

Green

Blue

Yellow

Indigo

Orange

Violet

Red

Purple

Nonspectral
colors

Figure 32 Newton's analysis of the physical solar spectrum and representation of the corresponding array of psychological colors. (*Top*) A Newtonian representation of the open-ended physical solar spectrum as dispersed by a prism. (Note that purple does not appear separately in the solar spectrum.) In Newton's day there was no way of knowing that the visible spectrum was only a very small part of a very broad electromagnetic spectrum extending from the longwave visible red into the invisible infrared, on into the very long radio waves, and far beyond, and in the other direction from the shortwave visible violet into the invisible ultraviolet, on into the very shortwave X rays, and far beyond. (*Bottom*) A Newtonian representation of the closed psychological color circle. The array of spectral colors is laid out in a curve to form a nearly complete circle. Purple, which is not in the solar spectrum, but which can be obtained by a mixture of the spectral colors adjacent to it, is then fitted into the gap to close and to complete the color circle. All colors of all hues and saturations are either on, or enclosed by, the color circle. Brightness, the third dimension of color, was not represented by Newton. (Note: Newton's circle shown here, and some of the other figures to follow, have been reversed right to left, with respect to the originals, to conform with modern representations of color space.) Redrawn after Newton's original figures (see Boring 1942 and Herrnstein and Boring 1965).

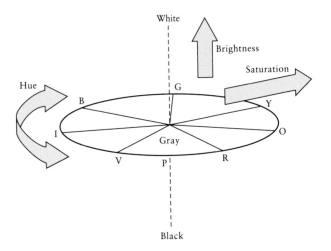

Figure 33 Newtonian color space. The circumference of the circle represents hue and the radii represent saturation. Brightness is represented in the third dimension (*dashed line*). The three-dimensional representation of color space was a later development, and was not included in Newton's original diagrams (see Boring 1942). Adapted from Williamson and Cummins (1983).

After a number of exploratory experiments, Newton came to realize that several of the principal psychological facts of color and of its optical mixture could be represented in a single diagram—a color circle (Figures 32 and 33). Two observations, already mentioned, provided the insight that led to this simple, but comprehensive, schema.

One of these observations was that red and violet, the two colors farthest removed from one another in the physical spectrum, seem to be closely related in the corresponding psychological array: both border on nonspectral purple. Newton saw that this close psychological relationship between physically distant red and violet could easily be realized in a simple plane diagram. All that was required was to draw the solar spectrum in a curve so as to form a nearly closed circle, leaving, for the moment, a gap between the red and the violet. Nonspectral purple, which is tinged with both red and violet, then filled the gap, linked those two end-colors, and neatly closed the circle. Thus, in this ingenious circular arrangement red and violet are, at the same time, distant from one another (separated on one side of the circle by all the other spectral colors) as they are in the physical world of color, and close to one another (separated on the other side of the circle only by nonspectral purple) as they are in the psychological world of color.

Another experimental observation linked the colors in a different way but in a manner still consistent with a circular arrangement. As mentioned above, mixtures of equal amounts of certain pairs of colors, widely spaced in the solar spectrum, produce a near-white or gray. When the colors of the spectrum were arranged in Newton's circle, it became apparent that those which were diametric to one another (and which we now know as complementary colors) were the ones which, when mixed, yielded white, or a gray/white. The common point for all such whites produced in this way is at the center of the circle.

The essence of Newton's color circle (Figure 33) may be expressed in a few words: All the different fully saturated hues of color (red, orange, yellow, . . . purple) are represented in their natural order around the circumference; white (or gray) is represented at the center; and degree of saturation of the various hues (the purity of color) is represented by distance along the corresponding radii from center to circumference. Note that an essential orthogonal dimen-

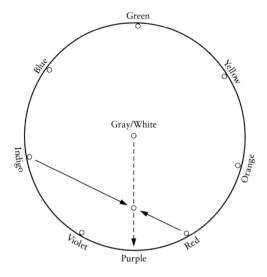

sion—the gray scale from the brightest white to the darkest black—was not considered in Newton's original circle. This third dimension, indicated here only by a dashed line, will be considered more explicitly, later on, in a discussion of the color solid. The practical importance of the color circle is that it enables one to predict, fairly accurately, both the hue and the saturation of any arbitrary optical (additive) mixture of colors. (A note of caution: The following additive rules do not apply to subtractive physical mixtures of painters' pigments. Such subtractive mixtures will be considered later.)

For simplicity, assume first a mixture of only two colors. Locate the two on the color circle (say red and indigo, as in Figure 34) and draw a straight line between them. The resulting compound color will be somewhere on that straight line depending on the relative amounts of the two colors. In this particular case, assuming more red than indigo, the resultant is a reddish violet—a purple. The exact location is given by a simple calculation. One can think of the line connecting the two colors as a lever, and the location of the mixture of the two on that line as the position of the movable fulcrum required to balance the lever. Thus the basic "law of the lever" applies. The procedure is much like balancing two children

Figure 34 Newton's theory of color mixture. The color circle may be used for approximating the compound color resulting from any optical mixture of colors. In the example shown here (*left*), indigo and red are mixed, but there is twice as much red as indigo. The locus of the mixture is therefore twice as far from indigo as from red, and the result is a purple that is somewhat more reddish than bluish. The predicted hue is given by the radial line (*dash*) drawn through the result of the addition, from center to circumference of the circle; the saturation is given by the distance from the center to the point of intersection of that radial line and the line connecting the two colors; brightness is not represented. As will be shown later, the predicted hue is more or less correct, but the saturation is not. This error results from Newton's use of a perfect circle to represent the color space. Redrawn after Newton's original figure (see Boring 1942). (*Right*) The "forbidden" zones in Newton's theoretical color space that cannot be filled with straight-line rules of color mixture, even with seven primaries.

on a seesaw. If equal amounts of the two colors are mixed, then the balance point of the mixture will lie halfway between the two. If there is twice as much of one color as of the other, then the balance point of the mixture will be twice as far from the lesser amount as it is from the greater amount, and so on. In short, simple ratios of the amounts of the two colors determine the locus of the mixture within the color circle. (There are numerous sophisticated physical and psychophysical methods for measuring amounts of light and color. To avoid unnecessary technical details, they will not be described here. One very simple method, using Maxwell's disks, will be described in a later section of this chapter.)

The hue of the predicted mixture is given by the radial line drawn from the center of the circle through the balance point of the mixture to its intersection with the circumference, where the hues are labeled. The saturation is given by the distance along that radial line from the center of the circle to the balance point of the mixture. If a third color were added to the mixture of the two, then the result would be determined in the same way; that is, by drawing a straight line between the color of the first mixture and the newly added color and locating the point on the line determined by the relative amounts as before. This straight-line process for calculating the outcome of optical mixtures of colors can be repeated indefinitely and in any order, for any number of colors.

Note that the predicted outcome of a mixture of any two primaries shown in Figure 34 must lie on a chord of the circle—not on the perimeter. Therefore, according to the theory, and in keeping with Newton's own observations, such a mixture will not be fully saturated. Newton's straight-line procedures can yield fully saturated compound colors only by mixing two primary colors that are immediately adja-cent to one another on the perimeter of the circle. This points up a significant limitation of the seven-primary Newtonian theory for, in essence, it requires that there be an infinite number of primaries (one at every point on the perimeter of the circle) to obtain full saturations of all colors. Therefore, as shown in the inset, use of only seven principal colors as primaries would, according to Newton's straight-line rules of mixture, form a slightly reduced color space bounded by a seven-sided polygon. No color located in the regions between the polygon and the perimeter of the circle could be formed by any combination of seven such primaries. (In effect, Newton's theory attempts to fit a polygonal peg into a circular hole.) For Newton's straight-line mixtures, these regions are "forbidden" zones in the full color space. And yet, although forbidden in theory, fully saturated spectral colors do appear there.

Many other color phenomena implicit in the perfect radial symmetry of a perfect circle (such as a nonspectral purple that is more saturated than any mixture of spectral red and violet) are also not in accordance with the now-known facts of color vision. But such discrepancies were inevitable. Newton had no way to measure the dimensions of various colors precisely and to assign numerical values to them—procedures essential for the formulation of an exact theory and for accurate calculations of mixtures. Bear in mind that Newton's original color circle was only a very rough first approximation. And Newton himself noted that it was "accurate enough for practice, though not mathematically accurate."

Accurate or not, Newton's color circle was a brilliant insight into the fundamental phenomenal relations among all the colors. Although incorrect in many special details, it was correct in all general principles. And the far-reaching theoretical importance of the color circle was much greater than its immedi-

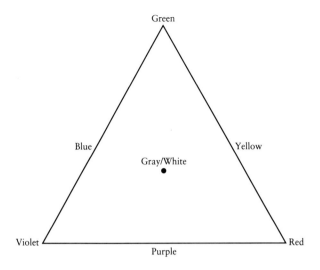

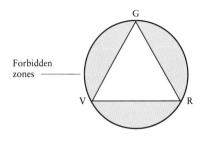

ate practical importance. It provided the foundation for nearly three centuries of research on the psycho-physiological bases of color vision.

The Young-Helmholtz trichromatic theory About 1800, the British physician and natural philosopher Sir Thomas Young pointed out that the principal facts of color mixture could be explained just about as well with only three primary colors (and their corresponding three retinal mechanisms) as with Newton's seven. (The empirical foundation for Young's theoretical advance had been laid long before by Jakob Christoffel Le Blon, a German painter and engraver. As early as 1722, Le Blon developed a primitive form of three-color printing.) Nearly half a century later, the German physician and physicist Hermann von Helmholtz further advanced this simplification. As a result, Helmholtz's name became attached to the trichromatic theory along with Young's.

Young's modification of Newton's color circle is shown in Figure 35. For Newton's circle with seven primaries Young substituted an equilateral triangle with three primary colors—one at each of the three vertices. The exact choice of primaries was somewhat arbitrary in the beginning and varied from time to time, but in the end, and for good reasons, Young

Figure 35 (*Left*) Young's color triangle. The three hypothetical primary colors are at the three vertices of the triangle. Shown at the midpoints of the sides are the colors produced by mixtures of pairs of the primary colors: blue from violet and green, yellow from green and red, and purple from red and violet. As in Newton's circle, gray/white is at the center of the figure, and distance from center to perimeter represents saturation. Note, however, that according to the theory, mixtures of pairs of primaries must fall on the straight lines connecting the two, and thus are necessarily somewhat less saturated than with Newton's seven primaries. Redrawn after Young's original figure (see Boring 1942). (*Right*) For comparison with Figure 34, Young's triangle is placed inside Newton's circle. The diagram shows very large "forbidden" zones that cannot be entered by Newtonian straight-line mixtures of color—given a circular representation of color space and these three, or any other set of three, primaries. Either the color space assumed or the theory of how that space is filled, or both, must be modified.

settled on a red, a green, and a violet. These three primaries completely spanned the physical spectrum and located all the colors in it on the two upper sides of the triangle, leaving only the nonspectral purples on the base.

The "simplest arrangement" The basic ideas underlying this triangular representation of the color space were derived from and are essentially the same as those underlying Newton's circle: white was located at the center of the figure, the fully saturated primaries and the intermediate hues were located on the perimeter, and amount of saturation was represented along the straight lines from the center to the perimeter. Young's trichromatic theory had the great advantage, however, that it was much simpler than Newton's theory in both conception and expression. Unfortunately this triangle with only three primaries suffered from one of the same major shortcomings as Newton's circle with seven primaries. Assume that the aim of the theory is to fill Newton's circular color space. As shown (Figure 35, *bottom*), in theory, every hue of some saturation can be obtained by a proper mixture of the three primaries (whatever they may be), but not every hue of full saturation. No point in the regions between the rectilinear triangle and a curvilinear boundary of color space (here Newton's circle) can be reached by any straight-line mixture using only three primaries located within that space. Here, again, are forbidden zones.

These discrepancies pose a problem. The boundary of a color space determined by experiment and the boundary of a model of color space arising from a color theory must be congruent for the theory to be completely correct. Considering the complexity of color vision, it is most unlikely that an experimentally determined color space can be fully and properly represented in the abstract either by the simplest of all conic sections (a perfect circle, as in Newton's theory) or by the simplest of all polygons (an equilateral triangle, as in Young's theory). Nevertheless, these were good successive approximations to the more exact theory that was soon to come.

Young's simplification of Newton's theory was based primarily on logic and intuition, and although it was consistent with some of the facts of color mixture known in his day, it was not demanded by them. Young made this clear in his article, "Chromatics," written in 1817 for the *Encyclopedia Brittanica:*

> If we seek for the simplest arrangement, which would enable it [the eye] to receive and discriminate the impressions of the different parts of the spectrum, we may suppose three distinct sensations only to be excited by the rays of the three principal pure colours falling on any given point of the retina, the red, the green, and the violet; while the rays occupying the intermediate spaces are capable of producing mixed sensations, the yellow those which belong to the red and green, and the blue those which belong to the green and violet.

As Young noted, "At least this supposition [of three primary sensations] simplifies the theory of colours; it may, therefore, be adopted with advantage, until it be found inconsistent with any of the phenomena . . . " Part of the simplification was in the reduction of the number of primary colors (and their underlying mechanisms) from seven to three. But equally important was the compensatory notion that "the rays occupying the intermediate spaces are capable of producing mixed sensations." That is to say, the three primary mechanisms were assumed to be broadly "tuned," with each partially overlapping its neighbors, and therefore capable, together, of covering the whole visible spectrum, despite the limited number of primaries. This insight opened the way for

a proper distinction between visible colored lights, represented as points in the color diagram, and physiological mechanisms of color, represented as broad bands. It will be essential throughout this whole essay to maintain this distinction between colored light stimuli and corresponding color-mediating mechanisms.

As it turned out, Young's insight was almost as deep and penetrating as Newton's. His supposition was consistent with one central fact about color vision: the "simplest arrangement," a trichromatic system, was the one Nature had actually chosen. Over a hundred years were to pass before this was to be demonstrated directly by experiment. But, already in the 1850s, Hermann von Helmholtz made a significant theoretical advance in this direction.

Helmholtz's protopigments Following Young and extending his ideas, Helmholtz further advanced the hypothesis that the three primary colors could be mediated by three overlapping processes in the retina. These hypothetical processes (Figure 36) will be called the *red sensitive*, the *green sensitive*, and the *blue sensitive*.[1] All three processes were broadly tuned and each responded to light over a broad band of wavelengths (as was proposed in Young's theory). Furthermore—and this is most important—there was complete overlap: each was assumed to be sensitive in some degree to the entire visible spectrum from red to violet. But each one was also assumed to be maximally sensitive (as indicated by its name) to a different specific region within the spectrum. Therefore, the overlap in sensitivity did not pose a problem for the theory.

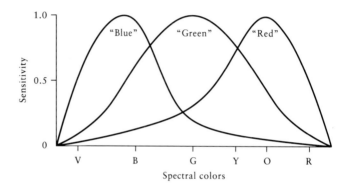

Figure 36 Helmholtz's three hypothetical retinal processes. Relative sensitivity of the three hypothetical retinal processes deduced by Helmholtz from the facts of color mixture. Note that each hypothetical process is broad-band and absorbs light over almost the entire visible spectrum, with its six principal colors here labeled *V* (violet), *B* (blue), *G* (green), *Y* (yellow), *O* (orange), and *R* (red). One process, however, is maximally sensitive in the orange-red region, one in the green region, and one in the blue-violet region. Hereafter, these three retinal processes will be referred to as the "red," the "green," and the "blue." Redrawn after Helmholtz's original figures (see Boring 1942).

1. Helmholtz actually called our blue-sensitive process *violet sensitive*. However, as he drew the curves, sensitivity to blue is greatest. Recognizing that fact, and in keeping with later usage, we shall continue to use the term *blue sensitive*. (Hereafter, color terms that refer to color-mediating mechanisms, rather than to colors themselves, will be set in quotation marks.)

The basic assumption was that because each of the three overlapping processes was excited by light most strongly in a different region of the visible spectrum, the differential excitation alone would be sufficient to account for the different influences of differently colored lights. This assumption (which has since turned out to be essentially correct) put Young's modification of Newton's theory into its modern physiological form: seven unrealistic mathematical points of Newton were replaced by three physiologically realistic broad bands of sensitivity, which are now known to be manifestations of the absorption bands of three different photopigments. In a very real sense, Helmholtz's hypothetical color-sensitive processes were *proto*pigments—the forerunners of the photopigments of the modern theory.

Although Helmholtz's physiological ideas were still speculative, psychophysical experiments on color mixture and on many other aspects of color vision strongly supported the emerging notion of three primary colors based on three corresponding broad-band photopigments, and the so-called Young-Helmholtz trichromatic theory of color vision was widely accepted from then on until Signac's time (and still is today). Indeed, in the late 1800s, optical mixture in accordance with trichromatic principles provided the theoretical basis for the technique of pointillism. Today, in a more exact form, the same trichromatic theory provides the means for understanding both the technique and, especially, the limitations of a strict pointillism in which complete fusion by optical mixture of the separate points or dots is supposed to take place.

Maxwell's triangle Contrary to widespread belief over the years, not all colors can be matched exactly in both saturation and hue by a Newtonian straight-line mixture of three positive spectral primaries—either in theory or in practice. All colors in the forbidden zones illustrated above with Newton's circle and with Young's triangle are beyond the reach of such mixtures. An understanding of the nature and extent of this theoretical and practical deficiency, and what it signified in actual mechanisms of color vision, required more exact quantitative methods than those used by Newton and Young. These methods were provided by the Scottish physicist James Clerk Maxwell in the 1850s. In a refined form, they provide the basis for the construction of modern color diagrams.

Maxwell made two essential contributions. One was an exact practical method for mixing and matching colors. The other was an exact theoretical method for specifying the locations of colors (and of mixtures of colors) in the color space formed by Young's triangle, or any similar triangle. The two methods were complementary and—for the first time—enabled quantitative theory to be checked directly against experimental practice.

The so-called Maxwell triangle was the first two-dimensional color space to be based on precise color mixing and color matching experiments. A simple method for the production of additive (optical) mixtures has been available since antiquity—indeed, since prehistoric times. Any rapidly rotating object, such as the stone weight on a primitive fire stick or on a spindle for spinning yarn, is all that is required. The rapid rotation leads to optical mixture of whatever colors are on the object. Standard color disks with painted sectors fuse the different colors in this way. The Maxwell disks (which are still in use today to illustrate basic principles of the optical mixture of color) use this same simple method, but with one ingenious modification to permit easy variation of the mixture. This modification consists of adjustable

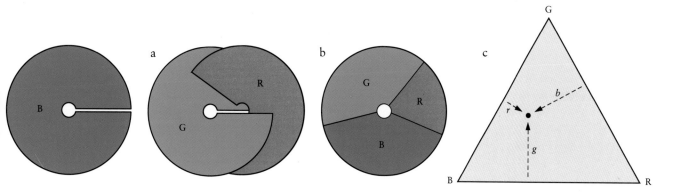

multiple sectors (Figure 37) assembled out of a number of radially slit, interlocking, and overlapping disks of various colors.

Suppose three such differently colored disks, representing three primaries, are interlocked to form one disk with three sectors. The proportions of the three differently colored sectors can be easily adjusted, by simply shifting the interlocking disks with respect to one another, before clamping them in their final position. Then, when the whole assembly is rotated at high speed, the three colors optically mix and fuse into one average color as if three differently colored lights had been superimposed. The sectors can be adjusted and readjusted to match any sample color. When a satisfactory match has been made, the resulting proportions of the three colors exposed on the disk can be directly translated into a single point in the color space formed by Maxwell's triangle (Figure 37).

This translation from colors on a disk to a point on a graph depends upon a simple mathematical relationship: The three colored sectors, no matter what their proportions, must always sum to unity—that is, together they cover one full disk. The sum total is a constant: If the size of one sector is increased, then

Figure 37 Maxwell's disks and Maxwell's triangle. (*a*) Three primary colors, *R*, *G*, and *B*, on radially slit disks can be overlapped and interlocked concentrically so as to form a single disk with three colored sectors in any chosen proportion. (*b*) The three overlapping disks can be clamped in the chosen positions, on a rotatable spindle, to form a single rigid disk. In rapid rotation the colors of the three sectors fuse and, by optical mixture, give a color determined by the relative proportions of the separate sectors. (*c*) This mixture can then be represented as a single point in Maxwell's triangle. The location of the point is given by three color coordinates *r*, *g*, and *b*, the relative lengths of which are proportional to the relative sizes of the corresponding sectors. Each coordinate originates on and is perpendicular to the side of the triangle opposite the color it represents. Redrawn after Maxwell's original figures (see Boring 1942).

one or both of the others must be correspondingly decreased. Maxwell saw at once that such sums to unity have a ready-made means of graphical representation: The position of any point within an equilateral triangle can be specified by a combination of three positive fractional numbers that add up to one. These three positive numbers represent the distances measured perpendicularly from each of the three sides of the triangle to the point in question. Thus any color produced by optical mixture of red, green, and blue sectors on Maxwell's disk can be represented within Maxwell's triangular color space in terms of three corresponding numerical stimulus values: r, g, and b. On the circular disk, each number represents the relative angular size of one of the colored sectors; on the triangular graph, the same number represents the relative length of the corresponding color coordinate.

Maxwell's triangular color space is analogous to Newton's color circle and to Young's color triangle, both in the way that the colors are arranged and in the way that mixtures of them are predicted. But it has the great advantage that the points within the color space (and the three coordinates that represent each such point) have precise meanings, both in terms of measurable amounts of color and in terms of the mathematical relations among those measures. Thus Maxwell provided the foundation for a more exact and directly testable trichromatic theory of color vision—an enduring quantitative theory still in use today.

The locus of the spectrum About 1860, Helmholtz came to grips with the problem that neither of the conventional color diagrams (Newton's perfect circle or Young's, and Maxwell's, equilateral triangle) properly represented the locus of the spectrum. Exact quantitative observations, made possible by Maxwell's advances in the measurement of color, showed that the various spectral colors are more complexly located with respect to the achromatic center of the diagram than had been believed before. For example, a fully saturated spectral yellow (about 580 nm) is relatively near the center, whereas a fully saturated spectral blue (about 475 nm) is relatively more distant. Based on such observations, Helmholtz drew the curved spectral diagram shown in Figure 38. This color space, with its curved upper perimeter representing fully saturated spectral colors, cannot be fitted with an interior equilateral triangle such as that of Young and Maxwell. Nevertheless, the trichromatic theory with its triangular representation can be retained. As shown, Helmholtz's new color space can be obtained with Newtonian straight-line rules of the mixture of three positive primaries if the locus of the spectrum lies within an ideal larger triangle formed by the three primaries, at least one of which (in this case the green) must be "supersaturated"—that is, located outside of the space containing real colors that can actually be seen.

Although the use of an imaginary supersaturated primary in the construction of a theoretical mixture diagram larger than the visible color space itself made room for the proper location of the spectral colors and eliminated the forbidden zones inherent to Newton's color circle and to Young's triangle, it introduced a new problem at the same time. Formerly the space of color vision was larger than the space of color theory; now the space of color theory was larger than the space of color vision. This new construction thereby raised the new and vexing question of the physiological and psychological meaning of supersaturated primaries and the attendant empty zones in the theoretical color space.

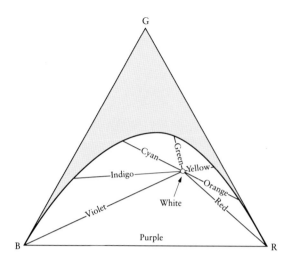

Figure 38 The Helmholtz color triangle. The locations, with respect to white, of the spectral colors red, yellow, green, cyan, indigo, and violet are represented on the curved line as labeled. Nonspectral purple falls on the straight line connecting red and violet. The three "basic sensations" are represented at the vertices of the triangle. The red, *R*, and blue, *B*, are at the base of the triangle on the two ends of the spectrum. The third primary sensation, *G*, represents an imaginary "supersaturated green." In theory, *R, G,* and *B* would be the colors seen if each primary mechanism were activated alone. In fact, no one experiences, under any conditions, a green that is several times more saturated than spectral green. Such a distant location is required by the theory in order to fill, by Newtonian straight-line rules of mixture, the color space bounded by the spectral colors and nonspectral purple. (For consistency with other illustrations, *R, G,* and *B* are used here instead of Helmholtz's original labels *R, A,* and *V.*) Redrawn after Helmholtz's original figures (see Boring 1942).

Helmholtz looked to the known physiology of vision for an explanation. He noted that spectral colors can appear somewhat supernormal in saturation if the eye is first exposed to and fatigued by the complementary color. In effect, one member of a complementary pair of colors can be strengthened by fatiguing or weakening the sensitivity of the eye to the other. In particular, the stronger "green-sensitivity" required here can be obtained by prior long exposure of the eye to red light. However, such fatigue from prolonged exposure is an unusual circumstance—out of the ordinary, and not adequate to account for color vision under normal circumstances. But as we shall see later on, Helmholtz's notion that one of the overlapping trichromatic mechanisms might be interfering with another, and preventing it from realizing its full potential, was on the right track.

Maxwell provided a very different and relatively simple mathematical solution to this problem. His solution involved the use, under certain conditions, of one (or more) of the three real spectral primaries as a "negative" color. In the classical Young-Helmholtz trichromatic theory, all primary influences were positive. Accordingly, in Maxwell's original quantitative representation of the theory (Figure 37), the three color coordinates (*r, g,* and *b*) each point in one direction only; namely, toward the interior of the triangle in the direction of the corresponding primary (*R, G,* and *B*). Thus, the effect of each positive primary is to "pull" a mixture in its direction. A negative influence, on the other hand, would "push" any color mixture away from that primary toward and, under the proper circumstances, even beyond the opposite boundary of the theoretical triangular color space. With proper amounts of negative and positive influences in the proper places, the boundaries of a theoretical triangular color space could be pushed and

pulled about and reshaped to fit practically any real visible color space that the facts of color vision might require. Maxwell's concepts soon led to significant practical and theoretical advances.

Helmholtz's ideas on the role of the three broadband retinal mechanisms of trichromatic vision and Maxwell's ideas on the mathematical description of trichromatic color space represent a significant branch point in the evolution of the trichromatic theory of color as it relates to this essay. The two different approaches illuminate two different facets of color vision: Helmholtz's work led to a better understanding of the basic physiological mechanisms of color vision whereas Maxwell's work led a more rigorous description of the psychological phenomena of the optical mixture of color. Let us continue with the more abstract Maxwellian branch, because of its direct relevance to optical mixture; we shall return later to the more concrete Helmholtzian branch, with its concern with physiological mechanisms.

Color standards The need, in industry, in art, and in research, for accurate and reproducible color standards became so great around the turn of the century that much attention was devoted to the problem. In the process, trichromatic theory was greatly advanced. Most well known among such standards is the *Munsell Book of Color,* a color atlas devised in 1905 by the painter and art teacher Albert H. Munsell. The atlas consists of more than fifteen hundred actual color samples of a wide range of hues, saturations, and brightnesses to be viewed under standard white (north skylight) illumination for comparison with the unknown sample. Another widely used system, also based on an array of sample colors, is the one devised by Wilhelm Ostwald, the 1909 Nobel laureate in chemistry, in 1917.

Both the Munsell and the Ostwald systems still enjoy wide practical use by textile manufacturers, interior decorators, commercial artists, printers, and others for whom such standards are necessary. But sample colors have many limitations. And early on, the need for an objective standard, requiring neither perishable samples nor subjective comparisons, became acute.

In 1931 the Commission Internationale de l'Eclairage set up a new standard system—the so-called CIE Chromaticity Diagram—based on the average of a very large number of human judgments about visual identity of different known, physically defined colored lights (see Boynton 1979). The CIE Chromaticity Diagram is obviously derived from and similar to the Helmholtz color space shown above in Figure 36. Furthermore, it is remarkably similar in its fundamentals to Newton's original color circle. In fact, standard Newtonian straight-line rules of color mixture are applicable, with suitable modifications, to modern methods of observing, measuring, and specifying color in the CIE diagram. The modifications are based largely on Maxwell's triangle and its accompanying mathematical theory of three stimulus values.

The CIE Chromaticity Diagram provides a means of specifying a sample color in terms of three stimulus values. The sample is lit by a standard illuminant that represents average daylight. The comparison color is provided by an optical mixture of three beams of light from the same standard illuminant, each of which has passed through one filter: a red, a green, or a blue. The amounts of the three lights are then adjusted, somewhat in the manner of Maxwell's disks, so that their optical mixture matches the sample. The three measured values of the lights then determine the locus of the point on the Chromaticity Diagram that represents the sample color.

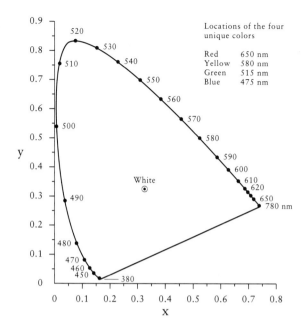

Figure 39 The CIE Chromaticity Diagram. All colors that can be obtained by the use of real lights lie inside the area enclosed by this horseshoe-shaped diagram. Construction of this plane diagram requires the use of only two coordinates, *x* and *y*, with both the *x* and *y* axes outside the boundaries of the diagram. Brightness (or luminance) is expressed in the third dimension (not shown here) with a third axis perpendicular to the other two. (For general discussion of the CIE system of colorimetry, see Boynton 1979.)

A match or mismatch is the only judgment that must be made by the observer; no attention need be paid to the hue or saturation of either the fixed sample or the adjustable optical mixture. Indeed, both saturation and hue may be altered by changes in the sensitivity of the eye by adaptation or contrast, for example, and the tristimulus match will still hold. For these reasons (and several others which need not be detailed here) some color scientists object to the use of color terms in reference to the CIE Chromaticity Diagram and to the portrayal of the diagram in color. But the fact that judgments about hue and saturation need not be made in the matching experiments does not mean that they cannot be made. Indeed, under fixed and well-specified conditions it is meaningful and useful to do so. Therefore, the restriction will not be observed here. Points on the diagram will be regarded as representing specific hues and saturations.

The triangular coordinates of Maxwell's theory are unfamiliar to most persons and somewhat awkward to use. Fortunately, any two-dimensional space, no matter what theoretical values are represented on it, can be completely and conveniently expressed in terms of the two conventional coordinates, *x* and *y*. With this simplification, one loses only the direct, immediate reference to the three hypothetical primaries, but these primaries can be reintroduced at any time, and expressed again in terms of three coordinates—if need be.

As shown in Figure 39, two quantities, *x* and *y*, are sufficient to specify any point in the CIE Diagram. As in Helmholtz's triangle, these coordinates, when fully extended over the range 0 to 1.0, map a region greater than the perceived color space enclosed by the CIE Diagram itself. The pair of coordinates, *x* = 0.33 and *y* = 0.33, specify the achromatic point (gray/white) near the center of the figure (just as did the center of Newton's color circle). The straight line from this achromatic centerpoint to any point on the perimeter of the color space specifies increasing saturation. The upper horseshoe-shaped portion of the perimeter of the color space shows the location of the spectral colors, and the rectilinear base of the color space represents the nonspectral

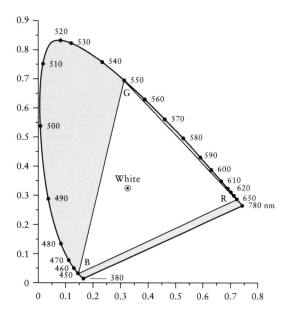

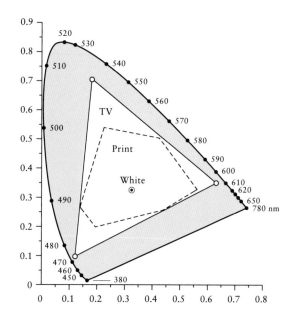

purples. Colors add according to simple Newtonian straight-line procedures. But the diagram cannot be completely filled by Newtonian mixtures of any three real primaries; at least one imaginary primary must be used.

Limitation of optical mixtures Assume that the spectral colors red (*R*), green (*G*), and blue (*B*) are the chosen real primaries (Figure 40). There is, within the triangle connecting these three real spectral primaries, a wide gamut of colors that can be produced by simple straight-line mixtures of the three. The great extent of this gamut can be appreciated by comparing it with the slightly smaller gamut of colors produced by the red, green, and blue phosphors commonly used in modern television screens, and with the still smaller gamuts of color available in color printing shown in the same figure. No matter how large the gamuts of colors produced by any set of three real primaries may be, none fills the entire color space. The problem of "forbidden" zones is still present, even in this modern CIE Chromaticity Diagram,

Figure 40 Various gamuts of color in the CIE Diagram. (*Left*) The shaded triangle shows the colors that can be obtained by mixing the three real lights *R, G,* and *B*. Following Newtonian straight-line rules of mixture, the color obtained by mixing any two of the three, in any proportion, must fall on the straight line connecting those two. Mixtures of all three, in any proportion, must fall within the triangle *RGB*. Note the outer "forbidden zone" in which colors are seen but which cannot be filled by any additive Newtonian mixture of these three real colors. Redrawn after Rossotti (1983). (*Right*) The approximate gamuts of colors obtainable by mixtures of three light-emitting phosphors (a red, a green, and a blue) commonly used in modern television (*solid line*); and the four colorant primaries used in graphic printing (*dotted line*). Redrawn after Kuehni (1983).

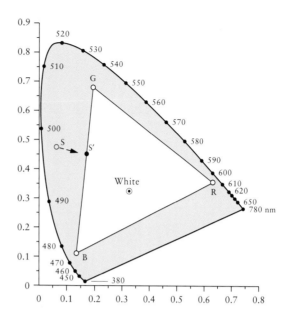

Figure 41 Forbidden zones in the CIE Diagram. The sample color S, in the forbidden zone, cannot be matched by any Newtonian straight-line combination of the three real primaries R, G, and B. A spurious match can be obtained, however, by adding a sufficient amount of the color R to the sample S to desaturate it sufficiently to bring it to the point S', within the gamut of color enclosed by the triangle RGB. Redrawn after Williamson and Cummins (1983).

if real positive primaries are used. The full extent of the outer bounds of the spectral colors as represented in the CIE diagram can be realized with Newtonian straight-line mixtures only by using one or more purely imaginary primaries, either partially or completely outside of the diagram: in essence, an extrapolation in the mathematical domain beyond what can be realized in vision itself. Such imaginary primary colors exist in theory only and are not available to the painter.

Because the real color space cannot be completely filled with simple straight-line mixtures of any three real spectral primaries, not every color can be matched with a mixture of three such primaries. There are forbidden zones. In the example shown here, the forbidden zone in the CIE Chromaticity Diagram is almost entirely on the side of the triangle opposite the chosen primary R. Suppose that a sample color S to be matched falls in this forbidden zone, outside the gamut of colors provided by the three chosen primaries, R, G, and B. The closest match that can be obtained by Newtonian straight-line

mixing procedures (Figure 41) is by completely eliminating the opposite primary, R, from the mixture, and then properly adjusting the remaining two primaries, G and B, so that the mixture is of the same hue as S.

This mixture of the two colors G and B is still less saturated than S. But by a clever manipulation a spurious, but informative, match can nonetheless be made using only the three primaries. The trick is simply to add a sufficient amount of complementary red R to the sample S to bring it within the triangular gamut of colors formed by the three primaries. In effect, the combining of R with S cancels some of the purity of the color S, thereby desaturating it and drawing it toward R. Thus, by combining the proper amount of a particular primary with a sample color in a forbidden zone, a close match with that diluted sample color can be made using three real spectral primaries only. This mathematical maneuver preserves the trichromatic theory, but in a modified form. Three primary lights are not sufficient to match any color, but, as we will see, three primary

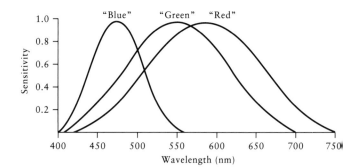

mechanisms, properly activated, are sufficient. The basis of trichromacy is not to be found in any three narrow-band "primary" colors themselves. Rather it resides in the three broad-band primary physiological mechanisms that mediate all colors.

Trichromatic mechanisms Let us now turn back to the Helmholtzian physiological branch of trichromatic color theory. The suggestion by Helmholtz that the "green" component of the trichromatic mechanism cannot realize its full potential because of competition with the "red" mechanism appears to be absolutely correct. In fact, both the "red" and the "blue" mechanisms "interfere" with and prevent isolation and activation of the "green" mechanism alone. This results because of the overlap of the broad absorption bands of the three photopigments. Two informative diagrams based on ones prepared by the color scientist Robert Boynton, at the University of California, San Diego, show schematically how all this can come about (Figure 42).

Assume that the hypothetical spectral sensitivity curves of the three mechanisms overlap as illustrated. (Qualitatively, these hypothetical curves are a reasonable approximation to the real sensitivity curves of human photoreceptor cells, the cones, which are determined largely by the spectral absorption characteristics of the photopigments in those cells.) Note that the "red-sensitive" mechanism alone will be activated by spectral lights of all visible wavelengths at or above about 700 nm. Similarly, the "blue-sensitive" mechanism alone will be activated by lights of wavelengths between 400 and 410 nm. Therefore, these pure, uncontaminated activations of the "red" and "blue" systems can be represented in the very corners of the color triangle shown below.

The "green" system is a different matter. There

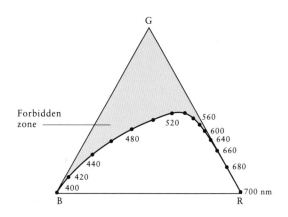

Figure 42 (*Top*) A set of hypothetical Young-Helmholtz spectral sensitivity curves for the three types of cones: *R*, *G*, and *B*. (*Bottom*) The color space delimited by these three curves in a triangular color diagram using Maxwellian principles. Note that these are hypothetical diagrams presented for illustrative purposes only. The sensitivity curves are qualitatively similar to those of real human cones and the color diagram is qualitatively similar to the human Chromaticity Diagram. Redrawn after Boynton (1979).

is no light within the visible spectrum that will stimulate the "green-sensitive" mechanism alone. From about 560 to 700 nm, both "red" and "green" will be stimulated, and points representing those spectral lights must lie on the straight line between the R and G corners of the triangle. The exact locations depend upon the relative contributions of R and G. At around 560 nm, the "red" and "green sensitivity" curves are of approximately equal amplitude; therefore 560 nm must be located about equidistant from the R and G corners of the triangle. Below about 560 nm, down to about 410 nm, all three systems will be activated to some degree. Around 500 nm, for example, the "red," "green," and "blue" mechanisms are all activated more or less equally. Therefore, in the triangular plot, R, G, and B each "pull" the point for 500 nm about equally toward their respective corners. Accordingly, that point must be located about in the center of the triangle. All other spectral lights can be located similarly, depending upon the relative amplitudes of the three sensitivity curves at the corresponding wavelength.

All points on the base of the triangle are non-spectral purples, and must be represented by straight-line combinations of R and B alone.

With this focus of the theory on trichromatic *mechanisms,* rather than on trichromatic primaries, many mysteries vanish. The locus of the spectrum and the location and extent of the forbidden zone in this color triangle can be fully explained in terms of the relative sensitivities of three different broad-band mechanisms, more or less as postulated by Young and Helmholtz. Therefore, the attachment of their names to the trichromatic theory is a well-deserved recognition of their deep insight into these fundamental physiological mechanisms of color vision. As will be shown later, the essentials of the theory have

long since been vindicated by direct physiological experiments, and the modern form of the theory differs little from that of one hundred fifty years ago.

It might appear that with a few further refinements and embellishments the classical trichromatic theory could give a full explanation of color vision. Certainly many prominent scientists have held to and advanced the trichromatic theory, and it is widely accepted. But the weight of authority—even that provided by such notables as Sir Isaac Newton, Sir Thomas Young, James Clerk Maxwell, Hermann von Helmholtz, and the distinguished members of the Commission Internationale de l'Eclairage—is not sufficient to overbalance the weight of visual experience itself. The facts of the interaction of color, as well as those of color mixture, are before our very eyes and simply cannot be ignored in any complete account of vision. Here the more comprehensive organic opponent-color theory makes a major contribution, complementary and equal in importance to the classical analytical trichromatic theory.

The organic approach— opponent-color theory

The theory that there are opponent pairs of colors is the outgrowth of an organic, or holistic, approach to the study of vision that focuses on the integrative action of the retina and of the brain. That is, it emphasizes the functions of complex webs of reciprocal interactions among the component parts of the visual system: how the separate parts act in concert rather than how they act individually. This theory had its origins in art rather than in science. In fact, it may be traced back to the use of contrast effects in the work of Renaissance painters. In their chiaroscuro, light was enhanced by contrasting it with dark, and vice

versa. In their colorations, saturation and brilliance of one hue were enhanced by contrasting it with another, and vice versa.

The contribution of Leonardo da Vinci Leonardo was probably the first to describe in any detail the basic facts of color contrast and the important role of contrast in color vision. Further, he saw and described the basic colors in terms of both brightness and hue. In his diaries, around 1490, he wrote:

> There are six simple colors. The first is white although philosophers do not accept white and black as colors, since the first is the cause of colors and the other their occlusion. However, since painters cannot renounce either of them we add them to the other colors and say: white should be the first of the simple colors, yellow the second, green the third, blue the fourth, red the fifth, and black the sixth.
>
> (Codex Vaticanus No. 1270)

Leonardo also studied color contrast and made practical use of it in his painting. He distinguished three pairs of opposed contrasting colors and called those pairs *colore retto contrario* (literally, colors directly opposed). Two of those were the chromatic pairs of complementary or opposed colors red-green and yellow-blue. The third was the achromatic pair white-black. These prescient observations and concepts show a remarkable similarity to modern developments in what ultimately came to be known as the opponent-color theory.

Goethe's theory of color Although considerable practical knowledge of spatial contrast effects of both brightness and color existed in the Renaissance, truly systematic scientific study of this problem began only about 1800. Some of that work was done by an amateur scientist, Johann Wolfgang von Goethe —the German poet and sometime painter. On the basis of the observed contrast between light and dark and between what we now call complementary colors, Goethe also advanced the idea that there were pairs of principal colors (at least two pairs; perhaps three), and that the members of each pair interacted with one another reciprocally. For a long time, however, scientists tended to dismiss all of Goethe's experimental work, and his color theory, as well, because of his misguided interpretation and unwarranted criticism of Newton's theory. Incidentally, Goethe was not alone in criticism of Newton's views on color. A contemporary, Robert Hooke, perhaps out of jealousy, claimed that Newton's conclusions were not new; Newton's admiring biographer, Sir David Brewster, claimed that they were not true!

The main reason for Goethe's misunderstanding of Newton's theory was that he did not always follow Newton's procedures closely when he attempted to reproduce critical experiments. And on the basis of a number of incorrect observations, resulting largely from wrong procedures, Goethe concluded that Newtonian law, with respect to color, was false. Further, Goethe argued that Newton's experimental findings and mathematical theories on the physics of light and color were accepted only because of Newton's great renown:

> A great mathematician was possessed with an entirely false notion on the physical origin of colours; yet, owing to his great authority as a geometer, the mistakes which he committed as an experimentalist long became sanctioned in the eyes of a world ever fettered in prejudices.

In mid-life Goethe embarked on a career of research to find support for this erroneous conclusion —research that was to lead ultimately to his now

famous and often much discredited *Farbenlehre* (Theory of Color). For a recent English edition see Matthaei 1971.

Goethe's critics have made their share of mistakes over the years, too. Much of the confusion about and criticism of Goethe's work has resulted from their failure to understand and to appreciate the distinction between the physical and the psychophysiological aspects of color. What was not generally recognized at the time—and not always even today—is that color results from the action of light on the eye; it is not present in the light itself. Newton had warned that "the rays are not colored," and Goethe also realized that colors are not in light itself, but that "the colors are acts of light." On this basis he attempted to make a distinction between the physiological and the physical and chemical aspects of light and color.

The concept of physiological colors, most important for this discussion, was a significant contribution (see Sepper 1988). Goethe regarded the physiological colors as those which may be said to belong to the eye itself; that is, to depend primarily upon the action and reaction of that organ. Simultaneous brightness contrast and simultaneous color contrast are clear-cut examples. Contrast effects, such as those illustrated in Figures 15 and 16, are not the result of physical or chemical interactions among the printed inks on the page itself. They result from interactions within the viewer's own eye and brain.

Goethe demonstrated many basic principles of these kinds of phenomena by impeccable experiments; most important and incontrovertible, perhaps, were those on colored shadows and similar contrast effects, some of which had been known to artists since the Renaissance. One of these experiments on colored shadows is shown in Figure 43.

Similar phenomena are often seen in everyday situations. High intensity mercury vapor and sodium vapor street lamps, for example, often induce complementary colors in the shadows cast in their strong silver-green and yellow-orange lights. (To be certain that the color is actually induced, one should always check the source of the light that illuminates the shaded area.)

Goethe's general views on interactions within the retina are well expressed in this one summary statement on simultaneous brightness contrast:

> A gray object on a black ground appears much brighter than the same object on a white ground. If both comparisons are seen together the spectator can hardly persuade himself that the two grays are identical. We believe this again to be a proof of the great excitability of the retina, and of the silent resistance which every vital principle is forced to exhibit when any definite or immutable state is presented to it. Thus inspiration already presupposes expiration; thus every systole its diastole. It is the universal formula of life which manifests itself in this as in all other cases. When darkness is presented to the eye it demands brightness, and *vice versa*; it shows its vital energy, its fitness to receive the impression of the object, precisely by spontaneously tending to an opposite state.

Concerning color itself Goethe wrote:

> If a coloured object impinges on one part of the retina, the remaining portion at the same moment has a tendency to produce the compensatory colour ... Thus yellow demands purple; orange, blue; red, green; and *vice versa*: thus again all intermediate gradations reciprocally evoke each other; the simpler colours demanding their compound, and *vice versa*.

No matter how far from the mark Goethe may have been in his views on the analytic physical aspects of light, it is now evident that his organic

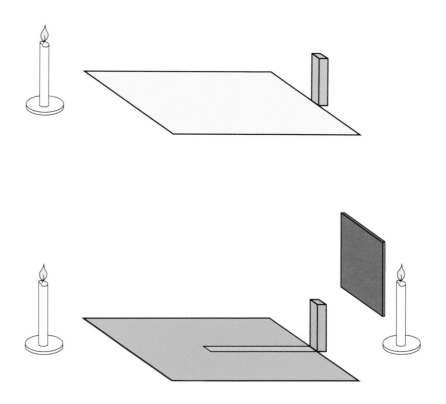

Figure 43　Goethe's colored shadow experiment, simplified. (*Top*) A sheet of white paper on a dark background is illuminated by the yellowish white light of a candle at the left. A vertical rod or other slender object is placed at the right so that it casts no shadow on the paper in the light of this candle. (*Bottom*) A second candle is placed on the right with a red glass in front of it so that the paper is illuminated by both candles, the combined light of which is reddish yellow. The paper under the shadow cast by the vertical stick is still illuminated only by the yellowish white light of the candle on the left. However, by contrast with the reddish yellow surrounds, the shadow now takes on the complementary bluish green hue. (The exact colors will depend upon the exact colors of the paper, of the light from the candles, and of the glass.) If a differently colored glass is used, the induced complementary hue will change accordingly. Based on Goethe's original drawing (see Matthaei 1971).

physiological concept of a simultaneous reciprocal interaction of opposing or complementary influences among neighboring parts of the retina is basic to our understanding of the psychophysiology of the visual system. Thus Goethe's work on brightness contrast, color contrast, and the like helped to fill a major gap in color theory. For all such phenomena were generally neglected by Newton in his studies on color and, later on, by Young and Helmholtz in theirs. Indeed, contrast effects were once dismissed by Helmholtz as nothing more than mere "unconscious inferences," unworthy of study. Goethe was more broad-minded. He did not dismiss analytic procedures; he rejected a one-sided approach:

> A century that has relied solely on analysis, and is almost afraid of its synthesis, is not on the right road. Only when both are together, like inhaling and exhaling, can science come alive.

Chevreul on the harmony and contrast of colors
Ideas about the interaction of color were further advanced by Michel-Eugène Chevreul, the renowned French chemist who is noted for his early studies on the animal fats now implicated in heart disease. Chevreul was called upon in 1824 to direct the dye plant of the famous Gobelin Tapestry Works in Paris. At the time of his appointment, many complaints were being made about the quality of some of the pigments prepared at the plant. To preserve the good name of the Gobelin, which had been founded in the 1500s and which in 1662 was made a royal manufactory under Louis XIV, Chevreul needed to discover and to eliminate the cause of this dissatisfaction. He found almost at once that some of the discontent about the gradual fading of certain light colors was well-founded, and he undertook chemical research to discover the causes of the impermanencies. But he could find no chemical basis at all for persistent complaints that the weavers made about the lack of vigor in some other colors. He first advanced the theory—and subsequently demonstrated by experiment—that the cause was not in the dyeing, but in the weaving: the appearance of a particular yarn in a woven tapestry was determined not only by the color and tone of that yarn itself, but also by the color and tone of the other yarns woven alongside of it. As Chevreul wrote:

> The art of the tapestry-weaver is based upon the *principle of mixing colors*, and on the *principle of their simultaneous contrast*.

Chevreul was very explicit about the distinction between optical mixture of color and interaction of color:

> There is a *mixture of colours* whenever materials of various colours are so divided and then combined that

the eye cannot distinguish these materials from each other: in which case the eye receives a single impression.

There is a *contrast of colours* whenever differently coloured surfaces are properly arranged and susceptible of being seen simultaneously and perfectly distinct from each other.

These two succinct statements contain the basic principles of pointillism and divisionism, respectively. And there is no doubt that both Seurat and Signac were fully conversant with these basic principles, for they had ready access to Chevreul's work.

Chevreul's specific rules concerning the mixture of color and the interaction of color cannot always be taken literally today, because color names are typically not well defined. Nevertheless, Chevreul showed how to determine, by experiment, exactly what rules do apply in any specific case. For example, for the benefit of the weaver he described in words and illustrated in color the outcome of various mixtures of colored threads and of the juxtaposition of differently colored yarns—something any weaver could easily do for himself with the particular colors he happened to have at hand.

Chevreul's work was directly relevant to an understanding of the practice of painting because in the production of Gobelin tapestries the weaver often worked directly from a model painting:

> Imitations resembling more or less those of painting can be made with materials of a certain diameter, such as threads of wool, silk, and hemp, adapted to the fabrication of Gobelin and Beauvais tapestries; the woolen threads exclusively employed in fabricating Savonnerie carpets; the small regular and irregular prisms of mosaics, and the coloured glass of the windows of gothic churches.

To reproduce the work faithfully, the weaver had to understand how the artist had achieved certain effects and to take care not to distort them in the weaving:

> When we attentively observe the rosy flesh-tints of a great many pictures, we perceive in the shadows a green tint more or less apparent, resulting from the contrast of rose with grey. (I presume that the painter has made his shadows without using green, and that he has not corrected the effect of contrast by using red.) Now a weaver ignorant of the effect of rose upon grey, in imitating the shaded part will have recourse to a green-grey, which will exaggerate an effect that would have been produced naturally by employing a scale of pure grey (without green).

One of Chevreul's colored illustrations was designed specifically to show the induction of color, by contrast, into gray. An adaptation of that illustration is shown here (Figure 44). As Chevreul points out:

> This example serves to demonstrate that if a painter has himself exaggerated the effects of contrast in his imitation, these effects will be still more exaggerated in the copy made in tapestry if we do not guard against the illusions produced by the causes now mentioned.

Chevreul's rediscovery and detailed analysis of the interaction of color were of great significance because the practical problems he faced led him to formulate general laws of simultaneous color contrast soundly based on experimental observations. His great work, *De la loi du contraste simultané des couleurs,* in which he published these observations and general laws in 1839, had an immediate influence on artists and artisans and is still used today. Indeed, it is still so much in demand that Martel's 1854 English translation, entitled *The Principles of Harmony and Contrast of Colors and Their Application to the Arts,* was reprinted as recently as 1967.

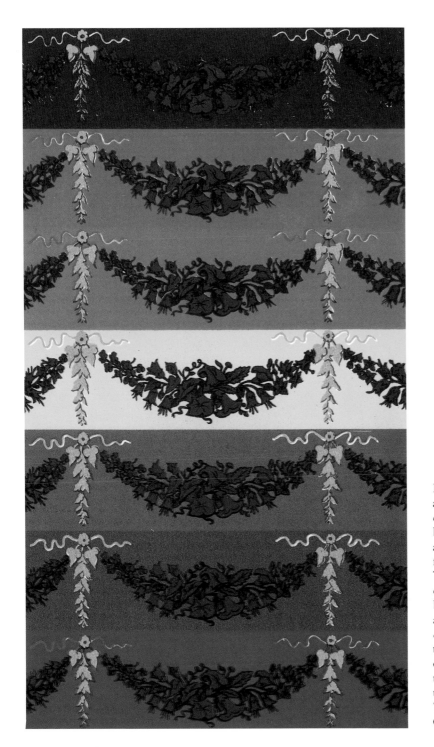

Figure 44 Festoons of blue flowers and gray arabesques on differently colored backgrounds. Note that both the blue flowers and the gray arabesques appear significantly different on the different backgrounds. The gray areas take on a tint of the complement of the color of the background. The blues are modified as if they had been mixed with a tint of the complement of the color of the background. This figure is based on Plate XIV of Charles Martel's third (1860) edition of his English translation of Chevreul's 1839 work *The Harmony and Contrast of Colors.*

Mach bands Many of the laws and principles governing the interaction of color were well established by the mid-nineteenth century, but few advances had been made toward an understanding of the physiological bases of these phenomena. An important development along these lines took place about 1865, when the Austrian physicist-philosopher-psychologist Ernst Mach first noticed that bright and dark bands appear at the edges of half-shadows (penumbras) where, according to physical calculations, none are expected (Figure 45). The visual "appearance" does not conform to the physical "reality." Rather, in accordance with an old German proverb, The brighter the light, the deeper the shadow.

These phenomena (now known as Mach bands) may easily be observed at the edge of virtually any shadow; for example, the shadow of your own head and shoulders cast on a sidewalk on a sunny day. The bands appear as bright and dark "halos" surrounding the shadow. At the outermost edge of the shadow, where the graded half-shadow borders on uniform, full sunlight, a band that is brighter than the full sunlight itself will appear. A little farther into the shadow, where the graded half-shadow borders on the uniform full-shadow, a band will appear that is darker than the full-shadow itself. As shown graphically in Figure 45, the appearance of these extraordinary bands does not conform to the physical distribution of the pattern of light and shade, for in it there are no such maxima or minima. The phenomena are psychophysiological; that is, they result from the integrative action of the visual system itself. The

Figure 45 The Mach bands. (*Top*) Representation of the half-shadow or penumbra between an area in full light (*left*) and in full shadow (*right*). The bright area at the left is uniform across its whole extent, and the dark area at the right is uniform across its whole extent. The half-shadow is graded uniformly between the bright and dark areas. At no point is there more light than in the full light or less than in the full shadow. Note, however, that a bright band appears where the half-shadow borders on the full light, and a dark band appears where it borders on the full shadow. These are the so-called Mach bands. There are no such maxima and minima in the physical distribution of light. Photo: Robert Shapley. (*Center*) A comparison of the form of the objective physical distribution of light across the figure above (*solid curve*, as measured with a photometer) and the form of the subjective perceived brightness across the same figure (*dashed curve*, as seen directly by the eye). A word of caution: The processes involved in printing a halftone figure may introduce distortions. Authentic Mach bands are best seen directly, under natural conditions, as at the edge of the shadow cast by a sharp-edged object in sunlight. Redrawn after Ratliff (1965). (*Bottom*) Mach bands may be generated by an optical mixture (or fusion) by the eye of an array of ramplike black stripes on a white background, as illustrated here. On the left the stripes are uniformly thin at one end and then turn into a uniformly thickening gradient at the other. On the right the stripes are uniformly thick at one end and then turn into a uniformly thinning gradient at the other. Viewed from a distance sufficient to produce fusion or partial fusion of the stripes, Mach bands will appear. A light band, perpendicular to the stripes, is seen in the middle of the left array; a dark band in the middle of the right array. There are no such maxima or minima in the thickness or thinness of the black stripes that are combined in the eye by fusion. Redrawn after Ratliff (1965), based on Mach's original illustration.

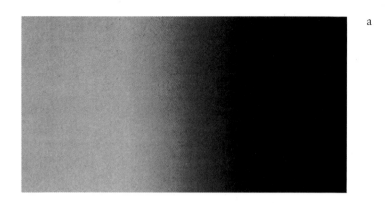

a

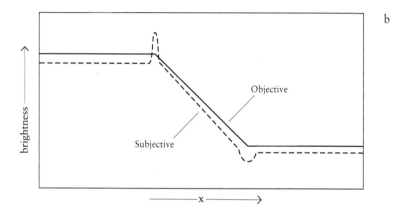

b

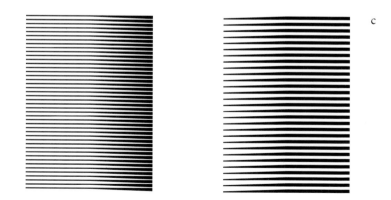

c

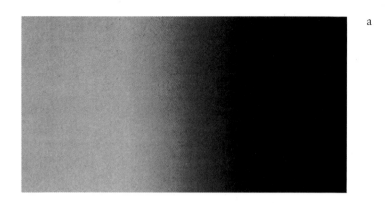

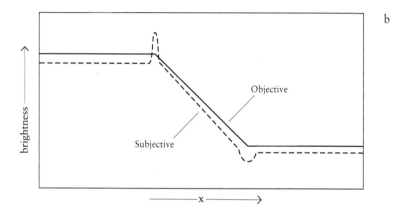

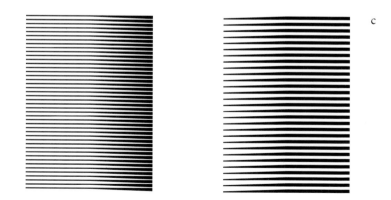

93

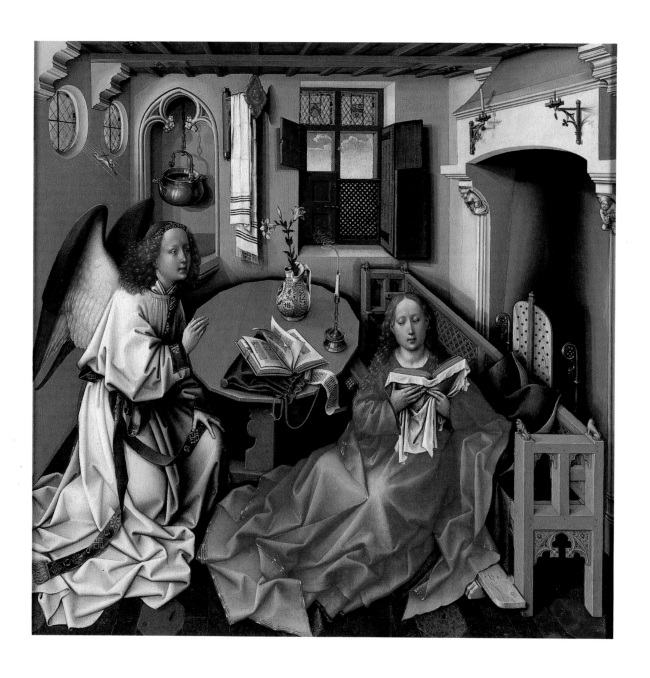

Figure 46 *The Annunciation* by Robert Campin (active by 1406; d. 1444). ca. 1425. Center panel from a three-panel altarpiece, oil on wood, 64.1 × 63.2 cm. © 1981 The Metropolitan Museum of Art, The Cloisters Collection, New York, 1956 (56.70). Mach bands and other border contrast effects are seen in the numerous half-shadows and overlapping shadows throughout the painting. See the accompanying detail of a small section of the panel. As is usually the case, the artist has exaggerated, or "forced," the contrast somewhat.

appearance of the Mach bands is most compelling, and they have been mistaken for physical phenomena many times. For example, shortly after X rays were discovered the light and dark Mach bands were mistaken for the maxima and minima in X-ray diffraction patterns. As a result, the first estimates of the wavelength of X rays were far from correct. Even in recent years, Mach bands have led to errors in the interpretation of clinical X rays (for an extended discussion of Mach bands see Ratliff 1965).

Many artists (including Signac) have made use of these phenomena, but almost certainly without any prior knowledge of Mach's findings. One such artist about whom there can be no doubt at all concerning his independent knowledge and portrayal of Mach bands is the Flemish painter Robert Campin. He was already active as early as 1406 and died in 1444—more than 400 years before Mach's scientific discovery! Campin's *Annunciation* (Figure 46) shows that he was a very close observer of the natural distributions of light and shade in ordinary surroundings. Shadows everywhere throughout the painting (as shown separately in detail) exhibit the Mach bands and other border contrast phenomena with truly extraordinary precision and fidelity.

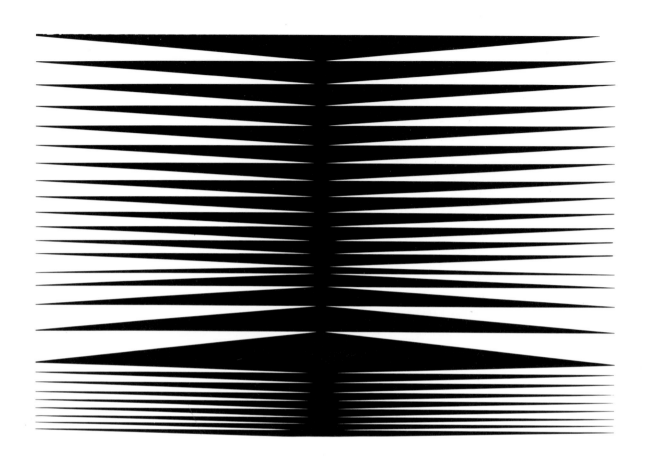

Figure 47 *Ascending and Descending Hero* by Bridget Riley. 1965. Emulsion on canvas, 182.9 × 274.3 cm. © 1988 The Art Institute of Chicago. All rights reserved. Gift of The Society for Contemporary Art. In the reproduction shown here, the stripes appear to be of a perfectly uniform and flat black color throughout. In the original painting, the artist's touch can be clearly seen, and a vertical stroke has been made where the vertical Mach band appears. This probably enhances the effect somewhat in the viewing of the actual work. Artists often exaggerate or "force" contrast phenomena in this way, and it is sometimes difficult to tell how much of the effect is in the painting and how much is in the viewing.

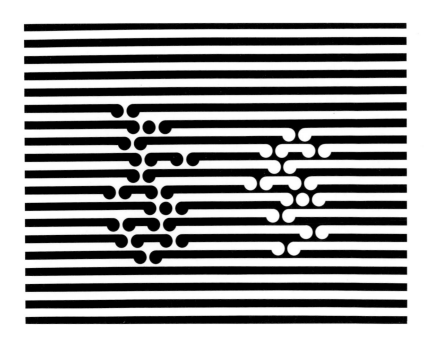

Figure 48 *Painting No. 1* by Gordon Walters (1919–). 1965. Acrylic on hardboard, 91.4 × 121.9 cm. Collection of The Auckland City Art Gallery, New Zealand.

One of Bridget Riley's black and white paintings, reproduced in Figure 47, is a good modern example of Mach bands in painting. When viewed at some distance, the partial fusion and integration of the ramplike black stripes results in a dark vertical band in the center of the array—a band which appears somewhat darker than the black horizontal stripes themselves. The negative of this array of stripes, which was used to print this reproduction, appears to have a bright vertical band in the center, as would be expected from Mach's work. Indeed, the technique used independently by Riley is remarkably similar to that used by Mach in his demonstration of the phenomena with an array of stripes, as shown here.

By means of careful psychophysical experiments, Mach was able to derive a theoretical explanation for these contrast phenomena in terms of the interdependence of neighboring points on the retina.

According to Mach:

> Since every retinal point perceives itself, so to speak, as above or below the average of its neighbors, there results a characteristic type of perception. Whatever is near the mean of the surroundings becomes effaced, whatever is above or below is disproportionately brought into prominence. One could say that the retina schematizes and caricatures.

The idea that whatever is above or below the mean of its neighbors "is disproportionately brought into prominence" is well illustrated by the brightness contrast effects already shown in Figure 15. The two physically identical gray disks appear very different because the one is above the mean, completely surrounded by black, and the other is below the mean, completely surrounded by white. The modern painting by Gordon Walters (Figure 48) illustrates this principle directly. The cluster of enlarged white

knobs on the white horizontal stripes reflects more white light than a comparable area of the stripes themselves, and the cluster as a whole, being above the mean, appears brighter overall although, physically, the white is the same everywhere. Similarly the cluster of enlarged black knobs on the black stripes reflects less light than a comparable area of the stripes themselves, and the cluster as a whole, being below the mean, appears darker overall although, physically, the black is the same everywhere.

By the time that Mach first studied these and other related contrast effects, sufficient knowledge existed about the anatomy and physiology of the retina for him to be more specific about underlying mechanisms than had been his predecessors. And he was able to attribute this "caricature" of the appearance of the real physical distribution of light and shade to reciprocal inhibitory interactions over known lateral interconnections within the retina.

Mach made two basic assumptions. One was that the brighter the light falling on a given part of the retina, the stronger the neural activity sent by that part to the brain. In short, amount of light—brightness—was signaled by amount of neural activity: a bright white spot of light would generate strong activity; a darker gray spot would generate a lesser amount of activity; and a very dark black spot would generate little or no activity. The other assumption was that neural activity generated by the action of light on one part of the retina could inhibit, or suppress, activity generated in another part, and vice versa. The familiar brightness contrast effects illustrated in Figure 15 would result from such reciprocal inhibition.

Reciprocal inhibition is nothing more than a form of negative feedback. And brightness contrast can be explained, to a good first approximation, in terms of the simplest first-order negative feedback reactions: the gray surrounded by white would be strongly inhibited and would be much darkened in appearance; the gray surrounded by black would be weakly inhibited, if at all, and would be darkened little, or not at all. Therefore, because of the different strengths of these inhibitory interactions, or negative feedbacks, a corresponding difference in the apparent brightness of the two physically identical gray spots would result. Similar inhibitory mechanisms are believed to account for the enhanced contrast where light shades into dark (for example, the bright and dark Mach bands demonstrated in Figure 45), and for the contrast of complementary colors, such as the pairs red-green and yellow-blue.

Mach's theory of reciprocal inhibitory interactions was just as fundamental a contribution as was Helmholtz's contemporaneous theory of three photosensitive mechanisms. Helmholtz's postulated sensitivity curves pointed to a realistic physiological basis for the optical mixture of color; Mach's postulated reciprocal inhibition pointed to a realistic physiological basis for the interaction of colors. Both of these basic theories of vision had to wait nearly a century for direct verification. However, even in the absence of direct proof, Mach saw the broad implications of his theory for color vision. In particular, he recognized the psychological primacy, uniqueness, and complementary relations of the four chromatic colors red, green, yellow, and blue, and of the achromatic colors black and white. Unfortunately, he stopped short of incorporating all of these facts into his theory of interaction and contrast to make a comprehensive theory of color vision. Nevertheless, a theory along these very lines was soon to come.

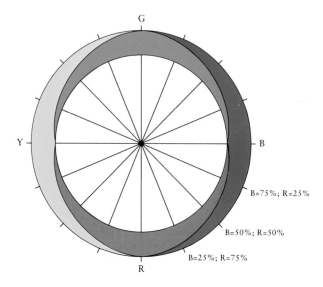

Figure 49 The Hering four-color circle. Note that there is no series of intermediate colors between the opposite and complementary pair red and green (or between the opposite and complementary pair yellow and blue) that appear both reddish and greenish (or both yellowish and bluish) at the same time. This mutual exclusion is not true of any pair of adjacent colors on the circle. Mixtures of green and yellow, for example, can appear both greenish and yellowish at the same time. Red-green and yellow-blue are *opponent* pairs, mutually exclusive. Redrawn after Hering's original figure reproduced in the translation by Hurvich and Jameson (1964).

The Hering opponent-color theory The researches and theories of Goethe, Chevreul, and Mach had a profound influence on the later work of a German physician and physiologist, Ewald Hering. About 1870 Hering formulated what is now known as the opponent-color theory; namely, that there are four principal colors arranged as opponent pairs: red-green and yellow-blue. The achromatic colors, black and white, were also regarded by Hering, just as they had been by Leonardo, as an opponent pair. Hering's major work is available in a translation by Hurvich and Jameson (see Hering 1964).

The Hering color circle in Figure 49 shows how the four chromatic colors—red, yellow, green, and blue—are interconnected by a series of intermediate transitional hues. There is a red-yellow, a yellow-green, a green-blue, and a blue-red series. That is, any color may be represented by one of these four colors or by a combination of no more than two of the four colors in the proper proportions. For example, pure blue is 100% blue; bluish red is 75% blue, 25% red; blue-red is 50% blue, 50% red; reddish blue is 75% red and 25% blue; pure red is 100% red. Note, however, that no color is ever both reddish and greenish, and none is ever both yellowish and bluish. Redness and greenness—and likewise, yellowness and blueness—are mutually exclusive. As Hering put it:

> Therefore since redness and greenness, or yellowness and blueness are never simultaneously evident in any color, but rather appear to be mutually exclusive, I have called them *opponent colors.*

The physiological bases of this opponent-color system were thought to be reciprocal interactions within the visual system. Following the ideas of Mach and others, Hering assumed that members of each pair produced signals of opposite sign in retinal neurons—that is, either excitatory or inhibitory—and thus mutually opposed one another.

Contrast: appearance or reality? In the late nineteenth century, the evidence for reciprocal inhibitory interactions in the visual system was based almost entirely on "illusory" visual phenomena such as brightness contrast and color contrast. That is to say, if one patch of gray surrounded by white appears darker than an identical patch surrounded by black, we regard that phenomenon as an illusion and accept it as clear evidence for some form of lateral interaction, or "cross talk," in the visual system. We tend to regard the difference in brightness when the surrounds are different as "appearance" and the equal brightness when the surrounds are equal as "reality." The fact is that both the visual experience of difference and of equality are "appearances," and that similar interactions are taking place under both conditions. The appearance of unequal brightness occurs when the end results of the interactions are unequal, the appearance of equal brightness when they are equal.

Much the same is true of color and color contrast. As Leonardo da Vinci wrote long ago: "Colors appear what they are not, according to the ground which surrounds them." But which color is what it is not? The one with a certain surround or the one without it? Leonardo does not tell us. Josef Albers's very similar contemporary view that "a color is almost never seen as that which it actually is" also presupposes that some color experiences are genuine and that others are not. But the fact is that any color appearance is just as real as any other. So-called normal visual experiences (which are common) and so-called illusory visual experiences (which are uncommon) are mediated by the very same psychophysiological mechanisms. Both are genuine experiences; each is actually what it is. Albers mistakes the unexpected for the unreal.

Hering was one of the first to realize that reciprocal interactions in the retina are all-pervasive and underlie our normal, everyday, visual experiences, as well as the so-called illusions. Hering wrote:

> The idea that the phenomena of simultaneous contrast are not merely "optical illusions," but rather the expression of an important vital characteristic of the visual system, has been emphasized especially by Plateau and Mach
>
> The most important consequences of reciprocal interactions are not at all those expressed in contrast phenomena, that is, in the alleged false seeing of the "real" colors of objects. On the contrary, it is precisely the so-called correct seeing of these colors that depends in its very essence on such reciprocal interactions, and *it is much more important to investigate the latter in the situation where we are not at all aware of them rather than where they attract our attention as contrast phenomena. It is to reciprocal interactions . . . that we owe, to a large extent, our visual acuity . . . as well as the possibility of recognizing objects by their colors* A closer familiarity with the consequences of this reciprocal interaction is essential for understanding the nature of our vision.

Furthermore, Hering pointed out that these reciprocal interactions have far-reaching consequences, not only for visual perception but even for the language of color. Indeed, ordinary language itself may be regarded as the author of the four-color opponent theory. That is to say, the color terms which first come to mind in the description of any color experience (after black and white) are those for the two pairs of opponent chromatic colors. They are the most basic of all the myriads of colors. As Hering put it, "language has long since singled out red, yellow, green, and blue as the principal colors of the multiplicity of chromatic colors." (See Ratliff 1976).

Independently, the psychophysiologist Charles Henry (who exerted a strong influence on Signac and other Neo-Impressionists) also pointed out the relation between the language of color and the principal colors in visual experience. The idea has since reappeared in modern anthropological and linguistic studies on universal color terms. Red, green, yellow, and blue are salient in our visual experience and it has been found that the terms for them (and for black and white) are translatable across many languages (see Berlin and Kay 1969). This relation between the language of color and the perception of color is understandable, for we now know definitely, as Mach had suggested as early as 1865, that these four opponent colors, and only these four colors, are psychologically unique. That is to say, each of the four opponent colors is comprised of a unitary hue, and is perceived as containing no infusion of neighboring hues. Orange, for example, is not unique; both red and yellow are perceived in it.

Thus, it is a fact that red, green, yellow, and blue are unique colors. Furthermore, it is a fact that black-white, red-green, and yellow-blue are opponent colors. The question is, Where do these fundamental facts about uniqueness, opponency, and the interaction of color stand in relation to the fundamental facts about trichromacy and the mixture of color?

One theory or two? It is clear that there is no place in the classical diagrams of color space for an expression of the uniqueness of the four opponent colors, nor of the pairwise interactions among them. Newton's color circle, the triangles of Young, Helmholtz, and Maxwell, the modern CIE Chromaticity Diagram, and the various color standards now available serve only to specify colors in terms of hue, saturation, and brightness, and to arrange them in such a manner that mixtures and matches may be predicted, more or less exactly, with simple Newtonian procedures. At best, there is only a hint of the now well-established uniqueness of and opponent relations among red, green, yellow, and blue. Consider the limitations of the most complete representation of color space—the so-called color solid.

The color solid is simply a variation on Newton's two-dimensional color circle with an extension into a third dimension: brightness. Leonardo clearly anticipated this development in his writings. But the first such three-dimensional figure to take full account of the crucial positions of all colors, of all saturations and brightnesses, was constructed by the German romantic landscape painter Phillipp Otto Runge (1777–1810) in the last year of his life. His diagram (first a sphere, later a double cone) was the forerunner of the double pyramid (or octahedron) widely used today. The modern form (Figure 50) was introduced by the psychologist Hermann Ebbinghaus in 1902, and has since undergone many further refinements.

Many of the complex relations and interrelations among the various colors are immediately and simultaneously evident in the Ebbinghaus color solid. As in Newton's original color circle, complementary relations are indicated by the directly opposite position of the complements. Red is directly opposite green, and yellow is directly opposite blue. Brightness, not represented in Newton's circle, is expressed in the third dimension. White, at one pole of the solid, is connected by the interior gray scale with black, at the opposite pole. All colors collapse into white at one extreme, and into black at the other. Throughout the solid, all gradations of hue, saturation, and brightness are laid out more or less in their

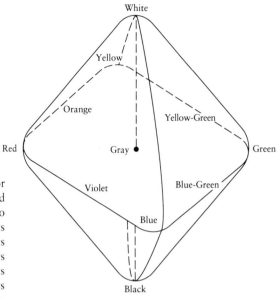

Figure 50 The Ebbinghaus color solid. The color space is represented by two pyramids, placed base to base. The upper pyramid represents the light colors, with white at its apex; the lower pyramid represents the darker colors, with black at its apex. The achromatic neutral grays are represented by the vertical line through the center of the solid joining black and white. All other points within the solid represent chromatic colors. The different hues are represented by different directions from the neutral grays in the center of the solid and the degree of saturation of a hue by distance from the center of the solid. The four unique colors—red, green, yellow, and blue—are presented at the four corners of the common base of the joined pyramids, with the members of the opponent pairs red-green and yellow-blue placed diagonally opposite one another. The base is tilted so that yellow, which is relatively bright, is near white; blue, being relatively dark, is near black. Compound colors are represented at intermediate points. This Ebbinghaus color solid, a 1902 refinement of Runge's original solid, is the prototype of all modern color solids (see, for example, Pope's color solid in Carpenter 1974). Redrawn after Ebbinhaus's original figure (see Boring 1942).

proper relations. All differences in brightness of the principal chromatic colors, and their intermediates, are shown. The common base of the double pyramids is tilted about the red-green axis so that pure yellow, being relatively bright, is toward the white pole; conversely, pure blue, being relatively dark, is toward the black pole. Even the odd assortment of mixed colors such as brown (a dark combination of red and yellow) and pink (a light combination of red and blue), which are not represented in the usual plane diagrams because of their darkness and lightness relative to other colors, find their place in the color solid. Thus this one solid figure shows at a glance many of the major phenomenal relations among practically all of the distinguishable colors.

The mosaic-like Munsell color solid, shown in Figure 51, is less exact than the more abstract, purely diagrammatic planes and solids with their associated mathematical formulae. It is therefore less useful for

Figure 51 The Munsell color solid. The Munsell colors are arranged here in a three-dimensional "solid" form to show the interrelations among all the colors simultaneously (courtesy of Munsell Color, 2441 N. Calvert St., Baltimore, MD 21218). All such figures are simply a variation on and extension of Newton's original color circle. On the left is shown the appearance of the solid as seen from the red side; on the right is the appearance from the green side. Below, left, is shown a section from yellow to blue, passing through gray in the center of the solid. Note how the intrinsic brightness of yellow is shown by the prominent upward bulge on the solid and the intrinsic darkness of blue by the opposite downward bulge. The tile-like mosaic of colors on the cross section through blue, gray, and yellow is made up of an array of actual Munsell color samples, as are all other sections. The surface of the solid is covered with facets of uniform color adapted from the Munsell color samples rather than with a continuously graded color. The passage through gray of the section from yellow to blue is another indication of the marked desaturation that can result from optically mixing yellow and blue. In near-equal proportions the result of such a mixture must be gray, not green. (A straight line on this plane section can be used in essentially the same way as a Newtonian straight line for predicting mixtures on the CIE Chromaticity Diagram. The only significant difference is that here the color is represented as an array of discrete samples rather than as a continuum.)

103

precise specification of sample colors or precise calculation of mixtures of colors, but it is actually much more useful for many practical purposes. The actual color samples are displayed in a convenient three-dimensional form that enables an artist or an artisan to see at once where a particular sample stands in relation to all the others in terms of hue, saturation, and brightness.

Some features of the opponent-color theory seem to be implicit in the various forms of the color solid. For example, in the Ebbinghaus solid the four projecting corners suggest the distinctiveness of the four unique colors. Similarly, the direct opposition, in all color solids, of the opponent pairs black and white, red and green, and yellow and blue, hints at their opponency. But all this is more apparent than real. The salience of the projecting corners misrepresents the saturation of the four unique colors relative to closely neighboring colors. And the opposition of pairs of colors actually represents their complementary relationship in optical mixtures of color rather than their contrasting relationship in the interaction of colors. These are two very different processes. Mixture of color results from direct superposition or very close juxtaposition of the colors involved. Interaction of color results from spatial arrangements of the colors involved. Both cannot be properly and fully represented on the same simple diagram.

Reconciliation Trichromacy has long been widely accepted as the most fundamental principle in the theory of color vision, while the opponent colors have been regarded as somewhat of a psychological curiosity, adequate only to account for various so-called illusions in the perception of brightness and color. But with all the available facts about opponency, contrast, and uniqueness taken together, the evidence for a theory of three paired opponent-color systems, including red-green, yellow-blue, and the achromatic black-white becomes just as compelling as the evidence for a three-color theory. And Hering's extremely important hypothesis about the essential role of reciprocal interactions in normal color vision, long supported by psychophysical evidence, has now been vindicated by direct electrophysiological experiments. Such experiments show clearly and unambiguously that there are indeed opponent-color processes in the visual system. These and other opponent processes are not mere aberrations that lead only to illusions. Reciprocal excitatory and inhibitory interactions are fundamental neural mechanisms basic to all aspects of vision, and are central to the theory of color and to the painterly practices of the colorist. The classical Young-Helmholtz trichromatic theory and the Hering opponent-color theory must somehow be reconciled and incorporated into a single more comprehensive theory.

III. Toward a unified theory of color

Today, more than a hundred years after the analytic Young-Helmholtz trichromatic theory and the organic Hering opponent-color theory first came into conflict, it is evident that both theories are at least partially valid. Whether one theory or the other comes to the fore is largely determined by which set, or subset, of facts about color is considered. Trichromatic theory focuses rather narrowly (although not exclusively) on visual phenomena that appear to be determined largely by the spectral characteristics of each of the three types of photoreceptors themselves. Opponent-color theory focuses rather narrowly (although not exclusively, either) on visual phenomena that appear to be determined largely by the spectral characteristics of the subsequent interaction and integration of the neural signals generated by those same three types of photoreceptors. Ultimately, however, any truly comprehensive theory of color must encompass all of the principal facts of color vision, and the trend today is toward an elaboration and a unification of these two theories.

Much is known today about the role of both the retina and the brain in color vision. But brain research is much more recent and consequently much less relevant to the understanding of turn-of-the-century color theory in general and of Color in Neo-Impressionism specifically than is research on the retina, which was already well advanced and already established in its present form at that time. Therefore, the following discussion will focus on retinal mechanisms. (For a recent account of vision and the brain, see De Valois and De Valois 1988).

It is abundantly clear from the writings of the Neo-Impressionists and from their techniques of painting that well before the turn of the century they were already making practical attempts to unify apparently disparate and seemingly conflicting ideas

about color. They were well prepared for these attempts (see Homer 1964; Callen 1982; Lee 1983; Thompson 1985). The Young-Helmholtz theory and the facts upon which it was based were readily available to them. The works of Helmholtz himself, as well as more general treatments by Rood (1879) and others, were standard handbooks for painters in the Neo-Impressionist movement. The trichromatic theory and its implications for painting were at their fingertips.

Furthermore, there is every indication that the Neo-Impressionists were thoroughly familiar with much of the evidence for the Hering opponent-color theory. In particular, they knew about and studied Chevreul's laws of simultaneous contrast which were available in both primary and secondary sources. However, there is no evidence at all that they were conversant with Hering's theory, as such. Indeed, there is only one brief reference to the opponent-color theory in works that they are known to have consulted—a mere acknowledgement of the existence of the new theory in a single footnote on the last page of Rood's book *Modern Chromatics*. But even though the Neo-Impressionists had no direct knowledge of the formal expression of Hering's theory per se, they were very familiar with and knowledgeable about its principal experimental underpinnings. This knowledge alone was sufficient for the application of a proto-theory of color opponency in their practice of painting.

Thus it is correct to say that in a certain sense the Neo-Impressionist painters were ahead of science in their search for a practical version of a unified theory of color. In their painting they had no choice; they, like all painters, had to confront problems of optical mixture and problems of interaction of color simultaneously. Scientists, on the other hand, could choose to focus their attention on only one problem or the other. But despite this advantage, the scientists were limited in what they could do. The necessary techniques for the direct photochemical and physiological study of color vision were not available to researchers until very recent times. As a result, most of the photochemical and physiological evidence bearing on both the trichromatic theory and the opponent-color theory has been discovered only within the past quarter of a century or so. Up to that time, almost all color scientists clung to the widely accepted and seemingly well-established Young-Helmholtz trichromatic theory.

There were some notable exceptions. As early as 1905, Johannes von Kries proposed a *zone theory,* which provided a synthesis of the rival theories: In it, the Young-Helmholtz theory operated at the retinal level; the Hering theory operated at the cortical level. The zone theory anticipated future developments but was too far ahead of its time to have a significant impact when it was first advanced. On the quantitative side, Erwin Schrödinger, later the 1933 Nobel laureate in physics, presented a paper in 1925 entitled "On the Relation of the Four Color to the Three Color Theory." This work showed the formal relation between the two theories—how the Young-Helmholtz color space could be transformed into the Hering color space (see Moore 1989). Nevertheless, the Hering opponent-color theory languished while the Young-Helmholtz trichromatic color theory continued to flourish.

Despite the popularity and the apparent supremacy of the trichromatic theory, the Hering opponent-color theory was kept very much alive during the past few decades by two psychologists now at the University of Pennsylvania—Leo Hurvich and Dorothea Jameson. Against all odds, they continued to pro-

claim the merit of and necessity for an opponent theory of color, but as a complement to rather than as a replacement of trichromatic theory. Their advocacy of the opponent theory was based largely on evidence from psychophysical studies of color. And it was greeted with much skepticism by many color scientists until the supporting evidence from recent direct physiological experiments became overwhelming.

Physiological bases of modern color theory

Two major lines of recent investigation are most important for an understanding of the basis of color vision generally and most relevant for the thesis of this essay specifically: spectral absorption of light by photopigments within individual photoreceptors of the eye, and spectral opponency of activity within the neural networks of the retina and the brain. For light entering the eye to be an effective stimulus to vision, it must first be absorbed by a photoreceptor. For scientific purposes, this can best be expressed in terms of the relative degrees of absorption of lights from different parts of the visible spectrum, that is, lights of different wavelengths. Such differential spectral absorption was hypothesized, but not proven, in the classical Young-Helmholtz theory. Similarly, for lights falling on different parts of the retina to contrast with or otherwise affect the appearance of one another, there must be some cross talk or interaction among the neural elements that they stimulate. For scientific purposes, this interaction can best be expressed in terms of the way in which lights from different parts of the spectrum, falling on different parts of the retina, reinforce or oppose one another in the generation of neural activity. Such

spectral reinforcement and opposition was hypothesized, but not proven, in the classical Hering opponent color theory.

Times have changed. Speculation has long since been replaced by direct evidence. Literally hundreds, perhaps thousands, of direct experiments have been carried out, in recent years, on spectral absorption and spectral opponency. A few illustrative examples of each type, in bare outline, are sufficient here to point the way toward a unified theory of color, and to indicate the relation of that unified theory to the practice of painting. First, however, it is necessary to consider some basic facts and fundamental principles.

Photoreceptors and trichromatic color theory

It is now very well established, on the basis of microscopic anatomy, that the retina is a duplex system (Figure 52). That is, there are two main classes of photoreceptors: rod shaped and cone shaped—the so-called rods and cones. The central zone of the retina, which yields high resolution of detail when one looks directly at and sharply focuses on an object, is almost a pure cone system. The intermediate zone of the retina between the central fovea and the far periphery, over which vision is more or less clear but not acute, is a mixed rod–cone system, with rods predominating. The far peripheral zone of the retina, by means of which one indistinctly sees all around— far right and left and up and down—while looking straight ahead, is also a mixed rod–cone system, but with the ratio of rods to cones much larger than in the near intermediate zone.

Common experience points to the cones as the mediators of the perception of chromatic color. For one thing, sensitivity to and discriminability of color

correspond rather closely to the distribution of the cones across the retina. With small spots of light, all chromatic colors are seen very well in the pure cone fovea and in the surrounding central ten degrees or so of the visual field where cones predominate; some chromatic colors are seen well and others not so well in the intermediate zone where rods and cones are mixed; and no chromatic color is seen at all in the far periphery. This would be more noticeable if it were not also true that outlines and details of objects are less well seen in the outer parts of the visual field, so that we typically move our eyes to view them more centrally. Furthermore, color vision in the periphery is size dependent.

Recent experiments by James Gordon and Israel Abramov at The Rockefeller University (in which experiments I served as a subject) show that it is misleading to term the peripheral retina color blind, or even "color deficient." The quality of color vision in the periphery depends crucially on stimulus size. If the stimulus is sufficiently large, a full range of well-saturated hues can be seen. Evidently, all three primary cone-related mechanisms are present throughout the entire retina. Presumably, though, the peripheral cones are so sparse and the neural networks connecting them so large that larger stimuli are needed to stimulate adequately all the color mechanisms. But these networks are not all the same size and, consequently, the various color mechanisms do not all have the same spatial "tuning." As stimulus size is reduced first one color will disappear, and then another, depending upon the location. This is the basis of the "color zones" mapped in perimetric studies in which color disappears as a small colored target is moved from the fovea toward the periphery. But given the right conditions, chromatic colors can be seen in any part of the retina.

Figure 52 Schema of the principal structures and interconnections within the retina. In this diagram the principal neural elements of the retina and the interconnections among them are reduced to their essentials; however, the characteristic features of each variety are preserved—the locations, the sizes, the shapes, and the contacts among them are fairly realistic. The photoreceptors are shown in the upper layer. Rods are shown in "gray" to represent their achromatic sensitivity. Cones are shown in "red," "green," and "blue" to represent their three different broad spectral sensitivities. The photoreceptors—rods (R) and cones (C) —make contact with the bipolar cells (B) which, in turn, make contact with the ganglion cells (G). The ganglion cells give rise to optic nerve fibers which connect the eye with the brain. The horizontal cells (H) make lateral interconnections at the level of the junction of the photoreceptors and bipolar cells; the amacrine cells (A) make lateral interconnections at the level of the junction of the bipolar cells and the ganglion cells. The set of arrows alongside the schema indicates the directions of the flow of information at each level. Based on a drawing by Dowling and Boycott (1966).

Photoreceptors

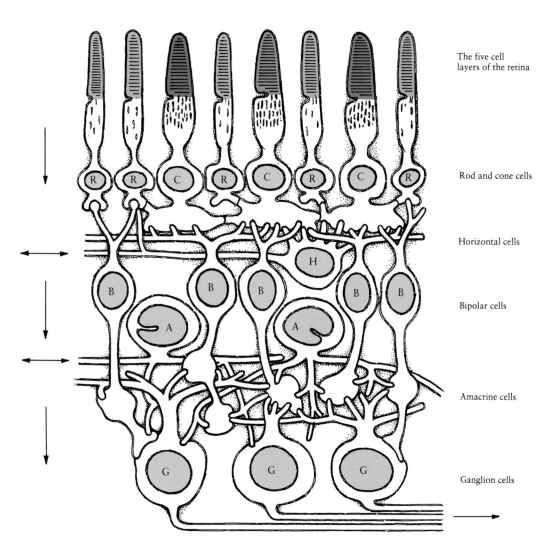

The five cell
layers of the retina

Rod and cone cells

Horizontal cells

Bipolar cells

Amacrine cells

Ganglion cells

Optic nerve to brain

109

The shift from day to night vision also implicates the cones in the perception of color. Only the rods, which are 100,000 times more sensitive than the cones, function in the most sensitive fully dark-adapted state that the eye achieves in the deep of night. (For this reason, a faint star is best seen by looking to one side of it so that its image falls on at least some sensitive rods rather than directly and only on the less sensitive pure-cone fovea.) In the transition from rod to cone vision, at twilight, the color of an object appears quite different from the color of the same object in the dark of night or in the light of day. This fact has long been known to both artists and scientists and probably provided the first scientific evidence for the duplex nature of the retina.

As early as 1825 the Czech physiologist Johannes Evangelista Purkinje noticed that in the late evening, as night fell, the appearance of the flowers in his garden gradually changed. Blue flowers that appeared darker than red and yellow flowers in the daytime gradually became much brighter than the red and yellow ones as darkness descended. This gradual color change at twilight, now known as the Purkinje shift, is simply the outcome of the gradual shift of dependence of vision on the less sensitive cones to the more sensitive rods. When twilight fades and the full dark of night approaches, the cones cannot detect the weakening light, and only the highly sensitive rods continue to respond. Because the absorption curves of the cones extend farther into the red end of the spectrum than do those of the rods, any loss of cone sensitivity results in a shift of the overall sensitivity of the retina toward the blue end. Eventually, all color fades with the gradually fading twilight, and anything that can be seen at all at night —even in the brightest full moonlight—appears only in shades of gray. This is common knowledge and is the physiological basis of the folk saying, All cats are gray at night.

The rods, acting alone, are insensitive to changes in color for they all contain the same photopigment. Although the absorption of light by this one photopigment (or by any other one) does vary with wavelength, such differential absorption alone is not sufficient for the discrimination of one color from another. This is because the photochemical effect produced in any one particular photopigment by light at any one wavelength of the visible spectrum is not unique; the same effect can be produced at different effective wavelengths simply by an appropriate adjustment of the intensity of the light (Figure 53). Consequently, a single photoreceptor can signal only variations in the amount of light absorbed by it—not the kind. Therefore, night vision, which depends upon only the one type of photopigment in the rods, is necessarily colorless, that is, achromatic. (This does not mean that the rods make no contribution at all to color vision. But any contribution they may make must be in concert with the cones.)

In summary, at least two photoreceptor types, each with a different spectral sensitivity, are required for true—that is, chromatic—color vision. Under those circumstances the different reactions of two, or more, different types of photoreceptors to light of the same wavelength can provide the basis for sensitivity to and discrimination of color. This minimum requirement is met, and exceeded, by the three types of cones postulated in the Young-Helmholtz theory. Each type is assumed to have a somewhat different photopigment and, consequently, a somewhat different spectral sensitivity. In accordance with the theory, color vision is best in the central pure cone region of the retina. Indeed, only when the cones function is true color vision possible. And because

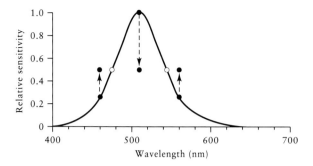

Figure 53 Color confusion by a single photopigment. The curve represents the relative sensitivity of a rod photopigment to lights of various wavelengths, but of equal energy. (One nanometer [*nm*] is one billionth of a meter.) One such pigment is not adequate for the reliable discrimination of one color from another. There are many points of confusion, even in the responses to an equal energy spectrum, as shown. For example, the two points indicated by the open circles are the same amplitude on the sensitivity curve, and therefore the eye cannot discriminate one corresponding wavelength from the other at these equal energies. The confusion becomes complete if one allows adjustment of both energy and wavelength. The response to virtually any wavelength of light can be matched by proper adjustment of the energy of light at any other wavelength. As shown, for example, a reduction of energy in the center of the curve would reduce the response correspondingly (*downwards arrow* and *solid circle*), and increases on the flanks of the curve would, correspondingly, increase the responses there (*upwards arrows* and *solid circles*). Thus these manipulations would produce responses that match exactly; one could not be discriminated from another.

the cones are relatively insensitive, color vision is best in the full light of day.

All of these well-known facts about the perception of light, shade, and color are consistent with the basic tenet of the Young-Helmholtz theory. That is, they are consistent with the notion that color is mediated by three cone types, each with a different photopigment—one with the maximum of its spectral absorption curve toward the red end, another with its maximum near the middle green, and the other with its maximum near the blue-violet end. Accordingly, the Young-Helmholtz theory was widely held in Signac's time, and still is accepted today. Acceptance of a theory is one thing, however; proof is another.

Proof positive

No one has yet succeeded in directly verifying the Young-Helmholtz theory by actually extracting three different photopigments from the photoreceptor cells by chemical means. However, by using the technique of microspectrophotometry, in which a very small beam of light may be passed through a single photoreceptor cell, it is now possible to measure the relative amounts of lights of different colors that are absorbed by a photopigment while it is still in its natural place within a photoreceptor. Such experiments were first carried out in the early 1960s by the biophysicists William Byron Marks, William H. Dobelle, and Edward F. MacNichol at The Johns Hopkins University in Baltimore. The absorption spectra of cones measured in this way fell into three overlapping but distinguishable classes, as required by the trichromatic theory. A few years later another line of strong supporting evidence was provided by the physiologists Tsuneo Tomita, Akimichi Kaneko,

Motohiko Murakami, and Eugene L. Paulter at Keio University in Tokyo. By inserting a very fine microelectrode into a photoreceptor cell (an extremely difficult task), they were able to measure the "action spectrum" of a single receptor—that is, the amount of neuroelectric activity elicited in response to stimulation by lights of different colors. Again, the cone types revealed by these electrophysiological measurements fell into three overlapping but distinguishable classes, very similar to those indicated by the earlier microspectrophotometry. (Note that the experiments by Marks et al. were done on cones of the macaque retina; those by Tomita et al. were on cones of the carp retina.)

The results of all of these and many other modern scientific measurements (summarized in Figure 54) are in good general agreement with the spectral characteristics of the three hypothetical photosensitive mechanisms postulated long ago in the Young-Helmholtz theory (Figure 36). Indeed, these recent findings based on direct observations correspond very closely to the quantitative theoretical predictions made in the mid-1800s largely on the basis of the optical mixture of colors and the matching of colors. And the three types of photosensitive mechanisms postulated then are clearly a sufficient basis for color vision.

It is true that the response of any one of the three types of cones may not be sufficient in itself to distinguish one color from another, as was shown in Figure 53. But the different responses of the three different types of photoreceptors, with their three different spectral sensitivities, are sufficient. The three different pigments may be thought of as taking a set of three different "measurements" of a monochromatic light at any particular wavelength. Because each such set differs from all the others (with some exceptions), the three types of cones, acting in concert, are therefore capable of receiving and transmitting unambiguous information about monochromatic lights across most of the visible spectrum. For more complex spectral distributions, however, the information about the composition of a particular color is ambiguous. There are many metameric colors: as the CIE Chromaticity Diagram shows so clearly, the same color can be produced by many different mixtures of light. But even though a trichromatic system is not sufficient to analyze the spectral composition of a colored light, it is sufficient to identify various colors and to discriminate one from another.

Thus, the basic trichromacy of human color vision appears today to be beyond any doubt. The very first stage in color perception, as Sir Thomas Young intimated long ago, and as Hermann von Helmholtz subsequently made more explicit, is in the differential absorption of light by three different types of photopigments. In fact, as time goes by, more and more evidence in favor of the Young-Helmholtz theory has accumulated. Even the genetic basis for the trichromatic theory now seems secure. Very recently the genes for the required three different types of light-absorbing molecules—real counterparts of Helmholtz's hypothetical red-sensitive, green-sensitive, and blue-sensitive substances—have been identified.

It might appear now that the modern form of the Young-Helmholtz theory represents The Truth, at last. It does appear to provide a satisfactory account of many and diverse aspects of color experience. However, the quantitative aspect of the trichromatic theory is based largely on color-mixture experiments, and its physiological confirmation is confined almost exclusively to experiments on the

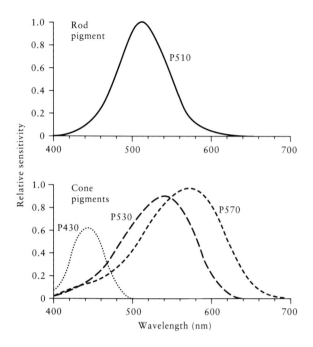

Figure 54 Relative spectral sensitivities of the rods and of the three types of cones. The sensitivities are for light of equal energy across the visible spectrum (wavelengths of 400–700 nm). The P numbers on the curves refer to the wavelength, in nanometers, of peak sensitivity. For the pigment under consideration, light at that wavelength is more effective than light, of the same energy, at any other wavelength. For comparison, the peak sensitivity of the rods, P510, and the peak sensitivity of the "red-sensitive" cone, P570, are both set equal to 1.0. In absolute terms, however, the rods are about 100,000 times as sensitive as the cones. (An accurate portrayal of low-amplitude portions of the curves near zero sensitivity requires a plot on a logarithmic scale.) (*Top*) The single pigment of the rods covers almost the entire visible spectrum. But this pigment alone is not a sufficient basis for the discrimination of one color from another (compare Figure 53.) (*Bottom*) All three cone types have very broadband sensitivities. Although all partially overlap one another, the so-called "red" cone type (P570) is more sensitive than the others at the orange-red end of the spectrum, the "green" (P530) more sensitive in the green region, and the "blue" (P430) more sensitive at the blue-violet end. These differences, small as they are, suffice to form the basis for very fine color discrimination. Note how the relative contributions of the three cone types vary with wavelength. These curves, based on a variety of modern scientific measurements, are a striking confirmation of Helmholtz's theory of three cone pigments (compare with Figure 36). Redrawn after Ratliff (1976).

photoreceptors. Thus, both the theory and the proof of the theory are limited in scope, for color vision is not confined to the phenomena of color mixture, and visual physiology is not confined to the functions of individual photoreceptors in the retina. In short, the trichromatic theory, well established and supposedly basic to the technique of pointillism, may well be The Truth but it is not The Whole Truth.

What is missing? The spatial interaction of color, which is basic to the technique of divisionism, is not treated at all by the classical Young-Helmholtz trichromatic theory of color vision. This is a major omission. As artists, artisans, and psychologists have long known, and as Signac emphasized in his book, adjacent colors do interact with one another and, as physiologists have more recently discovered by direct experimental observations, individual neurons are interconnected in extensive networks, both at the retinal level and in those regions of the brain where vision is mediated. The visual system is an organ; that is to say, an organized whole with active and interactive parts.

In brief, the major shortcoming of the Young-Helmholtz trichromatic theory, from the perspective of this essay, is that it is severely limited in scope. It accounts only (and incompletely) for the facts of color matching and color mixture under well-controlled and narrowly circumscribed experimental conditions. It fails to account for other equally important aspects of color. The common experience that neighboring colors interact with one another, as when one color suppresses or enhances another through the familiar phenomena of simultaneous contrast, has no place at all in the Young-Helmholtz trichromatic theory. Nor does the fact that there are four psychologically unique colors: red, yellow, green, and blue. For an account of these and related

phenomena one must turn to the competitive and seemingly contradictory Hering opponent-color theory. This broadening of color theory can be achieved without sacrificing or abandoning trichromacy. In fact, it turns out that trichromacy is an essential ingredient of opponency.

The physiological bases of the interaction of color

In a certain sense, the approximately 100 million photoreceptors in the retina perform an analysis of the image that falls on the fine, pebbly receptor mosaic that they form. Each photoreceptor, rod or cone, responds more or less selectively (and generally in accordance with the Young-Helmholtz theory) to a particular region of the spectrum. This is an essential first step in the encoding of information about the retinal image that is to be sent to the brain. But this initial analysis is almost immediately followed by the first in many stages of synthesis. This synthesis is accomplished, in the main, by two major processes: convergence and cross talk (Figure 55).

Convergence and combination of the separate neural signals generated by the "red-sensitive," "green-sensitive," and "blue-sensitive" cones must take place at some point in the visual system if the signals are to be mixed to produce the whole gamut of color appearances. Some of this integration begins almost immediately in the retina itself (Figure 55). Information from the more than 100 million photoreceptors (rods and cones) is funneled into the million or so neurons that form the optic nerve connecting the eye with the brain. This hundred-to-one reduction is more than a mere compression by brute force; it is actually a very sophisticated process of abstraction. Different kinds of information about

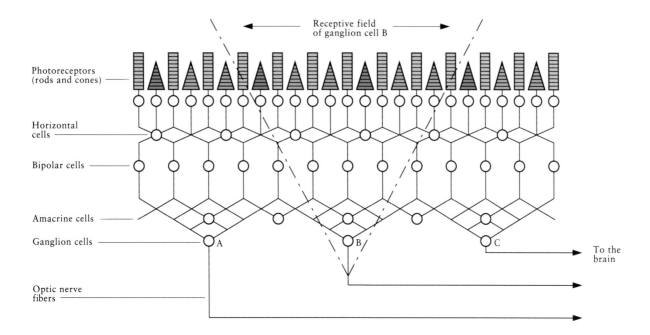

Figure 55 Schema of pathways for convergence and cross talk in the retina. The rods and cones (colored) and the neural interconnections below that fall within the region bounded by the dashed lines show how the activity of many photoreceptors may converge onto a single optic nerve fiber on its way to the brain. Also indicated are the lateral pathways (horizontal and amacrine cells) over which lateral interactions (or cross talk) may take place. Note that each photoreceptor does not have a "private line" to the brain. Generally speaking, each optic nerve fiber collects information from many photoreceptors and thus has a large receptive field—that is, a large area of the receptor mosaic from which it receives information that contributes to the response of that particular optic nerve fiber. Typically the ratio of convergence, or reduction, is hundreds to one rather than the ten to one or so shown in this simplified schema. Since there are many more receptors than optic nerve fibers, the receptive fields of neighboring fibers overlap. Therefore, any one particular receptor may contribute to the responses of several different optic nerve fibers. Thus, there may be divergence of information as well as convergence.

the pattern of light and shade and color imaged on the retina are sorted out and transmitted by way of separate lines or channels to the brain. There, it is somehow reorganized into a whole and seamless image once again. This "parallel processing" by neurophysiological mechanisms in the eye and the brain is capable of handling very large amounts of information very efficiently and very quickly. (It is interesting that recent advances in computer technology, providing much greater speed and efficiency, are also achieved by using parallel processing.)

Much of the abstraction that takes place initially within the retina results from cross talk over neural networks. As is evident in the schema in Figure 55, there are ample lateral interconnections in the retina itself for one pathway from the receptors to the optic nerve to "talk" to another. Such cross talk is essential to the interaction of color. And what happens in the retina is only a preview of similar, but much more complex, interactions that take place in the brain.

Through a series of such integrative stages, first in the eye and then in the brain, a well-organized visual image is finally formed that shows little or no evidence of having once been dissected into minute bits and pieces and then put back together again. In visual perception there is virtually no trace of the grain of the photoreceptor mosaic, no sign of the sorting out of information into separate channels, and little obvious evidence of the complex integrative action that has taken place—except in the interaction of color. And it was this clearly visible evidence of interaction that pointed up the need for and the way to the opponent-color theory.

Interaction of color and opponent-color theory

Hering succinctly expressed the opponent-color theory in terms of three pairs of antagonistic colors: an achromatic pair (black versus white) and two chromatic pairs (red versus green, and yellow versus blue). It is important to note that the chromatic part of the present-day opponent-color theory, although it involves the two opponent pairs (red versus green, and yellow versus blue) and therefore has at times been called a tetrachromatic theory, is itself actually a trichromatic theory, insofar as the cone pigments are concerned. Indeed, as will be shown later, the four-color opponent-pairs system does not require that there be a fourth type of cone. Opponency is not in conflict with trichromacy. The two pairs of opponent colors appear to result from the way in which the activity generated by the three cone types is subsequently integrated and reorganized in the retina of the eye and at higher levels of the visual system in the brain.

Furthermore, it is important to keep in mind that in the Hering opponent-color theory the achromatic colors black and white are also opponent pairs and that brightness, as well as color, depends at least in part on the interaction of opposed influences. This opposition of black and white was not mere speculation put forth by Hering to complete and to give a pleasing symmetry to his theory of opponent pairs. Brightness, as we have already shown, does depend strongly on contrast.

Hering originally assumed that the interaction of opponent colors took place by way of metabolic chemical changes in what he called the *visual substances* in the nervous tissue (see the Hurvich and Jameson translation of his book in Hering 1964). He

differentiated this visual substance from the photo-chemical substances in the receptors, for which he used the term *receptor substance*. (In German "Seh-substanz" for the nervous tissue versus "Empfangs-stoffe" for the receptors.) Hering turned to Mach for a possible physiological explanation of how one region of the retina might interact with another:

> How is it possible for the metabolic activity in one area of the somatic visual field to have an effect, depending in its nature and amount, on the nature and amount of metabolism in the surround, we do not know. As an anatomical substrate to carry such an effect we have the histological interconnections among the nerve elements in the brain as well as in the retina. In the year 1865 E. Mach referred to this when he assumed reciprocal interactions in the retina on the basis of his contrast experiments.

The Machian notion that the interaction was mediated by neural networks in the retina and in the brain was well advanced by the end of the nineteenth century, but direct electrophysiological evidence for such interaction was not obtained until the past few decades. This evidence came from studies of the electrical activity of individual neurons that carry information collected from an array of photoreceptors in the retina of the eye to neurons in the visual cortex of the brain.

This field of research was opened up by the biophysicist and 1967 Nobel laureate H. Keffer Hart-line, who in the 1930s was the first to succeed in recording the electrical activity of single optic nerve fibers. Hartline was also the first to show, by direct electrophysiological experiments, that lateral inhibitory interactions of the type postulated by Mach actually take place within the retina. And in the late 1950s, nearly a hundred years after Mach's theory was first advanced, Hartline and I demonstrated that lateral inhibitory interactions can indeed produce contrast effects such as the Mach bands and other edge effects—the very phenomena which figure so importantly in some of the work of both Seurat and Signac (see Ratliff 1965).

Most relevant to an understanding of opponent-color theory is a form of lateral interaction called *spectrally opponent*. Spectrally opponent simply means that a particular neuron, which collects and transmits information from a mixture of cone types, is excited by light from one part of the spectrum and inhibited by light from another part. (This opponency also has a spatial organization, which will be considered later.) Such spectrally opponent neurons were first found in the retina in 1956 by Gunnar Svaetichin, a neurophysiologist at the Venezuelan Institute of Neurology and Brain Research, Caracas. By inserting fine microelectrodes directly into the retina, Svaetichin could record the electrical activity of single neurons that was generated in response to light. Immediately below the photoreceptors where there are extensive lateral interconnections (see Figure 52) Svaetichin observed spectral response curves with a maximum at one end of the spectrum and a minimum at the other. The similarity between these opposed spectral responses and Hering's opponent color theory was evident and was immediately pointed out by Svaetichin. About 1960, a team of biophysicists at The Johns Hopkins University—Henry G. Wagner, Edward F. MacNichol, and Myron L. Wolbarsht—recorded the electrical activity of single optic nerve fibers that was elicited in response to spectral lights of various colors. These fibers, which form the pathway from the eye to the brain, also exhibit spectrally opponent processes. A few years later, similar spectrally opponent neurons were discovered at the level of the first connection

that the optic nerve fibers make with the brain: the lateral geniculate nucleus. These latter electrophysiological studies were conducted by three physiological psychologists at Indiana University: Russell De Valois, Israel Abramov, and Gerald H. Jacobs. Over the past two decades a very large number of related studies has been carried out on spectrally opponent neurons at all levels of the visual system from the retina to the visual cortex of the brain, and their general properties are now very well understood. (The experiments by Svaetichin and by Wagner et al. were on the carp retina; those by De Valois et al. were on the macaque monkey.)

Several types of spectrally opponent neurons have since been identified, and the basic coupling is more or less as postulated by Hering: "red-excitatory" versus "green-inhibitory" (or the reverse—"green-excitatory" versus "red-inhibitory"); and "yellow-excitatory" versus "blue-inhibitory" (or the reverse—"blue-excitatory" versus "yellow-inhibitory"). The spectral sensitivities of these opposed influences are much less specific than the names alone suggest. Actually, the opponent influences in any particular type of spectrally opponent neuron may be generated, more or less efficiently, by light anywhere within two rather broad bands, which together cover practically the whole visible spectrum (Figure 56). The color names of each type refer only to the approximate spectral locations of the maximal excitation and inhibition, not to the whole extents of the bands.

The different responses of the "red" versus "green" and "yellow" versus "blue" types of opponent neurons must each be the result of different organizations and integrations of the neural activity from the three available cone types. That is to say, the threefold trichromatic pattern of activity generated initially by the three types of cones must somehow be subsequently shaped by neural interactions in the retina and in the higher visual pathways into a more complex fourfold tetrachromatic pattern. Furthermore, this chromatic pattern must take the form of opponent pairs, and the achromatic opponent pair must be added to it. Only the beginning of the process of color vision takes place in the individual photoreceptors. Analysis of color at that level must be followed by a synthesis later on. As H. Keffer Hartline, the pioneer of modern electrophysiological studies of vision, once remarked:

> Individual nerve cells never act independently; it is the integrated action of all the units of the visual system that gives rise to vision.

How three becomes four

A current view of this integrative action in color vision (much oversimplified here) is as follows. The processes leading to the visual perception of color begin with an analysis—the differential absorption of light by the three different cone photopigments. This may be represented abstractly as three point-processes—R ("red"), G ("green"), and B ("blue"), more or less in the form of Young's triangle:

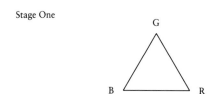

Stage One

All information about color must be mediated by the neural activity generated by these three cone

types. There is no other entrance to the visual mechanisms that underlie the perception of form and color. And this information alone must provide the physiological basis in the retina for the psychological facts of color mixture, and for the Young-Helmholtz trichromatic theory of color. It also provides the necessary two components for the opponent pair "red versus green" in the Hering opponent-color theory. In this first stage, however, there is no "yellow" to provide the opponent mate for "blue."

The "yellow" channel cannot be created out of thin air. It, too, must be derived from whatever information passes through the narrow openings from the outside world formed by the three cone types. The general consensus among physiologists and psychologists today is that the required "yellow" channel results from a further reorganization and combination of selected portions of the initial tripartite activity, possibly from information flowing in the "red" and "green" channels alone:

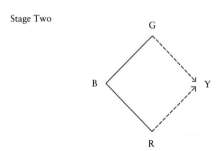

Once this fourth ("yellow") channel has been created by integration of some of the neural activity from the "red" and "green" channels, the necessary mate for the "blue" now exists, and the four channels can interact in the visual pathways from retina to brain and within the brain as two opponent pairs:

Stage Three

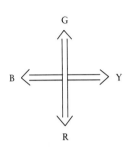

The three-stage schema of combination and recombination illustrated above is much oversimplified and highly abstract. It is intended only to show that there is no logical (or physiological) barrier in the way of a unified theory combining both an initial trichromacy of photoreception and a subsequent tetrachromatic opponency of integrative action. For simplicity, an explicit treatment of brightness and of the opponent "black" and "white" pair has been omitted. This achromatic opponent pair is absolutely essential in the Hering theory, however, and cannot be omitted in any complete account.

What is actually known in detail about the reorganization and integration of visual activity as it passes from the eye to the brain is far beyond the scope of this work and is not required to follow the arguments presented here. A few additional items must be considered, however, in order to be able to relate space in the opponent-color theory to space on the painter's canvas.

Spatial organization

To be physically and chemically realistic, the abstract four channels that make up the two opponent pairs, in modern theoretical formulations, must be thought of in physiological terms. First of all, they must be regarded realistically as comprising sensitivity and re-

119

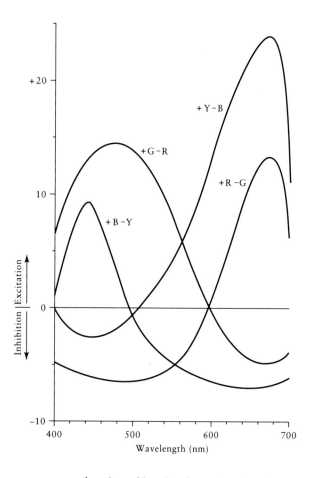

Figure 56 Spectrally opponent neurons. Examples of the spectral sensitivities of four types of opponent neurons: a "red-excitatory" versus "green-inhibitory" (+R-G), a "blue-excitatory" versus "yellow-inhibitory" (+B-Y), a "green-excitatory" versus "red-inhibitory" (+G-R), and a "yellow-excitatory" versus "blue-inhibitory" (+Y-B). The positive values indicate spectral regions in which a particular neuron may be excited; the negative values indicate spectral regions in which that same neuron may be inhibited. Based on experiments by R. De Valois, I. Abramov, and G. H. Jacobs. Redrawn after Ratliff (1976).

sponse to four broad bands of wavelengths (dictated, in part, by the real broad-band sensitivity of the photopigments involved) rather than to four narrowband monochromes or point-processes (as idealized here in these simple schemas). Furthermore, the spatial arrangements of the opponent pairs in the visual system itself must be thought of in still another real dimension—a physiological space (dictated by the actual spatial arrangements of networks of neural interconnections within the eye and the brain). This real configuration of color-mediating neural networks must be clearly distinguished from ideal conceptions of psychological color space. But the two are related. The interaction of color as seen depends

critically upon the configuration of the array of colors presented to the eye. And for the eye to recognize and to make use of this configuration, it must have some corresponding form. For, as the adage of the ancient Ionian School states, Like is known only by like.

A pairwise spatial organization of the four different color channels is suggested in the spatial distribution of color sensitivity across the retina (Figure 57). Equally saturated small spots of red, green, blue, and yellow are seen about equally well in the central zone of the retina, provided they are of equal size and equal energy. But as the spots are moved toward the periphery, sensitivity to redness and greenness diminishes first, and sensitivity to yellowness and blueness

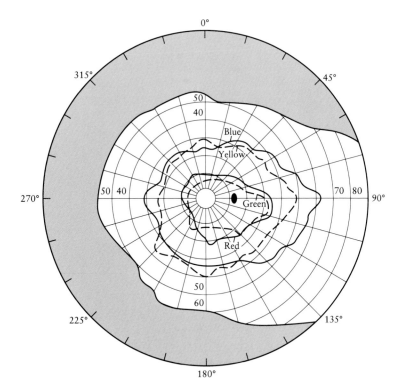

Figure 57 Chart of the retinal color zones. The entire visual field of the right eye is indicated by the outermost irregular solid line. (The nose, the brow, and the cheek limit the inner, upper, and lower portions of the field to about 50 or 60 degrees.) Note that the small zones that are sensitive to red and green are nearly the same size and shape. Similarly, the larger zones that are sensitive to yellow and blue are more or less congruent. Redrawn after Hurvich (1981).

diminishes later on. Maps of red and green zones of sensitivity thus measured are more or less congruent, as are the blue and yellow zones. This paired arrangement of red-green and blue-yellow sensitivity points to a linkage of these color channels that is consistent with the opponent-color theory. But such gross measurements of the color sensitivity of the whole eye can only be taken as indirect supporting evidence for the theory. For direct proof, one must turn to the more detailed study of the spatial properties of individual neural networks.

What are the most essential spatial properties? In particular, neural networks in the visual system must have some lateral reach. Otherwise, one touch

of color on the canvas could not appear to interact with another neighboring one. The most basic real spatial form of a spectrally opponent neural network is concentric (Figure 58). Physiological experiments show that, in general, an area of the retina that is maximally excited by red will be maximally inhibited by green in surrounding areas (or vice versa). Similarly an area that is maximally excited by yellow will be maximally inhibited by blue in surrounding areas (or vice versa). Such real physiological spectral and spatial relationships are neither implicit nor explicit in the abstract formulations of psychological color space such as Newton's color circle, Young's triangle, the CIE chromaticity diagram, and the Munsell

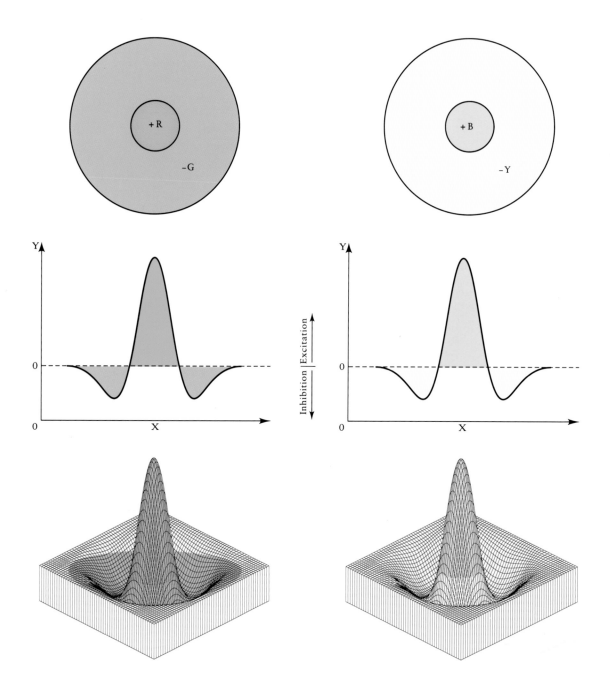

Figure 58 Spatial distribution of spectral sensitivity of opponent neurons. (*Top*) On the left are shown the spatial characteristics of the receptive field of a "red-excitatory green-inhibitory" neuron; on the right the receptive field of a "blue-excitatory yellow-inhibitory" neuron. The "red-green" neuron (*left*) is maximally excited by red light falling in the central zone, maximally inhibited by green light in the surrounding annulus. Similarly, the "blue-yellow" neuron (*right*) is maximally excited by blue in the center, and maximally inhibited by yellow in the surround. (*Center*) The two-dimensional graphs show the corresponding sensitivity profiles of the excitatory and inhibitory influences on the "red-green" and "blue-yellow" neurons. (*Bottom*) The three-dimensional graphs, each somewhat in the shape of a Mexican hat, show how these excitatory and inhibitory influences are distributed across the entire receptive fields of those neurons, the retinal regions to which they are sensitive. In other opponent neurons the roles of center and surround may be reversed so that the center is inhibitory and the surround is excitatory. Also, in some cases the spatial distribution of excitatory and inhibitory regions may be much more complex than in the examples shown here.

color solid. But these relationships do exist in both physiological color space and in psychological color experience, and they and their consequences must be considered in any complete scientific theory of color and in any application to painting where real color pigments are laid out in real spatial arrangements so that they may interact with one another visually.

Thus the interaction of color, which is revealed in so many different ways in common everyday visual experience, is not mere illusion which points to some aberration in the visual system. Rather it points to fundamental integrative mechanisms of color vision.

Recapitulation

In brief, the current view among physiologists and psychologists now doing research on color vision is that the four members of the chromatic opponent pairs arise from particular combinations and recombinations of the neural responses governed by the three types of photopigments and that the opponent pairs have certain generally concentric spatial arrangements. Consequently, in their modern forms, the Young-Helmholtz theory of trichromatic mechanisms in which colors combine with one another and the Hering theory of tetrachromatic mechanisms in which colors oppose one another are no longer regarded as contradictory, but as complementary. Each refers principally to different but equally fundamental processes in the visual system. The essentials of the Young-Helmholtz theory are brought out clearly and forcefully under one set of conditions (namely, mixture of color) and those of the Hering theory under another set of conditions (namely, interaction of color). The processes represented in both theories must eventually be incorporated into any comprehensive and full account of the mechanisms of vision.

Color from black and white

Some color phenomena may still appear to be inconsistent with both the Young-Helmholtz theory and the Hering theory. For example, the appearance of faint color in stationary black and white patterns, such as in Riley's *Current* (Figure 22), and in moving black and white patterns, such as Benham's disk (Figure 59), seems difficult to explain in terms of either of the classical theories. But modern research indicates that these colors can be accounted for on the basis of the dynamic properties of spectrally opponent and other known neural networks. The temporal characteristics of these black and white patterns, determined either by eye movements or by movements of the spatial patterns themselves, provide weak, but nonetheless effective, stimuli for the color-sensitive mechanisms. By proper temporal and spatial distributions of the black and white components of the patterns, the eye can be "tricked," as it were, into responding as if it were being stimulated by one or another particular spectral color.

Retinex color theory

Another example of a seeming contradiction of classical color theory is the demonstration in the late 1950s by Edwin Land, the inventor of Polaroid, that the appearance of "full color" may be produced in some cases by additive mixtures of lights from only two chromatic sources. This finding was once hailed by *Fortune* magazine as showing "that scientists since Newton have been completely fooled about the way the eye sees colors." The more carefully considered view of most color scientists, however, is that these striking effects are largely special cases of long-known color-contrast, color-assimilation, and color-induction phenomena.

As early as 1897, Louis A. Ducos du Hauron wrote in his work *La Triplice photographique:*

> During my last researches I have discovered a marvelous law by virtue of which an image, composed of only two monochromes, is capable of producing on the visual organs, under certain conditions, a colored sensation as complete as the trichromatic images, which I have already obtained . . . Observers actually believe that they see the three colors where they ought to be, although they know that they are actually absent.

Early in this century others reported on and made some practical use of these two-color mixtures to obtain "full color." A British patent on a two-color film was obtained by W. F. Fox and W. H. Hickey in 1914; and in 1926 the color scientist L. T. Troland wrote: "It has long been a matter of surprise to physicists that very satisfactory photographs in natural colors could be obtained by the use of only two primary colors." But special conditions are required and no practical method for widespread use of two-color systems for still photography, motion picture and television, or color printing has yet been developed. Both the merit and the potential of the long-known two-color theory have often been much exaggerated. Indeed, it is somewhat ironic that reproductions of the effects of Land's striking two-color demonstrations with slide projectors are still printed in popular magazines and quasi-scientific journals by means of standard four-color printing processes.

More recent studies by Land and his associates have led to the revision of their color theory, now expressed in terms of three (rather than two) independent receptor systems. Interactions are supposed to occur within each of these three systems. For each system, light flux from each point in a visual scene is evaluated in terms of its relationship to the average

Stationary In rotation

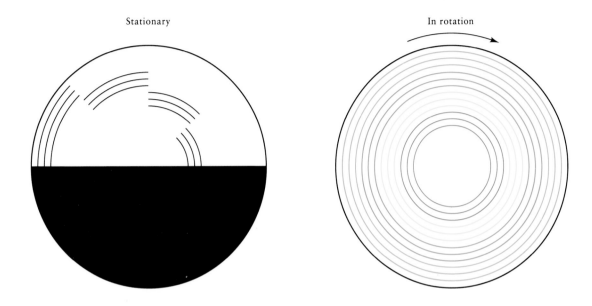

Figure 59 Benham's disk. When the
disk is rotated at about five or ten
revolutions per second, colored rings
are seen where the black stripes ap-
pear when the disk is at rest. If the
rotation is clockwise, the outer set of
lines appears bluish, the next set
greenish, the next yellowish, and the
inner one reddish. If rotation is
counterclockwise the colors are re-
versed: red outermost and blue in-
nermost. The placement, spacing,
and relative length of the lines and
the overall ratio of black to white in
the pattern are critical. Redrawn
after Bidwell (1899).

light from all neighboring points in extensive surrounding regions. (This "computation" is somewhat reminiscent of Mach's view of retinal interactions.) The images thus formed in each of the three systems are then compared with one another at some point in the visual system, rather than mixed (as in the Young-Helmholtz theory), and the colors of the final image thus generated are determined by those comparisons. No experiments have yet been devised to reveal the locations of the supposed interactions and comparisons. Therefore, Land coined the nonspecific word *Retinex* (from retina and cortex) to designate the uncertain locus of the three physiological mechanisms that are supposed to generate the three intermediate images and ultimately to combine them into the one colored image that is finally perceived.

Thus, in its present form, the Retinex theory is the long-standing trichromatic theory in another guise. The color scientist W. D. Wright made this very same point in a 1967 article about the advent of color television.

> The laws of colour mixture have been able to withstand the shock of Land's experiments with two-colour projection, so that we still believe there are three types of colour receptor in the retina, and whichever of the colour television systems is adopted the one thing we can be certain of is that it will be a three-colour system For exciting as Land's demonstrations undoubtedly were, they were only an elaborate form of Goethe's colour shadows experiments of 150 years ago and did not really undermine the foundations of the trichromatic theory of colour vision.

The essential trichromacy of human color vision has not been successfully challenged on any front. Modified or embellished it may be—but refuted? Not yet.

The modern Young-Helmholtz-Hering theory

The current well-established and generally accepted view of the most fundamental aspects of modern color theory may be summarized as follows. There are three primary photochemical processes at the receptor level in the retina of the eye (more or less as postulated in the Young-Helmholtz trichromatic color theory about a hundred and fifty years ago), and these processes account reasonably well for many of the facts of color mixture, such as the combination and fusion of small points of color in a strict pointillism. At higher levels in the visual system there are opponent processes (excitation and inhibition) in both the integrative action of the retina and of the visual centers of the brain (more or less as postulated in the Hering opponent-color theory about a hundred years ago). These processes account reasonably well for many of the facts of interaction of color such as the interplay and rivalry among large touches of color in the more lenient divisionism.

There is no contradiction here. One simply has to recognize that what happens in an early stage of the visual process may be subject to considerable modification and reorganization in a later stage. In short, the modern view is that the trichromatic and opponent-color theories are complementary. Both the mixture of color and the interaction of color are now regarded as essential components of any complete account of the basic mechanisms of color vision. Despite this advance, a truly comprehensive and completely unified theory of the whole of color still remains elusive, and will remain so for a long time to come. But more than enough is now known to assess and to understand both the merits and the shortcomings of the Neo-Impressionist technique.

IV. The theory of color and the practice of the artist

Much more is known in color science today about the optical mixture of color and about the interaction of color than was known in Signac's day. Despite these advances, the modern theory of color is not of much immediate importance for the practicing artist. In any specific case there are usually too many uncontrolled variables for the artist to apply details of scientific theory directly and rigorously throughout the work. The lighting of the subject, the texture of the canvas, the ground and the underpainting, the particular blend of pigments, the stiffness of the brush, the viscosity of the paint, the nature of the artist's touch, and many, many other factors—all of which are difficult to specify in advance or to control precisely—contribute to the outcome. Furthermore, there are many subtle aspects of color on which scientific theory is still silent. To a considerable extent, therefore, artists must adopt an empirical approach, and discover their own technical rules as they go along; the scientific theory of color and the actual practice of the colorist are still far apart. And in the quest of beauty itself, the science of color is of little or no aid at all to the artist.

Nevertheless, the many general scientific principles that have been elucidated do provide some helpful guidelines for artists. (See Kemp 1990.) In particular, they provide useful information on both the utility and the limitations of various methods of painting. And artists who understand fundamental scientific principles thereby know in advance how far and in what direction mastery of a given technique can take them. But science can only provide the means; the artist must provide the art. As the critic Félix Fénéon once remarked: "Mr. X can read optical treatises until eternity, but he will never create *La Grande-Jatte*." (See Lee 1983; Halperin 1988.)

A major obstacle in the way of Fénéon's would-be painter, Mr. X, is that painting is a synthesis rather than an analysis. The scientist who studies color can isolate some particular phenomenon and focus attention on it alone. For example, proponents of a particular theory of color vision may consider only the mixture of color and pay little or no attention to the interaction of color, or vice versa. The artist does not share this luxury. Artists must always be concerned with the appearance of the whole painting and thus with both the mixture of color and the interaction of color. For not only may the optical or pigmentary mixture of color in a particular place affect the appearance of the color there, but also a touch of some other color in another place may interact with it and affect it strongly. According to John Ruskin, "Every hue throughout your work is altered by every touch that you add in other places." It is no wonder that there has long been much confusion, in discussions of Neo-Impressionist painting, about the appearance of colors in various combinations and configurations.

Contradictions in the basic texts?

The outcome of the optical mixture of color should have been well-known to the Neo-Impressionists, for it was readily accessible to them in books they are known, by their own accounts, to have consulted (see Homer 1964; Broude 1978; Lee 1983). Perhaps most important among these books were Charles Blanc's *Grammaire des arts du dessin* (1867) and Ogden Rood's *Modern Chromatics* (1879)—the latter soon available, in the 1881 French edition, under the title *Théorie scientifique des couleurs*. Taken together these two texts (both excellent in their time) provided a possible source of confusion about the color of a particular optical mixture.

In some simple diagrams (Figure 60) Blanc showed how large expanses of the complementary colors red and green reciprocally heighten one another by contrast when placed in close juxtaposition. This effect is especially acute along the border that separates the two colors. But when the same colors are presented in very narrow alternate bands, they fuse in the eye and the individuality of the color disappears along with the individuality of the form. The directly opposing red and green destroy one another by this optical mixture, and the whole array appears gray. Blanc also pointed out that by adjusting the degree of interlacing or interpenetration of the two colors, a delicate reddish gray or greenish gray could be produced, as desired. He noted further that a similar phenomenon is produced on colored textiles starred or spotted with other colors.

Rood's work also contains complete and easy-to-understand explanations of the characteristics of optical mixtures. For example, following a discussion of the mixture of colored lights by the actual superposition of differently colored rays, Rood (1879) wrote as follows about the early findings of Jean Mile:

> Another method of mixing coloured light seems to have been first definitely contrived by Mile in 1839, though it had been in practical use by artists a long time previously. We refer to the custom of placing a quantity of small dots of two colours very near each other, and allowing them to be blended by the eye placed at the proper distance. Mile traced fine lines of colour parallel to each other, the tints being alternated. The results obtained in this way are true mixtures of coloured light, and correspond to those above given. For instance, lines of cobalt-blue and chrome-yellow give a white or yellowish-white, but no trace of green; emerald-green and vermilion furnish when treated in this way a dull yellow;

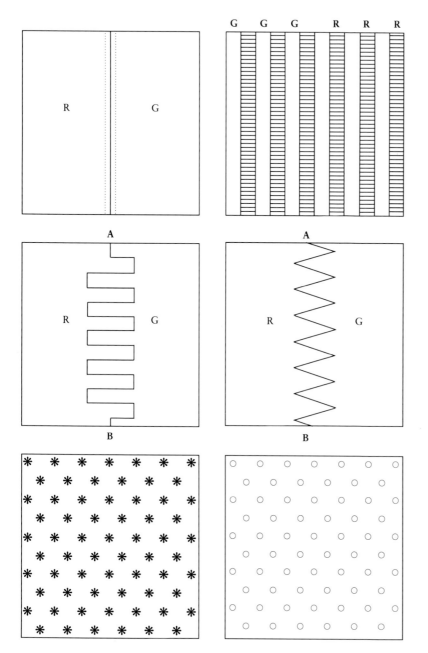

Figure 60 Early illustrations of optical mixture available to Seurat and Signac. Blanc (1867) described many practical methods of optical mixture that could be used by artists. These sketches are adapted from his book. The upper sketches are intended to show (*left*) how broad expanses of red (*R*) and green (*G*) interact with and heighten one another by simultaneous color contrast, especially near the common border as indicated by the dots, and (*right*) how the same colors in narrow bands (when viewed at the proper distance) can fuse by optical mixture and produce gray. The middle sketches are intended to show (*left*) how the uniform interpenetration (*A-B*) of the two colors results in a band of gray when optically mixed while (*right*) the graded interpenetration (*A-B*) of the same two colors will give a reddish gray passing through a gray to a greenish gray. The bottom sketches are intended to show how similar effects can be produced by starring yellow material with violet (*left*) and by spotting blue material with orange (*right*). With such materials the aim is usually to achieve only a partial fusion that will give a tinge of the superimposed colors to the background.

129

ultramarine and vermilion, a rich red-purple, etc. This method is almost the only practical one at the disposal of the artist whereby he can actually mix, not pigments, but masses of coloured light.

It would appear that the results of the method described by Blanc and that described by Rood are contradictory. Blanc's fusion of red and green (as in Figure 60) yields a gray; Rood's fusion of vermilion and emerald-green (using Mile's method) yields a dull yellow. But the two different results are not actually in conflict. Rather, they illustrate the inadequacies of common color names for the specification of colors. Blanc's red and green are very general terms, and the fact that he obtained gray from the mixture indicates that they must have been almost exact complements—diametrically opposite one another, at the ends of a straight line that passes near neutral gray, on the CIE Chromaticity Diagram (Figure 61). Rood's vermilion and emerald-green are somewhat more specific terms, and that more precise characterization (plus the dull yellow resulting from their fusion) indicates that these colors were probably closer to unique red and unique green than Blanc's. Therefore, the straight line connecting them on the CIE Chromaticity Diagram must have passed through a somewhat desaturated yellow. (Procedures for obtaining such apparently different results from mixtures of red and green—a gray from vermilion and blue-green, and a yellow from vermilion and emerald-green—were illustrated in Rood's book, using Maxwell's disks.) In any event, the apparent discrepancy between Blanc's results and Rood's is a good object lesson about possible sources of confusion: it shows clearly the inadequacy of common color names for the precise specification of colors, and for the prediction of the appearance of colors resulting from mixtures and from interactions. Furthermore, it is a good illustration of the frequent tendency toward gray in an optical mixture, which imposes a serious limitation on the use of some such mixtures in painting.

Confusion in color terms

The Neo-Impressionists learned their lessons from actual practice as well as from the theories of the day. But practice is not always a perfect teacher. As Alan Lee (1981) has pointed out, the modern painter Josef Albers—who always claimed to put practice before theory—was thoroughly confused about optical mixture and its role in the Neo-Impressionist technique. In *The Interaction of Color*, Albers wrote:

> From the impressionist painters we have learned that they never presented, let us say, green by itself. Instead of using green paint mixed mechanically from yellow and blue, they applied yellow and blue unmixed in small dots, so that they became mixed only in our perception —as an impression.

This is simply not so, as a glance at the CIE Diagram or the actual application of complementary pure yellow and pure blue spots on the canvas will show. Such an optical mixture produces gray. Albers's error may have resulted in part from the fact that artists seldom use pure colors: a so-called yellow, which is actually greenish yellow, and a so-called blue, which is actually greenish blue, will give an optical mixture with a greenish tint. Indeed, this is precisely what Chevreul instructed his tapestry weavers to do, over a hundred and fifty years ago, to avoid the appearance of gray:

> If we use a Yellow and a Blue inclining to Green more than to Red, the mixture will contain little or no Grey.

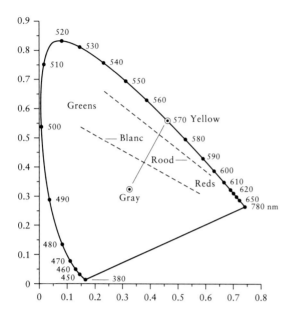

Some of the confusion about colors and mixtures of colors no doubt arises from the imprecise use of color terms—the terms used to describe color sensations themselves as well as the terms used to describe pigments and procedures of mixing those pigments. As the color scientist Dorothea Jameson (1982) has noted with respect to the same error by Albers mentioned above:

> More often than not, the names blue and yellow are just that: they are category names or labels that include a wide gamut of appearances. The appearance of the pigment labeled blue, when looked at alone, might more precisely be described as reddish-blue or greenish-blue or a blue that appears to have no trace of either reddish or greenish hue in addition to its blueness. The same is true for the pigment labeled yellow. Consequently, when Josef Albers . . . says that he puts blue and yellow dots in a pointillist array and gets green from their spatial [optical] mixture, he is certainly misleading the reader, but he might well be telling the truth. This is because his trial and error procedure would certainly have led him, if he wanted to get green from a spatial mixture, to use a yellow pigment that by itself in larger areas appeared

Figure 61 Optical mixtures of red and green: two different results. The discrepancy between the results of Blanc in the fusion of red and green and of Rood in the fusion of vermilion and emerald-green probably resulted from the use of very different reds and greens. There is a very wide range of acceptable reds and a very wide range of acceptable greens; and there is no way to determine today exactly what colors were used by Blanc and Rood. One can only assume that Blanc chose a pair toward the purple-red and blue-green ends and that Rood chose a pair toward the orange-red and yellow-green ends of those ranges. In that event, the straight line representing the mixture of Rood's pair in the CIE Chromaticity Diagram would have intersected yellow at a relatively high saturation, whereas the line for Blanc's pair would have intersected at a low saturation, near gray. The discrepancy could also have resulted from differences in saturation of the colors to be mixed. Even if the hues used by Blanc and Rood had been exactly the same, a mixture of a pair of low saturation would have been much more gray than a mixture of a pair of high saturation.

greenish-yellow and a blue pigment that appeared greenish-blue. If one were to do this, then the spatial mixture would have a greenish hue.

The above-described difference between an optical mixture of yellow and blue and an optical mixture of greenish yellow and greenish blue is very similar to the difference between the results of Blanc and Rood. Both comparisons illustrate the inadequacies of imprecise common color names and the difficulties that can arise in their use. Similar difficulties have arisen from the imprecise use of technical terms that are quite precise in themselves, such as optical mixture.

The meaning of optical mixture

The illustrations and discussions of optical mixtures by Blanc and the more rigorous treatments of such mixtures by Rood are thought by many to be the direct scientific precursors of the use of the divided touch in Neo-Impressionist technique. Certainly their books contain all the essentials of both the pigmentary mixture of color and the optical mixture of color. Indeed, the principal result that can be obtained by adherence to a strict pointillism is implicit in this one homely observation on optical mixture by Blanc (1873):

> If at a distance of some steps, we look at a cashmere shawl, we generally perceive tones that are not in the fabric, but which compose themselves at the back of our eye by the effect of reciprocal reactions of one tone upon another. Two colors in juxtaposition or superposed in such or such proportions, that is to say according to the extent each shall occupy, will form a third color that our eye will perceive at a distance, without having been written by weaver or painter. This third color is a resultant that the artist foresaw and which is born of optical mixture.

This is all well and good, but the Neo-Impressionists themselves claimed that they were divisionists, not pointillists. At the same time, however, they also claimed that optical mixture played a major role in their technique. How did this apparent contradiction come about? There is no question that the Neo-Impressionists understood the exact meaning of the term *optical mixture* and exactly what the process involved. Seurat carefully explained optical mixture to the critic Félix Fénéon by direct reference to some of Rood's demonstrations, with Maxwell's disks, of the differences between optical mixtures and pigmentary mixtures. And Fénéon, in one of his reviews, even went so far as to present some of Rood's numerical data that he had obtained from Seurat (see Halperin 1988). (Seurat's own notes on the role of optical mixture in his technique are too sparse to be of much use here.) Signac was even more explicit. He gave a very clear and very precise definition of optical mixture in *D'Eugène Delacroix au Néo-Impressionnisme*. This definition appears in a footnote in Section 8 of Chapter III:

> A pigmentary mixture is a mixture of material colors, a mixture of colored pastes. An optical mixture is a mixture of colored lights, for example, the mixture, at a particular point on a screen, of beams of light of diverse colors. —Of course, a painter does not paint with rays of light. But, just as a physicist can create the phenomenon of optical mixture by the device of a rapidly turning disk divided into diversely colored segments, so can a painter recreate it by the juxtaposition of tiny multicolored touches. On the rotating disk, or at a distance from the painter's canvas, the eye will isolate neither the colored segments nor the touches: It will only perceive the resultant of their lights, in other words, the *optical* mixture of the colors of the segments, the *optical* mixture of the colors of the touches.

Despite Signac's evident knowledge and full understanding of the exact meaning of the term *optical mixture,* he badly blurred the distinction between optical mixture of color and interaction of color elsewhere in his writings. In the definition quoted above, Signac is quite specific about the "juxtaposition of tiny multicolored touches." But time and again he railed against the use of the tiny dot (the most effective means of obtaining a true optical mixture) and exhorted his fellow Neo-Impressionists to broaden their brushstrokes. A typical example appears in Section 4 of Chapter V where Signac actually warns against the effects of optical mixture and praises the effects of contrast:

> The *point* (dot), as a word or as a procedure, has been used only by those who, because they cannot appreciate the importance and delight of the contrast and balance of elements, have seen only the method and not the spirit of *divisionism.* . . .
>
> The technique of *dotting.* . . simply renders a painting's surface more vibrant, but it does not ensure brightness, intensity of coloring, or harmony. For complementary colors, which are friends and enhance each other when contrasted, are enemies that destroy each other when mixed, even optically. A red surface and a green surface, contrasted, stimulate each other, but red dots mixed with green dots form a gray, colorless mass.
>
> *Divisionism* in no way requires a touch shaped like a *dot.* It can use this touch for small canvases, but utterly rejects it for larger compositions. The size of the *divided touch* must be proportioned to the size of the work, otherwise the picture is liable to lose its color. The *divided touch,* that changing, living "light," is therefore not the *point,* which is uniform, dead "matter."

Not only does Signac warn against the tendency toward gray and the loss of color in a true optical mixture (compare Figure 61), he goes on to extol the use of the interaction of visibly separate and distinct touches of color:

> It should not be thought that the painter who *divides* is laboring away at the tedious task of riddling the height and breadth of his canvas with little multicolored touches. Starting from the contrast of two hues, and disregarding the surface to be covered, he will oppose, gradate, and proportion his diverse elements on each side of the dividing line until he encounters another contrast, a new gradation. And so, through succeeding contrast, the canvas will be covered.
>
> The painter has played on his keyboard of color, just as a composer handles the diverse instruments to orchestrate a symphony: he has modified the rhythms and measures to suit his wishes, attenuated one element while enhancing another, and produced infinite modulations of a particular gradation. As he gives himself up to the joy of directing the interplay and strife of the seven colors of the prism, he will be like a musician multiplying the seven notes of the scale to produce his melody. How dismal, in comparison, is the toil of the pointillist And is it not natural that the many painters who have briefly used the *dot* for reasons of fashion or conviction have since abandoned this wearisome labor, despite the enthusiasm they had for it at first?

Farther along, in a discussion of the evolution of the divided touch, Signac wrote the following:

> The hatchings of Delacroix, the comma-stroke of the Impressionists, and the Neo-Impressionists' *divided touch* are identical technical conventions which serve to give more brilliance and splendor to color by eliminating all flat hues; they are the devices of artists for embellishing the painting's surface.
>
> The first two techniques, hatchings and comma-strokes, are now accepted; but so far the third, the *divided touch,* is not.—"Nature does not look like that," people say. "There are no multicolored spots on the face."—But does the face then display black, gray or brown, or hatchings, or comma-strokes? The black of

Ribot, the gray of Whistler, the brown of Carrière, the hatchings of Delacroix, the comma-strokes of Monet, and the Neo-Impressionists' *divided touches* are devices which these painters use to express their particular vision of nature.

When Signac speaks of divided touches that result in distinct and perceptible "multicolored spots on the face" he is not discussing the true optical mixture that he has so carefully defined earlier in his book. If separate and distinct spots are visible (as they are in practically all Neo-Impressionist paintings), then optical mixture has not taken place. Indeed, the above quotations from Signac's writings, along with an examination of his paintings, indicates that he believed that true optical mixture played a minor role in the technique of Neo-Impressionism. And yet, in Chapter VI of his book, he summarized the results of Neo-Impressionism as follows:

> By the elimination of all soiled mixtures, the exclusive use of the optical mixture of pure colors, a methodical divisionism and respect for the scientific theory of color, it guarantees maximum brightness, color, and harmony, a result which had previously not been attained.

All this is puzzling, to say the least. And the reader must always be on guard and attempt to determine from the context what Signac actually means in his writings—whether he is discussing a true optical mixture or not. Unfortunately, not everyone has been successful in deciphering the meaning of writings by and about the Neo-Impressionists. Many artists, art critics, art historians, and students of art have for years been misled, and have misled others, about the power and utility of placing "separate small touches of prismatic colors" on the canvas with the intent that the individual touches are then to

"fuse in the eye" when "viewed at the proper distance," thus resulting in "more intense hues" than the mixing of the same colors on the palette.

Confusion about optical mixtures and pigmentary mixtures

This matter has been discussed in great detail by J. Carson Webster (1944) in his reappraisal of the technique of Impressionism. In particular, as Webster noted, the false notion that a bright green can be made by spotting the canvas with pure yellow and pure blue has been repeated again and again. The following example, which Webster cites as particularly egregious, is typical of such errors:

> The Impressionists discovered that they gained vividness if, instead of mixing blue and yellow upon the palette, for instance, to form a green, they placed side by side on the canvas little streaks of blue and yellow, leaving it to the observer's eye to merge the two primary hues into the one derived hue, a phenomenon occurring as soon as the observer stepped back the proper distance. In effect the artist had foreseen the colour he wanted, had decomposed it while putting it on the canvas, and had left it to the observer's eye to recompose it while regarding the picture.

The explanation reads well, but it is wrong. As Webster correctly explains, the example of "vivid-green-from-touches-of-blue-and-yellow" is impossible. The fact is, as Rood had stated so clearly in his *Modern Chromatics*, the optical mixture of pure yellow and pure blue results in a neutral gray. This result is not intuitively obvious. It often comes as a surprise even to those who have considerable knowledge of color, either as painters or as scientists. For example, the physicist Hermann von Helmholtz, who is credited with the first clear scientific recognition (in

1852) of the differences between mixtures of spectral lights and mixtures of pigments, was surprised by the outcome of his own experiments. Concerning these early observations on the mixture of color, Helmholtz later remarked in his acceptance of the Albrecht von Graefe Medal:

> Not being inclined to describe in my lectures things I had not myself seen, I made experiments in which I blended the colors of the spectrum in pairs. To my astonishment, I found that yellow and blue gave not green, as was then supposed, but white. Yellow and blue pigments, when mixed, no doubt give green, and until then the mixing of pigments was supposed to produce the same effect as the mixing of the colors of the spectrum. This observation not only at once produced an important change in all the ordinarily accepted notions of color mixture, but it also had an even more important effect on my views.

But painters did not have to wait for Helmholtz's scientific "discovery." They could (and some did) discover it themselves, before Helmholtz. For example, the distinction between colors obtained by optical mixture and by pigmentary mixture was already well-known to Turner. He knew, as others had known before him, that one pigmentary color alone has a greater "power," as he put it, than a mixture of two and that a mixture of three impaired that "power" still more. And mixtures beyond that he described as "monotony, discord, mud." Turner went so far as to prepare two diagrams of three overlapping "primitive" colors to illustrate what he called mixtures of "dense material" (pigmentary) colors and mixtures of light. Turner's diagrams were very similar to the conventional modern diagrams of additive and subtractive mixtures, with the additive mixture of all three of the primitive colors producing white and the subtractive mixture of all three producing black.

Concerning all this Turner wrote:

> White in prismatic order is the union of compound light, while the mixture of our material colours becomes the opposite; that is, the destruction of all, or in other words—darkness. Light is therefore colour and shadow the privation of it by the removal of those rays of color, or subductions of power.

Apparently the Neo-Impressionists themselves also managed to reach a clear understanding of the essential differences between optical mixture of colors in the eye and the physical mixture of pigments on the palette, whether they understood all the scientific details or not. As Signac remarked to a colleague who mistakenly thought that a true optical mixture (as defined by Signac himself) was used to produce new more intense colors in the technique of divisionism:

> But no, dear Maitre, when I want a green, I use a green, and when I want a violet, I use a violet. . . . Division, contrast are not this at all! It is both simpler and more complex—and, especially, more useful.

See Cachin 1968.

There was no real need for the Neo-Impressionists to attempt to produce a green, or any other essential color, by optical mixture. Their palettes already contained a broad range of pigmentary colors: Signac used a "spectrum" palette (Figure 62) consisting of about a dozen colors, including white. And virtually any color needed that was not already on the palette could easily be obtained by a subtractive pigmentary mixture of closely neighboring colors with little loss of saturation. Additive optical mixture for this purpose would have been superfluous. The Neo-Impressionist technique served other purposes.

A clear understanding of additive mixtures and

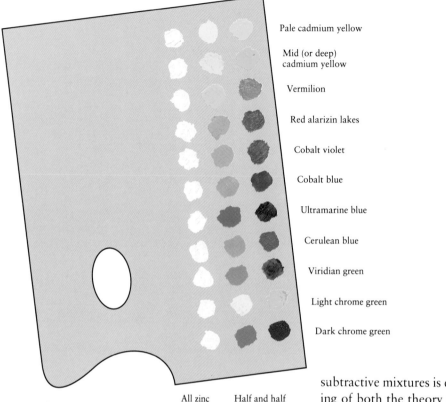

Pale cadmium yellow

Mid (or deep) cadmium yellow

Vermilion

Red alarizin lakes

Cobalt violet

Cobalt blue

Ultramarine blue

Cerulean blue

Viridian green

Light chrome green

Dark chrome green

All zinc white (or lead white)

Half and half mixture of "pure" color and zinc white (or lead white)

Figure 62 Signac's palette for *Le Petit déjeuner*. Based on the analysis by Anthea Callen (1982).

subtractive mixtures is essential to a full understanding of both the theory and the practice of Neo-Impressionist painting. What, precisely, is additive mixture and subtractive mixture, and what are the differences between them?

Additive versus subtractive mixtures

Since an additive mixture of yellow and blue beams of light produces a white on the projection screen and a subtractive mixture of yellow and blue pigments produces a green on the palette, there is a widespread belief that such mixtures must be governed by different laws. It is true that the practical rules for mixing colors may and often do differ in different circumstances. But the same fundamental physical and psychophysical laws apply in all cases.

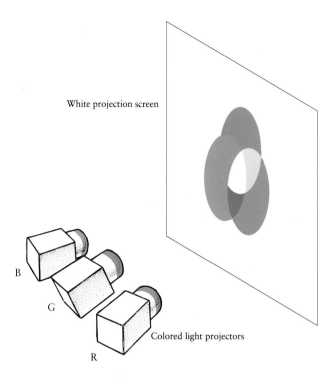

White projection screen

B

G

R

Colored light projectors

Figure 63 Additive mixture of projected lights. Additive mixture may be easily illustrated with three overlapping spots of blue, green, and red light projected on a screen. The colors realized from the additive mixture by superposition are those expected from the CIE Chromaticity Diagram. In fact, as portrayed here, the three overlapping spots form a sort of reduced and simplified version of the CIE Diagram. The center, where all three spots overlap, is a neutral gray or white. Where only red and green overlap, the resultant color is yellow; where blue and green overlap, the color is blue-green; and where blue and red overlap, it is purple.

Light and the perception of light are equally involved in all mixtures of colors whether those mixtures are obtained with pigments or with projectors. And the basic laws deduced from the study of the physics of light and the psychophysiology of color are applicable to both. Indeed, the proper distinction between additive and subtractive mixtures can only be made in terms of those laws; in particular, in terms of how light is *absorbed, reflected,* and *transmitted* by various substances, and how that light ultimately acts on the eye. (The acronym ART, sometimes used in art classes, helps to keep these three fundamental processes in mind.)

It is important to note at the very outset that the distinction between additive and subtractive mixtures is not simply a matter of the difference between light reaching the eye from projected beams or from painters' pigments. As a matter of fact, additive mixtures can be obtained either with projected beams or by use of painters' pigments. Likewise, subtractive mixtures can be obtained either with projected beams or by use of painters' pigments. Let us consider all such types of color mixture with special reference to the infamous pair, yellow and blue—so often the source of error and confusion in writings about color in Neo-Impressionism.

Additive mixture of colors

The superposition of colored spots of projected light (Figure 63) is the classic, tried-and-true method of demonstrating the additive (optical) mixture of colors. The CIE Chromaticity Diagram provides a simple and straightforward way to predict the outcome

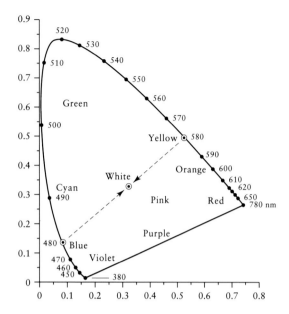

Figure 64 Additive mixture of yellow and blue monochromatic lights. A simple Newtonian straight-line construction on the modern CIE Chromaticity Diagram shows that an additive mixture of approximately equal amounts of yellow (580 nm) and blue (480 nm) light yields a neutral gray-white (midpoint of the line). Note well that the additive mixture of equal amounts of yellow and blue light is not green—it is gray-white.

of any such additive mixture, whether the mixture results from the actual superposition of two colored beams of light (such as colored spotlights directed onto a stage) or from the close juxtaposition of two differently colored touches of pigment (such as the use of small points or dots of color in a strict pointillism).

Consider pure spectral yellow and blue. All one needs to do in this particular case is to draw a straight line between the two points on the diagram that represent yellow and blue. As Newton found in his original experiments, if the two colors are of equal proportions, the mixture will be given by the point on the straight line midway between the two; if unequal, the mixture will be displaced from the midpoint by an amount proportional to the inequality. Here (Figure 64), assuming equal amounts of the two colors, the result is a colorless neutral gray. Similarly, in the case of a pointillistic optical (additive) mixture of two specific painters' pigments, Prussian blue and pale chrome yellow, the outcome is still a gray (Figure 65). In this particular case, practically the whole spectrum is involved in the additive combination.

But the controlling factors in an additive mixture are the perceived colors of each of the two components, not their spectral composition. In fact, the same results can be obtained with any of the many metamers of these two colors.

Such combination by the eye is the very essence of additive mixture and is the empirical basis for the original Newtonian laws of color mixture and for all such laws of optical mixture that have followed since. Thus, as shown in Figure 65, small touches of Prussian blue pigment and of pale chrome yellow pigment that are closely juxtaposed fuse in the eye by optical mixture. The two pigments are not physically mixed externally to the eye; the eye does the mixing. Note that the two processes of selective light absorption by the two different pigments take place in parallel and are completely independent of one another. And the optical mixture by fusion of the light from these pigments produces essentially the same result as does the direct superposition and resulting additive mixture of beams of blue and yellow light projected on a screen.

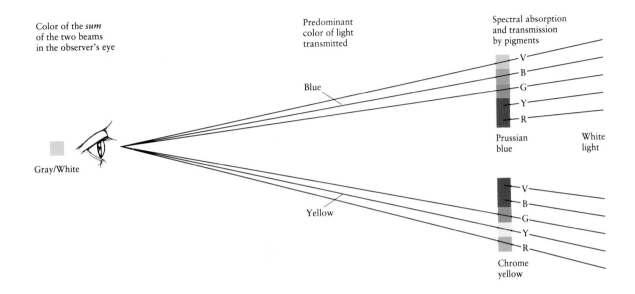

Color of the *sum*
of the two beams
in the observer's eye

Predominant
color of light
transmitted

Spectral absorption
and transmission
by pigments

Gray/White

Blue

V
B
G
Y
R

Prussian
blue

White
light

Yellow

V
B
G
Y
R

Chrome
yellow

Figure 65 Additive mixture of yellow and blue broad-band pigments. Pale chrome and Prussian blue are broad-band pigments. They are represented here, in a simplified form, as bands of absorption (shaded bands) or transmission (colored bands) across the visible spectrum. Pale chrome is centered on and transmits mostly yellow, but also transmits some red and green; it almost completely blocks blue and violet. Prussian blue is centered on and transmits mostly blue, but also transmits some green and violet; it almost completely blocks red and yellow. Note, however, that if the two pigments are placed in separate spots unmixed, as illustrated here, they act independently. One does not block light from the other. When the light rays from closely juxtaposed spots of pale chrome and Prussian blue are optically mixed in the eye by fusion, the result is a neutral gray-white. The same result (Figure 63) is obtained when pure monochromatic yellow and blue lights are mixed. (This diagram is highly schematic. For additive mixture to take place the differently colored touches of pigment would have to be very small and very close together.) Adapted from Laurie (1930).

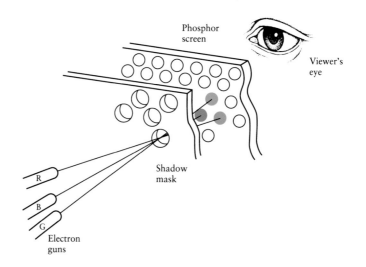

Figure 66 Additive mixture of color in television. In most models of conventional small-screen color television, the necessary three colors are provided by three phosphors arranged in tightly packed triads of small spots across the whole screen. Each colored point in a triad represents the same small local area of the image. At the proper viewing distance this pointillistic array of separate spots in any local area cannot be resolved, and fuse in the eye to give the desired optical (additive) mixture in the image of that place on the screen. A mask between the electron guns and the phosphor screen ensures that only the proper beam reaches its intended target. Some modern sets have the three different phosphors arranged in vertical rows (somewhat in the manner of Miles's method for optical mixture of pigments). In this case, alignment of electron guns is ensured by a vertical grill rather than a perforated mask. Redrawn after Osborne (1980) and Rossotti (1983).

Additive optical mixture by fusion in the eye is a common everyday experience for most of us. It is precisely how a wide gamut of colors is produced in modern color television. Three different phosphors, one that emits red light, another that emits green, and a third that emits blue, are placed in separate, closely packed triads of small spots distributed uniformly across the screen (Figure 66). At normal viewing distances, the eye cannot resolve the separate spots and they are optically mixed in an additive fashion, just as are the closely juxtaposed spots of pigment in a true pointillist painting. By electronically varying the amount of excitation of the different phosphors so that each emits the proper amount of light of its particular color, any of a wide range of color mixtures, including white, can be obtained (as was shown in Figure 40). For ordinary black and white television only two finely mixed phosphors, one that emits yellow and one that emits blue, are required to give a satisfactory approximation to the gray scale and to black and white. (Again, everyday experience disproves the notion that a pointillistic optical [additive] mixture of blue and yellow yields green.)

140

The small spots on the television screen are separate and distinct, as can be seen upon close inspection of the screen with a magnifying glass. But their combination, by fusion, at the proper viewing distance yields the same end result as if separate spots of light of those same colors were projected on a reflecting screen and actually superimposed there. In fact, very large-screen television actually uses three separate projectors, with the three enlarged images, each in one of the three primaries, overlaid on the projection screen in register. The three colored images are brought together by superposition on the screen rather than by fusion in the eye. But, in both small-screen television (directly viewed) and in large-screen television (projected), the additive mixture of color takes place in the eye. And, at the proper viewing distances, these two additive methods are essentially equivalent.

Thus, the mixed color obtained by a true pointillistic fusion in the eye of light from small spots of colored painters' pigments (or from small spots of colored TV phosphor) does not differ significantly from the mixed color obtained by superposition of the colors in projected beams of light. To reiterate: Additive optical mixtures can be obtained either with painters' pigments or with projected beams.

Subtractive mixture of colors

Often the outcome of an additive mixture of colors may seem contrary to the everyday experience of artists in mixing colored pigments on their palettes. As already mentioned, it is common knowledge that blue pigment physically mixed with yellow pigment does yield a saturated green, whereas the same two pigments optically mixed—as just described above—yields a neutral gray. The principal reason for the

difference is simple and straightforward. In an additive mixture by fusion, the two pigments act separately and independently of one another. The absorption of light by one pigment has no effect whatsoever on the light absorbed by the other. Thus the light reaching the eye from one pigment is not diminished in any way by the other pigment. In a physical mixture of two pigments, however, all of the light ultimately reaching the eye is subjected to two successive processes of absorption—one by each pigment in the mixture. Thus the light that passes through and is partially absorbed by one pigment is further diminished as it passes through and is partially absorbed by the second pigment on its way to the eye. That is why such a mixture is called subtractive.

Subtractive mixture is usually illustrated by a diagram such as that shown in Figure 67. This diagram should not be confused with the diagram of additive overlapping projected spots of light shown in Figure 63. Very different processes are involved. The controlling factors in a subtractive mixture are the spectral characteristics of the component parts, not their perceived colors. Here the diagram represents what happens when pigments are physically mixed together, either on the palette or on the canvas. The outcome of any such mixture can be predicted exactly, given an exact knowledge of the spectral absorption (that is, light subtraction) characteristics of the individual pigments and of the medium in which they are carried, et cetera. The artist never has such complete information, however, and must rely on empirical rules which are implicit in the subtractive mixture diagram shown here. (A systematic practical method of subtractive mixture for painters, based loosely on the spectral characteristics of the constituent pigments, was recently advanced by Wilcox 1989.)

Artist's canvas

Paint pigments

Figure 67 Subtractive mixture of painters' pigments. Subtractive mixture is usually illustrated by showing the color of various mixtures of three "primary" pigments. Nonoverlapping regions represent the pure (unmixed) pigments. Overlapping regions represent physical mixtures of the pigments. Note that the subtractive mixture of blue and yellow yields green. These three pigments are not natural primaries in the fundamental psychophysiological sense used in the Young-Helmholtz theory. Rather, they are artists' primaries chosen more or less arbitrarily so that mixtures of them will yield a broad continuum of spectral and nonspectral colors. Typically (as shown here) a red, a yellow, and a blue serve the purpose well. But which "primary" pigments are best for the artist depends upon the spectral characteristics of the pigments available (which change with advances in paint technology) and what gamut of color the painter wants the palette to cover.

In general, the subtractive mixtures of two pigments whose colors are near one another on the color circle produce intermediate colors, as illustrated. But mixtures of two complementaries, or of several colors widely spaced on the color circle, tend toward black or actually produce black. The reasons for this blackening are simple. Any single pigment absorbs only part of the light, and the remainder, which ultimately reaches the eye, gives the color of that pigment. Mixture with another different pigment absorbs more and different light and the color of the mixture is determined by the remainder of the two absorptions. All paint pigments are broad-band in their aborption, and mixture of several almost invariably leaves little or no light that is not absorbed by one pigment or another—thus the mixture appears very dark or completely black. Even a mixture of only two pigments, particularly complements such as red and green, which together absorb practically the whole visible spectrum, can also result in black. In short, all the peculiarities of subtractive mixture are explainable in terms of the spectral absorption

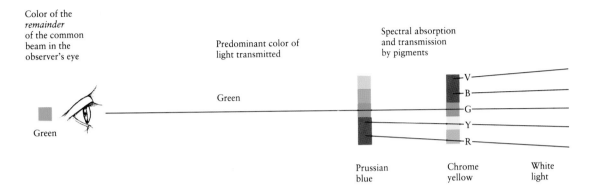

Color of the *remainder* of the common beam in the observer's eye

Green

Predominant color of light transmitted

Green

Spectral absorption and transmission by pigments

V
B
G
Y
R

Prussian blue

Chrome yellow

White light

and other physical characteristics of the involved pigments.

For example, the diagram in Figure 68 shows schematically how the subtractive mixture of a specific blue pigment, Prussian blue, and a specific yellow pigment, pale chrome, produces a vivid green. The shaded portion of each bar shows, roughly, the colors of the spectrum absorbed (that is, subtracted) by each pigment. Separately, Prussian blue absorbs mostly red and yellow, and pale chrome absorbs mostly blue and violet. The mixture of the two appears green, for that is the only color not strongly absorbed by one or the other of the two pigments. The two processes of absorption are serial and interdependent.

Subtractive mixture can take place just as well in a projected beam of light. Two colored pieces of glass inserted in the path of a single beam of light (such as that from an ordinary slide projector) produce essentially the same effect as does the physical mixture of two painters' pigments. The first colored glass absorbs (subtracts) part of the spectrum and

Figure 68 Subtractive mixture of yellow and blue: pigments. Prussian blue pigment transmits light in the green-blue-violet region of the spectrum, which yields a blue appearance overall. It absorbs (subtracts) most light in the red-yellow end of the spectrum. Pale chrome pigment transmits light in the red-yellow-green region of the spectrum, which yields a yellow appearance overall. It absorbs (subtracts) most of the light in the blue-violet end of the spectrum. When mixed together, Prussian blue and pale chrome absorb (subtract) practically all light in the red-yellow and blue-violet regions of the spectrum. Therefore, the remainder after the two subtractions is green. Adapted from Laurie (1930).

143

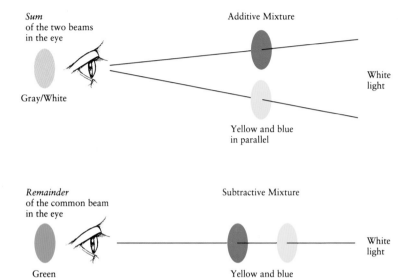

Sum
of the two beams
in the eye

Gray/White

Additive Mixture

White
light

Yellow and blue
in parallel

Remainder
of the common beam
in the eye

Green

Subtractive Mixture

White
light

Yellow and blue
in series

Figure 69 Schemas of additive and subtractive mixtures. The yellow and blue disks represent equally well either colored glass filters in projected beams of light or colored touches of pigment on the canvas. (*Top*) Additive mixture is a parallel process, and can be represented schematically by two separate pathways. The two differently colored glass filters (or differently colored touches of pigment) act separately and independently. What one filter (or one pigment) contributes to or removes from the mixture does not have an effect on the contribution of the other because they are in separate pathways. Such an additive (optical) mixture of yellow and blue sums to yield gray-white (compare with Figure 63).

(This diagram is highly schematic. For additive mixture to take place the two beams would have to be very small and very close together, unless projected as overlapping spots on a screen.) (*Bottom*) Subtractive mixture is a serial process, and can be represented by one common pathway. The two differently colored glass filters (or differently colored layers of pigments) act together and interdependently. What one filter (or one pigment) contributes to or removes from the mixture does have an effect on the contribution of the other because they are in a common pathway. Such a subtractive mixture of yellow and blue leaves a remainder that yields green (compare with Figure 67).

transmits the remainder. That part which is transmitted gives the color of the glass, as in a stained glass window. The second piece of glass placed farther along the beam will have its own absorption and transmission properties which, when the glass is alone in a beam of white light, give its characteristic color.

If the second glass is of a different color than the first, then it will absorb (subtract) at least some of the light transmitted by the first glass. Thus the color of the remainder which is finally transmitted through the second glass is the result of a subtractive mixture: each glass subtracts certain colors from the transmitted beam. (The order in which the two filters are placed in the beam is of no consequence.) To reiterate: subtractive mixtures can be obtained either with painters' pigments or with projected beams of light.

The distinction between additive and subtractive mixtures—a summary

Much of the confusion about additive and subtractive mixtures results from the terminology itself. The color of virtually any pigment, or filter, results from absorption (that is, subtraction) of part of the white light incident on it. Thus, subtractive processes are almost always involved in the creation of the colors contained in additive mixtures. Furthermore, it is evident that the type of mixture—additive or subtractive—is not intrinsic to or limited to either painters' pigments or projected beams. What distinguishes an additive mixture from a subtractive mixture is whether separate rays of light on their way to the eye are subjected to separate influences or whether individual rays are subjected to sequential influences. Additive mixture is a parallel process; subtractive mixture is a serial process (Figure 69). This distinction may be summarized as follows.

Addition With painters' pigments an additive mixture is produced by placing very small touches of differently colored pigments side by side on the canvas. The separate rays of light from them are combined by fusion in the eye. Similarly, with colored glass filters an additive mixture is obtained by placing differently colored filters in two different projectors placed side by side. The separate beams of light are combined for viewing by superimposing them on a screen. In these additive mixtures, the effects of the two paint pigments or of the two glass filters (as the case may be) on the colors of the two beams are parallel and independent.

Subtraction With painters' pigments a subtractive mixture is produced simply by mixing or layering dabs of differently colored pigments in the same spot on the canvas. The two different pigments thereby affect one and the same beam of light on its way to the eye. Similarly, with colored glass filters a subtractive mixture is produced simply by placing two differently colored filters in one projector. The two different filters thereby affect one and the same beam of light on its way to the eye. In these subtractive mixtures, the effects of the two pigments or of the two filters (as the case may be) on the color of the common beam are serial and interdependent.

Other factors

In the above discussion it has been assumed, for the sake of argument, that a beam of light makes a single passage through the pigment under consideration, and that which is not subtracted from the beam (that is, not absorbed or reflected) is transmitted to the eye. Such a simplification is adequate for a discussion of basic principles and of the basic differences be-

tween additive and subtractive mixtures. But in an actual painting the situation is far more complex. In the first place, paintings are not lit from behind; the light falls on the front surface. Some of this light may make a complete double passage through the pigment. That is, it may go all the way through to the white ground, or other substrate on the canvas, where it is reflected and passes all the way back through again before it exits on its way to the eye. Not all of the light makes the complete round trip. Some light is absorbed all along the way and some is reflected (and often scattered) at every interface. In the end, it is these losses (subtractions) by absorption and reflection that determine the remainder that is transmitted (remember the acronym, ART) and thus determine the color of the pigment or mixture of pigments.

In addition, a great many other factors may contribute to and modify significantly the outcome of any type of mixture in a real painting. Among these are the color of the ambient light under which the painting is viewed; reflections from and absorption by the protective varnish (usually not used by the Neo-Impressionists); the oil in which the pigments are ground; whether the pigments are ground fine or coarse; the thickness and surface texture of the paint; the color and texture of the ground on the canvas or panel; and the like. Furthermore, the surrounds have an important influence—both within the painting and without—because of the interaction of color. The Neo-Impressionists were much concerned about such effects and generally used white frames only, but sometimes they painted the frames (or even the outer borders of the paintings themselves) in colors complementary to adjacent regions on the canvas in an attempt to avoid any deleterious effect of the surround. At times, they even went so far as to cover

the walls of galleries, where the paintings were to be hung, with paper of some neutral color.

With all this emphasis on the differences between additive and subtractive mixtures, it should be kept in mind that additive mixture and subtractive mixture are seldom pure processes in painting. Practically every painter makes use of both types of mixture to some extent, either by choice or by chance. The slightest overlap of separate touches in a divided painting can lead to some subtractive mixture; incomplete mixture of pigments can leave separate flecks or streaks that fuse in the eye additively. Close inspection of virtually any painting, no matter what the technique, will reveal both processes at work, to some degree.

Such is the case in modern four-color printing—actually five-color, including the white paper left exposed. The three different chromatic colors of dots of ink and the black dots of ink overlap in some areas on the white paper and are only closely juxtaposed in others. Thus both additive and subtractive mixing play a role in color printing. Where the dots overlap the subtractive rules prevail; where they are juxtaposed they are fused visually, and the additive rules come into play. As mentioned above, in modern home color television sets, the three-colored spots are truly partitive; that is, they do not overlap at all and are combined by the eye. Thus only additive rules apply.

There is nothing arcane or mysterious about the two different processes of addition and subtraction. The underlying laws of physical optics, of physiological optics, and of the psychology of visual perception are the same throughout. And the differences between additive and subtractive mixtures are easily explained in terms of those laws, whether one uses projected beams of light or painters' pigments. Cru-

cial, in the end, is simply what quantity and quality of light, in what spatial and temporal configuration, ultimately reaches the eye.

Addition, subtraction, and interaction of color in actual practice

Knowing the sometimes deleterious effects of subtractive mixtures of pigments, the technique of the Neo-Impressionist was to use a limited number of "pure" or "prismatic" pigments already mixed to his satisfaction on his palette and to place these, without any further mixing, at separate locations on the canvas. These separate touches of pigment could produce combined effects on the canvas only through the additive optical mixture of color or through the interaction of color. With care to avoid overlap of touches, subtractive mixture could play no further role beyond that which had already taken place in the mixing on the palette. And, to minimize the deleterious effects of subtractive mixture, mixing on the palette was generally limited to mixtures of analogous colors and, on occasion, to mixtures with white.

The actual visual differences between subtractive mixture of color, additive mixtures of color, and interaction of color are illustrated in Figure 70. The top panel is a band of pure pale chrome pigment. The bottom panel is a band of pure Prussian blue. The left-hand section of the center panel is a subtractive mixture of the two colors—a green obtained by thoroughly mixing the two pigments on the palette before applying them to the canvas. The middle section is an additive mixture of the two colors—a somber dark gray color obtained by applying the two unmixed pigments on the ground in separate, small, closely juxtaposed points. At a viewing distance of a

few feet, the small points are optically fused into a single color. The two separate colors are discriminable only when viewed very closely, or under a magnifying glass, so that the separate points can be resolved by the eye. The right-hand section in the center illustrates the interaction of color, using the same two pigments. The pale chrome completely surrounded by Prussian blue is more luminous and less saturated than is the separate band of pale chrome at the top. Similarly, the blue completely surrounded by chrome is slightly darker than is the separate blue band at the bottom.

These simple examples show that subtractive mixture of color, additive mixture of color, and interaction of color are very different in terms of their end effects. It is now evident that these differences were well-known in a practical sense to the major Neo-Impressionist painters themselves, whether they knew the scientific principles well or not. But all such differences and distinctions were not fully appreciated by most of the critics of that time, nor by many students, teachers, and historians of art who have followed them. The difficulty throughout has been, and still is, the confusion of the practical rules for mixing colors and the natural laws governing those mixtures.

The interaction of color in painting

The evidence is clear that the close juxtaposition of small touches of unmixed "pure prismatic colors" which "fuse in the eye" by optical mixture does not produce some of the remarkable effects so often and so erroneously claimed for the technique of pointillism. The question then arises, What use did the Neo-Impressionists actually make of their divided technique? A complete fusion in the eye by optical

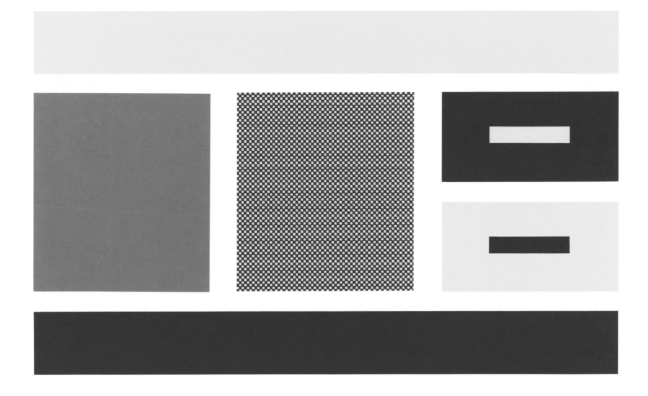

Figure 70 Subtractive mixture, additive mixture, and interaction of color. The top and bottom strips are pure pale chrome pigment and pure Prussian blue, respectively. The color in the left panel is formed by a subtractive mixture of the two colors. That is, the two pigments are physically mixed on the palette. The color in the center panel is formed by an additive mixture of the two colors. That is, two pigments are applied separately in small closely juxtaposed points. At the proper viewing distance the separate points fuse in the eye, resulting in a grayish color. The two panels on the right illustrate interaction of color—pale chrome surrounded by Prussian blue (top) and Prussian blue surrounded by pale chrome (bottom). Note that the effects shown here are limited by the process of color printing. It is not possible to reproduce the colors of the original pigments exactly on the printed page.

mixture certainly was not the major purpose. No historical studies, no scientific experiments, no analyses of technique, are required to prove this assertion; one merely has to look at a Neo-Impressionist painting. If fusion by optical mixture had been the purpose of the divided technique, one would see the expected resultant colors and not the separate, unfused points or touches of color. But, in fact, these separate points or touches, each clearly visible and distinct, are one of the hallmarks of a Neo-Impressionist painting. Indeed, it was this multicolored "confetti" that so enraged many of the critics of the school. After all, normal human flesh is not spotted with colored dots—"not covered with colored fleas," as one critic complained.

Almost alone among the critics in the heyday of Neo-Impressionism, Félix Fénéon seemed to comprehend what divisionism was all about. This is well illustrated by the following excerpt from a review by Fénéon. (The translation is from Thomson 1985.)

> From the very start, the impressionist painters, with that concern for truth which made them restrict themselves to interpretation of modern life directly observed and of landscapes painted directly, saw objects as interdependent, without chromatic autonomy, participating in their neighbors' reactions to light; traditional painting had considered them as ideally isolated and had placed them in an artificial and stingy light.
>
> These color reactions, these sudden perceptions of complementaries, this Japanese vision could not be expressed by means of murky gravies worked up on the palette. Therefore these painters made separate notations, allowing the colors to excite one another, to vibrate at brusque contacts and to recombine at a distance; they enveloped their subjects with light and air, modeling them in luminous tones, at times even daring to sacrifice all relief; in sum, they fixed sunlight upon their canvases
>
> If in M. Seurat's *Grande-Jatte* one considers, for in-

stance, an area as big as one's hand covered with a uniform tone, it will be found that each inch of this surface presents, in a swirling mass of minute spots, all the constituent elements of the tone. This lawn in the shade: little touches of paint that give the local value of the grass form a majority; others, of orange, are distributed sparsely, expressing the hardly perceptible solar action; others, of crimson, bring into play the complementary of the green; a cyanic blue, provoked by the proximity of a patch of grass in the sun, amasses its siftings toward the line of demarcation and thins progressively to this side. In the formation of the patch itself only two elements contribute, green, solar orange, all reaction dying under so furious an assault of light. Black being a non-light, this black dog will take on color from the reactions of the grass; its dominant therefore will be dark crimson; but it will be attacked also by a dark blue aroused by the neighboring luminous areas. This monkey on its leash will be accented by a yellow, its individual quality, and specked with crimson and ultramarine.

Fénéon's comments above were art criticism—in his hands a form of art in itself, and not a technical note on Neo-Impressionist painting. But with careful study of his review, in the light of what is known today, significant details of the Neo-Impressionist technique emerge. It is clear that although Fénéon accepted some role for optical mixture of separate notations "to recombine at a distance" by complete fusion, he saw just as clearly the greater importance of an incomplete fusion and of the interaction of color—the value of "separate notations, allowing the colors to excite one another . . . "

Webster made some very important points about retinal fusion of color, along these same general lines, in his 1944 reappraisal of Impressionism:

> Returning then to Impressionism in general, retinal fusion seems to have no place in it, but that does not mean that divided color is useless. It is important in that it

allows a color, no matter how contrasting, to be introduced into an area of another color while still maintaining its own hue. Retinal fusion, as well as pigment mixing, would defeat this end. Thus the divided color is not a means to resultant colors; it is a means for recording colors in intimate association, in interpenetration, as it were, within a given area, while allowing each to be seen for what it is. This is a natural means to colorfulness of the picture, granted the naturalistic interest in light. In the Neo-Impressionistic work the smallness of the touch allows more precise drawing of objects and a more careful "dosage" of the amounts of the respective colors; therein lies its value rather than in allowing a closer approach to retinal fusion.

Webster's clear and cogent remarks immediately caught the attention of scholars in the field, but in the long run they had little impact on the public at large. Some two decades later Robert L. Herbert still found it necessary to raise the issue again. In his catalog of the 1968 Guggenheim exhibition, *Neo-Impressionism,* he wrote:

> At the heart of Neo-Impressionist theory lies *mélange optique,* the optical mixture in the observer's eye of the separate particles of color. According to the painters and their friendly critics, the impurities and dull tones of traditional palette mixtures could be overcome by rendering the several constituent colors in separate strokes. These different colors would then combine in our eye to reconstitute the dominant hue sought after.
>
> *That this does not happen in Neo-Impressionist paintings* is a shock to the innocent observer. He discovers that with rare exceptions, he continues to see the separate colors no matter what his distance. Why then was the theory proclaimed?
>
> First, because it was a defense of the separate colors the artists really wanted and it therefore offered the support of a rational explanation. Observers could overcome the discomfort of the unknown and set about looking at the pictures with the conviction that they were party to the secret. Second, although it does not

happen, it is *toward* this optical mixture that the eye struggles. In so doing, an active vibration takes place in which the separate colors are seen in a stimulating shimmer. It is this vibration which forces the viewer to be active and which recapitulates the intensity of the real light dancing and sparkling over varied natural surfaces.

Vibration was the word which Seurat found in Charles Blanc's description of Delacroix' color mixture, and it remains the best description of the effects in his own painting. Instead of using yellow and blue to form green, as the misguided critics sometimes said, Seurat used several different greens for a grassy area, much as did Delacroix and the Impressionists. The essential vibration was that of the local color. Then he added, as has been seen, a number of other colors in varying quantities. Our eye registers the dominant green, but also these other hues without "mixing" them to form one uniform color. And Signac, when he wrote his defense of optical mixing in his book in 1899, was using brushstrokes as large as the tiles of mosaic, which neither he nor any one looking at his paintings, would really have thought capable of "mixing."

As noted earlier, there was actually no real need for the Neo-Impressionists to produce new colors by means of optical mixture. They already had many different colors available to them in pure pigments (Figure 71), and contrary to common belief, they used a fairly large number of them. According to Anthea Callen (1982), Seurat's palette for *Le Chahut* (The High-Kick) (see Figure 82) probably comprised at least a dozen colors, including white, and as we have already seen, Signac's palette for *Le Petit déjeuner* (Breakfast) (see Figures 52 and 94) probably consisted of an equal number. Furthermore, the Neo-Impressionist palette was an effective "prismatic" array. That is, it was limited to colors most closely approximating those of the solar spectrum, thereby excluding the earth colors and black. Here the Neo-Impressionists followed the pioneering

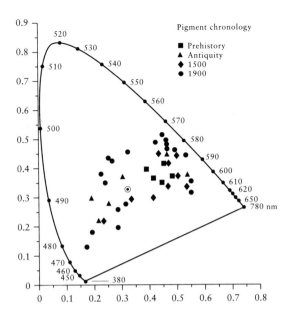

Figure 71 The artist's palette up to 1900. The chromaticity of each pigment is shown on the CIE Chromaticity Diagram. Redrawn after Jones 1967.

work of the Impressionists. As early as 1869 at Grenouillère, Renoir and Monet began to use pure, unmixed colors, "banning blacks, browns, and earth colors" (Pool 1967). And in the Neo-Impressionist technique, physical mixture to obtain intermediate hues was generally limited to blending of closely neighboring (analogous) colors on the color circle, and to the addition of small amounts of white. Consequently, little darkening and little desaturation resulted. Thus the major limitations of subtractive physical mixtures were largely avoided.

To recapitulate: A wide array of pure prismatic colors was already available to the Neo-Impressionists, and they used them. They had no real need to extend their palette by optical mixture.

True optical mixture, in which two or more colors add by fusion, lose their own identities altogether, and produce a new color, was of little or no significance in the Neo-Impressionist technique. Rather, it was the interaction of divided colors, more or less distinct, which was significant. As many scholars have pointed out over the years, the mere

"interpenetration" of a few touches of one color into a broad area of another color without true and complete optical mixture, can have important effects. At the proper viewing distance, a tinge of that one color may be given to the whole area, leading to what has been called a "delusive blend." Also, the "veil" of thin translucent color which seems to hang over many Neo-Impressionist paintings and to give them a cold "misty" appearance (as in Signac's *View of the Port of Marseilles 1905;* see Figure 7) is a most effective outcome of the Neo-Impressionist technique. This "impression of rather indistinct objects" and of the continual play of color around and upon them is given by the divided touch, near fusion, but not yet completely fused. Further, the interplay of properly chosen divided colors which are placed in intimate association, yet which still remain more or less distinct, can achieve a number of other very dramatic effects, such as luster, shimmer, sheen, scintillation, and contrast. These phenomena produce a liveliness and a vigor that cannot be achieved by more uniform tones. This was one of the great ad-

Table I Distinction between pointillism and divisionism in the Neo-Impressionist technique

Scale of brushstrokes		
Small	*Medium*	*Large*

↑— *Point of fusion*

	Pointillism	Delusive blend, etc.	Divisionism
Technique	Pointillism		Divisionism
Type of brushstroke	Points or dots		Broad touches
Effective range	Local		Global
Perceptual process	Optical mixture		Interaction of color
Visual result	A new hue	Delusive blend, etc.	Contrast of color
Physiological mechanism	Addition, by fusion		Reciprocal action, by "cross talk"
Stage of processing	Lower		Higher
Relevant theory	Trichromatic		Opponent-color

The Neo-Impressionist technique extends over a broad continuum from very small to very large touches. The smaller touches are pointillistic —often, as the term implies, in the shape of small more or less uniform points or dots. The larger divisionist touches are generally more rectangular—in the shape of the tesserae of a mosaic. The influence of small points or dots of color is generally local involving only closely juxtaposed near neighbors. (Many small spots may act in concert, however, even when not fused, and thereby result in more extended effects.) The range of influence of larger touches is generally more global, involving broad expanses of color. The significant perpetual process in pointillism is optical mixture of color; in divisionism, interaction of color in a variety of forms. The visual result in true optical mixture, at or below the point of fusion, is a new hue, in which the component hues have merged and lost their own identities. In the interaction of color there are many possible results ranging from a delusive blend (when the touches are small enough to nearly but not quite fuse) to contrast of color (when the touches are very broad). In between there are a whole host of possible phenomena, depending upon size and arrangement of touches; their hue, saturation, and brightness; etc. These include, among others, luster, shimmer, sheen, scintillation, vibration, and assimilation. These vital phenomena are characteristic of the Neo-Impressionist technique.

All color perception depends upon the activity of the visual system as a whole, including both the eye and the brain, but specific mechanisms can be identified and localized, and special theories relevant to those mechanisms can be developed and applied. The physiological mechanism underlying optical mixture is a simple additive combination by fusion. (The point of fusion on the absolute scale of size of the painter's touch is not fixed. It varies with viewing distance—as do all other visual phenomena that are size dependent.) The mechanism underlying contrast is a reciprocal lateral interaction or cross talk. Optical mixture takes place at an early stage in the retina; interactions take place at a later stage in the retina and in the brain. The theoretical basis for optical (additive) mixture is the Young-Helmholtz trichromatic theory. The theoretical basis for the interaction of color is the Hering opponent-color theory. For a more comprehensive and more satisfactory account of either process, however, the two theories must be combined into one.

vances of Neo-Impressionism over the more informal Impressionism from which it was derived.

As the preceding critical analyses by Fénéon, Webster, and Herbert have shown, and the subsequent discussion will emphasize further, the major benefits of the Neo-Impressionist technique arise neither from a very small-scale pointillism nor from a very large-scale divisionism. Rather, they originate in between these two extremes. As the accompanying table shows, small-scale pointillism and large-scale divisionism are distinctly different. Various works reproduced in this book illustrate the whole range of the Neo-Impressionist technique, and bring out this difference.

Seurat's large version of *Les Poseuses* (The Models) (see Figure 80), with its very small touches, is representative of works that approach the pointillist extreme. Selmersheim-Desgranges's *Jardin de La Hune* (Garden at La Hune, Saint-Tropez) (see Figure 92), with its very large rectangular tesserae, is representative of works that approach the divisionist extreme. Most Neo-Impressionists actually worked in the midranges where the divisionist technique dominates but merges subtly into pointillism. Seurat's later works, such as *Le Chahut* (see Figure 82), and some of Signac's works in that same period, such as

Le Petit déjeuner (see Figure 94) are representative of this more centrist approach. It is here in this middle ground, where the trichromatic theory and the opponent-color theory join forces, that some of the most vital and most vibrant phenomena are to be found, and they are the very essence of the Neo-Impressionist technique.

In summary, with the separation of colors by means of the divided touch into closely adjacent but more or less visually distinct areas, the interaction of color in all its various aspects comes into play and assumes a far more important role than does the true optical mixture of color. The interaction of color has probably always been of far more significance in the subtleties of art technique than has the more mechanical optical mixture, as is amply demonstrated in both the writings and the paintings of many artists over the years, ranging from Leonardo da Vinci, in the Renaissance, to Josef Albers, in the twentieth century. Delacroix himself, the painter whom Signac so much admired, strongly emphasized the importance of the interaction of color. He is reported to have said:

> Give me the mud of the streets and I will make the skin of a Venus out of it, if you will allow me to surround it as I please.

V. The art of the Neo-Impressionists: technique and temperament

Neo-Impressionism was influenced by the science of color, had its forerunners in art, followed established traditions, and interacted with other schools. But, even so, it was largely an empirical movement. The Neo-Impressionists, like the color scientists whose work they studied, were experimentalists as well as theorists. And most important for the artists in the movement, perhaps, were their own observations and practical experiences: the actual application of color on the canvas is a more forceful and more effective teacher than is the theory of color in the abstract. Whatever visual and artistic effect a particular touch of color placed in a particular location on the canvas may have is the true and effective outcome of that touch, no matter what may be said about it by any scientific or artistic theory. Furthermore, art is individual. The history of art, the theory of color, the tutelage of masters, the influence of colleagues and critics, and the social milieu may all provide painters with valuable guidelines, but any particular artist can only express himself in his own work using his own eye and his own hand. Every work of art, even within the confines of the narrowest school, must be personal to some degree: technique always bears the stamp of temperament.

The school of Neo-Impressionism is a very hard taskmaster and not many painters have had the disposition to submit completely to the strict discipline it imposes. Some few, precise and meticulous by nature, have adjusted readily to the demands of the technique. A few others have found their own free and spontaneous style to be inherently incompatible with all such rules and rigor. Still others, more versatile and flexible in their manner of painting, have easily adapted the technique, or variations on it, to their particular style. Three major figures in Neo-Impressionism—Georges Seurat, founder and leader of the movement; Henri Matisse, reluctant acolyte and later rebel; and Paul Signac, willing convert and principal disciple—exemplify in their different approaches to painting the profound effects of radically different temperaments on the use of a common technique.

Georges Seurat: the evolution of the Neo-Impressionist technique

What sort of man was the founder of Neo-Impressionism? The question is difficult to answer in any detail. One short and cryptic note on theory and a few personal letters are all that Seurat himself contributes to our understanding of a very private person. And what comes from the public record and from the writings of his friends and colleagues is only a rather sketchy account of a very complex and not very attractive personality—"distant and defensive." (Seurat's own mother, whom he visited regularly, learned about his mistress and his year-old baby son only two days before his death.) The key words and phrases used in what little Seurat's friends and colleagues did have to say about him illuminate many different facets of his persona: "taciturn," "extremely complex," "a love of contradiction," "deliberate," "cold exterior appearance," "careful," "guarded," "silent, except when questioned," "timid," "gentle," "persistent," "persuasive," "rational," "pensive," "prodigiously gifted," "serious and disciplined," "sincere," "bourgeois," and so forth (see Broude 1978). Although no two of the many word-portraits of Seurat are the same, all are tinged with the same color overall.

When all these and diverse other characterizations of Seurat the man and of Seurat the artist are taken together, a clear picture of an extremely intense person emerges—a man with an "overriding self-disciplined dedication to his work," a "possessive pride in his innovations," and an "anxious insistence on recognition of his status." Seurat's friends overlooked the rather dark and unpleasant side of his personality: his leadership and his achievements in the art of painting were much more important to fellow artists and to sympathetic critics. Indeed, according to all accounts, the few who managed to break through Seurat's psychological defenses (Signac was one of them) became strongly attached to him and were much influenced by him. Remote though Seurat was, his severe self-discipline and single-minded dedication to hard work provided the very temperament needed for the initiation and development of a radically new and extremely demanding technique.

Formal training

Georges Pierre Seurat was born on 2 December 1859 in Paris, where he spent his entire short life except for a year of compulsory military service at Brest. His father, a minor official in the Public Tribunal of an independent commune on the outskirts of the city, somehow managed to become a wealthy property owner. A generous and regular parental allowance enabled Seurat to devote all of his time and effort to art alone. In 1875, at the age of 16, he enrolled in a neighborhood municipal art school. There he studied under Justin Lequin, drawing from plaster casts and copying lithographs, all in preparation for later entry into the Ecole des Beaux-Arts in 1878. Seurat's teacher at the Ecole was Heinrich Lehman, one of Jean Auguste Dominique Ingres's best pupils and a recognized academic artist in his own right. Lehman's instruction of Seurat followed the usual practice of traditional academic studies, including drawing from plaster casts and from live models.

There was nothing particularly remarkable about any of Seurat's very early work—no evidence of any special latent talent, no subtle indication of the unorthodox *peinture optique*, as he sometimes called it, that ultimately emerged. In fact, if Seurat's

early works as a student had to stand alone and be judged entirely on their own merits, it is most unlikely that today they would attract any favorable attention or critical comment whatsoever (for examples, see Thomson 1985). Seurat was not yet an artist at that time—only a fairly competent art student.

Seurat gradually became dissatisfied with formal academic training and resolved, with two fellow students, Ernest Laurent and Edmond Aman-Jean, to withdraw from the Ecole and to form an independent school based on artistic principles found in the work of the old masters and further inspired by the new Impressionist movement. A mandatory year of military service at Brest, beginning in late 1879, put an end to this plan, but nevertheless made the break with the academic tradition complete. And when Seurat returned to Paris in 1880, he rented his own studio and worked reclusively and independently on his drawing and painting, except for whatever influences may have arisen out of further occasional contacts with his two young friends, Laurent and Aman-Jean.

The Neo-Impressionist technique

It is evident that the new impressionist technique did not spring into existence immediately and full-blown in Seurat's early work. Developments were slow and gradual (for details see Homer 1964; Thomson 1985). Three major innovations concerning contrast, color, and composition—all central to the new technique—appeared separately and in that sequence and then reached maturity together in his last paintings just before his early death in 1891, at the age of 31.

Enhanced contrast According to Seurat's own account, he had read Charles Blanc's *Grammar of*

Painting and Engraving while still a student in school, and through this work had become acquainted with Chevreul's laws on the harmony and contrast of colors. But there is no evidence of this acquaintance in his tutored academic work. The influence of a knowledge of those scientific laws (especially those concerning contrast) first appears later on in his earliest truly independent works—the many charcoal and conté crayon drawings he made soon after his return from Brest. Seurat's masterly use of strong contrast is especially well-illustrated in his drawing from that period entitled *Le Noeud noir* (The Black Bow) (Figure 72). (The expression of contrast is greatly facilitated by use of charcoal and conté crayon, and later on many other Neo-Impressionist artists used these media in addition to watercolor and oils.)

Line as such has no part in this extraordinary work; it is a tonal drawing throughout. Variations in the degree of darkness alone define and model the figure. Delineation of contour, relief of form, contrast of bow and background are all boldly accentuated by an intentional exaggeration of the variations in light and shade. The artist is less concerned here with accuracy of representation of the chiaroscuro than with its significance. As Charles Blanc described the role of the artist:

> Reality contains only the germs of
> beauty; from it he sets free beauty itself.

To "set free" certain desired effects, Seurat uses an extremely unrealistic distribution of light and shade across this scene. For reality, the background light at the back of the figure is much too strong, and in front it is much too dark. If the standing figure were removed, no easy transition could be made from the darkly lit right background to the brightly

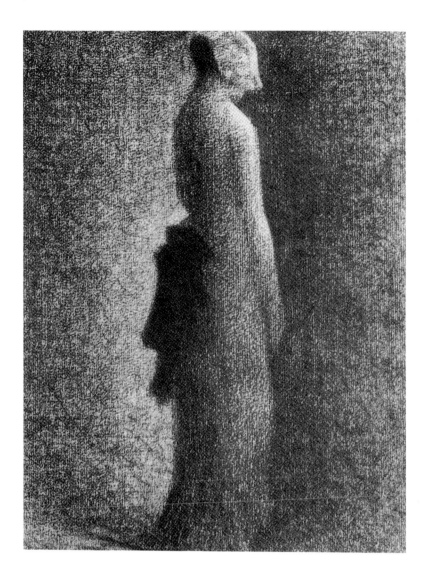

Figure 72 *Le Noeud noir* (The Black Bow) by Georges Seurat. ca. 1882. Conté crayon, 31 × 23 cm. Unsigned. Private collection. © Artists Rights Society, Inc., New York/ SPADEM 1988. Reproduced from Ratliff 1965, after Rewald 1954.

lit left background. Only at the very top of the figure and at the very bottom does the artist make an effort to bridge the two extremes with a more realistic graded transition. But it is the strong opposition of these extremes that forms the major attraction of the drawing. Together, the interaction and integration of the opposing contrast effects thus produced markedly extend the range of the chiaroscuro, clearly define the outlines of the figure in both the light and the shade, bring the form of the figure into high relief, and greatly accentuate the darkness of the black bow itself.

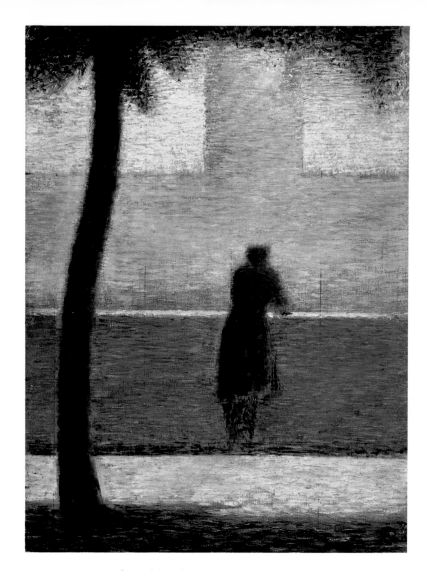

Figure 73 *Man Leaning on a Parapet* by Georges Seurat. ca. 1881. Oil on wood, 16.8 × 12.7 cm. Private collection, New York.

Figure 74 *Horse and Cart* by Georges Seurat. ca. 1883. Oil on canvas, 33 × 41 cm. Collection of the Solomon R. Guggenheim Museum, New York. Photo: Carmelo Guadagno.

Very strong forced border contrast, so evident in Seurat's early drawings, appears again and again (although usually somewhat more muted than here) in all of his major paintings, and in those of many of his followers. It is one of the distinguishing characteristics of the Neo-Impressionist technique.

Divided color In 1881, Seurat came across Philippe Gille's review in *Le Figaro* of the American physicist Ogden Rood's *Théorie scientifique des couleurs* (translated from the 1879 edition of *Modern Chromatics*). He obtained a copy of the book immedi-

ately. Thus very early on in Seurat's career he not only had access to the rather general descriptions of optical mixture and interaction of color in the work of Blanc, but he also had Rood's up-to-date and more rigorous scientific treatment in his hands. Taken together these two works contained full information on practically all important aspects of optical mixture and of the interaction of color. And both, having been written specifically for artists and artisans, were easily understood by Seurat, who had little or no formal training in the science of color.

A distinct divided touch, somewhat akin to

Mile's 1839 technique of closely packed thin parallel lines, appears almost at once in Seurat's *Man Leaning on a Parapet* (Figure 73). Seurat could have learned this technique from Blanc, who emphasized the cancellation of complementaries and the tendency of such mixtures toward gray. But more likely it came from Rood, who described it in part explicitly in terms of optical mixture as follows: "Mile traced fine lines of colour parallel to each other, the tints being alternated. The results obtained in this way are true mixtures of coloured light . . . " This tentative linear technique of divisionism appears to have been purely experimental. Actually, it was not very successful in achieving optical mixture (if that was the purpose) for in this painting the scale was too large for fusion of the separate lines at any reasonable viewing distance; the interplay and interaction of color would be a more likely result on such a scale.

Only remnants of the linear technique appear in Seurat's later paintings, as in *Horse and Cart* (Figure 74). When used more sparingly, this technique works to much greater advantage. The long thin parallel lines that make up the whole of *Man Leaning on a Parapet* are here limited (more effectively) to the

portrayal of various elongated forms only, such as the trunks of the trees, the shafts of the cart, and the harness of the horse. Most of the painting consists of a rather mechanical cross-hatching of *balayé* strokes leading to colors that are partially separated and partially overlapping (reminiscent of the background cross-hatching in some of his charcoal drawings). In retrospect, these interlaced strokes appear to be precursors of the more divided mosaic-like touch that was yet to come.

At this stage, Seurat's new technique was still experimental. Important early works such as *Une Baignade, Asnières* (The Bathers) (1883–1884) still show a very uncertain approach to painting as far as the brushstrokes are concerned (see Homer 1964; Thomson 1985). Some areas such as the skin and clothing of the figures are painted with smooth broad strokes. Some scumbling of one color over another here and there on the rough canvas did result in some small spots and points that are conducive to optical mixture. But this may have been accidental. An indisputable and clearly intentional separation of color does occur in some of the *balayé* strokes in the grass of the river bank. Although the regular cross-hatched strokes generally overlap in a mechanical manner, there is distinct separation in many places, as well, which can lead to either optical mixture or interaction of color, depending upon both the scale of the strokes and the viewing distance. Elongated, rather thin, linear strokes used earlier appear less frequently here—mostly in the rippling water. Characteristically, strong contrast of both brightness and hue appears throughout the painting, often much exaggerated to emphasize edges of forms and to bring figures into relief. *Une Baignade*—Seurat's first major painting, was not by any stretch of the imagination a fully developed pointillist or divisionist painting. But by 1884, when he exhibited *Baignade*, the foundation for his Neo-Impressionist technique had been laid.

Seurat's most influential work, *Un Dimanche après-midi à l'Ile de la Grande-Jatte* (Sunday Afternoon on the Island of the Grand Jatte) (see Figure 78), soon followed. It was first exhibited at the Eighth Impressionist Exhibition, which opened in May of 1886. (The date of 1884 is usually given for *La Grande-Jatte*, but is not strictly correct; according to art historians, Seurat actually continued to work sporadically on the painting from 1884 until the time of its exhibition in 1886.) *La Grande-Jatte* was referred to by Signac and others as the "Tableau-Manifeste" of the Neo-Impressionist movement. But the basic technique of this work is not a strict pointillism, based on scientific principles of optical mixture alone and consisting entirely of separate touches of "pure prismatic pigments" unmixed on the canvas.

Neither is it a true divisionism consisting only of separate and distinct broad touches or strokes. Rather the technique used is an almost indiscriminate mixture of virtually all of the several techniques Seurat had used up to that time. Many of these may be seen more or less separately and in isolation in a selection of the studies leading up to the final painting. Indeed, the preparation for and execution of this one painting recapitulates the entire evolution of Seurat's style up to that time and points directly to the final stages that were soon to follow.

The conté crayon study for *La Grande-Jatte* titled *Le Couple* (The Couple) (Figure 75) contains some of the same major features found in the earlier *Noeud noir* that were derived from Chevreul: the absence of line and the definition of contour by gradation (tonal variation) only, enhanced by strong contrast. These are also characteristic of many of the works in color that followed (see Thomson 1985). Halos of light, as around the dark skirt of the woman, are repeated in the oil study and in the final painting; the darkening of shadows near sunlit areas seen in many of the numerous studies in crayon for *La Grande-Jatte* appears again in the colored studies and in the final work itself. The cross-hatching by the crayon in the foreground is carried over later into a criss-cross of brushstrokes in the oils. Overall, the harmony and contrast of achromatic color in the drawings presage the harmony and contrast of chromatic color in the final work in oil.

The study in oil entitled *The Couple and Three Women* (Figure 76) is almost certainly based on *Le Couple*. As Thomson (1985) points out, marks along the side of the drawing correspond to the still-visible squaring of the canvas for the painting. According to Thomson's analysis, this painting is based on a color range limited to three primaries and three complementaries, but nonetheless it is extraordinarily luminous and colorful. The loose cross-hatching of broad brushstrokes is patchy and incomplete, with little overlap of the separate touches. The white halos around the two seated figures, and the pale color of the grass next to the standing woman's skirt, repeat the border contrast in the drawing for the study. Against the strong light, the edges of the shadows on the grass are very dark, tinged with blue. This sparse painting, with its limited palette of pure colors and its broad strokes, exhibits color and light—Seurat's aimed-for *chromo-luminarisme*—to much better advantage than some of his more finely executed works which soon followed. Here, in this hasty sketch, one sees tentative steps toward the later true divisionism that developed after Signac admonished all Neo-Impressionists to follow his lead and, along with him, to broaden their brushstrokes. Perhaps intuition and experience were leading Seurat in this direction while a

Figure 75 *Le Couple* (The Couple): study for *La Grande-Jatte* by Georges Seurat. ca. 1884–85. Conté crayon, 31.3 × 23.8 cm. British Museum, London. Courtesy Trustees of The British Museum.

Figure 76 *The Couple and Three Women:* study for *La Grande-Jatte* by Georges Seurat. ca. 1884–85. Oil on canvas, 81 × 65 cm. Fitzwilliam Museum, Cambridge (on loan from the Keynes Collection, King's College, Cambridge).

162

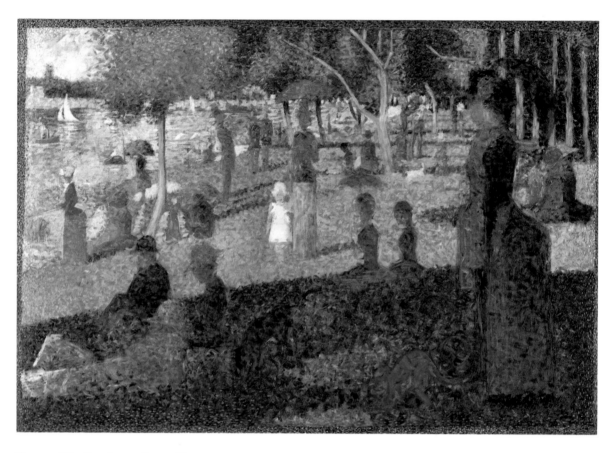

Figure 77 *Esquisse d'ensemble*: study for *La Grande-Jatte* by Georges Seurat. ca. 1884–85. Oil on canvas, 68 × 104 cm. © 1984 The Metropolitan Museum of Art, New York, bequest of Sam A. Lewisohn 1951 (51.112.6).

too-strict reliance on theory was leading in another.

The final study in oils, *Esquisse d'ensemble* (Figure 77), continues the use of broad *balayé* strokes throughout, except for some few narrow elongated strokes: horizontal on the surface of the water, vertical on tree trunks and on some clothing of standing figures. The *Esquisse* is full of light. In accord with Neo-Impressionist theory, it is illuminated by the intense local color, which is further enhanced by the strong contrast between neighboring regions of local color. Also in accord with theory, the light greens of the bright sunlit grass are further enlivened by small

scattered touches of pale and muted blue and orange, whereas the shaded areas of dark green are subdued somewhat with blue and violet (see Herbert 1968). Everywhere the harmony and the contrast of color are worked out in great detail, and both the overall composition and the color relationships are laid out in much the same form that they take in the final painting (see Thomson 1985). The study is complete in itself and, in some respects, is superior to the final work. In particular, the light in the *Esquisse* is the light of Northern France, in *La Grande-Jatte* itself it is almost too uniform and intense—the light of Southern Spain.

The final *Un Dimanche après-midi à l'Ile de la Grande-Jatte* (Figure 78) is a monumental work—almost a "mural on canvas," as it has been called. The scale alone (about 9×13 feet) is overwhelming and precludes simultaneous reproduction in one color print of the whole ensemble in sufficient detail to reveal all aspects of technique. Some of the most significant features can be seen, however, even in this scaled-down copy.

First, as in the studies, the use of strong contrast appears in several places; in particular, surrounding the bodice and skirt of the female member of the couple at the right. Haloes of light around the outer edges of shadows and a darkening of the inner edges (light and dark Mach bands) are also evident in many places. The pink of the light skirt of the central standing woman is intensified against the green of the grass and muted on the sunlit side. Blue is picked up in the shadows on the grass and orange in the light.

There is an "assault of light," as Fénéon once put it.

Brushstrokes are of all kinds and sizes. Many help to define form. Some are narrow and elongated to conform with outlines of clothing, trees, et cetera. Others radiate along with the ribs of parasols, run parallel on tree trunks, fall horizontally on reclining figures, or rise vertically on those standing. Grass is first cross-hatched with local color, and then spotted with the orange of full sunlight and the blue of dense shade. In short, virtually every technique of the brush and every law of the harmony and contrast of color that Seurat had learned by experience or study up to that time appear somewhere in this one painting. It was clearly an experimental work executed with a rapidly evolving and as yet unperfected technique. How such a polyglot of painterly languages comes off so well in the end is a great tribute to the genius of Seurat.

Un Dimanche après-midi à l'Ile de la Grande-Jatte is now widely regarded as the classical example of Neo-Impressionist painting. But at the time, many of the critics thought otherwise. In fact, there was much dissatisfaction with the painting, most of which was ignored by Félix Fénéon in his friendly and didactic reviews (see Halperin 1988). The critics were not entirely wrong. Seurat's Neo-Impressionist technique did not reach its highest stage of development until after much further struggle.

In particular, a fully developed divisionism was slow in coming. A more uniform style than in *La Grande-Jatte* appears in several landscape paintings from 1886 to 1888, including *Le Pont de Courbevoie*

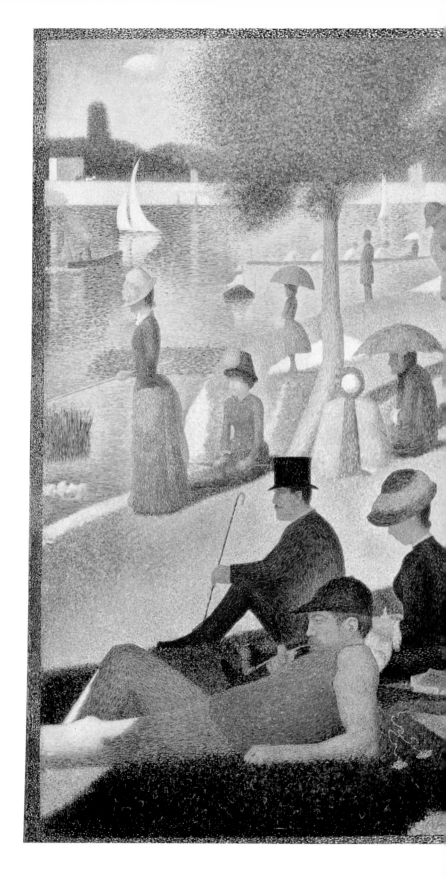

Figure 78 *Un Dimanche après-midi à l'Ile de la Grande-Jatte* (Sunday Afternoon on the Island of the Grand Jatte) by Georges Seurat. ca. 1884–85. Oil on canvas, 225 × 340 cm. (without later addition of painted border, 207.6 × 308 cm). © 1987 The Art Institute of Chicago. All rights reserved. Helen Birch Bartlett Memorial Collection (1926.224).

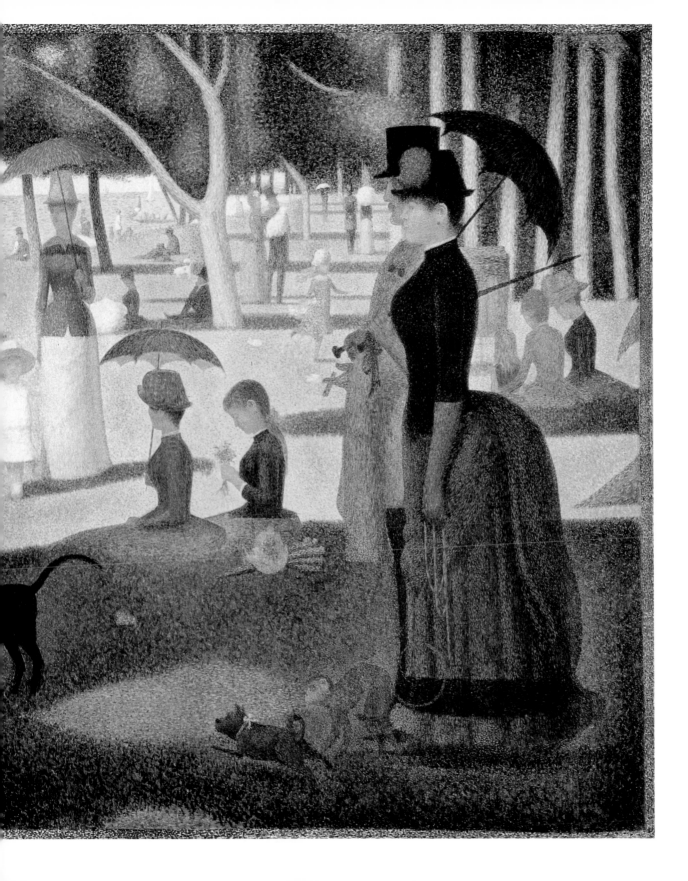

(The Bridge at Courbevoie) (ca. 1886–87), and in several marine paintings such as *The Maria, Honfleur* (1886) and *Port-en-Bessin, un dimanche* (Port-en-Bessin, Sunday) (1888). But the exemplar of the fully developed new painting was *Les Poseuses* (1887–88)—the first major figure subject executed in the new technique.

The three principal studies for this painting, one of which is shown here (Figure 79), show a definite departure from the rather uncertain and eclectic technique of *La Grand-Jatte*. The divided touch is used throughout, with more or less uniform mosaic-like strokes predominating. There are only a few lapses, here and there, into the cross-hatching and swept-over strokes of the earlier works. As before, close attention is paid to the harmony and contrast of colors, with special emphasis on the use of contrast in the delineation of form and in the modeling of the figure.

The final painting (Figure 80) goes much farther—perhaps too far, in some respects. The models are posed in the corner of Seurat's studio, with *La Grande-Jatte* forming the entire backdrop on one wall. The other wall is bare, except for three small paintings, and a hanging cloth bag. *La Grande-Jatte* is painted here, in this much-reduced copy, with broad divisionist touches, somewhat more in the style of the various studies for *Les Poseuses*, rather than in the style of the original *Grande-Jatte* itself. The models themselves and the remainder of the room are executed in a divided touch so fine that few of the brushstrokes can be resolved at any reasonable viewing distance. And in the high inaccessable location where the painting is now hung in the Museum of the Barnes Foundation the Neo-Impressionist technique is hardly recognizeable—except in the more divided copy of *La Grande-Jatte* behind the models.

Figure 79 *Poseuse de profil* (Model in Profile): study for *Les Poseuses* by Georges Seurat. ca. 1887–88. Panel, 24 × 14.6 cm. Louvre, Paris. Cliché des Musées Nationaux, Paris. Photo: © Réunion des Musées Nationaux. Color transparencies courtesy Giraudon/Art Resource, New York.

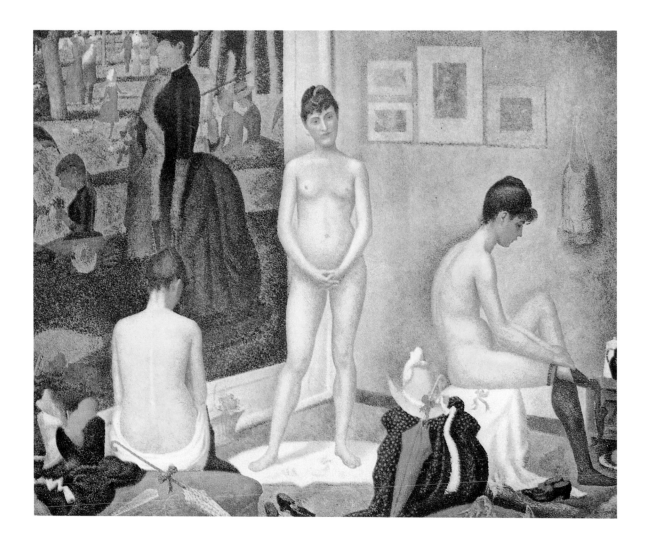

Figure 80 *Les Poseuses* by Georges
Seurat. ca. 1887–88. Oil on canvas,
200 × 250 cm. Reproduced from
Seurat by R. Thomson (1985), Salem
House/Phaidon Press, Salem, New
Hampshire. Painting owned by The
Barnes Foundation, Merion Station,
Pennsylvania.

Figure 81 *Les Poseuses* (small version) by Georges Seurat. ca. 1888. Oil on canvas, 39.4 × 48.7 cm. Private collection, Switzerland. Color transparencies courtesy Giraudon/Art Resource, New York.

Some years after *Les Poseuses* was first exhibited in Paris, Signac complained that the touches were too small and that they gave the painting a "gray look" overall. It is possible that Seurat himself recognized immediately that he had overshot the mark somewhat. A small version—*a petit réplique*—of *Les Poseuses* (Figure 81) painted soon afterwards (ca. 1888) reverts to the more relaxed and more "divisionist" technique, with much larger touches such as those seen in the earlier individual studies for each of the three models. (There have been some claims that this small version was only another of the several studies for *Les Poseuses,* but no less an authority than Félix Fénéon himself identifies it as a later copy.) Homer (1964) attributes the larger touches to the smaller scale of the second version, but this would seem to require smaller touches as well, rather than larger ones (according to Signac, touches "must be proportioned to the size of the work"). More likely, it was simply another logical step in the evolution of Seurat's style.

Whatever the reasons for the broadened divisionist brushstrokes, it appears that even Seurat himself was reluctant to submit completely to a too-strict pointillist technique which, according to some, "knows only slaves." Perhaps at that time he only recognized dimly what Signac saw clearly many years later: that the dots were too small in the original painting. In any event, Seurat's technique settled in this middle range exhibited in the later version of *Les Poseuses,* with touches neither much too large nor much too small, and he did not significantly depart from it thereafter.

Composition: the (pseudo) science of Henry As mentioned earlier, the psychophysiologist Charles Henry was closely associated with the Neo-Impres-

sionists, and they were at least conversant with his ideas about the relation of line and color to the feelings and emotions engendered by a painting (see Arguelles 1972; Halperin 1988). Indeed, in Seurat's final figure paintings one sees some evidence of the influence of the so-called dynamogenic aesthetic theories of Henry. As Signac wrote: "If Seurat's *Le Chahut* and *Le Cirque* were not composed of dynamogenic lines, hues, and values, they would not be, in spite of their titles, paintings of movement and joy." But the nature and extent of Henry's influence on the later painting of Seurat and on the painting of the Neo-Impressionists in general is highly debatable. Henry's theory of expression was very specific and quite detailed; Seurat's adaptation of it was very general and quite sparse. The discipline of experimental aesthetics was not a science in Seurat's day (and has not yet reached that status, even today). And any strict and rigorous analysis of Seurat's paintings in terms of Henry's theory leads, at the same time, to clear consistencies and flat contradictions.

For example, the color relationships in *Le Chahut* (The High-Kick) (1889–90), as analyzed by Homer (1964), do show a reasonable correspondence with Henry's aesthetic chromatic circle (*cercle chromatique*)—local colors ranging from red-orange to yellow (in Henry's so-called Dynamogeneous Gay Zone) do dominate the painting, while the complementaries of these colors in the blue range (Henry's Inhibitory Sad Zone) only play a minor and mainly contrasting role. All this (Figure 82) is in accordance with Henry's theory for the intended expression of gaiety. But the main linear directions in the painting (depending on somewhat arbitrary choices by the analyst) move upward and to the left. The legs of the dancers and the neck of the bass-viol clearly form most of the principal lines in the work. But their

left-upward orientation is about 90 degrees off of the right-upward axis that is required by strict adherence to Henry's aesthetic protractor (*rapporteur esthétique*) for expression of gaiety. Thus they directly contradict the theory. If the painting is based on any aesthetic theory at all, it must be on Seurat's much simpler and more general rules adapted from Henry's theory:

> *Gaiety* of tone is the light dominant; of *color*, the warm dominant; of *line*, lines above the horizontal.
>
> Calmness of tone is the equality of dark and light; of color, the equality of warm and cool; and of line, the horizontal.
>
> Sadness of tone is the dark dominant; of color, the cool dominant; and of *line*, downward directions.

All analyses of paintings in terms of such aesthetic theories are treacherous. Too much depends upon subjective decisions by the analyst on what to measure and what not to measure and too little upon objective comparison with the theory itself. Nevertheless, there is no doubt at all that Seurat's thinking was influenced by Henry (and by many others writing on aesthetics): Seurat's simplified version of Henry's theory given above was expressed by him in a letter to Maurice Beaubourg (for the full text of the letter see Lee 1983). But, on the other hand, there is considerable doubt that the moods expressed in Seurat's paintings derive directly from adherence to Henry's or any other theory of aesthetics. The rather somber and stolid mood of *La Grand-Jatte* can best be attributed to the rather flat, stiff, formal, and frieze-like figures scattered, mute and uncommunicative, across the painting like cut-outs for a stage setting. The lively and gay mood of *Le Chahut* and *Le Cirque* (The Circus) can best be attributed to the boisterous action and smiling expressions of the dancers, the implied music and noise of the crowd accompanying the action, et cetera. One hardly needs to rely upon Henry's *cercle chromatique* or *rapporteur esthétique*, with their complex mathematical relations, to achieve such ends.

Seurat and science

Seurat had the intense and well-disciplined temperament required to search out and to apply strict rules in his painting; he did rely strongly upon what he learned about the science of the harmony and contrast of colors from Chevreul and others; he did make use of much of what he learned about the science of the mixture of colors and of the interaction of colors from Blanc and from Rood; and he did simplify and fix in his mind some of the general principles of Henry's "scientific" aesthetic theory of expression (see Homer 1964). But it would be too much to say he painted in a strict adherence to well-established scientific principles. Seurat was strongly motivated by science, but was principally guided by his own experience in art. He believed deeply in the efficacy of a close adherence to a well-developed and thoroughly tested technique based on principles that he had read about in scientific works and seen in works of art, for it was in his very nature to do so. "Others," he once remarked to Angrand, "may see poetry in what I do." But, "No," he said, "I apply my method, and that's all." But despite all of Seurat's disclaimers and his insistence on the efficacy of a standardized technique, art overshadows method in his magnificent works. Seurat's art is a unique personal statement, just as much as is the art of the more rebellious, more individualistic Matisse.

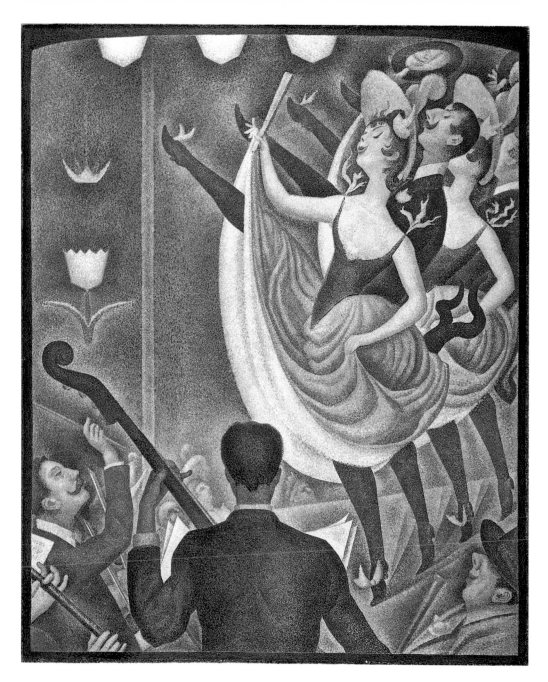

Figure 82 *Le Chahut* (The High-Kick) by Georges Seurat. ca. 1889–90. Oil on canvas, 171.5 × 140.5 cm. Collection of the Rijksmuseum "Kröller-Müller," Otterlo, The Netherlands.

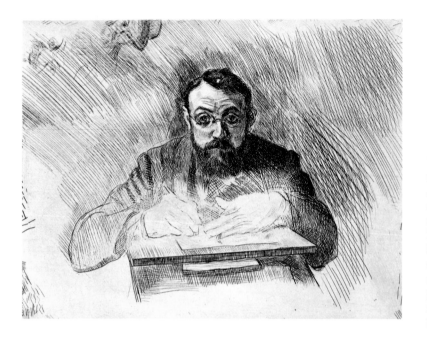

Figure 83 *Le Graveur, auto-portrait* (Self-Portrait as an Etcher) by Henri Matisse (1869–1954). 1903. Etching and drypoint, 15.1 × 20.1 cm. Collection of The Museum of Modern Art, New York, gift of Mrs. Bertram Smith. This self-portrait was made at about the same time that Matisse made his brief foray into Neo-Impressionism. © Succession H. Matisse/Artists Rights Society, Inc., New York 1990.

Matisse: the summer Neo-Impressionist

Henri Matisse (Figure 83) was born on 31 December 1869 in Le Cateau, France, where his father was a grain merchant (for a biographical sketch see Barnes and De Mazia 1933). Early studies to become a lawyer were interrupted by a serious illness. During the enforced idleness of a lengthy convalescence Matisse turned to art for distraction. He took a course in "design" for makers of embroidery and later began independent painting. Finally he gave up law altogether and devoted himself entirely to art, for the whole of his life. During his long career, spanning more than six decades, he worked as a painter, sculptor, printmaker, draftsman, muralist, designer, and fabricator of paper cutouts. And yet there was something uniquely Matisse in all his works in all these different media. Self expression dominated all other influences on his art.

In 1892, Matisse went to Paris to undertake a serious and systematic study of art. His first instructors there were Adolphe William Bouguereau and Gabriel Ferrier. But Matisse was dissatisfied with their teaching and after about a month he withdrew from their classes and became a free student at the Ecole des Beaux-Arts. He made a very favorable impression on Gustave Moreau, who was then engaged in criticizing the work of the Beaux-Arts students, and was soon invited to study in Moreau's own studio, where he stayed for four years. This was a most important phase in Matisse's early career. Moreau's respect for his students' individuality tempered with his insistence on a thorough grounding in the traditions provided a perfect environment for the young Matisse.

About a year after Matisse's arrival in Paris he exhibited several paintings at the Exposition of the Société Nationale des Beaux Arts (the Salon du Champs-de-Mars), and one of his paintings, *Reader,* was bought by the French government. But Matisse's early success was accompanied by considerable controversy about his abilities and accomplishments. Pierre Puvis de Chavannes, president of the Société, was a strong supporter of Matisse, and Jean Beraut, an influential member of the jury, was an equally strong opponent. After much debate the president's favorable view won out, and Matisse became an associate member of the Société. This immediately gave him high standing as an artist and put him in a position where he was no longer subject to the partisan politics of the jury.

Matisse's success in his early painting made him acutely conscious of an inner conflict between the museum world of the old masters and his own modern world. According to his own reports, strong tension soon developed in him between the old and traditional and the new and original. How to express his own perception in his work and at the same time follow long-standing tradition became a major problem for him. The problem was particularly acute because at that time a part of his income was earned by making and selling copies of old masters in the Louvre (see Barnes and De Mazia 1933). In his own words:

> It seemed to me that on entering the Louvre I was losing sensation of life which was of my time, and . . . that the pictures I was painting under the direct influence of the masters did not represent what I felt intimately in me. . . . But I have always maintained one foot in the Louvre so that, even when going forth adventurously, I have always had an anchor in the native land.

Matisse did not find his own way immediately. He worked in Brittany with the Impressionist painter Emile Wery in the summer of 1896 and painted there again in the summer of 1897. That same year he met, and was influenced by, Camille Pissarro, Pierre Bonnard, Edouard Vuillard, and Paul Serusier. His Impressionist *Dinner Table* (1897), which he felt was the first real expression of himself, met with the same immediate disapproval that the academicians gave to all such work at the time, and the public meekly followed their cue. But Matisse continued his search for his own way. That search took many different directions. In 1898 he went to London to study Turner. He discovered Japanese art in Paris. He became acquainted with Pierre Laprade and André Derain. He went to Corsica for a year. In 1899 he bought an important painting by Paul Cézanne. He worked for a time in sculpture. From 1900 to 1904, he came more and more under the influence of Impressionists and Neo-Impressionists, working in Toulouse and Paris. In 1903 he studied the exhibition of Mohammedan art in Munich. Overall, his first years of study were a period of rapid growth, broad exploration, and significant accomplishment.

By this time, Matisse had accumulated an enormous reservoir of knowledge and experience, but had not yet found an outlet for his own rapidly growing talent that was completely acceptable to him. In his continuing search he turned for a time to Neo-Impressionism. *Nature morte: buffet et table* (Interior: Sideboard and Table) (1899) was perhaps his first serious attempt to paint in the Neo-Impressionist manner. It was undoubtedly stimulated by the appearance of Signac's manifesto, *D'Eugène Delacroix au Néo-Impressionnisme.* But color was not applied throughout that painting (Figure 84) in strict accordance with Signac's theories. Opposed colors

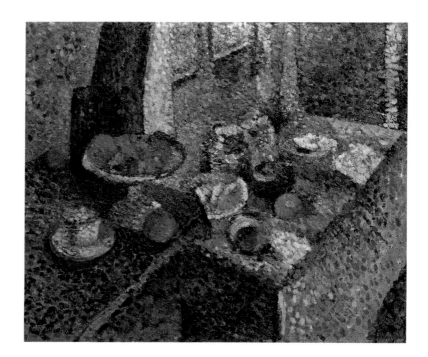

Figure 84 *Nature morte: buffet et table* (Interior: Sideboard and Table) by Henri Matisse. 1899. Oil on canvas, 67.5 × 82.5 cm. Private collection, Switzerland. © Succession H. Matisse/Artists Rights Society, Inc., New York 1990.

were deliberately interlaced in various places, resulting in some rather muddy gray tones, which Signac specifically warned against. Matisse was not one to be bound by rules.

Matisse continued to dabble in Neo-Impressionism on his own, but eventually a tutored introduction to the method came about through his friendship with Cross. During the summer of 1904, he stayed with Cross and Signac at Saint-Tropez, where he lived in La Ramode, one of Signac's houses there. Matisse painted actively in the Neo-Impressionist style for only about one year, and was almost literally as well as figuratively a "summer Neo-Impressionist."

At Saint-Tropez Matisse's search for his own style soon led to a quarrel with Signac, who found the brushstrokes in Matisse's *The Terrace, Saint-Tropez* so broad that they amounted to "treason." This incident indirectly resulted in Matisse's one major painting in the Neo-Impressionist style, according to legend (see Elderfield 1978). Disturbed by the quarrel with Signac and the ensuing reprimand, Matisse was taken for a walk along the beach by his wife where she posed with their son Pierre for *Le Gouter (Golfe de Saint-Tropez)*. This work, known in English as *By the Sea*, was the basis for the subsequent smaller but full compositional study (Figure 85) for his *Luxe, calme, et volupté*. The title of the painting comes from the following couplet in Baudelaire's *Invitation au Voyage*:

La, tout n'est qu'ordre et beauté,
Luxe, calme, et Volupté.

176

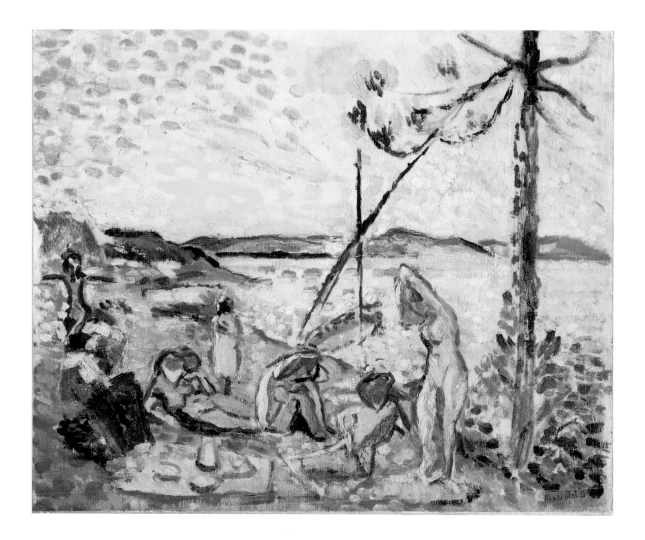

Figure 85 Study for *Luxe, calme, et volupté (Saint-Tropez, late summer)* by Henri Matisse. 1904. Oil on canvas, 32.2 × 40.5 cm. Signed lower right: Henri Matisse. Private collection, promised gift of the Hon. Mrs. John Hay Whitney to the Museum of Modern Art, New York. © Succession H. Matisse/Artists Rights Society, Inc., New York 1990.

Matisse completed the final large painting in Paris, just in time for the exhibition of the *Indépendants* in March 1905. This was Matisse's one and only major painting in the Neo-Impressionist style. Signac's animosity toward Matisse must have been short-lived: he purchased this important work and for many years it hung in his villa La Hune at Saint-Tropez.

Matisse immediately grasped the essentials of the Neo-Impressionist technique. In this one painting (and in the preparatory study shown here) can be seen almost all of the major artistic effects that can be produced by divisionism. There is little of pointillism and little optical mixture in either of the two studies or in the final painting itself. Following Signac's dictum, the brushwork is broad and rectangular and many of the color effects are due primarily to interaction, in the form of color contrast—often much exaggerated. For example, in the final painting (not shown here) the sky is much too dark near the bright side of the tree trunk and much too light near the dark side. The same applies to the color of the water seen behind the standing nude. Against the sunlit side of her body the water is almost black; against the shaded side it is very light. Everywhere there is strong contrast of opponent pairs: reds interact with greens, and yellows interact with blues. The impression of the strong light and the heat of summer is striking. Some contours are exaggerated. The edge of the bluish shadow of the seated figure in the center is accentuated with broad dark strokes, and the figures themselves are heavily outlined. All necessary, Matisse thought, because the "breaking up of color led to the breaking up of form, of contour." This "repair" of the effect of Matisse's too-broad brushstrokes—a too-extreme divisionism—foreshadowed his lifetime emphasis on heavy line and strong contour as well as color. He was tormented by "l'eternel conflit du dessin et de la couleur"

Luxe, calme, et volupté is widely regarded as the principal achievement in Matisse's Neo-Impressionist period. Even so, it is not a great Neo-Impressionist painting (as Matisse himself soon acknowledged). It is a personal variation on the established method and lacks the harmony and contrast of color so evident in Signac's work. Indeed, this work (and the two major studies for it) is a reminder that technique alone cannot produce a great work of art. And matters are made even worse when the laws on which the technique is based are violated. Although *Luxe, calme, et volupté* was painted under the direct influence of Signac and Cross, the fundamental laws of harmony and contrast, which they espoused so strongly, are not adhered to throughout the work. Indeed, some neighboring greens and yellows and some reds and blues actually clash, rather than harmonize. Similarly, in Matisse's *Le Port d'Abaill* (1905) the Mach bands at the edges of shadows are correctly represented in accordance with Neo-Impressionist theory as strong bands of light and dark tones. But instead of using complementary opposed colors, which would enhance the simultaneous contrast, he sometimes used noncomplementary colors, which clashed. This must have been the effect he wanted to achieve, for he was well-schooled enough to know in advance what the result would be.

Matisse was well on the way to becoming a Fauvist—one of the "wild beasts" (see Jacobus 1983). He seemed to delight in following the rules of the Neo-Impressionist theory up to a point and then in deliberately violating them as if he wished to see what new effect might result. In a certain sense, Matisse's paintings tested the outer bounds of Neo-Impressionist theory, which he came to regard as op-

pressive. He was later to speak of the "tyranny of Divisionism" and to compare it to living "in a house too well kept, a house kept by country aunts." "One has to go off into the jungle to find simpler ways that won't stifle the spirit," he said. His own emerging style, with its emphasis on line and contour, and his own peculiar talents, somewhat more in the domain of abstraction, were clearly incompatible with a strict adherence to the rules and the technique of color in Neo-Impressionism. On seeing a canvas Matisse had just finished, Henri-Edmond Cross said to him: "You won't stay with us long."

The metamorphosis of Matisse

Matisse's final break with Neo-Impressionism occurred in the summer of 1905. A series of four paintings, all variations on the same theme, a landscape at Collioure, show his "escape" in the orderly evolution of one of his most renowned early works, *Bonheur de vivre* (Joy of Life). Evolution—with the implication of a long selective process—may be the wrong word to use here. The transformation was so great, so rapid, and so little affected by outside influences that it appears to have been more of a metamorphosis—a predetermined change already destined to occur, like the unfolding of a flower. The four paintings are shown here. They illustrate in a remarkable way Matisse's growing need for a direct and utterly personal expression; a need, expressed in his own words, "The artist, . . . encumbered with all the techniques of the past and of the present, asked himself: 'what do I want?' This was the dominating anxiety of Fauvism. If he starts within himself, and makes just three spots of color, he finds the beginning of release from such constraints."

Landscape at Collioure (Figure 86), probably the first of the summer studies leading to *Bonheur de vivre,* is painted in a rather abstract Neo-Impressionist style—markedly divisionist, with long, broad, sinuous brushstrokes, similar to those of some of van Gogh's works. But it is color without contour: "Construction by colored surfaces," as Matisse once described the Fauvist technique. Form is subordinate to color, and the landscape itself would hardly be recognizable and identifiable as Collioure, were it not for the title and for the work's relation to the paintings that followed.

The next *Landscape at Collioure* (Figure 87) is unmistakably a study of the setting for *Bonheur de vivre.* The painting was done *alla prima*—wet into wet—but each and every color was kept as pure and bright as possible, more or less in the Neo-Impressionist manner, by keeping them separate and distinct rather than by slurring one into the other (see Elderfield 1978). However, long continuous lines and broad areas of solid uniform color overpower the more mosaic-like divisionist touches scattered here and there and show more clearly Matisse's move away from the influence of Signac and Neo-Impressionism.

A very small (ca. 5-×-7-inch) sketch on wood of the same landscape, *Joy of Life,* now in the Barnes Collection and not shown here, laid out the fundamental arrangement of the masses of color, still somewhat in the divisionist manner, with a mere suggestion here and there of what were later to become the principal human figures. In the final study of this summer series, *Landscape:* study for *Bonheur de vivre* (Figure 88), the setting is clearly the same Collioure, and the human figures are all properly introduced, although in a rather sketchy manner. Some divisionist touches still remain in this study, but Matisse's own style clearly dominates the work as a

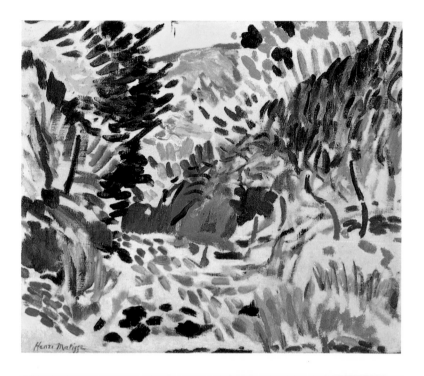

Figure 86 *Landscape at Collioure (Collioure, summer)* by Henri Matisse. 1905. Oil on canvas, 32.9 × 41.3 cm. Collection of Mrs. Bertram Smith. © Succession H. Matisse/Artists Rights Society, Inc., New York 1990.

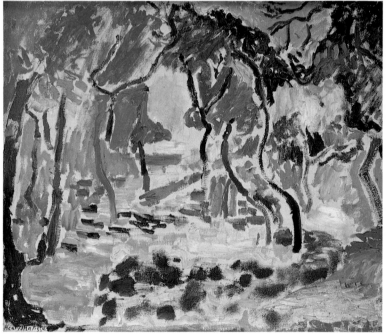

Figure 87 *Landscape at Collioure:* study for *Bonheur de vivre* by Henri Matisse. 1905. Oil on canvas, 46 × 55 cm. Statens Museum for Kunst, Copenhagen, Copenhagen, Denmark, J. Rump Collection. © Succession H. Matisse/Artists Rights Society, Inc., New York 1990.

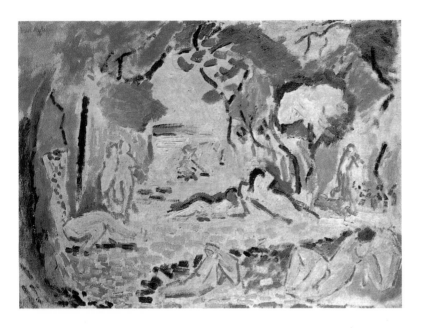

Figure 88 *Landscape:* study for *Bonheur de vivre* by Henri Matisse. 1905. Oil on canvas, 16½ × 21⅜ in. Private collection, San Francisco. Reproduced from *Matisse* by J. Jacobus (1983), Harry N. Abrams Inc., New York. © Succession H. Matisse/Artists Rights Society, Inc., New York 1988.

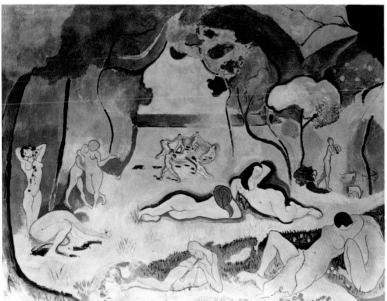

Figure 89 *Bonheur de vivre* (Joy of Life) by Henri Matisse. 1905–06. Oil, 68½ × 93¾ in. © Succession H. Matisse/Artists Rights Society, Inc., New York 1990. Photo: © 1991 The Barnes Foundation, Merion Station, Pennsylvania.

181

whole. The heavy contours surrounding the figures are typical of his later work and are in strong contrast to the release of color from the constraints of fixed contours in the first *Landscape at Collioure* (Figure 86). Matisse was beginning to answer the troubling question he had put to himself— "What do I want?"

The final large *Bonheur de vivre* (Figure 89) was completed in the fall and winter of 1905–06. This work bears little resemblance to the first *Landscape at Collioure* executed under the influence of Cross and Signac. It is pure Matisse. No longer did he allow the "breaking up of color" to lead to the "breaking up of form, of contour." Rather, form and contour play perhaps a greater role than color itself in this work. Indeed, with all chromatic color removed—as in this black and white reproduction—Matisse's personal touch is instantly recognizable.

In painting *Bonheur de vivre*, Matisse had escaped at last from the "tyranny of divisionism." Nevertheless, Neo-Impressionism was more than an interlude for him. As a matter of fact, many of his later works show that he retained much from the scientific and empirical foundations of Color in Neo-Impressionism and often applied it in his treatment of color throughout the remainder of his career (see Elderfield 1978; Jacobus 1983). He was master of the technique but he would not be mastered by it. And, despite evidence to the contrary, Matisse always steadfastly denied any scientific basis for his work—quite unlike Signac, his principal tutor in Neo-Impressionism.

Signac: disciple and divisionist

Paul Signac was neither as rigid as Seurat nor as rebellious as Matisse in his approach to Neo-Impressionism. Signac was a dedicated Neo-Impressionist and early on was strongly influenced by Seurat, the founder and acknowledged leader of the movement. But, even so, he had his own ideas and intuitions, and later on his influence on Seurat was almost as great as Seurat's had been on him. Furthermore, he had his own very distinctive personal style, evident in his hundreds of watercolors—a style which he managed to sublimate almost entirely in his Neo-Impressionist paintings. Signac was well aware of the many advantages offered by watercolor over oil in the expression of dynamic forces and vital principles. In his *Traite de l'aquarelle* he wrote:

> The watercolorist can record everything that happens, everything that introduces life and variety into the permanent motif. His simple material permits him to triumph over the elements and to record the most elusive effects, even under the most unfavorable conditions.

Evidently Signac had a more equable and manageable disposition than either Seurat or Matisse, and was better able to control his inner urges. Only rarely does the spontaneous and fluid self-expression of his watercolors (Figures 8 and 90) appear in his divisionist oil paintings. And usually such paintings were of the sea and sailing, which lend themselves naturally to a more lively treatment. *Les Moulins à*

Figure 90 *Rotterdam* by Paul Sig-
nac. 1906. Watercolor and pencil on
paper, 25.4 × 40.6 cm. © 1988 The
Metropolitan Museum of Art, New
York, Alfred Stieglitz Collection
1949 (49.70.19). Signed, inscribed,
and dated lower right: P. Signac Rot-
terdam 1906.

183

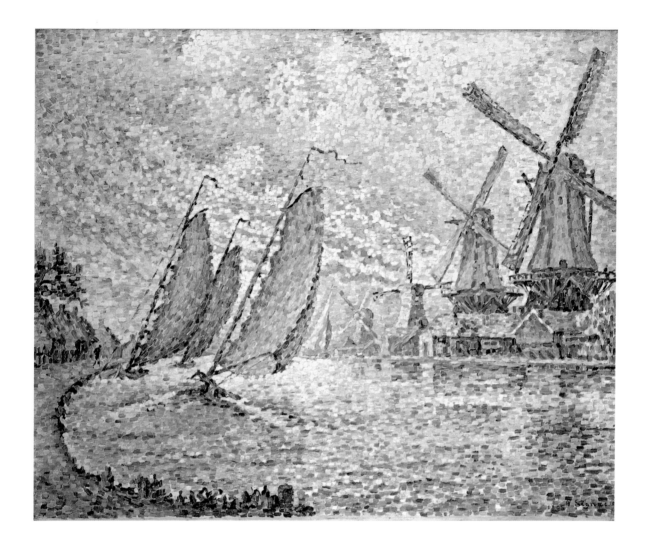

Figure 91 *Les Moulins à Overschie*
(The Windmills at Overschie) by Paul
Signac. 1905. Oil on canvas, 25
× 37¼ in. Signed and dated lower
right. The Museum of Fine Arts,
Springfield, Massachusetts.

Overschie (The Windmills at Overschie) (Figure 91) is
a typical example of a temporary escape by Signac
from the usual stiff and formal Neo-Impressionist
style. Indeed, the free style of Signac's watercolors,
which he painted throughout his life, seemed to offer
a "safety valve" from the severe constraints of Neo-
Impressionism—as was once stated by his grand-
daughter Françoise Cachin (1971). Nevertheless, it is
evident, in looking at the whole of Signac's work,
that his temperament was not entirely suited to
Seurat's technique, and that he put his own stamp on

Neo-Impressionism. In particular, Signac was primarily responsible for turning the whole movement away from a too-strict pointillism and toward a more lenient and more effective divisionism.

There may be some doubt that Signac fully understood all aspects and all details of the scientific theory of optical mixture on the basis of merely reading about it, but there is no doubt at all that he became fully aware of both the advantages and the limitations of a true optical mixture when it was put into practice. As mentioned above, when Signac saw

Figure 92 *Jardin de La Hune* (Garden at La Hune, Saint-Tropez) by Jeanne Selmersheim-Desgrange (1879–1958). 1909. Oil on canvas, 64.8 × 79.5 cm. Signed and dated lower right: J. Selmersheim-Desgrange 1909. © 1989 Indianapolis Museum of Art, Indianapolis, Indiana, The Holliday Collection (79.290).

185

the large version of Seurat's *Les Poseuses* once more at Vollard's in 1897, ten years after he had first seen it, he complained that it was too divided—that the too small brushstrokes gave the painting a mechanical and petty look and a gray tone overall. He concluded then and there that it had been quite proper for him and his followers to "broaden our brushwork," as he characterized the move toward a more relaxed divisionism.

The 1909 painting *Jardin de La Hune* (Garden at La Hune, Saint-Tropez), by Jeanne Selmersheim-Desgrange, shows how closely many of Signac's followers adhered to his precepts (Figure 92). Almost every mosaic-like touch of the brush in this colorful and exuberant work is separate and distinct from all the others. But it is important to note that, with the broad brushstrokes used here, the technique is not pointillism, in the strict sense of using points or dots (see Lee 1983). Furthermore, optical mixture of colors is not significant, except possibly when the painting is viewed from a very great distance. The broad-stroke technique is Signac's prescribed divisionism; the "pure" colors of the limited palette are visibly separated on the canvas. But this work is divisionism in the extreme, and Signac himself seldom went that far. Nevertheless he set the stage for the second phase of Neo-Impressionism, beginning in the early 1900s, and in which all true pointillism virtually disappeared.

Le Petit déjeuner (now in the collection of the Rijksmuseum "Kröller-Müller" in Otterlo, The Netherlands) is one of Signac's most celebrated works. It was painted in 1886–87, at the height of the first stage of Neo-Impressionism and during the time that he was writing his book on the origin and evolution of the movement. His Neo-Impressionist technique had just reached its peak of perfection, and the

painting is a most remarkable composition. The subject of the painting and the arrangement of the furniture and the figures are a restatement of a scene painted some ten years earlier by Signac's friend Gustave Caillebotte in his *Déjeuner* of 1876. (Interestingly, much the same scene appears again, some ten years later, in Edouard Vuillard's *La Famille au déjeuner* of 1896.) Although the scenes are very similar, the styles of the two paintings are very different. Caillebotte's canvas is a retrograde Impressionism (see Varnedoe 1987); Signac's is a forward-looking Neo-Impressionism. Indeed, Signac's painting is virtually a complete treatise on his view of the advanced state of Neo-Impressionism in general and of divisionism in particular.

Let us approach this masterpiece by way of a pen-and-ink drawing he executed on paper (Figure 93) entitled *La Salle à manger* (The Dining Room). It was published early in 1887 and was almost certainly a study for *Le Petit déjeuner* (see Szabo 1977). (It is interesting that Seurat did a very similar stippled pen and ink study for his *La Parade*, also in 1887. Signac and Seurat must have been in very close communication at that time.) Not one continuous line is made by a stroke of the pen anywhere in this drawing. It is stippled throughout with nearly equal round dots. At any reasonable viewing distance, the dots do not fuse (except where they are very tightly packed to produce the darkest tones). Control of the distribution of light and shade is achieved almost entirely by the spacing of the individually distinct dots. And the contrast effects achieved by the interactions among differently stippled areas in this black-and-white study presage the effects of interaction of brightness and of interaction of color that were later to appear in the painting itself. For example, the "halos" (Mach bands) around the matchbox and around the edge of

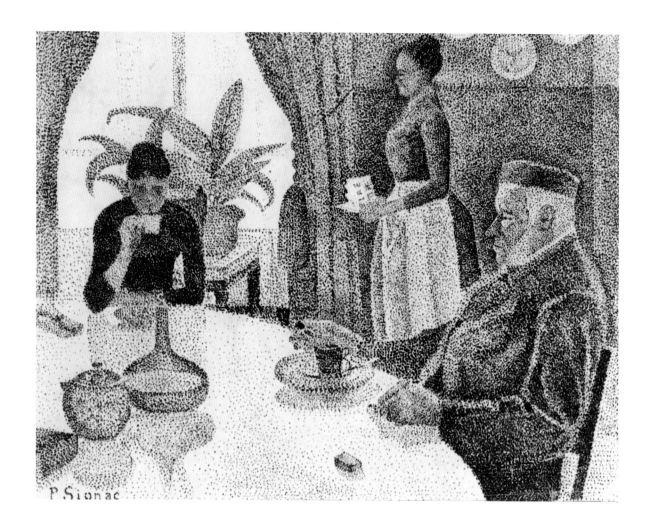

Figure 93 *La Salle à manger* (The
Dining Room) by Paul Signac. 1887.
Pen and ink on paper, 17.8 × 23.3
cm.
Signed in pen in lower
left corner: P. Signac. Also inscribed
below, under the mat: La Salle à
manger, P. Signac. Published in *La
Vie moderne,* 9 April 1887.

the shadow of the decanter are much enhanced by the closer spacing of the stippled dots some distance away. These effects can be very powerful and can be exerted over great distances.

Incidentally, it is most interesting (and still an unsolved scientific puzzle) that one can clearly resolve the separate dots at the same time one perceives their combined effects on the apparent brightness in their own immediate neighborhood and in more distant adjacent areas. This is somewhat like the "delusive blend" of colors in Neo-Impressionism, the individual points having a combined effect while remaining more or less distinct and separate.

In the oil painting *Le Petit déjeuner,* the effects of the integrative action of the visual system were fully and masterfully exploited by Signac (Figure 94). The play of light in this painting is most interesting (see Herbert 1968; Callen 1982). The whole scene is lit from the back. This *contrejour* throws the seated woman, with her back to the direct bright light of the window, into sharp contrast. The back light almost flattens her figure into a silouhette because the small amount of front light allows few tonal gradations, and therefore permits little modeling of the face and upper body. The other two figures, half-facing the window, are illuminated by both direct light from outside and diffuse reflected light from within, and are nicely modeled. Small objects here and there also

Figure 94 *Le Petit déjeuner* (Breakfast) by Paul Signac. 1886–87. Oil on canvas, 89 × 115 cm. Signed and dated lower left: 86 P. Signac 87; lower right: Op. 152. Collection of the Rijksmuseum "Kröller-Müller," Otterlo, The Netherlands.

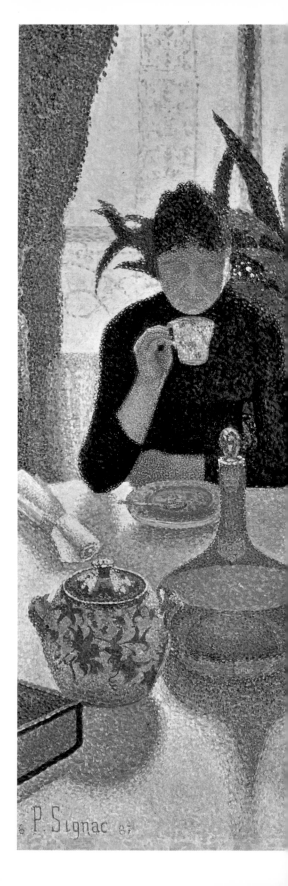

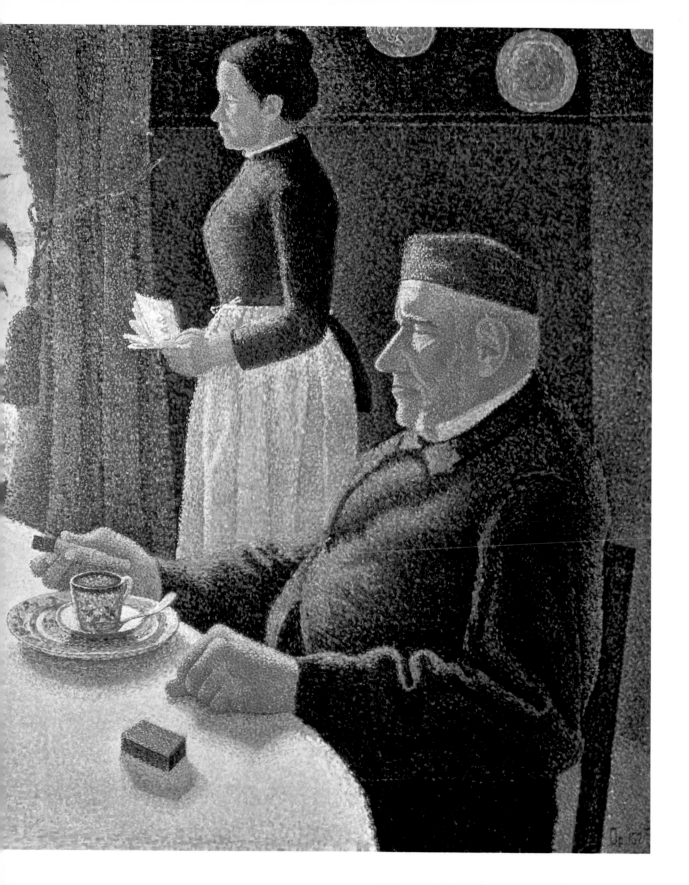

show Signac's careful attention to the interplay of light and shade. Signac saw, and understood very well in practical terms, how neighboring areas of light and shade and color influence the appearance of one another. On the basis of this understanding, he has carefully represented Mach bands and related brightness–contrast effects in the various half-shadows throughout the work. Note especially the dark and light lines at the edges of the double shadow of the decanter, the shadow of the teapot, the variations in brightness around the matchbox, and elsewhere. (As mentioned earlier, there is no evidence whatsoever that Signac and other Neo-Impressionists were aware of the prior work of the physicist Ernst Mach on these contrast phenomena. Evidently their observation of the Mach bands—revealed in their painting of them—was an independent "discovery.") Similarly, one can see interaction of color throughout the painting. The distinctive and rather unusual palette featuring oranges, blues, and purples is very harmonious overall, and specific color contrasts as in the shadows of the objects on the table are especially effective and pleasing to the eye. All such effects give the painting a certain vitality, for as the viewer alters distance and position with respect to it, they change in subtle and interesting ways.

Thus, through the interaction of color, which is partly under the control of the spectator, a painting can seem to take on a life of its own. The artist can help this vital process along by emphasizing certain striking aspects of the subject. For example, in this painting, where Signac saw contrast he forced additional contrast. That is to say, he selected a pigment which appeared by itself on the palette to be of the proper color and brightness. But when that touch of color was placed on the canvas, surrounded by other contrasting touches of color, the spectator's eyes

then further accentuated the contrast. By this artifice, the contrast is doubly exaggerated and the painting appears to have much more contrast than would the original scene. As Shakespeare's poet remarked in *Timon of Athens* when commenting that his artist friend's painting was more than a mere imitation of nature:

> It tutors nature; artificial strife
> Lives in these touches, livelier than life.

> (1.1.39–40)

So it is in *Le Petit déjeuner*. In addition to the normal strife between excitation and inhibition in our visual system, Signac, too, has added a touch of "artificial strife" on the canvas.

It is evident that divisionism, in the sense of broad strokes of unmixed pigment from a limited palette, and interaction of color, in the sense that the color and tone of adjacent areas of the canvas mutually affect one another, are most essential to the technique of Neo-Impressionism. Pointillism, in the extreme, and optical mixture, in the strict meaning of the term, are not essential to the technique.

Recognition and dissemination of these facts was Signac's major contribution to the Neo-Impressionist movement. And it was Signac's efforts that led to the reemergence of Neo-Impressionism in the twentieth century as a distinct style with the major emphasis on vibrant color combinations—almost more in the manner of Delacroix than in the manner of Seurat. Indeed, it was the interplay of color, rather than the optical mixture of color, which Signac understood so well and emphasized so much throughout the years in both his writings and his paintings. This understanding was soundly based on both the science of color and the practice of the colorist.

Conclusion

In Neo-Impressionism the scientific theory of color had an influence on the accepted technique, and the rules of that technique had an influence on the practice of individual artists within the movement. But those influences were not always controlling. The use of small touches of pure color by the Neo-Impressionists may have been inspired by the theory of the optical mixture of color, but in the actual application of those touches on the canvas the theory of the interaction of color turned out to be more relevant, and a strict pointillism almost immediately gave way to a more lenient divisionism. Similarly, the movement with its fairly well defined rules of technique attracted many adherents. But in actual practice, each and every painter put his or her own stamp on the technique and in the end many scattered far and wide.

Every artist is subject to many and diverse influences but, in the final analysis, art is individual. And that is as it should be.

The triumph of color There are those who fear understanding, fear that knowledge destroys, and fear that when the web of mystery around a thing of beauty is disentangled and removed, then beauty itself will flee.

> Do not all charms fly
> At the mere touch of cold philosophy?
> There was an awful rainbow once in heaven:
> We know her woof, her texture: she is given
> In the dull catalogue of common things.
> Philosophy will clip an Angel's wings,
> Conquer all mysteries by rule and line,
> Empty the haunted air, and gnomèd mine—
> Unweave a rainbow.
>
> Keats, *Lamia*, II, 229

But the Neo-Impressionist painter's "cold philosophy" is merely the understanding of the historical and lawful basis of the technique and cannot be seen directly in the painting. All painting rests on the laws of nature whether the painter understands those laws or not. Both Seurat and Signac sought such understanding, unlike the rebellious Matisse, who said:

> My choice of colours does not rest on any scientific theory; it is based on observation, on feeling, on the very nature of each experience. Inspired by certain pages of Delacroix, Signac is preoccupied by complementary colours, and the theoretical knowledge of them will lead him to use a certain tone in a certain place. I, on the other hand, merely try to find a colour that will fit my sensations.

There is no doubt that there are wide differences among individuals in their color preferences, their particular likes and dislikes. As the Russian proverb explains, In taste and in color, comrades pull asunder. But sensations are another matter; the basic psychophysiology of color is more or less the same in everyone, everywhere. And when Matisse finds a color that will fit his sensations, that fit expresses some fundamental truth about color, and the perception of color, which transcends Matisse's own particular idiosyncracies and his own personal experiences. As Alberti (1404–1472) wrote:

> Among colours there are certain friendships, for some joined to others impart handsomeness and grace to them. When red is next to green or blue, they render each other more handsome and vivid. White not only next to grey or yellow, but next to almost any colour, will add cheerfulness. Dark colours among light ones look handsome, and so light ones look pretty among dark ones.

The perceived friendships (and antagonisms) among colors are universal and enduring truths. What was true about color in the 1400s was still true 400 years later in the 1800s, and is still true today. Whether the artist chooses to exploit those truths in some systematic way based on the accumulated artistic and scientific knowledge of centuries past or simply on the basis of his own immediate personal intuition and direct personal experience is irrelevant, as far as color appearances are concerned. The appearance of color is determined by certain enduring physical, physiological, and psychological events and processes. Color is as color does. And the truth about color always triumphs over our necessarily incomplete theories and imperfect techniques.

Color in Neo-Impressionism had broad theoretical bases in both art and science, as is fully recounted in this essay and in Signac's *D'Eugène Delacroix au Néo-Impressionnisme*. But, in the end, any artist who wishes to succeed as a colorist must go beyond painters' theories of the brush and scientists' theories of color. In art, practice always takes precedence over theory. For it is the ultimate appearance of color in the resulting work of art itself, and not the underlying theory or the means of its application which is paramount. As Signac himself wrote in 1884:

I paint like this because it is the technique that seems to me best suited to give the most harmonious, the most luminous, the most *colorful* result.

D'Eugène Delacroix
au Néo-Impressionnisme

Extracts from and editions of Signac's
D'Eugène Delacroix au Néo-Impressionnisme

Signac's most important work, *D'Eugène Delacroix au Néo-Impressionnisme,* was first published serially in *La Revue Blanche,* Paris. Chapters I and II, under the title *La Technique de Delacroix,* appeared in volume XVI, number 118, 1 May 1898. Chapters III–VI, under the title *L'Impressionnisme et le Néo-Impressionnisme,* appeared in volume XVI, number 119, 15 May 1898. Chapters VII and VIII, under the title *La Disgrace de la couleur,* appeared in volume XVI, number 122, 1 July 1898.

Substantial extracts of the work, translated into German, were published almost simultaneously in the review *Pan,* in the May–October 1898 issues. Chapter II of the book, under the title *La Technique de Delacroix,* was published in *Revue populaire des arts,* 8 October 1898.

D'Eugène Delacroix au Néo-Impressionnisme, published by the *Editions de La Revue Blanche,* 1899, was the first publication of the whole work in one volume.

A complete German edition—*Von Eugene Delacroix zum Neo-Impressinismus*—translated by C. Hermann, was published in Krefeld in 1903, and reissued at Charlottenburg in 1910.

The second French edition was published by H. Floury, Paris, in 1911; the third edition in 1921; and the fourth edition in 1939.

In the meantime the work was published in Danish—*Fra Delacroix til Neo-Impressionnismen,* translated by E. Clemssen and Hollatz-Bretagne, Copenhagen, 1936 (reissued in 1946).

Extracts of the *Note Préliminaire* and of Chapter IV were reproduced in the preface to the catalog of the exposition *Le Néo-Impressionnisme,* Paris, Galerie de France, 1942. Chapter VIII was reproduced by A. Lhote in *De la palette à l'écritoire,* Paris, 1946. Chapters IV and V appeared in *L'Art de la peinture,* published by J. Charpier and P. Seghers, Paris, 1957.

In 1964, a new edition in French was published: *D'Eugène Delacroix au Néo-Impressionnisme,* edited and with introduction, biographical sketch, appendices, and bibliography by Françoise Cachin (granddaughter of Signac), by Collection Miroirs de l'art, Hermann, Paris, 1964. The second edition of this annotated version is in the Collection Savoir, Hermann, Paris, 1978.

A translation into English of brief portions of Section 7 in Chapter IV of the 1964 edition appear in *Seurat in Perspective,* edited by Norma Broude, published by Prentice-Hall Inc., Englewood Cliffs, New Jersey, 1978, pp. 58–59. An English translation of other more substantial excerpts from the book and a general summary of its contents are included in Linda Nochlin's *Impressionism and Post-Impressionism, 1874–1904,* published by Prentice-Hall Inc., Englewood Cliffs, New Jersey, 1966, pp. 117–123.

The present volume—translated from the third (1921) edition—is the first translation of the whole work into English.

A note on the translation

Signac's *D'Eugène Delacroix au Néo-Impressionnisme* is written in a rather unconventional style and printed in a rather unusual format. The main objective of this translation is to preserve and to convey both the intent and the spirit of the original turn-of-the-century work. In the belief that Signac's personal style and unique format should be disturbed as little as possible, the translation is somewhat more literal than literary, with the emphasis on the intended meaning and essential quality of the original French rather than on a complete transformation into modern English.

PETITE BIBLIOTHÈQUE D'ART MODERNE

Paul Signac

D'Eugène Delacroix

au

Néo-Impressionnisme

henri Floury

4 RUE DE CONDÉ

Overleaf: A facsimile of the original
cover of the 1921 French edition of
Signac's *D'Eugène Delacroix au Néo-
Impressionnisme.*

PAUL SIGNAC

———

From
Eugène Delacroix

to

Neo-Impressionism

———

THIRD EDITION

———

PARIS

H. FLOURY, BOOKSELLER AND PUBLISHER
1, BOULEVARD DES CAPUCINES, 1

——

1921

TABLE OF CONTENTS

———

The cover of this volume was designed

BY

M. THÉO VAN RYSSELBERGHE

———

(printed by)
MATHA, IMPRIMERIE R. LUCAS

TO THE MEMORY OF

THE PAINTERS

GEORGES SEURAT,

HENRI-EDMOND CROSS.

AND

IN THE CAUSE OF COLOR.

PRELIMINARY NOTE

1. The Neo-Impressionist painters are the artists who established and, after 1886, developed the technique called *divisionism* by using as their mode of expression the optical mixture of tones and hues.[1]

Obedient to art's enduring laws of rhythm, measure, and contrast, these painters came to their technique because of their desire to achieve a maximum of brightness, color, and harmony which seemed to them unattainable by any other mode of expression.

Like all innovators, they astonished and aroused the public and the critics, who reproached them for using an irregular technique that would dissipate any talent they might have.

Our purpose, in these pages, will not be to defend the merits of these painters, but to show their much decried method as traditional and normal, as a technique fully anticipated by Eugène Delacroix and one which he all but formulated, and which was bound to follow upon that of the Impressionists.

1 Paul Signac's use of the term "optical mixture" (*mélange optique*) is not always consistent with his own careful and precise definition of that term given in Section 8 of Chapter III. In some cases, Signac means a true and complete optical mixture of two or more colors into one new hue (as he defined the term) and in other cases he appears to mean only an incomplete optical mixture (as in a partial fusion in which one color is given a tinge of another) or even the lateral influence of one neighboring color on another (as in the contrast of colors). The reader must determine the intended meaning of the term from the context in which it is used. (Ratliff's note)

Must we here disclaim any intention of comparing the Neo-Impressionists with their illustrious predecessors? All we seek to prove is that they may rightly invoke the teachings of these masters and take their place in the line of champions of color and light.

2. It might seem pointless to expound a technique of painting. Painters should be judged solely by their works and not by their theories. But it is for their technique in particular that the Neo-Impressionists are attacked: it is apparently regretted that they should lose their way in futile experiments; there are many who condemn them in advance for the method they use, without making any serious study of their canvases; in their case, the examination stops short at the *means* and ignores the benefits of the *ends*. We therefore find it legitimate to come to the defense of their mode of expression and to demonstrate its logic and richness.

We may then allow ourselves the hope that the works of these artists will be examined without prejudice, for even though a technique which is accepted as sound does not endow its users with talent, why should it diminish the talent of those who find in it the best means of expressing their thought and their desire?

3. We shall find it very easy moreover to demonstrate that the reproaches and criticisms brought against the Neo-Impressionists are all a part of the tradition, and were endured by their predecessors, and indeed by all artists who introduced an unfamiliar mode of expression.[1]

[1] Note of 1921.

In this new edition, no change has been made in the original text published in 1899 by the Revue Blanche.

Only the dedication has been modified. The name of our dear friend HENRI-EDMOND CROSS has been inserted beside that of GEORGES SEURAT, and the words "in the cause of color," which seemed to us timely, have been added. (Signac's note)

I

DOCUMENTS

Divisionism; anticipated by Delacroix.—Analogy between his technique and that of the Neo-Impressionists.—Quotations from Delacroix, Baudelaire, Charles Blanc, Ernest Chesneau, Théophile Silvestre, and Eugène Véron—Similar experiments encounter an identical reception: some criticisms.

1. There is a widely held, erroneous belief that the Neo-Impressionists are painters who cover their canvases with multicolored *petits points* (dots). We shall later prove what we affirm at the outset, namely that the trivial procedure of *dotting* has nothing in common with the aesthetic of the painters defended in these pages, or with the technique of *division* used by them.

The Neo-Impressionist does not paint with *dots*, he *divides*.

This *dividing* is a way of:

Securing all the benefits of brightness, color, and harmony by:

1. The optical mixture of uniquely pure pigments (all the hues of the prism and all their tones)[1];
2. The separation of the diverse elements (local color, color of lighting, their reactions, etc. . . .);
3. The balance and proportion of these elements (in accordance with the laws of contrast, gradation, and irradiation);
4. The choice of a brushstroke which fits to the size of the painting.

1 Because the words *ton* [tone] and *teinte* [hue] are generally used interchangeably, we wish to make it clear that by *hue* we mean the quality of a color, and by *tone* the degree of saturation or brightness of a hue. The gradation from one color to another will create a series of intermediary *hues*, and the gradation of one of these *hues* towards light or dark will pass through a succession of *tones*. (Signac's note)

The method formulated in these four paragraphs was, therefore, to govern color for the Neo-Impressionists, most of whom have applied, in addition, the more mysterious laws which control lines and directions and ensure that they will be harmonious and beautifully ordered.

Armed with his knowledge of line and color, the painter will make a firm choice with respect to the linear and chromatic composition of his painting, selecting for it dominant directions, tones, and hues which are appropriate to his subject.

2. Before proceeding farther we shall invoke the authority of the lofty and lucid genius of Eugène Delacroix: the foregoing rules of color, of line, and of composition, which sum up *divisionism,* were promulgated by this great painter.

We shall restate, point by point, the entire aesthetic and technique of the Neo-Impressionists, and then, comparing each aspect with the lines written by Eugène Delacroix on the same issues in his letters, his articles, and the three volumes of his journal (*Journal d'Eugène Delacroix,* published by Messrs. Paul Flat and René Piot through Plon and Nourrit), we shall show that these painters are simply following the teaching of the master and continuing his experiments.

3. We have already said that the aim of the Neo-Impressionists' technique is to achieve a maximum of color and light. Is not this aim clearly signified in the noble cry of Eugène Delacroix:

"The enemy of all painting is gray!"

To obtain this luminous, colored brilliance, the Neo-Impressionists use only pure colors which, insofar as matter can come close to light, approximate the colors of the prism. Do they not here also follow the counsel of the man who writes:

"Banish all the earth colors."

They will always use these pure colors with the fullest respect for their purity, taking good care not to sully them by mixing them on the palette (except, of course, with white and with neighboring colors, for all the hues of the prism and all their tones). They will juxtapose them, using small, precise strokes, and will obtain, through the interplay of optical mixtures, the outcome they seek, with the advantage that, whereas all mixtures of pigments tend to discolor as well as to darken, all optical mixtures tend towards clarity and brilliance. Delacroix indeed divined the supreme merits of this method:

"Hues, of green and of violet, applied crudely, here and there, in the light areas, without mixing them."
"Green and violet: it is essential to apply these tones one after another; and not to mix them on the palette."

These colors of green and violet are, in fact, almost complementary and would, if they had been mixed as pigments, have produced a drab and dirty hue, one of those grays that is the *enemy of all painting;* whereas juxtaposed, they will recreate optically a fine, pearly gray.

The Neo-Impressionists have done nothing more than generalize logically from the treatment Delacroix imposed on green and on violet, and apply that treatment to the other colors.

Alerted by the experiments of the master and enlightened by the research of Chevreul, they have established this unique and sure method of achieving both light and color:

Replace all pigmentary mixtures of antagonistic hues by their optical mixture.

4. Since all uniform color appears to them devoid of life or luster, they strive to make the smallest area of their canvases shimmer through the optical mixture of touches of color, juxtaposed and gradated.

Now Delacroix has clearly enunciated the principle and the advantages of this method:

"It is good that the touches should not be blended materially. They blend naturally with one another at a distance required by the law of sympathy which has associated them together. The color thus obtained has greater energy and freshness."

And farther on:

"Constable says that the green of his meadows is of a superior quality because it is composed of a multitude of different greens. The greenery of the common flock of landscape painters lacks intensity and life because they ordinarily give it a uniform hue. What he says here of the green of meadows can be said of all tones."

This last sentence proves clearly that the decomposition of hues into shaded touches, which is so important a part of *divisionism,* was anticipated by the great painter, who was inevitably led by his passion for color to realize the benefits of optical mixture.

But to achieve optical mixture, the Neo-Impressionists have been obliged to use small strokes, so that the diverse elements, observed at the proper distance, will recreate the desired hues, and no longer be perceived in isolation.

Delacroix had thought of using such small strokes and had some intimation of the advantages that this technique might have to offer, for he writes these two notes:

"Yesterday, while working on the child near the woman at the left in *L'Orphée* (Orpheus), I remembered those manifold small strokes applied with the small brush and as if in a miniature, in Raphael's Virgin which I saw in the rue Grange-Batelière."

"Try to see the big gouaches by Corregio in the Museum. I believe they were done with very small strokes."

5. For the Neo-Impressionist, the diverse elements which must recreate the hue through their optical mixture will be distinct from one another: light and local color will be clearly separated, and the painter will, as he wishes, make first one and then the other dominate.

Surely we find this principle of the separation of elements in the following lines of Delacroix:

"Simplicity of local areas and breadth of light."
"One must reconcile color as 'color' and light as 'light.' "

Again, the balance and proportion of these separate elements are clearly indicated:

"If too much dominance is accorded to the light and the breadth of the planes there will be an absence of half-tints with a consequent loss of color; the contrary fault is particularly harmful to large compositions intended to be viewed from a distance. Véronèse is superior to Rubens in the simplicity of his local areas and in breadth of his light."
"To prevent a loss of color under such a broad light the local hues of Véronèse have to have very strong tones."

6. The contrast of tone and of hue, which the Neo-Impressionists are the only ones among contemporary painters to observe, was likewise defined and imposed by the master:

"My palette shining with the contrast of colors."
"A general law: the greater the opposition, the greater the brilliance."
"The satisfaction offered, in the spectacle of things, by the beauty, proportion, contrast, and harmony of color."
"Although it contradicts the law that requires shining colors to be cool, the contrast of shining yellow placed on violet skin tones ensures the production of the effect."
"When you have a little more light at the edge of a well-defined plane than at the center, you accentuate its flatness or its projection . . . adding black serves no purpose, it will not give you any relief."

This note from one of his Moroccan travel notebooks shows how important to Delacroix were the laws of contrast and of complementary colors, which he knew to be inexhaustible sources of harmony and power:

"From the three primary colors the three secondaries are formed. If to a secondary tone you add the primary tone which is opposed to it, you annul it;

that is to say, you produce from it the requisite half-tint. Thus, adding black is not adding half-tinting, but rather sullying the tone whose real half-tint is to be found in its opposite tone, as we have said. So we have green shadows in the red. The heads of the two peasant children: the one which was yellow had violet shadows, and the one which was more sanguine and red, green shadows."

7. According to the Neo-Impressionist technique, light—yellow, orange, or red—is, according to the time of the day and the effect, added to the local hue, making it warm or more golden where the illumination is strongest. Shadow, the faithful complement of light, its regulator, is violet, blue, or bluish green, and these elements modify and cool down the darker portions of the local color. These cool shadows and warm lights, whose strife and interplay, both with one another and with the local color, create the contour and modeling of the painting, are diffused, blended, or contrasted over the entire surface of the painting, illuminating it here, dimming it there, their place and proportion being determined by the chiaroscuro.

Now, these yellow or orange lights, these blue or violet shadows, which have aroused so much hilarity, are categorically prescribed by Delacroix:

"In Véronèse's paintings, the linen is cool in the shadow, warm in the light."
"The golden and red tones of trees, blue, luminous shadows."
"The tones of chrome in the light areas, and the blue shadows."
"At Saint-Denis du Saint-Sacrement, I had to paint the lights in pure chrome yellow and the half-tints with Prussian blue."
"The dull orange in the highlights, the most vivid violets for the passage of shadow and gleams of gold in the shadows opposed to the ground."
"All edges of shadow are tinged with violet."

8. The Neo-Impressionists have often been taxed with exaggeration of their color and with loud, gaudy painting.

They will disregard these criticisms, coming as they do from people of whom one can say, along with Delacroix, that:

"Earth colors and olive have dominated their color to such an extent that nature, with its bold, lively tones, is, in their eyes, a discord."

The painter who is truly a colorist—that is to say, one who, like the Neo-Impressionists, submits color to the rules of harmony—will never have to fear that an excess of color will make his work appear gaudy. He will leave it to more timorous souls to wish for "not color, but just a nuance" and will not fear to seek brilliance and power by all possible means. For Delacroix warns him that:

"A painting will always appear grayer than it is, because of its oblique position under the light . . ."

and shows him the sorry effect of a drab, colorless painting:

"It will look like what it really is: earthy, dismal, and lifeless. -— Earth thou art and to earth thou shalt return."

Therefore he will not fear to use the most brilliant hues, those tints:

". . . which Rubens produces with bold and potent colors, such as the greens, the ultramarines."

Even when he would like to obtain grays, he will use pure hues whose optical mixture will give him the desired resultant, so greatly superior to the resultant—not gray, but dirty—obtained by a pigmentary mixture. These intense and brilliant colorations will be still further heightened, when the painter sees fit, by gradation and contrast.

If he knows the laws of harmony, he should never fear committing an excess. Delacroix incites him, even commands him, to go to the extreme in color:

"The half-tint, that is to say all the tones, must be exaggerated."
"All the tones must be exaggerated. Rubens is exaggerated. So is Titian. Véronèse is sometimes gray, because he strives too much after truth . . ."

9. This means of expression, the optical mixture of small, colored touches, placed methodically one beside the other, leaves but little room for skill or virtuosity; the hand is of very little importance; only the brain and the eye of the painter have a part to play. By resisting the charms of the brushstroke, by choosing a technique which is not showy, but conscientious and precise, the Neo-Impressionists paid heed to the stern reproof of Eugène Delacroix:

"The most important thing is to avoid the infernal convenience of the brush."

"Young people are infatuated solely by the skill of the hand. Perhaps there is no greater obstacle to any sort of real progress than this universal mania to which we have sacrificed everything."

Then Delacroix returns again to the dangers of an execution which is too facile:

"The fine, free, and proud brush of Van Loo leads only to approximations: style can result only from thorough research and experiment."

To defend the little touches which shock those who, because they cannot appreciate the harmonic merits of the result, are brought up short by the novelty of the method, we will cite the following lines of Delacroix on *the touch*. Everything he says about this technique, which he used to give color greater splendor and brilliance, can be applied to the procedure used to the same end by the Neo-Impressionists:

"There are in all the arts means of execution adopted and agreed upon, and that person who knows not how to read these indications of thought is but an imperfect connoisseur; the proof is that the vulgar prefer above all the smoothest paintings with the fewest touches, and prefer them for that reason."

"What are we to say of masters who sharply accentuate their contours while abstaining from the touch?"

"Contours no more exist in nature than do touches. One must always come back to the accepted means in every art, which are the language of that art."

"Many of these painters who take the greatest care not to use the touch,

on the pretext that it is absent from nature, exaggerate the contour which is likewise absent."

"Many masters have not allowed the touch to be perceived, thinking no doubt that they were thereby coming close to nature which, in actual fact, does not have it. The touch is one of a number of means which help to render thought in painting. No doubt a painting can be very beautiful without showing the touch, but it is childish to see in this a resemblance to the effect of nature; one might as well put real colored reliefs into the picture, on the ground that bodies have projections."

At the distance required by the size of the painting, the technique of the Neo-Impressionists will not be shocking: at this distance, the touches disappear and all that the eye will perceive will be the charms of light and harmony that they procure.

Perhaps this note by Delacroix will induce some people to take the necessary trouble to understand and judge a divided painting:

"Moreover, everything depends on the distance required for viewing the painting. At a certain distance, the touch blends itself into the whole composition, but it gives the painting an accent which could not be produced by mixing the colors together."

Delacroix tries in several places to persuade those who, because their real love is only for very dull and very sleek pictures, are disconcerted by any painting which is vibrant and highly colored, and warns them that:

"Time restores to the work its final total effect, effacing the touches, both the earliest and the latest."
"If one would argue from the absence of touches in certain paintings of the great masters, one must not forget that time deadens the touch."

10. Would one not say that all these notes of Delacroix on color were written by an adherent of *divisionism* for the purpose of defending his ideas? And there are so many other points on which the Neo-Impressionists could invoke the testimony of the master!

These repeated notes by one whose precepts they strive to follow

show them so clearly the importance he attributes to the role of line, that they cannot fail to secure for the harmony of their colors the benefits of rhythmic arrangement and measured balance:

"The influence of the principal lines is immense in a composition."

"A good arrangement of lines and of colors: an arabesque, so to speak."

"In any object one may wish to draw the first thing to grasp is the contrast of its principal lines."

"Admirable balance of lines in Raphael."

"A solitary line alone has no significance; a second one is needed to give it expression. A major law: one note alone [is not] music . . ."

"The composition presents almost the configuration of a Saint-Andrew's cross . . ."

"If, to a composition which is already interesting for its subject, you add an arrangement of lines which heightens the impression . . ."

"The straight line is nowhere found in nature."

"Never parallel lines in nature, be they straight or curved."

"There are some lines that are monsters: the straight line, a regular serpentine, and above all, two parallels."

11. Having settled upon his linear composition, the Neo-Impressionist will consider how to complete it by a combination of directions and colors appropriate to the subject, and to his conception, and the dominant elements will vary with his intention of expressing joy, calm, sadness, or intermediate feelings.

Being thus concerned with the effect of lines and colors on the mind, he will, once again, simply be following the teaching of Delacroix.

Here is what the master thought about this significant constituent of beauty, so much neglected by so many painters today:

"All this arranged with a harmony of lines and color."

"Color is nothing if it is not fitting to the subject and does not enhance the painting's effect through the imagination."

"If, to a composition which is interesting for its choice of subject, you add an arrangement of lines which heightens the impressions, a chiaroscuro that thrills the imagination, and color adapted to the characters, then you have harmony and its combinations adapted to a unique melody."

"A conception, when it has become a composition, needs to move within its own particular ambiance of color. There is obviously a particular tone as-

signed to some part of the painting which becomes the key and and governs the rest. Everyone knows that yellow, orange, and red inspire and represent ideas of joy and opulence."

"I see painters as prose writers and poets. Rhyme fetters them; the indispensable shaping of the verse, which gives it so much vigor, is analogous to the hidden symmetry and the balance, at once the fruit of skill and inspiration, which governs the encounters or the divergence of lines, the *taches*[1], the highlights of color. . . . But, more active sense organs and a heightened sensibility are needed to discern an error, a discord, an improper relation in lines and in colors."

12. While the Neo-Impressionists strive to express the splendors of light and color in nature, and draw the materials for their works from this source of all beauty, they believe that the artist must choose and arrange these elements, and that a painting composed linearly and chromatically will display an order superior to the chance outcome of direct copying from nature.

In defense of this principle they would cite these lines by Delacroix:

"Nature is only a dictionary, where one looks for words . . . where one finds the elements which make up a sentence or a story; but no one has ever considered a dictionary to be a composition, in the poetic sense of the word."

"Furthermore, nature is far from being always interesting in its total effect. . . . While each detail offers us something perfect, the assemblage of these details is rarely, in its effect, equivalent to what is produced by a complete composition in the work of a great artist."

13. One of the principal charges laid at their door is that they are too scientific to be artists. We shall see that all that is involved consists

1 Common meanings of the word *tache* are spot, stain, speckle, and (figuratively) blot or blemish. With the advent of the Impressionists, *tache* took on a specific meaning in art: Each touch (*touche*) of uniform color, juxtaposed in a painting. (Sometimes *tache* is translated as dash-stroke or splash of color. By 1906, *tachisme* began to be used to characterize the technique of the Neo-Impressionists: A method of painting (by a *tachiste*) with juxtaposed small *taches* of unmixed color (synonym: *pointillism*). That meaning is now obsolete, and, since about 1955, *tachisme* has become a generic term for the European equivalent of the American abstract expressionism and, more loosely, action painting. Both *tache* (as spot, touch, or dash of color) and *tachisme* (as action painting) have now entered the English vocabulary of painting. However, the exact meaning intended here by Delacroix, and by Signac later on in the book, is uncertain. Therefore, throughout the translation, the term *tache* is left in the original French. (Ratliff's note)

of four or five precepts enunciated by Chevreul which elementary school pupils should know. But let us show, here and now, that Delacroix demanded for the artist the right to be knowledgeable about the laws of color.

"The art of the colorist is obviously related, in some respects, to mathematics and music."

"Concerning the artist's need to be scientific. How this science can be acquired independently of ordinary practice."

14. It is curious to note that, even in the smallest details of their technique, the Neo-Impressionists put Delacroix's advice into practice.

They paint only on supports covered with white, so that the light will show through the touches of color, imparting to them greater brilliance and also greater freshness.

Now, Delacroix notes the excellent results of this procedure:

"What gives so much delicacy and brilliance to painting on white paper is undoubtedly the transparency inherent in the whiteness of the paper itself. It is probable that the first Venetians painted on very white backgrounds."

The Neo-Impressionists have cast aside the gilt frame, with its gaudy brilliance which alters or destroys the harmony of the painting. They use, as a rule, white frames, which provide an excellent transition between the painting and the background, and enhance the saturation of the hues without disturbing their harmony.

It might amuse the reader to know that a painting bordered by one of these discreet and sensible white frames—the only ones, except for the contrasting frame, which do not harm painting replete with light and color—is just for that reason peremptorily banned forthwith from the official or pseudo-official Salons.

Delacroix, a perfect harmonist who feared to introduce into his composition a foreign and perhaps discordant element, anticipated the advantages which white frames would offer, for he considered using them to adorn his decorations at Saint-Sulpice:

"They (the frames) can have a good or bad influence on the effect of the picture—the gold wasted in our time—their form in relation to the character of the picture."

"A gilt frame of a character unsuitable to that of the work, taking up too much space for the picture."

"At Saint-Sulpice, surround the paintings with frames of white marble. . . . If one could make frames with white stucco."

15. Here we will end these citations. To show, however, that we have not distorted his texts, we will reproduce the following excerpts from the major critics who have studied Delacroix. They all refer to his continual preoccupation with his search for a sound, scientific technique based on contrast and optical mixture, and recognize the logic and excellence of this method, which is in so many ways similar to the much criticized technique of *divisionism*.

From Charles Baudelaire:

"This incessant preoccupation is the source of his never-ending research into color."

"It resembles a bouquet of flowers, skillfully matched." (*L'Art Romantique* [Romantic Art])

"This color is unequalled in the science it displays: the color, far from losing its cruel originality in this new and more complete science, remains sanguinary and terrible. This balance of red and green is pleasing to our soul.

"In color we find harmony, melody, and counterpoint." (*Curiosités esthétiques* [Aesthetic Curiosities])

From Charles Blanc (*Grammaire des arts du dessin* [Grammar of Painting and Engraving]):

"Color, being subject to fixed rules, can be taught like music. . . . It is because he knew these laws, and had studied them thoroughly, having first divined them intuitively, that Eugène Delacroix was one of the greatest colorists of modern times."

"Once the law of complementary colors is known, how sure is the touch with which the painter will intensify the brilliance of his colors or temper his harmony. Knowing this law through intuition or study, Eugène Delacroix took care not to spread a uniform tone over his canvas."

"The boldness with which Delacroix had brutally slashed the naked torso of this figure with strong green hatchings . . ."

From Ernest Chesneau (*Introduction à l'oeuvre complet d'Eugène Delacroix* [Introduction to the Complete Artistic Works of Eugène Delacroix]):

"He had stumbled upon one of the secrets which is not taught in schools and which too many of the professors themselves do not know: the fact that, in nature, a hue which seems uniform results from the union of a host of diverse hues, perceptible only to the eye which knows how to see."

Théophile Silvestre, who spent long hours in Delacroix's studio, reveals to us (*Les Artistes français* [The French Artists]) precise details about the well-reasoned, scientific technique to which the master, despite his feverish impatience, was willing to subject his fiery inspiration:

"Through one experiment after another, he had finally arrived at an absolute system of color which we will attempt to convey in summary form. Instead of simplifying local colors by generalizing them, he multiplied the tones endlessly and opposed one against another to give each one a double intensity. Titian seemed to him monotonous and it was indeed only much later that he recognized the full grandeur of the Venetian master. The vividness of Delacroix's work is therefore the result of intricacies of contrast. While in Rubens color shines like a tranquil lake, in Delacroix it sparkles like a river spattered by a sudden shower.

"An example of the matching of tones in Delacroix: if, in a figure, green dominates the shadows, red will dominate the lights; if the lighted part of the figure is yellow, the shaded portion is violet; if it is blue, then orange is opposed to it, and so forth, in every part of the painting. To apply this system, Delacroix made a sort of cardboard dial, which could be called his chromometer. At each measured interval was placed, as around a palette, a small patch of color, with its analogous colors immediately neighboring, and its contrasting color diametrically opposite.

"To understand fully this arrangement, look at the face of your clock and imagine that twelve o'clock represents red; six o'clock green; one o'clock orange; seven o'clock blue; two o'clock yellow; eight o'clock violet. The intermediary tones were subdivided into smaller intervals, resembling the half-hour, quarter-hours, minutes, etc. . . .

"... This almost mathematical knowledge, instead of chilling his works, enhances their precision and solidity."

From Eugène Véron (*Eugène Delacroix*):

"Until the last day of his life, he studied the laws of the complementary colors, the ways in which they are modified by light, and the effects of the contrast of tones.

"Delacroix made frequent use of this optical mixture, through which he creates the sensation of a color which was never on his palette. In this respect he achieved an amazing sureness of touch, because in him science and consciousness were added to his natural gift.

"It can be observed that the coloring is most admired in those of his works where the contrasts are boldly emphasized by the brushstrokes and made directly visible."

"To him, composition means to arrange the relationships of line and color in such a way that the aesthetic significance of the subject is accentuated."

16. The abuse and witticisms which have greeted the divided paintings are of a piece with those which were once aimed at the work of Delacroix. Is not this similar reception an indication that the experiments were also of a like nature?

Like the Neo-Impressionists, Delacroix was called a *madman*, a *savage*, and a *charlatan;* and just as the powerful coloring of his figures earned him the title of *painter of the Morgue, of the plague-stricken, of malignant cholera*, so has the technique of division been the subject of all-too-witty allusions to small-pox and confetti.

This kind of wit shows little variation. Would one not say that the following comments on the master's various exhibitions were written today, on the subject of the Neo-Impressionists' paintings?

Salon of 1822 (*Dante et Virgile* [Dante and Virgil]):

"This is not a painting; it is a real *tartouillade*."

E. Delécluze (*Moniteur Universel*)

221

"Viewed at a distance sufficient to render the brushwork invisible, this painting produces a remarkable effect. Viewed close up, the strokes are so hatched, so incoherent, though devoid of timidity, that it is impossible to believe that, with the degree of talent for execution which has been attained in our school, any artist could have adopted such an extraordinary manner of working."

C.-P. LANDON

(*Annales du Musée de l'Ecole moderne des Beaux-Arts*)

Salon of 1827 (*Mort de Sardanapalus* [Death of Sardanapalus]):

"M. Delacroix lacks good will rather than talent; he counts as progress only those of his works which he creates out of tasteless extravagance."

D.

(*Observateur des Beaux-Arts*)

"Messrs. Delacroix, Scheffer, Champmartin, the guiding stars of the new school, have received no award, but in compensation, they will be granted a daily two-hour sitting at the Morgue. We must encourage young talent."

(*Observateur des Beaux-Arts*)

"At a distance the effect is that of decoration. Close up, a shapeless daub."

(*Journal des Artistes et des Amateurs*, 1829)

On the *Pieta* (Eglise Saint-Denis du Saint-Sacrement):

"Kneel down then before all these repulsive figures, before this Magdalene with the eyes of a tippler, this crucified Virgin, inanimate, plastered over and disfigured; before this hideous, putrefied, ghastly body, which is insolently presented to us as the image of the Son of God!

"He plays at the Morgue, and with the plague-stricken, and with malignant cholera. This is his pastime and his amusement."

(*Journal des Artistes*, 20 October 1844)

If a municipal council had the audacity to entrust the decoration of one of its walls to a Neo-Impressionist, would we not immediately find in the papers a protest of this sort:

"And it is a painter, to this degree indifferent to his reputation and, so little confident in his work, who is chosen, on the strength of such sketches and mere jottings of his thoughts, to decorate an entire hall in the palace of the Chamber of Deputies! It is to such a painter as this that one of the greatest commissions of our time in the sphere of commemorative painting has been entrusted! In truth, the responsibility is not merely assigned; it could well be compromised!"

(*Le Constitutionnel*, 11 April 1844)

"We are not saying: this man is a charlatan; but we are saying: the man is the equal of a charlatan!

"We will not accuse the administration of the City's art galleries on account of their choosing Monsieur Delacroix to execute so heavy a task: we are too well-acquainted with the sound and lofty ideas which generally govern their deliberations to believe otherwise than that these persons had their hands forced in this affair. But, we do accuse the men who sit on our councils or in our legislative assemblies, scheming or soliciting in favor of those who owe their reputation not to talent, science, or knowledge, but to coteries, cliques, and audacity."

(*Journal des Artistes*, 1844)

"Should we not fear that one day, beholding the ceilings of our palaces and museums covered with these shapeless illuminations, our descendants will be seized with the same astonishment that we ourselves feel when we see our ancestors place *La Pucelle* (The Maiden) by Chapelain among the masterpieces of poetry."

ALFRED NETTEMENT (*Poètes et artistes contemporains* [Contemporary Poets and Artists], 1862)

II

THE CONTRIBUTION OF DELACROIX

The colorist evolution.—Delacroix influenced by Constable, Turner; guided by the oriental tradition and by science.—From "Dante et Virgile" to the decorations of Saint-Sulpice.—Advantages of his scientific method.—Examples.—His progressive conquest of light and color.—What he did, what he left to be done.

1. Delacroix therefore knew a great many of the advantages afforded to the colorist by the use of optical mixture and contrast. He even anticipated the benefits of a technique which would be more methodical and precise than his own and would bestow still greater clarity on light and still greater brilliance on color.

If we study the painters who, in this century, were the representatives of the colorist tradition, we will see them, from generation to generation, brightening their palette and obtaining more light and color. Delacroix was to find help in the studies and experimentation of Constable and Turner; then Jongkind and the Impressionists profited from the contribution of the romantic master; finally the Impressionist technique evolved towards the mode of expression used by Neo-Impressionism: THE DIVIDED TOUCH.

2. Delacroix had scarcely left Guérin's studio in 1818 when he felt the inadequacy of the palette overloaded with somber, earthy colors—the one which he had used until then. When painting *Le Massacre de Scio* (The Massacre at Chios) (1824), he dared to eliminate useless ochres and earthy colors, replacing them with such lovely glowing, pure colors as cobalt blue, emerald green, and madder lake. Despite this boldness, the feeling of insufficiency was soon to return. In vain he arranged on his palette a variety of half-tones and half-tints, carefully prepared in ad-

vance. He still felt the need for new resources, and, for his decoration of the Salon de la Paix, he enriched his palette (which, in Baudelaire's words, "resembled a bouquet of flowers, skillfully matched") with the resonance of cadmium, with the sharpness of zinc yellow, and the energy of vermilion, the most intense colors which a painter has at his disposal.

Using these strong colors—yellow, orange, red, purple, blue, green, and yellow-green—to offset the monotony of the many dull colors in use before he began his experiments, he was to create the romantic palette, muted and yet turbulent.

It may be properly remarked that these pure, vivid colors are precisely those which later on were to compose, to the exclusion of all others, the simplified palette of the Impressionists and of the Neo-Impressionists.

3. Perpetually tormented by his desire to obtain more brilliance and luminosity, Delacroix did not rest content with the improvement of his instrument, he also strove to perfect the manner of using it.

When he came upon a harmonious combination in nature, when a chance mixture confronted him with a lovely hue, at once he would jot it down in one of his numerous notebooks.

He visited the museums to study the coloring of Titian, Véronèse, Velazquez, and Rubens. In comparison with the color of the masters, his own always seems to him too lifeless and somber. He made numerous copies of their works, in the hope of discovering the source of their power. He gleaned among their riches and adapted all the results of his studies to his own use, without sacrificing anything of his personality.

4. If the color of *Le Massacre de Scio* is already much more sumptuous than that of *Dante et Virgile,* the progress is due to the influence of the English master Constable.

In 1824, Delacroix was finishing the *Scène du Massacre de Scio* (Scene from the Massacre at Chios), which he was planning to exhibit at the Salon, when, a few days before the opening, he had the opportunity to see some of Constable's paintings which had just been bought by a

French art lover and were going to be shown in the same exhibition. He was struck by their color and brightness, which seemed to him miraculous. He studied their technique and saw that instead of being painted in flat colors, they were composed of a quantity of small, juxtaposed touches which, at a certain distance, were reconstituted as hues of an intensity far superior to that of his own paintings. This was a revelation to Delacroix: within a few days he completely repainted his canvas, hammering the color, previously spread out flat, with unblended touches of pigment, and using transparent glazes to make it throb. At once he saw his canvas acquire unity, space, and light, gaining in power and in truth as well:

"He had, says E. Chesneau, stumbled upon one of the great secrets of Constable's power, a secret which is not taught in the schools and which too many of the professors themselves do not know: the fact that, in nature, a hue which seems uniform results from the union of a host of diverse hues, perceptible only to the eye that knows how to see. Delacroix had derived so much profit from this lesson that he would never forget it; we can be sure that it led him to his technique of modeling through hatching."

It may be added that Delacroix, confident in his own genius, openly acknowledged that he had been influenced by the English master.

In 1824, when he was painting *Le Massacre de Scio,* he wrote in his journal:

"Saw the Constables. Constable does me much good."

And farther on:

"I saw a sketch by Constable again: an admirable and unbelievable work."

And in 1847, the year in which, for the third time, he touched up his *Massacre,* he wrote the note which we have already cited, but which we will not fear to repeat, because it shows him to be already preoccupied with one of the most important aspects of the future technique of the Neo-Impressionists: the infinite gradation of elements.

"Constable says that the green of his meadows is of a superior quality because it is composed of a multitude of different greens. The greenery of the common flock of landscape painters lacks intensity and life because they ordinarily give it a uniform hue. What he says here of the green of meadows can be said of all tones."

And, in the evening of his life, Delacroix did not renounce the enthusiasm of his youth.

In 1850 he wrote to Théophile Silvestre:

"Constable, that admirable man, is one of the glories of England. I have already spoken to you about him and of the impression he made on me when I was painting *Le Massacre de Scio*. He and Turner are real reformers. Our school, which now abounds in men with this sort of talent, has greatly profited from their example. Géricault had come back completely stunned after seeing one of the large landscapes he had sent us."

It is therefore quite certain that Delacroix was initiated through Constable into the benefits to be obtained from gradation. He saw at once the considerable advantages to be derived from it. From henceforth he would banish all flat colors and make his color vibrate by means of glazing and hatching.

But soon the initiate, better informed of the resources which science offers to colorists, was to surpass his teacher.

5. In 1825, still deeply stirred by this revelation and disgusted by the insignificant, flaccid work of the painters who were then in fashion in France—Regnault, Girodet, Gérard, Guérin, and Lethière, the dreary pupils of David who were preferred to Prud'hon and Gros—Delacroix decided to go to London to study the English masters of color of whom his friends, the brothers Fielding and Bonington, had repeatedly written to him in terms of highest praise. He came back filled with wonderment at the unsuspected splendor of Turner, Wilkie, Lawrence, and Constable, and made immediate application of their teaching.

As we have said, it is from Constable that he derived his hatred of

flat colors and his technique of painting with hatchings; his love of pure, intense color was to be kindled by the paintings of Turner, who had already cast off all fetters. The unforgettable recollection of these strange, enchanting expanses of color would spur him on until his dying day.

Théophile Silvestre (*Les Artistes français* [The French Artists]) points out the similarity between these two kindred geniuses and the way in which the powers of each unfolded:

"We found, on viewing their canvases, that there was a great resemblance, in certain respects, between Delacroix's late style, light pink, silvery, and delightful in its gray, and Turner's late sketches. There is, however, not the slightest imitation of the English master by the French master; we will merely note that in their last years these two great painters display almost the same kind of color inspiration. They rise higher and higher in the light, and nature, losing for them day by day its reality, becomes an enchantment.

"He (Turner) had the idea that the most illustrious artists of all the schools, not excepting the Venetians, had fallen far short of the pure and joyous brilliance of nature, both because of their conventional darkening of the shadows and because of their refusal to make a forthright trial assault of their skill on all the lights exhibited to them by creation in its virgin state. He therefore experimented with the most brilliant and most novel colorations.

"Delacroix, a man even more ardent than Turner, and more pragmatic, did not venture out so far, but, like the English artist, he ascended imperceptibly from a harmony as dark as the sounds of a violoncello, to one which was as light as the strains of an oboe . . ."

6. His journey to Morocco (1832) was to be still more rewarding to him than his visit to England. He came back dazzled by the light and intoxicated by the harmony and power of Oriental color.

He studied the colors of carpets, fabrics, and faience. He saw that the elements of which they were composed, intense and almost gaudy when taken separately, are reconstituted as hues of extreme delicacy and are juxtaposed in accordance with immutable laws which ensure their harmony. He observed that a colored surface is only pleasing and brilliant to the extent that it is neither smooth nor uniform; that a color is beautiful only if it vibrates with a flickering luster which brings it to life.

Very quickly he found out the secrets and rules of the Oriental tradition. This knowledge would enable him, later on, to venture upon the most daring assemblages of hues and the most extreme contrasts, while still conserving their harmony and softness. From then on his works would reveal something of that flamboyant, resonant, and melodious Orient. His unforgettable impressions of Morocco would supply his varied chromatism with the tenderest of harmonies and the most dazzling of contrasts.

Charles Baudelaire, in his impeccable critique, has not failed to point out the influence that the Moroccan journey had on Delacroix's color:

"Observe that the general color in the paintings of Delacroix has also something of the color peculiar to Oriental landscapes and interiors."

CH. BAUDELAIRE (*Art Romantique*)

When he returned to France and became aware of the research of Bourgeois and Chevreul, he saw that the precepts of the Oriental tradition were in perfect accord with modern science. And, when he would go to the Louvre to study Véronèse, he realized that the Venetian master, of whom he says: *"All that I know, I owe to him,"* had also been initiated into the secrets and the magic of Oriental color, probably by Asians and Africans who, in his time, brought to Venice the riches of their art and of their industry.

7. He saw that a knowledge of the precise rules governing the harmony of colors, which he had found to be applied in the works of the master colorists and in Oriental decoration, would be of great assistance to him. He caught in nature the fleeting interplay of the complementary colors and wished to know the laws to which it is subject. He set about studying the scientific theory of color, and the reactions of successive and simultaneous contrasts. And, as the outcome of these studies, he would present the contrasts objectively on his canvas and use optical mixture.

8. Turning everything to his account, adopting the discoveries of some, and the techniques of others—and these acquisitions, far from diminishing his individuality, imparted to it increasing vigor,—Delacroix had at his disposal the richest chromatic repertoire ever possessed by any painter.

What a long road he had traveled since his first painting, *Dante et Virgile,* in which the color now seems to us quiet and almost dull, but which nevertheless appeared at first to be revolutionary in its boldness! Monsieur Thiers, one of the rare critics who defended this canvas when it was exhibited at the Salon of 1822, could not help finding it *"somewhat crude."*

Le Massacre de Scio, which was conceived under the influence of *Les Pestiférés de Jaffa* (The Victims of the Plague at Jaffa) by Gros, and in which the color benefits from Constable's influence, showed such progress and marked so categorically Delacroix's complete break with all official convention and academic method that his earliest defenders abandoned him. Gérard declared: *"This is a man who runs on the rooftops";* Monsieur Thiers was alarmed and reproved such audacity, and Gros said:

"Le Massacre de Scio is the massacre of painting!"

He then placed his incomparable science in the service of his fiery dash and daring and created for himself a technique founded entirely on method, calculation, logic, and on set purpose, which did not chill his impassioned genius but raised it to new heights.

9. This knowledge of the scientific theory of color allowed him, first of all, to harmonize two neighboring hues or to enhance by contrast, and to arrange pleasing encounters of hues and tones through the harmony of similar colors or the analogy of opposites. Then, as one advance led to another, this constant observation of the interplay of color led him to the use of the optical mixture and the exclusion of all

flat colors, which for him were disasters. From then on, he took good care not to spread a uniform color over his canvas: he made a hue vibrate by superimposing on it touches of one of its close neighbors. Example: a red would be hammered with touches, either of the same red in a lighter or darker tone, or of another red, slightly warmer—more orange—or a little colder—more violet.

Having thus raised the intensity of the hues through the vibration and gradation of tone upon tone and of small intervals, he created, by the juxtaposition of two more remote colors, a third hue resulting from their optical mixture. His rarest colorations are the result of this ingenious artifice and not of mixing on the palette. Suppose he wishes to modify a color, to calm or tone it down. He does not sully it by mixing it with an opposite color; he obtains the desired effect by superposing light hatchings which shift the hue in the desired direction without spoiling its purity. He knows that complementary colors enhance one another if they are opposed and destroy one another if they are mixed: if he desires brilliance, he obtains it by the contrast resulting from their opposition; on the other hand he uses their optical mixture to obtain hues which are gray, and not muddy, and which no amount of blending on the palette could render so fine and lustrous.

By juxtaposing in this manner neighboring or opposite elements, while varying their proportion or their intensity, he creates an infinite series of hues and tones unknown before, brilliant or delicate as his purpose dictates.

10. A few examples taken from the masterpiece, *Femmes d'Alger dans leur appartement* (Women of Algiers in Their Apartment), will illustrate the application of these various principles.

The orange-red bodice of the woman reclining at the left has a blue-green lining: these areas, in complementary hues, enhance one another in mutual harmony, and this favorable contrast gives the fabrics an intense brilliance and luster.

The negress's red turban stands out against a door-curtain striped in

varied colors, but it meets only the greenish stripe, the very one that creates the most satisfying harmony with this red.

Red and green alternate on the paneling of the wardrobe, providing another example of binary harmony: the violet and green of the floor tiles, the blue of the negress's skirt and the red of its stripes offer harmonies which are no longer those of complementary but more closely related colors.

After these examples of the analogy of opposites, we would have to cite almost every part of the painting as an application of the harmony of like colors. Each part quivers and vibrates, because of touches of tone upon tone, or of almost identical hues, for which the subtle master has hammered, dabbed, caressed, and hatched the various colors, having first laid them flat and then worked them over again by means of his ingenious method of gradation.

The outstanding brilliance and the glowing charm of this work are due not just to this use of tone on tone and of small intervals, but also to the creation of artificial hues resulting from the optical mixture of more remote elements.

The green trousers of the woman at the right are flecked with little yellow designs; this green and this yellow mix optically and create a local yellow-green which is really the soft, shining color of a silken fabric. An orange bodice is enhanced by the yellow of its embroideries; a yellow scarf, rendered more intense by red stripes, blazes out in the middle of the painting, and the blue and yellow ceramic tiles of the background merge in an indefinably green hue of rare freshness.

We will also mention the examples of gray hues obtained by the optical mixture of pure opposed elements: the white of the blouse worn by the woman at the right is interrupted by a soft, imprecise hue, created by the juxtaposition of little flowers in pink and green; the soft, shimmering hue of the cushion on which the woman at the left is reclining is produced by the mingling of little red and greenish embroideries which, being adjacent, are reconstituted as an optical gray.

11. This science of color which enables him, in this way, to harmonize the smallest details of the painting and to embellish its smallest surfaces also furnishes him with the means of controlling the chromatic composition and applying firm rules to achieve overall harmony.

Having established, through reasoned balance and skillful contrast, the physical harmony of his painting, from the smallest detail to the entire design of the work, the painter can, with equal scientific certainty, ensure its harmony in the mental sphere. Using this science as his inspiration directs, he decides on this or that arrangement and makes one color or another dominate depending on the subject he wishes to treat. On every occasion his color has an aesthetic language that fits his thought. The drama he has conceived, the poem he wishes to chant, are always expressed in an appropriate color. Eloquent color and lyrical harmony —in these lie the great strength of Delacroix's genius. This understanding of the aesthetic nature of color is the source of his ability to express his vision with such sureness and breadth and to paint successively triumphs, dramas, intimacies, and sorrows.

A study of the psychological aspect of color in the paintings of Delacroix would take us too far afield. Here we will simply refer to *La Mort de Pline* (The Death of Pliny), expressed by mournful harmonies of a dominant violet, and the calm of *Socrate et son démon familier* (Socrates and His Familiar Demon), obtained by the perfect balance of greens and reds. In *Muley-abd-er-Rahman entouré de sa garde* (Muley-abd-er-Rahman with His Guard), the tumult is conveyed by the almost dissonant harmony of the large green parasol against the blue of the sky, already highly charged by the orange of the ramparts. There is no better match for the subject of the *Convulsionnaires de Tanger* (Ecstatics of Tangier) than the extreme vividness of all the colors, carried on this canvas almost to a pitch of frenzy.

The tragic effect of *Le Naufrage de Don Juan* (The Shipwreck of Don Juan) is due to a dominant dark glaucous green, toned down with mournful blacks; the funereal effect of a white, a sinister glitter amidst all this gloom, completes the harmony of desolation.

In *Femmes d'Alger,* the painter wants to express not passion but simply the peaceful and contemplative life within a sumptuous interior: there is therefore no dominant, no *key* color. All the warm, cheerful hues will be balanced by their cool and tender complementary colors in a symphony of decoration, from which emerges a marvelous impression of a calm and delightful harem.

12. However, Delacroix had not yet arrived at all the brilliance and harmony which would eventually be his. If we continue our careful examination of *Femmes d'Alger,* which we have chosen as an example of the application of the scientific method, we shall see that it lacks the perfect unity in diversity that would characterize his last works.

Although the background, costumes, and accessories throb with an intense and melodious brilliance, the flesh tones of the faces may, in comparison, seem flat, somewhat dull, and out of harmony with the rest.

If the casket shines more brightly than the jewels it is because Delacroix has made the smallest surfaces of the fabrics, the door-curtains, the carpets, and the ceramics shimmer, by adding to them numerous minute details and little adornments, in multiple coloring which either calms down or stirs up these areas of the painting; whereas he has painted flesh in a hue which is almost monochromatic, because, in reality, it does have this appearance. He has not yet dared to introduce, in this painting, multicolored elements not justified by nature. Only later would he rise above cold accuracy and no longer fear to emphasize flesh tones by means of artificial hatchings in order to obtain more brilliance and light.

13. The riches of his palette are never exhausted. He gradually frees himself from the chiaroscuro of his first works. A more powerful chromatism invades the entire surface of his canvases; the black and the earthy colors disappear with the flat colors; pure and vibrant hues replace them: his color seems to become immaterial. Using optical mixture, he creates hues which generate light. If there were a little more light

in the Galerie d'Apollon or a little less timid caution in the Senate and the Chamber of Deputies, so that one could study Delacroix's decorations close up, it would be easy to see that the freshest hues and most delicate flesh tones have been produced by the juxtaposition of rough green and pink hatchings, and that the luminous brilliance of the skies is the outcome of a similar method. At a distance, these hatchings disappear, but the color which results from their optical mixture reveals itself powerfully, whereas a flat color, seen at this distance, would fade out or be lost.

Delacroix finally reaches the crowning achievement of his work: the decoration of the Chapelle des Saints-Anges (Chapel of the Holy Angels) at Saint-Sulpice. All the progress accomplished in forty years of effort and struggle is here summed up. He is now completely rid of the dark mixtures and bituminous grounds which obscure some of his works and are now coming to the surface, with resulting cracking and damage.

For the decoration of this chapel, he paints with nothing but the simplest and purest colors; he finally rejects the subordination of his color to chiaroscuro; light pervades the entire scene: not a single black hole, not one dark spot in discord with the other parts of the painting, no more opaque shadows or flat tints. He composes his hues from all the elements which are to enhance and enliven them, without any concern for imitating appearances or natural coloration. Color for the sake of color, with no other pretext! Flesh, decors, accessories, everything is handled in the same manner. There is now not one single particle of the painting which does not throb, quiver, or shimmer. Each local color is forced up to its maximum intensity, but always in harmony with its neighbor, each influencing the other. All the colors blend with the shadows and lights in a harmonious and colorful whole, perfectly balanced, where nothing is discordant. The melody emerges clearly from the variety of powerful elements which compose it. Delacroix has finally attained unity in complexity and brilliance in harmony, which he has been seeking all his life.

14. For half a century, therefore, Delacroix labored to achieve more brilliance and light, and in so doing showed the colorists who were to succeed him the path to follow and the goal to be attained. He still left much for them to do, but his contribution and teaching would greatly simplify their task.

He proved to them all the advantages of a scientific technique, of calculation and logic, in no way fettering the passion of the painter, but strengthening it.

He delivered to them the secret of the laws which govern color: harmony of like, analogy of opposites.

He showed them how inferior a uniform and flat coloring is to a hue produced by the vibration of diverse combined elements.

He secured for them the resources of the optical mixture, which makes possible the creation of new hues.

He advised them to banish as much as possible somber, muddy, and dull colors.

He taught them that it is possible to modify and tone down a hue without sullying it by mixing on the palette.

He pointed out to them the influence of color on the mind, which is a part of the painting's effect; he initiated them into the aesthetic language of hues and tones.

He called on them to venture all, to have no fear that their harmonies will be over-colored.

The mighty creator is also the great educator: his teaching is as valuable as his work.

15. It must however be recognized that Delacroix's paintings, despite his efforts and his science, are less luminous and less colorful than those of the painters who followed in his steps. *L'Entrée des Croisés* (The Entrance of the Crusaders) would appear somber between Renoir's *Déjeuner des Canotiers* (The Boating Party) and Seurat's *Le Cirque* (The Circus).

Delacroix drew from the romantic palette, overloaded as it was with colors, some brilliant, others—too many of them—earthy and somber, all that it could yield.

All that he needed to serve his ideal better was a more perfect instrument. To create such an instrument, he would merely have had to exclude from his palette the earthy colors that cluttered it to no purpose. He did them violence in order to extract some brilliance from them, but it did not occur to him to paint only with the pure and potent colors of the prism.

It was the task of another generation, that of the Impressionists, to make this further advance.

Everything is part of a chain and comes in its own due time: complication is followed by simplification. If the Impressionists simplified the palette, and achieved greater color and luminosity, they owe this to the experiments of the romantic master and to his struggles with the complicated palette.

Moreover, Delacroix needed those colors, muted and yet warm and transparent, which the Impressionists rejected. Bound by his admiration for the old masters, Rubens in particular, he was too deeply interested in their craft to abandon the rich mixtures, the brown concoctions, and the bituminous grounds which they had used. It is the use in most of his paintings of the classic techniques which gives these works their somber appearance.

There is a third reason: although he had studied the laws of complementary colors and optical mixing, Delacroix was far from knowing all their possibilities. During a visit which we paid to Chevreul at Les Gobelins, in 1884, which was our introduction to the science of color, the distinguished scientist told us that, around 1850, Delacroix, whom he did not know, had written to him expressing a wish to talk with him about the scientific theory of color and to ask him about several points which were still tormenting him. They arranged to meet. Unfortunately, Delacroix's chronic sore throat prevented him from going out on the day they had fixed. And they never did meet. Perhaps, if this had not

happened, the scientist would have made the painter's understanding more complete.

Théophile Silvestre recounts that, when Delacroix was in his prime, he was still saying: *"I see every day that I do not know my craft."* He had therefore a presentiment of methods more fruitful than those he had used. If he had known all the resources of optical mixing, he would have generalized the technique of juxtaposing hatchings of pure colors, which he had used in certain parts of his works; he would have painted only with colors which, as nearly as possible, approximate those of the solar spectrum.—The colored light which he had achieved in the flesh tones of his decorative paintings by striping them with *pronounced* green and pink, as Charles Blanc put it, would then have permeated all his works.

A saying attributed to Delacroix expresses his efforts well: *"Give me the mud of the streets,"* he declared, *"and I will turn it into the luscious colored flesh of a woman,"* by which he meant that, through contrast with other intense colors, he would change this mud and color it as he wished.

This is indeed the summing up of his technique: He strives to enhance dull mixture through the interplay of pure elements; he does his utmost to create light from muddy colors.

If only he had rejected this mud, instead of embellishing it!

But now other painters came forward who were to accomplish a new advance towards light by painting solely with the colors of the rainbow.

III

THE CONTRIBUTION OF THE
IMPRESSIONISTS

*Jongkind the forerunner. Renoir, Monet, Pissarro, Guillaumin, Cézanne,
Sisley.—They are first influenced by Courbet and Corot; Turner
leads them back to Delacroix.—The simplified palette.—Impres-
sionism.—Pure colors dulled by mixtures.—Sensation and method.*

1. The painters who, following after Delacroix, were to be the
champions of color and light, were those who eventually received the
name of *Impressionists:* Renoir, Monet, Pissarro, Guillaumin, Sisley,
Cézanne, and their admirable forerunner, Jongkind.

Jongkind was the first to reject the flat color, breaking up his col-
ors, fragmenting his touch to infinity, and obtaining the rarest coloring
by the combination of multiple, almost pure elements.

During this period, the future Impressionists were influenced by
Courbet and Corot—except for Renoir, whose style was derived from
Delacroix, of whose works he made copies and interpretations. They
still painted in large patches, flat and simple, and seemed to be seeking
white, black, and gray, rather than pure and vibrant colors, whereas
Fantin-Latour, the painter of *Hommage à Delacroix* (Homage to Dela-
croix) and of so many other solemn or serene works, was already using in
his drawings and paintings tones and hues which, if not intense, were at
least gradated and separated.

But in 1871, during a long stay in London, Claude Monet and
Camille Pissarro discovered Turner. They marveled at the splendor and
enchantment of his coloring; they studied his works and analyzed his
craft. They were in the first place struck by his snow and ice effects.
They were astonished to see how he had succeeded in producing the

sensation of the whiteness of the snow while they had so far been unable to achieve this with their large patches of ceruse (white lead) spread out flat with broad brushstrokes. They saw that this marvelous result was obtained not by a uniform white, but by a number of touches of diverse colors, placed side by side and reconstituting the desired effect at a distance.

This technique of multicolored touches, which first became apparent to them in these snow effects because they were surprised not to see such effects conveyed with the customary white and gray, was next displayed to them in the most intense and brilliant paintings of the English painter. It is this device that makes these pictures appear to have been painted not with common pastes but of colors that have no material substance.

2. When they returned to France, full of their discovery, Monet and Pissarro joined Jongkind, who had by then completely mastered the efficacious technique which enabled him to render on canvas the most fleeting and subtle interplay of light. They noted the similarity between his procedure and that of Turner; they understood the immense advantage to be derived from the purity of the one and the technique of the other. Little by little, the blacks and the earthy colors disappeared from their palettes, and the flat colors from their paintings, and soon they began to break down these hues and to reconstitute them on the canvas in tiny, juxtaposed, comma-shaped strokes.

In this way the Impressionists were led back, by the incontestable influence of Turner and Jongkind, to the technique of Delacroix, from which they had departed in their attempt to constitute the *tache* by opposing white and black. For is not the comma-shaped stroke of the Impressionists' paintings merely the hatching of the great decorations of Delacroix, reduced to the smaller scale required for painting directly from nature? It is really the same technique which each one of them is using in pursuit of the same end: light and color.

Jules Laforgue aptly noted this affiliation:

"The vibrant canvases of the Impressionists created by thousands of dancing specks. A marvelous discovery, anticipated by that mad enthusiast for movement, Delacroix, who in the cold fury of romanticism, and not satisfied with violent movements and raging color, modeled with vibrant hatchings."

NOTES POSTHUMES (*La Revue Blanche*, 15 May 1896)

3. But, while Delacroix used a complicated palette, composed of both pure and earthy colors, the Impressionists would use a simplified palette of seven or eight colors, the most brilliant, and the closest to those of the solar spectrum.

From 1874 on, Monet, Pissarro, Renoir—who was the first? it matters little—have no colors on their palettes besides yellows, oranges, vermilions, lakes, reds, violets, blues, and intense greens such as viridian and emerald.

This simplification of their palette, which affords them the use of only a very limited range of colors, inevitably leads them to break down the hues and multiply the components. They exert themselves to reconstitute color through the optical mixture of innumerable multicolored comma-strokes—juxtaposed, crossed, and jumbled together.

4. Profiting from these new resources—decomposition of hues, exclusive use of intense colors—they were able to paint landscapes of the Ile de France or Normandy which are much more brilliant and luminous than the Oriental scenes of Delacroix. For the first time, it is possible to admire landscapes and figures which are really sunlit. There is no further need for a somber, bituminous foreground, such as their precursors, even Turner, used for the purpose of contrast, to give their backgrounds the semblance of light and color.

The painting's entire surface glows with sunlight; the air flows freely; the light envelops, caresses, and casts its radiance over the forms, penetrates everywhere, even into the shadows, which it illuminates.

Captivated by the enchantments of nature, the Impressionists, through their swift and sure method of execution, succeeded in render-

ing the transience of the spectacles nature offers. They are the glorious painters of fleeting effects and swift impressions.

5. They achieved so much brilliance and brightness that they were bound to shock the public and the majority of painters, impervious as they were to the splendor and charm of color. Their canvases were driven out of the official Salons and, when they could be exhibited in the low mezzanines or small gloomy shops, they were the object of sneers and insults.

Nevertheless, they influenced Edouard Manet, who, until then, was more enamored of the *tache*, and the opposition between black and white, than of the play of color. Suddenly, his canvases became bright and golden. Henceforward, he would place his authority and genius at the service of the Impressionists, and would combat, in the official Salons, the hostility which they endured, both collectively and individually, during their independent exhibitions.

And for twenty years the struggle continued; but gradually, the adversaries, even the most obstinate of them, felt the Impressionists' influence. Palettes brightened up, the Salons became light almost at the expense of color. Winners of the Prix de Rome, with crafty incomprehension, plundered the innovators and vainly tried to imitate them.

Impressionism will certainly leave its stamp on an epoch in the history of art, not only through the outstanding achievements of these painters of life, movement, joy and sunlight, but also through the considerable influence it exercised on all contemporary painting, in which it renewed the use of color.

It is needless to trace the history of the movement here; we would merely seek to define the effective technical contribution of the Impressionists: simplification of the palette (colors of the prism exclusively) and decomposition of hues into multiple elements. Nevertheless, we who have profited from their experiments will allow ourselves here to express to these masters our admiration of their lifelong refusal to yield or compromise and for their work.

6. However, they did not obtain every possible advantage from their luminous, simplified palette.

What the Impressionists did was to admit only pure colors to their palettes; what they did not do, and remained to be done after them, was to maintain absolute respect, in all circumstances, for the purity of these pure colors. By mixing the pure elements at their disposal, they reconstituted the dull, somber hues, precisely those they apparently wished to banish.

Not only did they tone down their pure colors by mixing them on the palette, but they also diminished their intensity still further by allowing chance brushstrokes to bring opposite elements together on the canvas. In the cheerful abandon of their rapid execution, an orange touch collides with a touch of blue which is still fresh, a slash of green crosses madder which is not yet dry, violet sweeps over yellow, and this repeated mixing of opposing molecules spreads over the canvas a gray which is neither optical nor delicate, but pigmentary and dull, and which singularly diminishes the brilliance of their painting.

7. Furthermore, there are illustrious examples that would suggest that, for these painters, muted colors are not without charm, and dull tones not devoid of interest. Has not Claude Monet, in certain canvases from the admirable series of *Cathédrales* (Cathedrals), used his finest endeavor to blend together all the gems of his dazzling palette in order to obtain in complete fidelity to the original, the gray, murky hue of the old walls, crumbling beneath their mould? In the paintings of Camille Pissarro's late period there is not the least trace of pure color. In particular, in his *Boulevards* of 1897–98, the great painter strove to reconstitute, by complex mixtures of blue, green, yellow, orange, red, and violet, the dismal, lifeless hues of the mud in the streets, of the decaying houses, the chimney soot, the blackened trees, the leaden roofs and the rain-soaked crowds, which he sought to represent in their sad reality. But, in this case, why exclude ochres and earth colors, which still have a warm and transparent beauty and provide gray tints which are much more delicate

and varied than those obtained by grinding up pure colors? Of what use are such fine materials if their brilliance is to be dimmed?

Delacroix strove to create light with colors devoid of it: the Impressionists who, by right of conquest, have light on their palette, extinguish it.

8. We must also point out that, in their use of optical mixing,[1] the Impressionists reject all precise scientific methods. As one of them so delightfully expressed it: *"They paint the way birds sing."*

In this respect, they are not the successors of Delacroix who—as we have shown—attached so much importance to a sure and certain technique for the application of the laws which govern color and regulate its harmony.

Though they were aware of these laws, the Impressionists did not apply them methodically. On their canvases, one contrast will be observed, and another omitted; one reaction will be correct, another questionable. An example will show just how deceptive sensation can be if it is not controlled. Our Impressionist is painting a landscape from nature: He has before him green grass or leaves, partly in sunlight, partly in shadow. In the green of the shadowed areas which are closest to sunlit spaces, the keen eye of the painter senses a fleeting sensation of red. Pleased that he has perceived this coloring, the Impressionist swiftly places a touch of red on the canvas. But, in his haste to capture the sensation, he scarcely has time to verify the precision of this red which, subject in some degree to the whim of the brushstroke, is expressed as an orange, a vermilion, a lake ... even a violet. It was, however, a very

1 A pigmentary mixture is a mixture of material colors, a mixture of colored pastes. An optical mixture is a mixture of colored lights, for example, the mixture, at a particular point on a screen, of beams of light of diverse colors.—Of course, a painter does not paint with rays of light. But, just as a physicist can create the phenomenon of optical mixture by the device of a rapidly turning disk divided into diversely colored segments, so can a painter recreate it by the juxtaposition of tiny multicolored touches. On the rotating disk, or at a distance from the painter's canvas, the eye will isolate neither the colored segments nor the touches: It will only perceive the resultant of their lights, in other words, the *optical* mixture of the colors of the segments, the *optical* mixture of the colors of the touches. (Signac's note)

precise red, strictly subordinated to the green, and not just any red. If the Impressionist had known this law—*shadow is always slightly tinted by the complementary of the light*— he could have just as easily produced the exact red, purple for a yellow-green, orange for a blue-green, as the chance red with which he contented himself.

It is hard to see how science could, on this occasion, have done harm to the improvisation of the artist. On the contrary, we see clearly the advantages of a method which forestalls such discords; for, minimal though they are, they do not contribute to the beauty of a painting any more than faults of harmony enhance a musical score.

9. Absence of method often causes the Impressionist to err in the application of contrast. If the painter is alert or if the contrast is very pronounced, the clearly felt sensation will find its exact means of expression; but, in less favorable circumstances, when contrast is perceived only vaguely, the sensation will remain unexpressed or will be conveyed without precision. And in Impressionist paintings, we will in fact come upon the shadow of a local color which is not the exact shadow of that hue, but of another more or less analogous to it, or even find a hue which is not logically modified by the light or the shadow: a blue, for example, more colored in light than in the shadow: a red warmer in the shadow than in the light, a light which is too dim or a shadow which is too brilliant.

This same arbitrariness appears in the way in which the Impressionists fragment their color. It is agreeable to observe their questing insight at work, but some guiding notions would not seem to be out of place. Not having such notions, and not wishing to miss any fortunate chance, they test out their palette on the canvas, putting a little of *everything* everywhere. This polychromatic turmoil contains antagonistic elements: As they neutralize each other, so do they dull the entire painting. In a strong contrast of light and shade, these painters will add blue to the orange of light, and orange to the blue of shadow, thus turning to gray both of the hues they wished to render more intense through opposi-

tion, and attenuating thereby the effect of contrast they were apparently seeking. An orange light will not have, as its counterpart, the appropriate blue shadow, but a green or violet shadow, an approximation. In one single picture, one part will be illuminated by red light, another by yellow light, as if the time could be, simultaneously, two o'clock in the afternoon and five o'clock in the evening.

10. Observation of the laws of color, exclusive use of pure hues, abandonment of all muted mixtures, methodical balancing of elements —these were the further advances which the Impressionists left to be accomplished by the painters anxious to take up their search.

IV

THE CONTRIBUTION OF THE
NEO-IMPRESSIONISTS

*Impressionism and Neo-Impressionism.—Georges Seurat: Un dimanche
à la Grande-Jatte.—Exclusive use of pure hues and optical
mixing.—Divisionism: it guarantees maximum brilliance and inte-
gral harmony.—A matter of technique and not of talent.—Neo-
Impressionism stems from Delacroix and the Impressionists.—The
common technique allows free play for individuality.*

1. It was in 1886, at the last exhibition of the Impressionist group
—"*8th Exhibition of Paintings by Mrs. Marie Bracquemont, Miss Mary
Cassatt, Messrs. Degas, Forain, Gauguin, Guillaumin, Mrs. Berthe Mori-
sot, Messrs. Camille Pissarro, Lucien Pissarro, Odilon Redon, Rouart,
Schuffenecker, Seurat, Signac, Tillot, Vignon, Zandomeneghi—from
May 15th to June 15th—1, rue Lafitte*"—that, for the first time, works
were shown which were painted solely in pure hues, separated, balanced,
and optically mixed, in accordance with well-reasoned method.

Georges Seurat, the inaugurator of this new advance, exhibited
there the first divided painting, *Un Dimanche après-midi à l'Ile de la
Grande-Jatte* (Sunday Afternoon on the Island of the Grand Jatte), an
epoch-making picture, and one which testified to exceptional artistic
skill; around this work, Camille Pissarro, his son Lucien Pissarro, and
Paul Signac also exhibited canvases painted in accordance with a closely
similar technique.

The unaccustomed brilliance and harmony of the paintings of these
innovators were noticed at once, though not well received. These quali-
ties were obtained by applying the fundamental principles of *division-
ism.* Since that time, the technique, advanced by the experimentation
and the contributions of Messrs. Henri-Edmond Cross, Albert Dubois-

Pillet, Maximilien Luce, Hippolyte Petitjean, Théo van Rysselberghe, Henri van de Velde, and some others, has not ceased to develop, despite sad deaths, and attacks and desertions notwithstanding; it has culminated in the precise method which we outlined at the beginning of this study and designated as the technique of the Neo-Impressionist painters.

If these painters, whose specific quality would be caught better by the epithet *chromo-luminarists,* have adopted the name of *Neo-Impressionists,* their aim was not the servile courting of success (the Impressionists were, at the time, still immersed in their struggle); they desired to pay tribute to the work of their precursors and to reveal the common goal underlying the divergence of method, namely: *light* and *color.* It is in this sense that the term *Neo-Impressionist* must be understood, for the technique used by these painters has nothing in common with Impressionism: whereas the method of their predecessors depends on instinct and immediacy, they have founded their own on reflection and permanence.

2. The Neo-Impressionists, like the Impressionists, have only pure colors on their palette. But they totally reject any mixing on the palette, except, of course, the mixture of colors which are contiguous on the chromatic circle. The latter, gradated among themselves and lightened with white, will tend to reconstitute the diverse hues of the solar spectrum and all their tones. An orange, mixed with a yellow and a red, a violet shading into red and blue, a green passing from blue to yellow, are, with white, the only elements at their disposal. But, by varying the proportion of this handful of pure colors so as to mix them optically, they obtain an infinite number of hues, ranging from the most brilliant to the most gray.

Not only do they banish from their palettes any mixture of muted colors, they also avoid sullying the purity of their colors through the encounter of opposite elements on their support. Every brushstroke, taken pure from the palette, remains pure on the canvas.

So, just as if they were using colors prepared from more brilliant powders and more sumptuous materials, they may claim that their brightness and coloring exceeds that of the Impressionists, who dim to grayness the pure colors of the simplified palette.

3. The technique of *divisionism* must do more than assure maximum brightness and coloration through the optical mixture of pure elements: By proportioning and balancing such elements, in accordance with the rules of contrast, gradation and irradiation, it guarantees the integral harmony of the work.

These rules, which the Impressionists observed only intermittently and instinctively, were always and rigorously applied by the Neo-Impressionists. Their precise scientific method does not disable their power to sense; it guides and protects it.

4. It would seem that the painter, standing in front of his white canvas, must have, as his first preoccupation, the choice of the curves and arabesques which will mark out the surface, and of the hues and tones which will cover it. This is a rare enough concern in a time when most paintings resemble instantaneous photographs or futile illustrations.

To reproach the Impressionists for neglecting such concerns would be childish, because their intention was obviously to grasp the arrangements and the harmonies of nature, as they present themselves, and to be totally untroubled by order or combination. *"The Impressionist sits on the bank of a river,"* as their critic Théodore Duret puts it, and paints what he has in front of him. And they proved that, in this manner, one could work wonders.

The Neo-Impressionist, herein following the advice of Delacroix, will not begin a canvas before he has determined how it shall be arranged. Guided by tradition and science, he will harmonize the composition with his conception; that is to say, he will adapt the lines (directions and angles), the chiaroscuro (tones), and the colors (hues), to fit the

character that is to dominate. The dominant line will be horizontal for calm, ascending for joy, and descending for sadness, with all the intermediate lines representing all the other sensations in their infinite variety. A polychromatic interplay, no less expressive and diverse, is coupled with the play of lines: Ascending lines will be matched with warm hues and light tones, while with descending lines, cool hues and dark tones will predominate; a more or less perfect balance of warm and cool hues, and of pale and intense tones, will add to the calm of the horizontal lines. By thus subordinating color and line to the emotion he has felt and seeks to render, the painter will play the role of a poet, a creator.

5. In general terms it can be said that a Neo-Impressionist work is more harmonious than a painting by an Impressionist for, in the first place, the constant attention to contrast produces a more exact harmony in its details and, secondly, its rational composition and aesthetic language of colors bestow on it an overall harmony and a harmony of an intellectual order which the Impressionist work renounces.

Far be it from us to compare the merits of these two generations of painters; the Impressionists are established masters whose glorious task is done and has secured acceptance. The Neo-Impressionists are still experimenting and understand how much remains for them to do.

It is a question not of talent but of technique, and we display no lack of due respect to these masters if we say: the Neo-Impressionist technique guarantees, more than does theirs, the full integration of brightness, color, and harmony. We have likewise found it possible to say that the paintings of Delacroix are less luminous and colorful than those of the Impressionists.

6. Neo-Impressionism, which is characterized by this quest for total purity and complete harmony, is the logical extension of Impressionism. The adepts of the new technique have merely brought together, set in order, and developed the researches of their precursors. Is not *divisionism,* as they understand it, comprised of the elements of Impres-

sionism, combined into a system: brilliance (Claude Monet), contrast (which Renoir almost always respects), and the technique of small touches (Cézanne and Camille Pissarro)? Does not the example of Camille Pissarro, who, in 1886, adopted the procedure of the Neo-Impressionists, thus shedding on the nascent group the luster of his great renown, reveal the link which unites them to the preceding generation of colorists? There is no abrupt change perceptible in his works but, little by little, the grayish mixtures disappeared, reactions were noted, and the Impressionist master, simply by a process of evolution, became a Neo-Impressionist.

In any case, he has not continued along this path. As a direct descendant of Corot, he does not seek brilliance through opposition, as did Delacroix, but softness through the encounter of similar colors; he will take care not to juxtapose two remote hues in order to obtain a vibrant note through their contrast, but rather exerts himself to diminish the distance between these two hues by mixing each with intermediate elements which he calls *passages*. But, the Neo-Impressionist technique is based precisely on the contrast for which he feels no need, and on the brilliant purity of the hues, which are an affliction to his eye. From *divisionism* all he has taken is the method, the *petit point* (dot), the use of which is precisely to permit the notation of this contrast and the preservation of this purity. It is therefore very understandable that this device, which gives indifferent results when used in isolation, did not hold his interest.

There is another mark of affiliation: *divisionism* appeared for the first time at the last exhibition of the Impressionist painters. There, these masters welcomed the innovative works of Seurat and Signac as being well within their tradition. Only later, when the importance of the new movement became clear, did the split occur, and then the Neo-Impressionists exhibited separately.

7. If Neo-Impressionism derives directly from Impressionism, it also owes much to Delacroix, as we have seen. It represents the fusion

and development of the doctrines of Delacroix and of the Impressionists, a return to the tradition of the former with all the benefits of the contribution made by the latter.

As proof we will cite the genesis of Georges Seurat and Paul Signac.

Georges Seurat studied at the Ecole des Beaux-Arts, but his intelligence, his will, his clear and methodical mind, his very pure taste and his painter's eye saved him from the School's detrimental influence. Diligently frequenting museums, leafing through art books and engravings in libraries, he drew from his study of the classical masters the strength to resist the teachings of his professors. During these studies, he observed that there are analogous laws governing line, chiaroscuro, color, and composition, both in Rubens and in Raphael, and in Michelangelo and in Delacroix: rhythm, measure, and contrast.

The Oriental tradition, the writings of Chevreul, Charles Blanc, Humbert de Superville, O. N. Rood, and H. Helmholtz gave him guidance. He analyzed the works of Delacroix at length, easily observing in them the application of the traditional laws regarding both color and line and saw clearly what still remained to be done to accomplish the progress glimpsed by the romantic master.

Seurat's studies gave birth to his sound, fertile theory of contrast, to which he thereupon submitted all his works. He first applied it to chiaroscuro: Using such simple resources as the white of a sheet of Ingres paper and the black of a conté crayon, skillfully gradated or contrasted, he executed some four hundred drawings, the most beautiful *painter's drawings* in existence. This perfect science of values makes it possible to say that these *drawings in black and white* are more luminous and colorful than many paintings. Then, having thus mastered contrast of tone, he occupied himself with hues in the same manner and, from 1882 onwards, he applied the laws of contrast to color and painted with separated elements—using muted colors, it is true—without being influenced by the Impressionists, whose very existence was, at this time, unknown to him.

Paul Signac, on the other hand, from the time of his first studies in

1883, felt the influence of Monet, Pissarro, Renoir, and Guillaumin. He was not associated with any studio and it was while working directly from nature that he captured the harmonious interplay of simultaneous contrast. Then, while studying with admiration the works of the Impressionist masters, he came to the idea that they had a scientific technique; it seemed to him that the multicolored elements, whose optical mixture reconstitutes the hues in their paintings, were separated methodically, and that the reds, yellows, blues, and greens were arranged in accordance with absolute rules. The effects of contrast, which he had observed in nature without knowing their laws, appeared, so he thought, to have been applied by the Impressionists in accordance with a theory.

A few lines from *L'Art Moderne* (Modern Art) by J.-K. Huysmans, in which, speaking of Monet and Pissarro, he discusses complementary colors, yellow lights, and violet shadow, led Signac to assume that the Impressionists understood the science of color. He attributed the splendor of their works to this knowledge and felt himself to be a zealous disciple when he studied, in Chevreul's book, the straightforward laws of simultaneous contrast.

Knowing the theory, he was able to state the contrasts with objective precision, whereas he had hitherto only noted them empirically, and with a greater or lesser degree of correctness dependent on the vagaries of sensation.

Each local color was haloed by its true complementary color, shading into the adjacent color through swept-over strokes which, by their interplay, intimately mixed the two elements. This method was acceptable when the local color and the reaction of the neighboring color were of analogous or closely related hues, such as blue on green, yellow on red, etc. But when these two elements were opposites, such as red and green, or blue and orange, they blended to form a dull, soiled pigmentary mixture. His disgust with these blemishes led him inevitably, step by step, to the separation of the elements into distinct touches, that is, to optical mixing, which offers the only means of shading two opposite colors into one another, without tarnishing their purity. And so he came

to simultaneous contrast and optical mixing, along a very different path from that followed by Seurat.

In 1884, at the first exhibition of the group called Les Artistes Indépendants (The Independent Artists), in the huts in the Tuileries, Seurat and Signac met each other for the first time. Seurat exhibited his *Baignade* (The Bathers), which had been refused at the Salon of the same year. This work was painted in large flat strokes, swept over one another, and fed by a palette composed, like that of Delacroix, of both pure and earth colors. The use of these ochres and earth colors dulled the painting and made it seem less brilliant than those which the Impressionists painted with a palette reduced to the colors of the prism. But the artist's respect for the laws of contrast, his methodical separation of the elements—light, shade, local color, reactions—and the correct proportioning and balance of these elements, bestowed upon the canvas a perfect harmony.

Signac showed four landscapes painted solely with the colors of the prism, applied to the canvas in tiny comma-shaped touches after the manner of the Impressionists, but already free of mixtures toned down on the palette. Contrast was respected and the elements were mixed optically, but without the precision and balance of Seurat's rigorous method.

Enlightened by their mutual experimentations, Seurat soon adopted the Impressionists' simplified palette and Signac turned to good account the very valuable contribution of Seurat: the methodically balanced separation of elements.

And, as we saw at the beginning of this chapter, the two of them, together with Camille and Lucien Pissarro, whose enthusiasm had been aroused, represented the beginning of Neo-Impressionism at the Impressionist exhibition of 1886.

8. All those Neo-Impressionist paintings look the same, and their creators' personalities are obliterated by the method they use in common: such will be the comment of a visitor to the exhibitions.

Undoubtedly, that visitor was trained a long time ago to distinguish the works of the painters only with catalogue in hand. One must indeed be highly resistant to the interplay of color and have but little awareness of the delights of harmony to confuse a Seurat, with its golden glow, its delicacy, its local colors softened by light and shade, and a Cross, where the local colors explode, dominating the other elements.

Show some illuminated manuscripts from Epinal and some Japanese prints to children or primitive people: They will not be able to distinguish between them. But people with some rudiments of artistic education will already be able to discern the difference between these two kinds of images. And others, more informed, will be able to attach the name of an artist to each Japanese print.

Show them paintings by different Neo-Impressionists: Those in the first group will say they are paintings "like the others"; those in the second will call them all *pointillés* (dotted) without discrimination; and only adepts in the third group will be able to recognize the personality of each painter.

Just as there are people incapable of distinguishing a Hokusai from a Hiroshige, a Giotto from an Orcagna, a Monet from a Pissarro, so there are those who confuse a Luce with a van Rysselberghe. These beginners should complete their artistic education.

9. The truth is that as many differences exist among the Neo-Impressionists as, for example, among the various Impressionists. If a Neo-Impressionist sacrifices this or that element to the sense he wishes to give his work (judging that there is more to be gained from contrasts of light than the pursuit of local color, or conversely), his personality, if he has one, will there find reason—among a hundred others we could cite—to express itself with the most intense frankness.

If a technique has produced the great synthetic compositions of Georges Seurat, the graceful or powerful portraits of van Rysselberghe, the ornamental canvases of van de Velde; has enabled Maximilien Luce to portray streets, people, and labor; Cross to express the rhythm of

movement in harmonious decors; Charles Angrand to depict life in the countryside; Petitjean to capture the slender nudity of nymphs; and has had the suppleness to adapt itself to temperaments so distinct, and to bring forth works of such variety, could it, out of anything but malice or ignorance, be accused of annihilating the personality of those who adopt it?

The discipline of the *divided touch* has not been harder for them than the constraint of rhythm is for a poet. Far from harming their inspiration, it has given their works an austere, poetic content, removed from optical illusion and anecdote.

Delacroix too thought that the constraint of a well-reasoned and precise method could only enhance the style of a work of art.

"I see painters as prose writers and poets. Rhyme fetters them; the indispensable shaping of the verse, which gives it so much vigor, is analogous to the hidden symmetry and the balance, the fruit of both skill and inspiration, which governs the encounters or the divergence of lines, the *taches*, the highlights of color."

V

THE DIVIDED TOUCH

The divided touch of the Neo-Impressionists; it alone permits optical mixing, purity, and proportion.—Divisionism and the point (dot).—Delacroix's hatchings, the comma-stroke of the Impressionists, the divided touch, identical conventional methods; why accept the first two and not the third? it is not more troublesome and offers advantages over the other two.—Divisionism and decorative painting.

1. In the Neo-Impressionist technique, many, because they are insensible to the results of harmony, color, and light, have seen only the method. This technique, the effect of which is to ensure such results through the purity of the elements, their balanced proportions, and their perfect optical mixture, does not reside necessarily in the point (dot), as they imagine, but in any touch of any form that is precise, not swept over, and of a size proportioned to that of the picture:—the touch may have any form, because its purpose is not to create optical illusions but to render truly the diverse colored elements of the hues; its precision allows it to be proportioned; it is not swept over and therefore retains its purity; its dimensions are proportional to the size of the painting and uniform for that painting, so that, at a normal distance, the optical mixture of dissociated colors occurs easily and reconstitutes the hue.

How can one otherwise note with precision the interplay and encounter of opposed elements: the quantity of red that tinges the shadow of a green, for example; the effect of an orange light on a blue local color or, inversely, of a blue shadow on an orange local color? . . . If these antagonistic elements are combined otherwise than by optical mixing, the outcome will be a muddy hue; if the touches are swept over one another soiling is likely to occur; if they are juxtaposed as touches which

are imprecise, though pure, methodical proportioning will no longer be possible and there will always be one element dominating at the expense of the others. This technique has the further advantage that it guarantees to each colored pigment its maximum intensity and full bloom.

2. This *touche divisée* (divided touch) of the Neo-Impressionists, though disciplined by the new technique, is the same procedure as the hatching of Delacroix and the comma-stroke of the Impressionists.

These three techniques have a common aim: to give color its greatest possible brilliance, by creating colored lights through the optical mixing of juxtaposed pigments. Hatchings, comma-strokes, divided touches are three conventional methods, identical, but each accommodated to the particular requirements of a corresponding aesthetic: so the interlinking of the techniques runs parallel to that of the aesthetic conceptions, and doubles the bond which unites so closely the master of Romanticism, the Impressionists, and the Neo-Impressionists.

Delacroix, that soaring and yet thoughtful spirit, covers his canvas with impetuous hatchings, which, for all their fine fury dissociate color methodically and precisely: and, by this method, which favors optical mixing and rapid modeling that follows the form, he satisfies his double concern for color and movement.

Eliminating all dull or somber colors from their palette, the Impressionists had, with the small number left to them, to reconstitute an extended spectrum. Thus they were led to a technique which was more fragmented than that of Delacroix and, instead of his romantic hatchings, they executed tiny strokes laid on from the tip of a lively brush and entangled in a multicolored cluster—adroit methods, well-suited to an aesthetic compounded wholly of sudden, fleeting sensation.

Jongkind, before them, and also Fantin-Latour, had used a similar technique, but had not gone to such lengths in fragmenting their touch. At the beginning of the 1880s, Camille Pissarro (paintings of Pontoise and Osny) and Sisley (landscapes of the Bas-Meudon and at Sèvres) exhibited canvases painted with complete fragmentation. At that time,

parts of Claude Monet's paintings displayed this same manner, alongside areas of light, flat scumbling. Only later did this master appear to abandon all uniform hues and cover the entire surface of his canvases with multiple comma-strokes. Renoir likewise separated his elements, but into touches which were larger—as demanded by the size of his canvases—and flatter, swept by his brush over one another. Cézanne, seeking neither to imitate nor to display dexterity, juxtaposed, by means of square, precise touches, the diverse elements of the decomposed hues, and came closer to the methodical *divisionism* practiced by the Neo-Impressionists.

These latter painters attach no importance to the form of the touch, because they do not require that it should model, express a feeling, or imitate the form of an object. For them, a touch is only one of the infinite colored elements which will, when assembled, compose the painting, an element having precisely the same importance as a note in a symphony. Sad or cheerful sensations and calm or animated effects will be expressed, not by virtuosity with the brush, but by the combinations of lines, hues, and tones.

Is not this simple, precise mode of expression, the *divided touch,* in full accord with the clear and methodical aesthetic of the painters who use it?

3. The Impressionists' comma-shaped stroke, in some cases, plays the expressive role of the hatchings in Delacroix as, for example, when it renders the form of an object—leaf, wave, blade of grass, etc.—but, at other times, like the Neo-Impressionists' *divided touch,* it represents only the colored components, separated and juxtaposed, which can be reconstituted by optical mixing. It is clear that when the Impressionist wishes to paint objects with a uniform flat appearance—blue sky, white linen, monochrome paper, a nude, etc.—and he renders them by means of small multicolored commas, the role of these touches can only be explained by his need to adorn the surfaces by multiplying upon them the colored components, without any regard for copying nature. The

Impressionists' comma-stroke is therefore a transition from the hatchings of Delacroix to the Neo-Impressionists' *divided touch,* for it plays the role of either technique, depending on the circumstances.

Likewise, Cézanne's stroke is the connecting link between the Impressionist and the Neo-Impressionist manner of execution. The common, but differently applied, principle of the optical mixture unites these three generations of colorists who, using similar techniques, all seek light, color, and harmony. They have the same end in view and, to achieve it, they use almost the same means. . . . The means have undergone refinement.

4. *Divisionism* is a complex system of harmony, an aesthetic rather than a technique. The *point* (dot) is only a means.

To divide means to seek the power and harmony of color by representing colored light through its pure elements and by using the optical mixture of these pure elements, separated and measured out in accordance with the essential laws of contrast and gradation.

Separation of elements and optical mixture ensure purity, that is to say, the brightness and intensity of the hues; gradation enhances their luster; contrast, regulating the agreement of like colors and the analogy of opposites, subordinates these powerful yet balanced elements to the rules of harmony. The basis of *divisionism* is contrast: Is not contrast art?

Pointiller (dotting) is the mode of expression chosen by the painter who places color on canvas in *petits points* (small dots) instead of spreading it out flat. He covers a surface closely with little multicolored touches, pure or dull, striving to reproduce, by optical mixing of these multiple elements, the varied hues of nature, without seeking balance or caring for contrast. The *point* (dot) is only a brushstroke, a procedure, and, like all procedures, of minor importance.

The *point* (dot), as a word or as a procedure, has been used only by those who, because they cannot appreciate the importance and delight of the contrast and balance of elements, have seen only the method and

not the spirit of *divisionism*.

Some painters have tried to secure the advantages of *divisionism* and have not been successful. And certainly, among their works, the paintings in which they tried out this technique are inferior in harmony, if not in brightness, to those which preceded or followed their periods of experimentation. The reason is that the technique alone was used, while the "divina proportione" was absent. They must not hold *divisionism* responsible for their failure: they dotted (*pointillé*) and did not divide (*divisée*) . . .

At no time have we heard Seurat, Cross, Luce, van de Velde, van Rysselberghe, or Angrand talk of dots, or seen them preoccupied with dotting (*pointillé*).—Read Seurat's lines, dictated to his biographer Jules Christophe:

"Art is Harmony, Harmony is the analogy of Opposites, the analogy of what is Similar, of tone, hue, and line; tone, that is to say light and dark; hue, that is to say red and its complementary green, orange and its complementary blue, yellow and its complementary violet. . . . The means of expression is the optical mixture of tones and hues and of their reactions (shadows) in accordance with firmly fixed laws."

In these principles of art, which are those of divisionism, is there any reference to the use of *dots*? Or any trace of a petty concern with the technique of *pointillage* (dotting)?

Moreover, one can *divide* without *dotting*.

Consider an oil study made by Seurat from nature, on a wood panel, from the bottom of a small cigar box; it is not *dotted* but *divided* because, despite its hasty execution, the touch is pure, the elements are balanced, and contrast is respected. And it is these qualities alone, and not a minute application of tiny strokes, that comprise divisionism.

The technique of *dotting* has a more modest role: it simply renders a painting's surface more vibrant, but it does not ensure brightness, intensity of coloring, or harmony. For complementary colors, which are friends and enhance each other when contrasted, are enemies that destroy each other when mixed, even optically. A red surface and a green

surface, contrasted, stimulate each other, but red dots mixed with green dots form a gray, colorless mass.

Divisionism in no way requires a touch shaped like a *dot*. It can use this touch for small canvases, but utterly rejects it for larger compositions. The size of the *divided touch* must be proportioned to the size of the work, otherwise the picture is liable to lose its color. The *divided touch,* that changing, living "light," is therefore not the *point,* which is uniform, dead "matter."

5. It should not be thought that the painter who *divides* is laboring away at the tedious task of riddling the height and breadth of his canvas with little multicolored touches. Starting from the contrast of two hues, and disregarding the surface to be covered, he will oppose, gradate, and proportion his diverse elements on each side of the dividing line until he encounters another contrast, a new gradation. And so, through succeeding contrast, the canvas will be covered.

The painter has played on his keyboard of color, just as a composer handles the diverse instruments to orchestrate a symphony: he has modified the rhythms and measures to suit his wishes, attenuated one element while enhancing another, and produced infinite modulations of a particular gradation. As he gives himself up to the joy of directing the interplay and strife of the seven colors of the prism, he will be like a musician multiplying the seven notes of the scale to produce his melody. How dismal, in comparison, is the toil of the pointillist. . . . And is it not natural that the many painters who have briefly used the *dot* for reasons of fashion or conviction have since abandoned this wearisome labor, despite the enthusiasm they had for it at first?

6. The hatchings of Delacroix, the comma-stroke of the Impressionists, and the Neo-Impressionists' *divided touch* are identical technical conventions which serve to give more brilliance and splendor to color by eliminating all flat hues; they are the devices of artists for embellishing the painting's surface.

The first two techniques, hatchings and comma-strokes, are now accepted; but so far the third, the *divided touch,* is not.—"Nature does not look like that," people say. "There are no multicolored spots on the face."—But does the face then display black, gray, or brown, or hatchings, or comma-strokes? The black of Ribot, the gray of Whistler, the brown of Carrière, the hatchings of Delacroix, the comma-strokes of Monet, and the Neo-Impressionists' *divided touches* are devices which these painters use to express their particular vision of nature.

In what respect is the divided touch more of a convention than the other methods? Why should it be more embarrassing? As a simple colored element it can, through its very impersonality, lend itself to any subject.

And, if it is a merit for a process in art to match the processes in nature, we may observe that nature paints with nothing but the colors of the solar spectrum, infinitely gradated, and does not leave room for one square millimeter of flat color. Is not *divisionism* the method which conforms more than any other to this natural technique? And does a painter render a finer tribute to nature when by striving, like the Neo-Impressionists, to recreate on the canvas the light, its essential principle, or by slavishly copying it from the smallest blade of grass to the tiniest pebble?

We will moreover endorse the following aphorisms of Delacroix:

"Cold exactitude is not art."
"The artist's purpose is not to reproduce objects exactly."
"For, what is the supreme end of every kind of art, if not the effect?"

7. The effect sought by the Neo-Impressionists, and obtained by *divisionism,* is a maximum of light, coloration, and harmony. Their technique therefore appears to be well suited to decorative compositions, to which some of them have indeed applied it from time to time. But, being cut off from official commissions, and having no large walls to decorate, they await the time when they will be allowed to execute the great undertakings of which they now dream.

At the viewing distance required by the usual dimensions of works of this kind, the details of the technique, suitably adapted, will disappear, and the separated elements will be reconstituted into brilliantly colored lights. The *divided touches* themselves will be as invisible as the hatchings of Delacroix in his decorations of the Galerie d'Apollon (Gallery of Apollo) or the Senate library.

Moreover, these *divided touches,* which can be shocking when seen too close, will be only too easily removed by the hand of time. In a few years the impastos diminish, the colors run into one another, and the painting will then be only too well unified.

"A painting is not to be sniffed," said Rembrandt. When listening to a symphony, one does not sit in the midst of the brass, but in the place where the sounds of the different instruments blend into the harmony desired by the composer. Afterwards one can enjoy dissecting the score, note by note, and so study the manner of its orchestration. Likewise, when viewing a divided painting, one should first stand far enough away to obtain an impression of the whole, and then come closer in order to study the interplay of the colored elements, supposing that these technical details are of interest.

If Delacroix could have known all the resources of *divisionism,* he would have overcome all the difficulties he encountered when decorating the Salon de la Paix (Hall of Peace), at the Hôtel de Ville (City Hall of Paris). The panels which he had to cover were dark and he never succeeded in making them luminous. He complains in his *Journal* that, despite repeated attempts he could not, on this site, recover the brilliance of his sketches.

At Amiens, there are four admirable compositions of Puvis de Chavannes: *Le Porte-Etendard* (The Standard Bearer), *Femme pleurant sur les ruines de sa maison* (Woman Weeping over the Ruins of Her House), *La Fileuse* (Woman Spinning), and *Le Moissoneur* (The Reaper), all placed in the intervening spaces between windows opposite *La Guerre* (War) and *La Paix* (Peace); they are invisible because of the dazzling light from the windows that frame them.

It is a fact that in these circumstances a *divided* decoration would have created colored hues on these panels which would have emerged victorious over the excessive brightness of the adjacent windows.

Even the Neo-Impressionists' small canvases can be seen as decorative. These are neither studies, nor easel paintings, but "exemplary specimens of an art of great decorative development, which sacrifices anecdote to arabesque, analysis to synthesis, fugitive to permanent, and confers on nature, which finally grew tired of its precarious reality, an authentic reality," writes Monsieur Félix Fénéon. These canvases which restore light to the walls of our modern apartments, which insert pure color within rhythmic lines, which recall the charm of Oriental carpets, mosaics, and tapestries, are they not also decorations?

―――――

VI

SUMMARY OF THE THREE
CONTRIBUTIONS

Such an abundance of sentences,—but the evidence had to be produced in full in order to convince people of the legitimacy of Neo-Impressionism by establishing its ancestry and its contribution,—may we not condense them in the following synoptic table?

AIM

DELACROIX.
IMPRESSIONISM. } *to give color the greatest possible brilliance.*
NEO-IMPRESSIONISM.

MEANS

DELACROIX.
{
1. *Palette composed of both pure and muted colors;*
2. *Mixing on the palette and optical mixture;*
3. *Hatchings;*
4. *Methodical and scientific technique.*

IMPRESSIONISM.
{
1. *Palette composed solely of pure colors approximating those of the solar spectrum;*
2. *Mixing on the palette and optical mixture;*
3. *Comma-shaped or swept-over brush-strokes;*
4. *Technique of instinct and inspiration.*

NEO-IMPRESSIONISM. $\left\{\begin{array}{l}\text{1.} \quad \textit{Same palette as that of Impressionism;} \\ \text{2.} \quad \textit{Optical mixture;} \\ \text{3.} \quad \textit{Divided touch;} \\ \text{4.} \quad \textit{Methodical and scientific technique.}\end{array}\right.$

RESULTS

DELACROIX.

By repudiating all flat colors and using gradation, contrast, and optical mixing, he succeeds in drawing from the partially toned-down elements available to him a maximum of brilliance, whose harmony is guaranteed by a systematic application of the laws governing color.

IMPRESSIONISM.

By composing its palette only from pure colors, it obtains a much brighter and more colorful result than that of Delacroix; but the brilliance of this result is lessened by soiled pigmentary mixtures and its harmony is limited by an intermittent and irregular application of the laws governing color.

NEO-IMPRESSIONISM.

By the elimination of all soiled mixtures, the exclusive use of the optical mixture of pure colors, a methodical divisionism and respect for the scientific theory of color, it guarantees maximum brightness, color, and harmony, a result which had previously not been attained.

VII

TESTIMONIES

1. We had already shown at the beginning of this study, with the aid of numerous citations, that this technique of *divisionism,* established by the Neo-Impressionists and presented by us as the normal development of the Impressionist technique, was remarkably well anticipated and almost completely prescribed by Delacroix. But there were others too who had foreseen all the resources which the Neo-Impressionists' future contribution, the divided touch with pure elements, could offer to art.

Let us listen to Charles Blanc, who has already called our attention to all the benefits of a scientific technique based, like divisionism, on contrast and optical mixing. In his *Grammaire des arts du dessin* (Grammar of Painting and Engraving), he explains that, if color is to have brilliance, it must not be laid down flat, and advises recourse to the Oriental technique, which conforms precisely to the procedure of the Neo-Impressionists:

"When the Orientals, who are excellent colorists, have to paint a surface which will seem to be one single whole, they always make the color vibrate by laying tone upon tone."

Farther on, he cites a portion of a study by Monsieur A. de Beaumont, published in the *Revue des Deux Mondes,* to point out the great charm and power of a color which has undergone infinite shading. The quotation shows clearly the common ground, in matters of technique, between Neo-Impressionism and the richest of all traditions in the realm of color, that of the East:

"The more intense is the color, the more the Orientals make it shimmer, so as to create more shades, to render it still more intense and thereby prevent

dryness and monotony, in a word, to produce that vibration without which a color is as insupportable to our eyes as a sound would be to our ears, under the same conditions."

Nevertheless, there are so many people who like flat smooth painting, that it would seem the eyes are less sensitive than the ears.

2. Here is still more positive testimony in the words of John Ruskin, teacher of aesthetic principles, and a skillful and far-sighted critic.

Let us cite first these excerpts from his *Elements of Drawing,* a book which every artist ought to know and which was first translated into French by the Neo-Impressionist painter Henri-Edmond Cross:

"I have a profound repugnance for everything which resembles the skill of the hand."

Delacroix himself had said:

"What one must shun is the infernal convenience of the brush."

Does not the divided touch of the Neo-Impressionists, placed simply on the canvas, without virtuosity and without evasion, fully meet the demands of these two masters ?

Ruskin shows next that a color can only be beautiful if it is carefully gradated, and he tells us how important is this much neglected technique:

"You will find in practice that brilliancy of hue, vigor of light, and even the aspect of transparency in shade are essentially dependent on this character alone; hardness, coldness, and opacity result far more from equality of color than from nature of color.

"It is not indeed physically impossible to meet with an ungradated piece of color, but it is so supremely improbable, that you had better get into the habit of asking yourself invariably, when you are going to copy a tint, not 'Is that gradated?' but 'Which way is that gradated?' and at least in ninety-nine out of a hundred instances, you will be able to answer decisively after a careful glance,

though the gradation may have been so subtle that you do not see it at first. And it does not matter how small the touch of color may be. Though not larger than the smallest pin's head, if one part of it is not darker than the rest, it is a bad touch. For it is not merely because the natural fact is so, that your color should be gradated; the preciousness and pleasantness of color itself depends more on this than on any other of its qualities, for gradation is to colors just what curvature is to lines, both being felt to be beautiful by the pure instinct of every human mind, and both, considered as types, expressing the law of gradual change and progress in the human soul itself. The difference in mere beauty between a gradated and ungradated color may be seen easily by laying an even tint of rose-color on paper, and putting a rose-leaf beside it. The victorious beauty of the rose as compared with other flowers depends wholly on the delicacy and quantity of its color gradations, and all other flowers being either less rich in gradation, not having so many folds of leaf; or less tender, being patched and veined instead of flushed."

Next, Ruskin asserts that Turner, with his passion for color, did not overlook this means of embellishing his tints:

"You will not, in Turner's largest oil pictures, perhaps six or seven feet long by four or five high, find one spot of color as large as a grain of wheat ungradated."

Are not the Neo-Impressionists, whose paintings are endlessly divided to infinity, the most faithful in their respect for this important factor of beauty which is gradation, and without which there is no beautiful color?

Having thus stated the importance of gradation, Ruskin urges the painter to study it in nature, where he will constantly find its harmonious traces:

"No color exists in nature under ordinary circumstances without gradation. If you do not see this, it is the fault of your experience. You will see it in due time, if you practice enough. But in general you may see it at once."

Moreover, he indicates clearly how to obtain a beautiful gradation on canvas and points out the advantage of such a procedure over the use of a flat tint:

"Lay the subduing tints in small touches."

"If a color is to be darkened by portions of another, it is, in many cases, better to lay the uppermost color in rather vigorous small touches, like finely chopped straw, over the under one, than to lay it on as a tint, for two reasons: that the play of the two colors together is pleasant to the eye; the second, that much expression of form may be got by wise administration of the upper dark touches."

Is not this method, "small touches, like finely chopped straw," precisely that which is used by the Neo-Impressionists?

But, better still, they wish these little fragmented touches to be of pure colors:

"Practice the production of mixed tints by interlaced touches of the pure colors out of which they are formed, and use the process at the parts of your sketches where you wish to get rich and luscious effects."

Divided touches of pure colors: therein lies the entire Neo-Impressionist contribution:

"The best color we have the power to achieve is that which we obtain by STIPPLING."

Now, the literal translation of STIPPLING is: *pointillage*.

This is not a word that Ruskin uses once and by chance. To this technique, which he so particularly recommends, he devotes a whole chapter entitled, BREAKING ONE COLOR IN SMALL POINTS THROUGH OR OVER ANOTHER.

"This is the most important of all processes in good modern oil and water-color painting."

"In distant effects of rich subject, wood, or rippled water, or broken clouds, much may be done by touches or crumbling dashes of rather dry color, with other colors afterwards put cunningly into the interstices. The more you practice this, when the subject evidently calls for it, the more your eye will enjoy the higher qualities of color. The process is, in fact, the carrying out of the principle of separate colors to the utmost possible refinement; using atoms of color in juxtaposition instead of large spaces. And note, in filling up minute

interstices of this kind, that if you want the color you fill them with to show brightly, it is better to put a rather positive point of it, with a little white left beside or round it in the interstice, than to put a pale tint of the same color over the whole interstice. Yellow or orange will hardly show, if pale, in small spaces, but they will show brightly in firm touches, however small, with white beside them."

3. We find once again these valuable arguments in favor of the Neo-Impressionist technique again in a study on Ruskin, published in the *Revue des Deux Mondes* (March 1897) by Monsieur Robert de la Sizeranne, who quotes or summarizes the opinions of the aesthetic master.

The Neo-Impressionists reject all somber or dull colors; Ruskin says:

"Away with gray, black, brown, all this tar used by French landscapists at mid century, who seem to look at nature through a black mirror! One must darken each tint by mixing it, not with somber colors, but with its appropriate tint simply intensified."

The Neo-Impressionists reject all mixing on the palette; Ruskin says:

"One must keep one's palette tidy in order to see the pure tint clearly and also so as not to be inclined to mix one's tints there."
"No more mixing on the palette than on the canvas; mix two colors together, and keep them in that spot; do not mix further."

Do Neo-Impressionist paintings resemble mosaics? Ruskin says:

"One must consider all nature purely as a mosaic of different colors which one should copy one by one in all simplicity."
"Is it frescos then that one should produce? Yes, and better yet, mosaics."

And this citation, which is not meant to make the Neo-Impressionists regret having adopted a technique in which the skill of the hand has no importance:

"Only in a meticulous system of drawing, consisting of conscientious and strengthened lines, of flat colors, one by one dissociated and laboriously put down point by point, and of parcelling out of color, clear, cautious, and straightforward, what role will the breadth of the stroke, the savoury fluidity of the touch, the virtuosity of the hand, the liberty of the brush, play? They will play no role, because they must not play one. The virtuoso is a pharisee who takes pleasure in himself and not in beauty. . . . He is a tight-rope walker who juggles with his ochres, his ultramarines, his cinnabars, instead of rendering them up as tribute to peerless nature and endless sky. He says: 'Regard my cleverness, my versatility, my skill.' He does not say: 'See how She is beautiful and how She surpasses all our poor human artifices!' "

Are not these lines the best response one can give to critics who reproach the Neo-Impressionists for the discreet impersonality of their technique?

Next, these precepts, so clearly Neo-Impressionist that they seem to be written by one of the adherents of *divisionism*:

"Place the bright colors in little points on the others or in their interstices, and carry the principle of separated colors to its refinement and farthest extreme, using atoms of colors in juxtaposition rather than in large spaces. And finally, if you have time, rather than merely mixing, copy nature in flower, punctuated with diverse colors—the foxglove, for example, and the calceolaria. And produce the mixed tints with the intersection of touches of diverse harsh tints out of which the mixed tints will therefore be formed."

This use of little points of pure color to form mixed hues, extolled by Ruskin, is so close to the technique of the Neo-Impressionists and the common ground of principles is so evident, that the writer in the *Revue des Deux Mondes* cannot help using the following words, calling *pointillism* what it would have been more accurate to call *Neo-Impressionism*:

"Do we not have here, already in 1856, a prophecy of pointillism? It is just that."

Can one help being astonished to find that this *stippling*, recommended by the English aesthetician as the best means of giving color

splendor and harmony, is precisely the *divided touch* which shocks so many French critics?

4. We end these testimonies with several excerpts from the work of an American scientist, O. N. Rood: *Théorie scientifique des couleurs* (Modern Chromatics), a book written, states the author, *"for painters and ordinary persons"*—as if such matters were of any concern to the one or the other!

We shall see that Rood also recommends the use of gradation, optical mixing and the *divided touch,* and is astonished that so many people are unaware of their virtues.

"One of the most important characteristics of color in nature is the endless, almost infinite gradations which always accompany it . . . If a painter represents a sheet of paper in a picture by a uniform white or gray patch, it will seem quite wrong, and cannot be made to look right till it is covered by delicate gradations of light and shade and color. We are in the habit of thinking of a sheet of paper as being quite uniform in tint, and yet instantly reject as insufficient such a representation of it. In this matter our unconscious education is enormously in advance of our conscious; our memory of sensations is immense, our recollections of the causes that produce them utterly insignificant; and we do not remember the causes mainly because we never knew them. It is one of the tasks of the artist to ascertain the causes that give rise to the highly complex sensations which he experiences.

"All the great colorists have been deeply permeated by a sentiment of this kind, and their works, when viewed from the intended distance, are tremulous with changing tints—with tints that literally seem to change under the eye, so that it is often impossible for the copyist to say exactly what they are, his mixtures never seeming to be quite right, alter them as he will.

"Among modern landscape paintings, those of Turner are famous for their endless quantity of gradation, and the same is true even of his watercolor drawings.

"There is, however, another lower degree of gradation which has a peculiar charm of its own, and is very precious in art and nature. The effect referred to takes place when different colors are placed side by side in lines or dots, and then viewed at such a distance that the blending is more or less accomplished by the eye of the beholder. Under these circumstances the tints mix on the retina, and produce new colors. This communicates a soft and peculiar brilliancy to the surface, and gives it a certain appearance of transparency; we seem to see into it

and below it. At the right distance, adjacent tints blend, and what near at hand seemed a mass of purposeless daubs becomes an effective picture. This same method of mixing colors on the retina of the observer is also used more or less in oil painting with excellent effect; it lends to them a magical charm, the tints seeming purer and more varying; the very fact that the appearance of the painting changes somewhat according as the observer advances or retires from it being an advantage, communicating to it, as we might say, a certain kind of life.

"Oil paintings in which this principle is not used labor under one quite demonstrable disadvantage: As the observer retires adjacent tints blend, whether it was the intention of the artist or not; and if this has not been calculated for, a new and inferior effect is pretty sure to be produced.

"In watercolor drawings the same mode of working is constantly used under the form of stippling, more or less formal; and with its aid certain results of transparency and richness can be attained, which otherwise would be out of the reach of the artist. If the stippling is formal and quite evident, it is apt to give a mechanical look to drawing, which is not particularly pleasant; but properly used, it has great value, and readily lends itself to the expression of form.

"In cashmere shawls the same principle is developed and pushed to a great extent, and much of their beauty is dependent on it."

Thus, a painter like Delacroix, an aesthetician like Ruskin, and a scientist like Rood have foreseen or prescribed the various methods which comprise the Neo-Impressionists' innovative contribution, and they even seem to recommend especially that part of their technique which is most attacked today, and occasions such annoyance: the use of touches of pure elements.

———

VIII

THE EDUCATION OF THE EYE

Progress with each generation.—The painters who were reviled are the educators.—Obstacles encountered by the colorists.—For want of education, the public is insensitive to harmony and afraid of any fine color.—What shocks is the brilliance, and not the technique, of the Neo-Impressionists.

1. Why then has *divisionism,* which can claim for itself advantages that the other techniques cannot offer, encountered so much hostility? The reason is that in France people revolt against any new thing in art and are not merely insensitive, but hostile, to color. (Consider the fact that our national guide book, the *Joanne,* does not simply provide information, but finds it necessary to provoke laughter and incomprehension in the tourist who views the colors of Turner's admirable canvases in the South Kensington Museum.)

The complaint against Neo-Impressionist art was twofold: it was innovative, and the paintings executed in accordance with its technique shone with an unwonted brilliance.

There is no need to list here all the innovative painters who have been reviled in this century, and have subsequently imposed their particular vision on the public. Injustice, struggle, and triumphs: that is the history of art.

On first appearance anything which is new meets opposition; then comes a slow habituation and acceptance. People grasp the intention of the technique which they found shocking, and see power and harmony in the color which once provoked outcry. The unconscious education of the public and the critics has gone so far that they see the objects of the real world as the innovator has chosen to represent them: his method, previously despised, is now their criterion. And, in his name, the next

original venture will be ridiculed, until the day arrives when it too will triumph. Each generation is, in hindsight, amazed at its error, and goes on to repeat it.

Around 1850, someone wrote the following lines about Corot's paintings—because, yes, the gentle Corot offended the public's taste:

"How can Monsieur Corot see nature as he presents it to us? . . . It is in vain that Monsieur Corot would seek to impose upon us his manner of painting trees; these are no trees, they are smoke. We can say that we have never, in our walks, had the occasion to see trees like those of Monsieur Corot."

And twenty-five years later, when Corot had triumphed, his name was evoked in a disavowal of Claude Monet:

"Monet sees everything in blue! Blue ground, blue grass, blue trees. Lovely trees of Corot, full of mystery and poetry, see what has become of you! You have been drenched in a washerwoman's bluing tub!"

A single generation does not twice make the effort which is required to assimilate a new way of seeing things. The detractors of Delacroix had to yield to his supporters. But the supporters did not understand the colorists who came after him, the Impressionists. These too have triumphed, and today the fanciers of the work of Monet, Pissarro, Renoir, and Guillaumin misuse the reputation for good taste which they have gained by their choice and condemn Neo-Impressionism.

It takes more than a quarter of a century for a development in art to be accepted. Delacroix struggled from 1830 to 1863; Jongkind and the Impressionists, from 1860 to 1890. Around the year 1886, Neo-Impressionism appeared, a normal development of the previous trials and experiments, which, in accordance with the tradition, can look forward to several more years of struggle and toil before its contribution receives approval.

At times even financial interest unites with ignorance to hinder the progress of an innovative movement which causes embarrassment. Gustave Geffroy puts it well:

"Producers whose names have standing in the business world, and all those who live off a product satisfied by success, form an association, acknowledged or tacit, against the art of tomorrow."

2. It is particularly when innovation tends towards light or color that it meets a churlish reception. Changes in the subjects of painting, corresponding to changes in literary fashion, are easily accepted by the same people who become alarmed at the slightest new touch of brilliance. The distortions of the Rose-Croix movement certainly did not provoke as much hilarity as did Monsieur Monet's blue locomotives or the violet trees of Monsieur Cross. Rarely does a drawing, a statue, arouse the wrath of an uncomprehending public: but a bold use of color always does.

All pure, bold color is shocking; people only admire paintings that are flat, smooth, muted, and dull. If, on the pretext of shading, half a figure is covered with bitumen or brown, the public willingly accepts it, but not the use of blue or violet. But shadows are always tinged with this blue or violet which repels the viewers, not with the excremental hues which have their approval. Optical physics would say the same thing.

There is, in fact, an easy, simple science of color, which all should learn and which, if it were known, would prevent many foolish judgments. It can be summed up in ten lines which should be taught to children in elementary school during the first hour of the first lesson of the most elementary art course.

Charles Blanc deplores the public's ignorance regarding this subject and, still speaking of Delacroix, writes:

"Many people assume that the art of coloring is a pure gift from Heaven and that it has secrets that cannot be communicated. This is an error; coloring is learned like music. From time immemorial, the Orientals have known its laws, and these laws have been passed on from generation to generation, from the beginning of history until our own time. Just as musicians can be trained to be at least skillful and accurate, through instruction in counterpoint, so can painters be taught to avoid slights to harmony, through instruction in the phenomena of the simultaneous perception of colors.

"The elements of color have not been analyzed and taught in our schools, because in France it is thought useless to study the laws of color, in accordance with that false saying which is currently in favor: 'draftsman are made, colorists are born.'

". . . The secrets of coloring! Why call them secrets, these principles that every artist should know and should have been taught to everyone!"

Les Artistes de mon temps: Eugène Delacroix

(The Artists of My Time: Eugène Delacroix)

These laws of color can be learned in a few hours. They are summed up in two pages of Chevreul and Rood. The eye guided by them need only train itself to see still better. But, since the time of Charles Blanc, the situation has scarcely changed. Nothing has been done to propagate this special education. Chevreul's discs, which, used as a form of entertainment, could prove to so many eyes that they do not see and could teach them to see, are not yet adopted by our elementary schools, despite all the efforts of the great scientist in this direction.

It is this simple science of contrast which forms the solid basis of Neo-Impressionism. Without it, there will be no lovely lines or perfect colors. While we see every day what services it can render to the artist, by directing and fortifying his inspiration, we have yet to discover what harm it can do him.

In the preface to his book, Rood demonstrates how important it is:

"I will add that it has been my endeavor also, to present in a simple and comprehensible manner the underlying facts upon which the artistic use of color necessarily depends. The possession of these facts will not enable people to become artists; but it may to some extent prevent ordinary persons, critics, and even painters, from talking and writing about color in a loose, inaccurate, and not always rational manner. More than this is true: a real knowledge of elementary facts often serves to warn students of the presence of difficulties that are almost insurmountable, or, when they are already in trouble, points out to them its probable nature; in short, a certain amount of rudimentary information tends to save useless labor."

The art of the colorist is, indeed, not a matter of placing reds, greens, and yellows side by side, without regard for rule or measure. The

painter must know how to arrange these diverse elements, sacrificing some so as to give weight to others. Noise and music are not synonymous. Juxtaposition of colors, however intense, with no concern for contrast, is merely daubing, and not coloring.

3. One of the serious reproaches addressed to the Neo-Impressionists is that they are too scientific to be artists: They are, it is said, so buried in their experiments that they cannot freely express their sensations.

To this we reply that the lowliest Oriental weaver knows as much about this as they do. These notions which are held against them are not very complicated. The Neo-Impressionists are not unduly scientific. But ignorance of the laws of contrast and harmony is too great an ignorance.

Why then would their mastery of these rules of beauty blot out their sensations? Is a musician, because he knows that the 3/2 proportion is harmonic, or a painter, because he is aware that orange together with green and violet forms a ternary combination, any less of an artist, less able to feel and to impart emotion? Théophile Silvestre has said: "This almost mathematical knowledge, far from chilling works of art, increases their exactness and their solidity."

The Neo-Impressionists are not slaves to science. They apply it as their inspiration directs: They make their knowledge serve their intention. Can we reproach young painters for refusing to neglect this essential component of their art when we see a genius like Delacroix forcing himself to study the laws of color and profiting from this inquiry? As Charles Blanc points out in this note:

"It is because he knew these laws and had studied them thoroughly, having first divined them intuitively, that Eugène Delacroix was one of the greatest colorists of modern times."

4. The public is more concerned with the subject of a painting than with its harmony. As Ernest Chesneau observes:

"The most gifted members of that public that attends exhibitions do not seem to suspect that one must cultivate one's senses in order to attain full enjoyment of the intellectual pleasures, of which the senses are only organs, to be sure, but organs one must use. People are too little aware that to understand and judge—in other words, to appreciate—painting, sculpture, or architecture, the eye must be true just as the ear must be true if it is to appreciate music. Pursuing this rigorous comparison to its end, let us add that eyes as well as ears, even when they are true by nature, need a progressive training in order to perceive fully the delicacy of the art of sounds and the art of colors."

<div align="right">

"*La Chapelle des Saints-Anges à Saint-Sulpice*"

(*L'Art*— Tome XXVIII)

"The Chapel of the Holy Angels at Saint-Sulpice"

(Art—Volume XXVIII)

</div>

As a matter of fact, most painters are insensitive to the charm of line and color. Rare are the artists who think, along with Ruskin, that "gradation is to colors what curvature is to lines," and, with Delacroix that "there are some lines that are monsters: two parallels." The painters of our time are concerned with other matters than these principles of beauty. We can assert that not one in a hundred has taken the trouble to study this basic element of his art. Gavarni, speaking of the master's paintings, declares:

"It's a daub for a folding screen. . . . It's like toilet paper or wall coverings; and then there are people who will tell honest citizens that it's supernatural! . . . We have indeed reached the Lower Empire in the realm of words and we are splashing in puddles of color."

And the Goncourts write (*La Peinture à l'Exposition de 1885* [Paintings of the 1885 Exhibition]):

"Delacroix, to whom has been denied the supreme quality of colorists, harmony."

Most critics are indeed so little instructed in matters of technique that they can hardly perceive the harmony between two hues or the disharmony between two lines. They judge rather by the subject, the

trend, the genre, paying no attention to the "painterly" qualities. They write literature about painting and not art criticism. We will cite this note by Delacroix: " '*Oculos habent et non vident,*' ['Having eyes they see not'—Trans.] which means: '*Of the rarity of good judges of painting.*' " He who said: "For more than thirty years I have been the prey of beasts," had suffered enough from the ignorance of the public and the critics to be fully aware of the difficulties which colorists encounter. In his *Journal* he writes:

"I know well that the ability of a colorist is more troublesome than estimable. . . . It requires more active organs and a greater sensibility to discern the fault, the discord, the false relation of line and color."

And, on the same subject, he writes to Baudelaire (8 October 1861):

"These mysterious effects of line and color which alas, only a few adepts perceive. . . . This musical and arabesque quality . . . means nothing to many people, who view a painting as the English view a country when they travel."

Might we not say that Delacroix still endures the consequences of this hatred or indifference towards color which so greatly grieved him in his lifetime? It seems to us that his works are completely ignored. We need only recall the cold reception of the exhibition of his work at the Ecole des Beaux-Arts, by a public who flocked enthusiastically to that of Bastien-Lepage, which opened at the same time nearby, at the Hôtel de Chimay. And never, during the long visits we have paid, at Saint-Sulpice, to the decorations in the Chapelle des Saints-Anges, have we been disturbed by a visitor.

Eugène Véron, the biographer of Delacroix, has taken good note of this continuing injustice:

"Should we conclude that the crowds who hurry to these exhibitions have finally come to understand his genius? To be sure of our answer, we need only compare the reticence of visitors, and their embarrassed silence, when the canvases of Delacroix met their gaze, with the twittering and chirping of the women at the Salon or at the exhibitions of the clubs, when they found themselves

before some canvas by a so-called current master of the French School. There is frank, sincere admiration for you. Has anyone ever seen the like at exhibitions of Delacroix? There is nothing extraordinary about this; it would be extraordinary if things were otherwise."

5. What exasperated so many people when they viewed the work of Delacroix was not so much its frenzied romanticism as its hatchings and intense color; and in Impressionist painting the offense was the novelty of their comma-strokes and their coloring. And in the Neo-Impressionist contribution, the cause of dismay—much more so than the *division* of the touch—is the unwonted brilliance of their canvases. In support of this statement, let us cite a case which is pertinent. The paintings of Monsieur Henry Martin whose technique is borrowed entirely from Neo-Impressionism find favor with the public, the critics, the municipal commissions, and the State. In his work, the *point* (dot) does not shock, and is, even so, useless, and therefore troubling, because it is gray, dull, and muted, offering no advantages of brightness or natural coloring which might compensate for the possible disadvantages of the technique. As practiced by him, *pointillism* is accepted at the Luxembourg and the City Hall of Paris, while the great Seurat, the originator of divisionism, and the creator of so many calm, majestic works, remains unrecognized (at least in France, for Germany, being better informed, has succeeded in acquiring *Les Poseuses* [The Models] and other important canvases which we will see one day at the Berlin Museum).

Perhaps the passing years will bring the public to complete its education: Let us hope for a time in which it will be more sensitive to harmony and will no longer fear the power of a color, but will calmly appreciate its beauty and see that a painter's most vivid colors are timid in comparison with those in which nature decks herself. There has at least been great progress, thanks to the Impressionist masters. Viewers who formerly expressed amazement or protested when they saw Impressionists' paintings now recognize that the Monets and the Pissarros mingle in perfect harmony with the works of Delacroix, Corot, Rousseau, and Jongkind, of which they are the outcome.

Similarly, the public may one day acknowledge that the Neo-Impressionists have been the current representatives of the colorist tradition, of which Delacroix and the Impressionists were the champions in their time. What painters have a greater right to call these predecessors their guardian spirits? Not those who paint in black, white, or gray, or those whose coloring recalls "a heap of old rotten vegetables"—singled out by Ruskin as the supreme degree of ugliness which color can attain —or those who paint in flat colors. For these techniques bear no relation to the principles of the masters whom the Neo-Impressionists claim as their own.

It is perhaps easy to paint more brightly than the Neo-Impressionists, but with a loss of color—or to put more color on, with a darkening of the picture. Their color is situated in the middle of the radius which, on a chromatic circle, goes from the white center to the black circumference. And in this location it is endowed with the fullest saturation, power, and beauty. The time will come when a way will be found to make better use of the colors which the painter now has at his disposal, or to use finer materials or new techniques—for example, the direct fixation of rays of light on sensitized supports; but the fact remains that it was the Neo-Impressionists who found out how to obtain from the resources available in our time the most luminous and colorful result; beside one of their canvases, and despite the criticism which such a work may encounter, any picture, even of great artistic quality, will appear dark and colorless.

Of course, we do not measure the talent of a painter by the proportion of brightness and color in his paintings; we know that with white and black one can produce masterpieces and that there is colorful and luminous painting which is devoid of merit. But if this quest for color and light is not the whole of art, is it not an important part of it? Is not an artist one who strives to create unity in variety through the rhythms of his hues and tones and who places his science at the service of his sensations?

6. Reading the pronouncement of Delacroix: "Cowardly painting is the painting of a coward," the Neo-Impressionists can be proud of their austere and simple painting. And if it is passion rather than technique which makes artists, they can be confident: Theirs is the fruitful passion for light, color, and harmony.

At all events, they have not done over again what was done before; they have had the perilous honor of producing a new manner and of expressing a personal ideal.

They will be able to develop further, while still standing firmly based on that purity and contrast which they will never give up, knowing as they do its significance and the delight it affords. Gradually ridding itself of the fetters which first encumbered it, *divisionism,* which has enabled these painters to give expression to their dreams of color, grows supple and ripens, and promises still more fruitful resources to come.

And if their number does not yet include an artist who, because of his genius, can bring about the acceptance of this technique, they have at least found the way to simplify his task. This triumphant colorist has only to come forward: His palette has already been made ready for him.

1899. Paris, Saint-Tropez.

A select list of works in English on Signac, Neo-Impressionism, and Color

Albers, Josef. 1963. *Interaction of color.* Text of the original edition with selected plates 1971. New Haven, Connecticut: Yale University Press.

Arguelles, Jose A. 1972. *Charles Henry and the formation of a psychophysical aesthetic.* Chicago and London: The University of Chicago Press.

Arizona University Art Gallery, Tuscon. 1968. *Homage to Seurat: paintings, watercolors, and drawings by the followers of Seurat.* Collected by Mr. and Mrs. W. J. Holliday, Indianapolis. Tuscon: University of Arizona Art Gallery.

Barnes, Albert C., and Violette De Mazia. 1933. *The art of Henry Matisse.* Merion, Pennsylvania: The Barnes Foundation Press.

Berlin, Brent, and Paul Kay. 1969. *Basic color terms: their universality and evolution.* Berkeley and Los Angeles: University of California Press.

Bernier, Georges, editor. 1983. *Catalogue of the exhibition "La Revue Blanche: Paris in the Days of Post-Impressionism and Symbolism."* New York: Wildenstein and Co., Inc.

Bidwell, Shelford. 1899. *Curiosities of light and sight.* London: Swan Sonnenschein & Co., Ltd.

Blanc, Charles. 1873. *The grammar of painting and engraving.* Translated from the French of Blanc's *Grammaire des arts du dessin* by Kate Newell Dogget, with the original illustrations. Chicago: S. C. Griggs and Co.

Bock, C. C. 1981. *Henri Matisse and Neo-Impressionism, 1898–1908: studies in the fine arts—the Avant-Garde.* Ann Arbor, Michigan: UMI Research Press.

Boring, Edwin G. 1942. *Sensation and perception in the history of experimental psychology.* The Century Psychology Series, edited by Richard M. Elliott. New York and London: D. Appleton-Century Company.

Bouret, Jean. 1973. *The Barbizon School and 19th century French landscape painting.* Greenwich, Connecticut: New York Graphic Society.

Boynton, Robert M. 1979. *Human color vision.* New York: Holt, Rinehart & Winston.

The Brooklyn Museum. 1980. *Catalogue of the exhibition "Belgian Art, 1880–1914"* held at the Brooklyn Museum April 23–June 29, 1980. New York: The Brooklyn Museum.

Broude, Norma. 1974. New light on Seurat's 'dot': its relation to photo-mechanical color printing in France in the 1880s. *The Art Bulletin.* 56:581–589.

————, editor. 1978. *Seurat in perspective.* Englewood Cliffs, New Jersey: Prentice-Hall Inc.

Cachin, Françoise. 1968. The Neo-Impressionist Avant-Garde. *Art News Annual.* 34:54–65.

————. 1971. *Paul Signac.* Translated from the French by Michael Bullock. Greenwich, Connecticut: New York Graphic Society.

Callen, Anthea. 1982. *Techniques of the Impressionists.* Secaucus, New Jersey: Chartwell Books Inc.

Carpenter, James M. 1974. *Color in art: a tribute to Arthur Pope, with "An introduction to color" and "Supplement: The Pope color solid"* by Howard T. Fischer. Cambridge, Massachusetts: Fogg Art Museum, Harvard University.

Chamberlin, G. J., and D. G. Chamberlin. 1980. *Colour: its measurement, computation and application.* London: Heyden & Son Ltd.

Chevreul, Michel Eugène. 1967. *The principles of harmony and contrast of colors and their applications to the arts.* Based on the first English edition of 1854 as translated from the first French edition of 1839, *De la loi du contraste simultané des couleurs.* With a special

introduction and explanatory notes by Faber Birren. New York: Van Nostrand Reinhold Company Inc.

Courthion, Pierre. 1972. *Impressionism.* Translated from the French by John Shepley. New York: Harry N. Abrams Inc.

Day, R. H., and M. K. Jory. 1978. Subjective contours, visual acuity, and line contrast. In *Visual Psychophysics and Physiology.* J. C. Armington, J. Krauskopf, and B. R. Wooten, editors. pp. 331–340. New York: Academic Press Inc.

Dayez, Anne. 1974. *Catalogue of the exhibition "Impressionism: A Centenary Exhibition."* Translation of *Centenaire de l'Impressionnisme.* New York: The Metropolitan Museum of Art.

Delacroix, Eugène. 1937. *The Journal of Eugène Delacroix.* Translated from the French by Walter Pach. New York: Covici, Friede, Inc.

De Valois, Russell L., and Karen K. De Valois. 1988. *Spatial vision.* Oxford and New York: Oxford University Press.

Dowling, J. E., and B. B. Boycott. 1966. Organization of the primate retina: electron microscopy. *Proceedings of the Royal Society of London B Biological Sciences.* 166:80–111.

Elderfield, John. 1978. *Matisse in the Collection of the Museum of Modern Art.* New York: The Museum of Modern Art.

Evans, R. M. 1948. *An introduction to color.* New York: John Wiley & Sons Inc.

———. 1974. *The perception of color.* New York: John Wiley & Sons Inc.

Falk, David S., Dieter R. Brill, and David G. Stork. 1986. *Seeing the light: optics in nature, photography, color, vision, and holography.* New York: Harper & Row, Publishers Inc.

Friedlaender, Walter. 1971. *David to Delacroix.* Translated by Robert Goldwater. New York: Schocken Books Inc.

Gerstner, Karl. 1986. *The forms of color: the interaction of visual elements.* Cambridge, Massachusetts: The MIT Press.

Halbertsma, K. J. A. 1949. *A history of the theory of color.* Amsterdam: Swets & Zeitlinger.

Halperin, Joan Ungersma. 1988. *Félix Fénéon: aesthete and anarchist in Fin-de-Siecle Paris.* New Haven and London: Yale University Press.

Hammacher, A. M. 1962. *Van Gogh's relationship with Signac.* In *Catalogue of the exhibition "Van Gogh's Life in His Drawing and Van Gogh's Relationship with Signac"* held at the Marlborough Gallery, London, May–June 1962.

Herbert, Eugenia W. 1961. *The artist and social reform.* New Haven, Connecticut: Yale University Press.

Herbert, Robert L. 1958. Seurat and Jules Cheret. *The Art Bulletin.* 40:156–158.

———, editor. 1965. *Catalogue of the exhibition "Neo-Impressionists and Nabis in the Collection of Arthur G. Altschul."* New Haven: Yale University Press.

———. 1968. *Catalogue of the exhibition "Neo-Impressionism, The Guggenheim Museum."* New York: The Solomon R. Guggenheim Foundation.

———. 1988. *Impressionism: art, leisure, and Parisian society.* New Haven: Yale University Press.

Herbert, Robert L., and Eugenia W. Herbert. 1960. Artists and anarchism: unpublished letters of Pissarro, Sig-

nac and others. *Burlington Magazine.* 102 (November, December 1960):473–482, 517–522.

Hering, Ewald. 1964. *Outlines of a theory of the light sense.* Translated by Leo M. Hurvich and Dorothea Jameson. Cambridge, Massachusetts: Harvard University Press.

Herrnstein, Richard J., and Edwin G. Boring. 1965. *Source book in the history of psychology.* Cambridge: Harvard University Press.

Homer, William I. 1964. *Seurat and the science of painting.* Cambridge, Massachusetts: The MIT Press.

Hunt, R. W. G. 1987. *The reproduction of colour in photography, printing and television.* 4th edition. Tolworth, England: Fountain Press.

Hurvich, Leo M. 1981. *Color vision.* Sunderland, Massachusetts: Sinauer Associates Inc.

Jacobus, John. 1983. *Matisse.* New York: Harry N. Abrams Inc.

Jameson, Dorothea. 1983. Some misunderstandings about color perception, color mixture and color measurement. *Leonardo.* 16:41–42.

Jameson, Dorothea, and Leo M. Hurvich. 1975. From contrast to assimilation: in art and in the eye. *Leonardo.* 8:125–131.

Jones, Stephen Rees. 1967. *The history of the artist's palette in terms of chromaticity.* In *Application of science in examination of works of art.* Proceedings of the September 1965 seminar. William J. Young, editor. pp. 71–77. Boston, Massachusetts: Museum of Fine Arts.

Judd, Deane B. 1960. Appraisal of Land's work on two-primary color projections. *Journal of the Optical Society of America.* 50:254–268.

Kemp, Martin. 1990. *The science of art: optical themes in Western art from Brunelleschi to Seurat.* New Haven, Connecticut: Yale University Press.

Kuehni, Rolf G. 1983. *Color: essence and logic.* New York: Van Nostrand Reinhold Company Inc.

Land, Edwin H. 1974. The retinex theory of colour vision. *Proceedings of the Royal Institute of Great Britain.* 47:23–58.

Laurie, A. P. 1930. *The painter's methods and materials.* London: Seeley, Service and Co. Ltd.

Lee, Alan. 1981. A critical account of some of Josef Albers' concepts of color. *Leonardo.* 14:99–105.

Lee, Ellen Wardwell. 1983. *The aura of Neo-Impressionism: the W. J. Holliday Collection of the Indianapolis Museum of Art.* Bloomington, Indiana: The Indiana University Press.

Marx, E. 1973. *The contrast of colors.* New York: Van Nostrand Reinhold Company Inc.

Matthaei, Rupprecht, editor. 1971. *Goethe's color theory.* American edition translated and edited by Herb Aach. With a complete facsimile reproduction of Charles Eastlake's 1820 English translation of the "didactic part" of the Color theory. New York: Van Nostrand Reinhold Company Inc.

Maus, M. O. 1979. *Catalogue of the exhibition "Post-Impressionism: Cross-Currents in European Painting."* London: Royal Academy of Arts.

Milner, John. 1988. *The studios of Paris: the capital of art in the late 19th century.* New Haven, Connecticut: Yale University Press.

Moore, Walter. 1989. *Schrödinger—life and thought.* Cambridge: Cambridge University Press.

Nassau, Kurt. 1983. *The physics and chemistry of color: the fifteen causes of color.* New York: John Wiley & Sons Inc.

Nochlin, Linda. 1966. *Impressionism and Post-Impressionism,1874–1904: sources and documents.* Englewood Cliffs, New Jersey: Prentice-Hall Inc.

Osborne, R. 1980. *Lights and pigments.* London: John Murray.

Pollock, Martin, editor. 1983. *Common denominators in art and science.* Aberdeen, Scotland: Aberdeen University Press.

Pool, Phoebe. 1967. *Impressionism.* New York and Washington: Praeger World of Art Paperbacks, Praeger Publishers.

Ratliff, Floyd. 1965. *Mach bands: quantitative studies on neural networks in the retina.* San Francisco, California: Holden Day Inc.

———. 1971. Contour and contrast. *Proceedings of the American Philosophical Society.* 115:150–163.

———. 1976. On the psychophysiological bases of universal color terms. *Proceedings of the American Philosophical Society.* 120:311–330.

———. 1985. The influence of contour on contrast: from cave painting to Cambridge psychology. *Transactions of the American Philosophical Society.* 75:1–19.

Rearick, Charles. 1985. *Pleasures of the Belle Epoque: entertainment and festivities in turn-of-the-century France.* New Haven and London: Yale University Press.

Rewald, John, editor, with L. Pissarro. 1943. *Camille Pissarro: letters to his son Lucien.* New York and London: P. P. Appel. 3d edition 1972, Mamaroneck, New York.

———. 1946. *The History of Impressionism.* Revised and enlarged edition 1961. New York: The Museum of Modern Art.

———. 1948. *Georges Seurat.* Paris: A. Michel.

———, editor. "*Extraits du journal inedit de Paul Signac.*" 1949. *Gazette des Beaux-Arts.* 6th ser., no. 36, pp.97–128 (translation of pp. 166–174; 1894–95); 1952. No. 39, pp. 265–284 (translation of pp. 298–304; 1897–98); 1953. No. 42, pp. 27–57 (translation of pp. 72–80; 1898–99).

———. 1956. *Post-Impressionism.* New York: The Museum of Modern Art.

———. 1958. *Post-Impressionism, from van Gogh to Gauguin.* 3d edition 1978. New York: The Museum of Modern Art.

Rich, Daniel Catton. 1935. *Pictorial analysis of "La Grande-Jatte."* In *Seurat and the Evolution of "La Grande-Jatte."* pp. 15–25. Chicago: The Renaissance Society of the University of Chicago.

Richardson, John Adkins. 1971. *Modern art and scientific thought.* Urbana, Illinois: University of Illinois Press.

Rood, Ogden. 1973. *Modern chromatics, student's textbook of color with applications to art and industry.* Including a facsimile of the first American edition of 1879. Preface, introduction, and commentary notes by Faber Birren. New York: Van Nostrand Reinhold Company Inc.

Rossotti, Hazel. 1983. *Colour.* Princeton, New Jersey: Princeton University Press.

Seitz, William C. 1965. *The responsive eye.* New York: The Museum of Modern Art.

Sepper, Dennis L. 1988. Goethe contra Newton: polemics and the project for a new science of color. Cambridge: Cambridge University Press.

Shapley, Robert. 1985. The importance of contrast in the perception of brightness and form. *Transactions of the American Philosophical Society.* 75:20–29.

Spiess, W. 1971. *Victor Vasarely.* New York: Harry N. Abrams Inc.

Sutter, Jean, editor. 1970. *The Neo-Impressionists.* Translated by C. Deliss. Neuchatel, London and Greenwich, Connecticut: New York Graphic Society.

Szabo, George. 1977. *Catalogue of the exhibition "Paul Signac (1863–1935): Paintings, Watercolors, Drawings and Prints."* Robert Lehman Collection. Drawings Galleries. New York: The Metropolitan Museum of Art.

Thomson, Richard. 1985. *Seurat.* Salem, New Hampshire: Salem House/Phaidon Press.

Thorold, A., editor. 1980. *Catalogue of the exhibition "Artists, Writers, Politics: Camille Pissarro and His Friends (An Archival Exhibition)."* Oxford: Ashmolean Museum.

Varnedoe, Kirk. 1987. *Gustave Caillebotte.* New Haven and London: Yale University Press.

Verheijen, F. J. 1961. A simple after image method demonstrating the involuntary multi-directional eye movements during fixation. *Optica Acta.* 8:309–311.

Wade, Nicholas. 1982. *The art and science of visual illusions.* Boston, Massachusetts: Routeledge & Kegan Paul of America Ltd.

Walls, G. L. 1960. "Land! Land!" *Psychological Bulletin.*

Walraven, Jan. 1981. *Chromatic induction: psychophysical studies on signal processing in human colour vision.* Utrecht, The Netherlands: Drukkerij Elinkwijk B.V.

Weber, Eugene. 1986. *France: Fin de Siecle.* Cambridge, Massachusetts and London, England: Belknap Press.

Webster, J. Carson. 1944. The technique of Impressionism: a reappraisal. *The College Art Journal.* 4 (November 1944):3–22.

Wilcox, Michael. 1989. *Blue and yellow don't make green.* Rockport, Massachusetts: Rockport Publishers.

Williamson, Samuel J., and Herman Z. Cummins. 1983. *Light and color in nature and art.* New York: John Wiley & Sons Inc.

Wright, W. D. 1968. *The rays are not coloured.* New York: Elsevier Science Publishing Co. Inc.

Wurmfeld, Sanford. 1985. *Catalogue of the exhibition "Color Documents: A Presentational Theory."* Plates from treatises published from the 18th century to the present. New York: Hunter College Art Gallery.

List of art works

293

on masonite, 21⅞ × 35⅞ in. Private collection, New York. Photo: Geoffrey Clements.

page 65
Maximilien Luce by Paul Signac. 1890. Charcoal drawing reproduced on cover of *Les Hommes d'aujourd'hui*. Bibliothèque d'Art et d'Archéologie, Paris.

page 94–5
The Annunciation by Robert Campin. ca. 1425. Center panel from a three-panel altarpiece, oil on wood, 64.1 × 63.2 cm. © 1981 The Metropolitan Museum of Art, The Cloisters Collection, New York, 1956 (56.70).

page 96
Ascending and Descending Hero by Bridget Riley. 1965. Emulsion on canvas, 182.9 × 274.3 cm. © 1988 The Art Institute of Chicago. All rights reserved. Gift of The Society for Contemporary Art.

page 97
Painting No. 1 by Gordon Walters. 1965. Acrylic on hardboard, 91.4 × 121.9 cm. Collection of The Auckland City Art Gallery, New Zealand.

page 157
Le Noeud noir (The Black Bow) by Georges Seurat. ca. 1882. Conté crayon, 31 × 23 cm. Unsigned. Private collection. © Artists Rights Society, Inc., New York/SPADEM 1988.

page 158
Man Leaning on a Parapet by Georges Seurat. ca. 1881. Oil on wood, 16.8 × 12.7 cm. Private collection, New York.

page 159
Horse and Cart by Georges Seurat. ca. 1883. Oil on canvas, 33 × 41 cm. Collection of the Solomon R. Guggenheim Museum, New York. Photo: Carmelo Guadagno.

page 162
Le Couple (The Couple): study for *La Grande-Jatte* by Georges Seurat. ca. 1884–85. Conté crayon, 31.3 × 23.8 cm. British Museum, London. Courtesy Trustees of the British Museum.

page 163
The Couple and Three Women: study for *La Grande-Jatte* by Georges Seurat. ca. 1884–85. Oil on canvas, 81 × 65 cm. Fitzwilliam Museum, Cambridge (on loan from the Keynes Collection, King's College, Cambridge).

page 164
Esquisse d'ensemble: study for *La Grande-Jatte* by Georges Seurat. ca. 1884–85. Oil on canvas, 68 × 104 cm. © 1984 The Metropolitan Museum of Art, New York, bequest of Sam A. Lewisohn 1951 (51.112.6).

pages 166–7
Un Dimanche après-midi à l'Ile de la Grande-Jatte (Sunday Afternoon on the Island of the Grand Jatte) by Georges Seurat. ca. 1884–85. Oil on canvas, 225 × 340 cm (without later addition of painted border, 207.6 × 308 cm). © 1987 The Art Institute of Chicago. All rights reserved. Helen Birch Bartlett Memorial Collection (1926.224).

page 168
Poseuse de profil (Model in Profile): study for *Les Poseuses* by Georges

Seurat. ca. 1887–88. Panel, 24 × 14.6 cm. Louvre, Paris. Cliché des Musées Nationaux, Paris. Photo: ©Réunion des Musées Nationaux. Color transparencies courtesy Giraudon/Art Resource, New York.

page 169
Les Poseuses by Georges Seurat. ca. 1887–88. Oil on canvas, 200 × 250 cm. Reproduced from *Seurat* by R. Thomson (1985), Salem House/Phaidon Press, Salem, New Hampshire. Painting owned by The Barnes Foundation, Merion Station, Pennsylvania.

page 170
Les Poseuses (small version) by Georges Seurat. ca. 1888. Oil on canvas, 39.4 × 48.7 cm. Private collection, Switzerland. Color transparencies courtesy Giraudon/Art Resource, New York.

page 173
Le Chahut (The High-Kick) by Georges Seurat. ca. 1889–90. Oil on canvas, 171.5 × 140.5 cm. Collection of the Rijksmuseum "Kröller-Müller," Otterlo, The Netherlands.

page 174
Le Graveur, auto-portrait (Self-Portrait as an Etcher) by Henri Matisse. 1903. Etching and drypoint, 15.1 × 20.1 cm. Collection of The Museum of Modern Art, New York, gift of Mrs. Bertram Smith. © Succession H. Matisse/Artists Rights Society, Inc., New York 1990.

page 176
Nature morte: buffet et table (Interior: Sideboard and Table) by Henri Matisse. 1899. Oil on canvas, 67.5 × 82.5 cm. Private collection, Switzerland. ©

page 177
Study for *Luxe, calme, et volupté (Saint-Tropez, late summer)* by Henri Matisse. 1904. Oil on canvas, 32.2 × 40.5 cm. Signed lower right: Henri Matisse. Private collection, promised gift of the Hon. Mrs. John Hay Whitney to the Museum of Modern Art, New York. © Succession H. Matisse/Artists Rights Society, Inc., New York 1990.

page 180, top
Landscape at Collioure (Collioure, summer) by Henri Matisse. 1905. Oil on canvas, 32.9 × 41.3 cm. Collection of Mrs. Bertram Smith. © Succession H. Matisse/Artists Rights Society, Inc., New York 1990.

page 180, bottom
Landscape at Collioure: study for Bonheur de vivre by Henri Matisse. 1905. Oil on canvas, 46 × 55 cm. Statens Museum for Kunst, Copenhagen, Copenhagen, Denmark, J. Rump Collection. ©

page 181, top
Landscape: study for *Bonheur de vivre* by Henri Matisse. 1905. Oil on canvas, 16½ × 21⅜ in. Private collection, San Francisco. Reproduced from *Matisse* by J. Jacobus (1983), Harry N. Abrams Inc., New York. © Succession H. Matisse/Artists Rights Society, Inc., New York 1988.

page 181, bottom
Bonheur de vivre (Joy of Life) by Henri Matisse. 1905–06. Oil, 68½ × 93¾ in. © Succession H. Matisse/Artists Rights Society, Inc., New York 1990. Photo: © 1991 The Barnes Foundation, Merion Station, Pennsylvania.

page 183
Rotterdam by Paul Signac. 1906. Watercolor and pencil on paper, 25.4 × 40.6 cm. © 1988 The Metropolitan Museum of Art, New York, Alfred Stieglitz Collection 1949 (49.70.19).

page 184
Les Moulins à Overschie (The Windmills at Overschie) by Paul Signac. 1905. Oil on canvas, 25 × 37½ in. The Museum of Fine Arts, Springfield, Massachusetts.

page 185
Jardin de La Hune (Garden at La Hune, Saint-Tropez) by Jeanne Selmersheim-Desgrange. 1909. Oil on canvas, 64.8 × 79.5 cm. © 1989 Indianapolis Museum of Art, Indianapolis, Indiana, The Holliday Collection (79.290).

page 187
La Salle à manger (The Dining Room) by Paul Signac. 1887. Pen and ink on paper, 17.8 × 23.3 cm. All rights reserved, The Metropolitan Museum of Art, New York, Robert Lehman Collection (1975.1.710).

pages 188–9
Le Petit déjeuner (Breakfast) by Paul Signac. 1886–87. Oil on canvas, 89 × 115 cm. Collection of the Rijksmuseum "Kröller-Müller," Otterlo, The Netherlands.

Glossary of technical and art terms

achromatic color A neutral color possessing no hue or saturation: black, white, and all intermediate shades of gray.

additive mixture of colors The fusion by the eye of two or more colors into one new color due to the close juxtaposition of small points or dots of paint (as in a strict pointillism), the rapid succession of colored patches (as with Maxwell's disks), or the actual superposition of projected beams of colored light (as with spotlights on a stage). The two or more color components act in parallel and independently until mixed in the eye. Synonymous with optical mixture of colors. Such mixtures provide much of the empirical basis for Newton's theory of color and for the Young-Helmholtz trichromatic theory. Examples: When equal amounts of red and yellow are optically (additively) mixed the result is orange; when equal amounts of yellow and blue are optically (additively) mixed, the result is gray. Cf. subtractive mixture.

analogous colors Colors that are similar: colors close to one another in the physical spectrum or in the psychological color space. Cf. complementary colors.

assimilation Synonymous with spreading effect and reverse contrast. The change in the appearance of one color so that it becomes more similar to a color placed nearby. Cf. color contrast.

balayé Swept-over strokes of paint, generally thicker at the beginning and thinner at the end. Often criss-crossed to some extent in Neo-Impressionist paintings.

la belle époque Turn-of-the-century France from about 1885–1915. That era is often identified with the good life —good food and wine, good companionship, and good entertainment. This nostalgic view of the *époque* is exemplified by the poster art of those days, in particular that of Jules Cheret, illustrating the gaiety of the cafes, cabarets, and music halls. The period is also closely identified with the art of the Impressionists and Neo-Impressionists, which flourished during that same time. Historians look back, however, and see an *époque* that was not so *belle* for most of the French people. Rather, that time was characterized by poverty, political and labor unrest, the anarchist movement, threats to the stability of the Republic, and dissension within the Church—all culminating in the disastrous First World War.

brightness The lightness or darkness of a color. One of the three dimensions (saturation and hue are the other two) that specify a given color. *See also* value; tone.

brilliance The quality of intense, often sparkling or glittering brightness.

Chevreul's Illusion Bands of the same color arranged in physically uniform steps of intensity, but which appear fluted, brighter near the darker adjacent step and darker near the brighter adjacent step.

chiaroscuro Representation of forms by the painter in gradations of light and shade alone without regard to chromatic color; or, more generally, the overall arrangement and balance of the light and dark parts in a painting.

chroma Generally, the vividness of that quality of color (other than black, white, or gray) combining hue and saturation. Sometimes saturation alone.

chromatic Relating to color (other than black, white, and gray, which are achromatic colors).

chromatic color Any color other than black, white, and gray. The spectral colors red, yellow, green, and blue, the nonspectral purples, and all their intermediates and derivatives. Cf. achromatic color.

chromatic induction A color, or a change in color, brought about (induced) by the presence of another neighboring color, as in simultaneous color contrast. *See also* color contrast; contrast of color; interaction of color.

chromaticity diagram A diagram in which the spectral colors are specified in terms of dominant wavelength and saturation. The nonspectral colors are specified in terms of the dominant wavelength of their spectral complements and saturation.

chromo-luminarisme A technique of painting that enhances color and light. One of Seurat's preferred names for the Neo-Impressionist technique. *See also* divisionism; *peinture optique;* pointillism.

color The quality of the sensation of light. Due to the action of light on the eye but not in the light itself. The dimensions of color are hue, saturation, and brightness. Chromatic colors are red, green, yellow, blue, purple, and all their intermediates and derivatives. Achromatic colors are black, white, and all intermediate shades of gray. *See also* hue; tone.

color circle A circular representation of the psychological color space, with the principal chromatic colors arranged around the perimeter of the circle in the order that they appear in the physical spectrum and with the nonspectral purples between red and violet. Complementary colors are usually placed diametrically opposite one another. In some color circles (such as Newton's), saturation is also represented. Neutral achromatic gray is in the center; amount of saturation increases with distance along the radii of the circle from center to periphery. *See also* color solid.

color contrast Intensification of the differences in hue, saturation, and brightness between two colored areas resulting from their juxtaposition. *See also* chromatic induction; interaction of color; simultaneous contrast; successive contrast.

color solid An extension of the color circle, which represents hue and saturation, into a third dimension in order to represent brightness as well. Usually more or less in the form of two cones or two pyramids placed base to base. Black and white are at the two apexes with the neutral gray

scale connecting them through the center of the solid. *See also* color circle.

complementary colors A pair of contrasting chromatic colors that produce a neutral (achromatic) gray color when combined by optical (additive) mixture in suitable proportions. Usually represented as diametrically opposite one another in the color circle or color solid. Cf. analogous colors.

compound color A color made up of two or more primary colors.

cone One of the two types of photoreceptor (rods and cones), or first-order neuron, in the human retina (predominantly in the fovea). So named because of its short cone shape. The cones are less sensitive than the rods, function best in bright light, and subserve fine pattern and color vision. There are three types of cones, each with a different spectral sensitivity. Cf. rod.

conté crayon A trade name for synthetic chalks in black, red, or brown. The black is often used in place of natural charcoal crayons.

contrast The degree of difference between the lightest and darkest parts of a painting.

contrast of color A juxtaposition of two dissimilar colors, usually reciprocally influencing the appearance of one another, enhancing their differences. *See also* chromatic induction; color contrast; interaction of color.

contrejour Against the (day) light. In painting, with the light behind the subject. The subject is thereby silhouetted in strong contrast against the intense back light with little tonal variation in the weaker front light.

divisionism The Neo-Impressionist technique of painting with a divided touch advocated by Signac. Often synonymous with, or inclusive of, pointillism, but distinguished from it by Signac and in this book. In divisionism, the

touches are separate, generally nonoverlapping, and visually distinct. This leads to the interaction of color, a global effect, due to the relatively large size of brushstrokes, and relatively large distances between the interacting colors. Divisionism exploits opponent processes (excitation and inhibition) in the integrative action of neurons in the retina and visual areas of the brain (Hering's opponent-color theory). Cf. pointillism.

dosage Generally, the regulation of measured amounts of a substance during a process. In painting, the controlled application of measured or carefully determined amounts of color, as with small nearly identical touches.

esquisse Generally, a sketch. More precisely, in oil painting, the final compositional sketch in oil. Usually a complete work, but without the careful finish and attention to detail of the final painting itself.

excitation In neurophysiology, the generation of neural activity in response to a stimulus. Generally regarded as a positive response. Cf. inhibition.

fauve A wild animal. Fauvism: a movement in painting (first exhibit: 1905) exemplified by the work of Henri Matisse (generally as the acknowledged leader) immediately after his Neo-Impressionist period. Not a coherent group. Distinguished by the fierce use of bold, strident, and vivid colors, rough draftsmanship, and free treatment of form, with vibrant and often decorative results.

fovea The small, central, pure cone region of the retina of the eye (as opposed to the periphery which contains both cones and rods) that affords the most acute pattern vision and the best color vision. *See also* cone.

gradation In painting, a graded transition or passage from one hue or shade to another.

halftone A print made from an image photographed through a special fine screen so that details of the image are reproduced in very small uniformly spaced dots. The dots are made larger where the image is to appear darker. More generally, any of the shades of gray between white and black in a photograph or charcoal drawing.

harmony (of color) Color harmonies are those combinations of color which are found empirically to be pleasing to the eye. Most theories of harmony are based on the work of Michel-Eugène Chevreul (ca. 1840), who distinguished two kinds of harmony, harmonies of analogous colors and harmonies of contrasting colors. Many attempts have been made since then to elucidate rigorous scientific principles of color harmony. These include works by Charles Blanc (ca. 1865), Ogden N. Rood (ca. 1880), David Sutter (ca. 1880), Charles Henry (ca. 1890), and George D. Birkhoff (ca. 1930). Although some general principles have emerged, no precise concept of color harmony has yet been worked out. Most competent artists rely more on their own intuition and experience than on any formal principles of harmony.

Hering theory *See* opponent-color theory.

hue The chromatic quality of a color, such as red, green, yellow, blue, purple. One of the three dimensions (saturation and brightness are the other two) that specify a given color. *See also* color; tone.

induction In visual perception, a change in the appearance of one area due to the presence of another area. *See also* chromatic induction.

inhibition In neurophysiology, the suppression of neural activity in response to a stimulus. Generally regarded as a negative response. Cf. excitation.

intensity Generally, the strength of a process or quality. In color terminology, sometimes synonymous with saturation or brightness.

interaction of color The change in the appearance of one color resulting from the presence of another color nearby in space and time. *See also* chromatic induction; color con-

trast; contrast of color. Cf. additive mixture of colors; optical mixture of colors.

interference colors Colors that result from interference between two lightwave trains that reinforce each other when in phase, and cancel each other when out of phase. Usually due to reflection from thin multiple layers of material.

iridescence The play of rainbow colors in light reflected from thin films, as from a soap bubble.

local color The natural color of an area or an object in a standard light (usually north daylight) against a neutral background, without influences from the surrounds such as contrast, shadows, and reflections.

luster A sheen or surface light such as that reflected from polished metallic surfaces.

Mach bands The light and dark bands or stria seen at the two edges of half-shadows, or similar distributions of light and shade. The light band appears at the boundary between the half-shadow (penumbra) and the full light. The dark band appears at the boundary between the half-shadow and the full shadow (umbra). There are no maxima or minima in the physical distribution of light where the light and dark bands appear. First reported in the scientific literature by Ernst Mach in 1865. Mach bands are different from and not to be confused with the border contrast at a sharp step in illumination. Cf. Chevreul's Illusion.

mélange optique Optical mixture.

metamers Colors which appear identical but which have different constituents.

neuron A specialized cell that is the fundamental functional unit of the nervous system.

opalescence The reflection of an iridescent play of colors as from the gemstone opal.

opponent colors Generally, pairs of complementary colors diametrically opposite one another on the color circle which, when optically mixed, yield gray. More specifically, in color theory, only the two opponent pairs red-green and yellow-blue.

opponent-color theory The theory, advanced by Ewald Hering (ca. 1870), that the fundamental mechanism of chromatic color vision—namely, spectral opponency in neurons of the retina and cerebral visual areas—consists of two pairs of opponent processes: one that mediates red versus green and one that mediates yellow versus blue. A third opponent process mediates the achromatic colors white versus black. The opponent-color theory offers an explanation of the interaction of color and provides the rationale for the technique of divisionism. The opponent-color theory is now regarded as complementary to the trichromatic color theory, and modern color theory incorporates both. *See also* tetrachromatic theory. Cf. trichromatic color theory.

optical mixture of colors The combination, in the eye, of two or more colors into one new color. The mixture may take place by fusion of small, closely juxtaposed points of color, by fusion of colors presented in rapid succession, or by superposition of projected beams of colored light. Synonymous with additive mixture of colors. Cf. subtractive mixture of color.

parallel processing The transmission and treatment of information in separate and independent channels from one stage to the next. Optical (additive) mixture of colors is a parallel process up to the point where the light reaches the eye. Cf. serial processing.

peinture optique A technique of painting based on principles of psychophysiological optics. One of Seurat's preferred terms for the Neo-Impressionist technique. See also *chromo-luminarisme;* divisionism; pointillism.

pointillism The Neo-Impressionist technique of painting with small touches of pure color advocated by Seurat. In

pointillism, the touches are separate, generally nonoverlapping, but visually indistinct. This leads to the fusion of color, a local effect due to the relatively small size and close juxtaposition of these small "points" of paint. Exploits the optical (additive) mixture of color (Young-Helmholtz trichromatic theory). In theory, points of different colors fuse in the eye to produce a new color by optical mixture. In practice, the points are seldom small enough and closely packed enough to achieve this result, and the actual Neo-Impressionist technique of pointillism usually produces only a *near*-fusion or delusive blend of colors, sometimes yielding an overall veiled and misty effect. Some of the most striking Neo-Impressionist technical effects occur in the midrange between a strict pointillism and a strict divisionism, where the one technique merges into the other. Cf. divisionism.

primary colors In theory, any of a set of colors from which all other colors can be produced. In practice, all other colors cannot be obtained from a limited set of primary colors, but very wide gamuts of color can be obtained. Physiological primaries, generally a red, a green, and a blue, are those which effectively stimulate the three basic photoreceptor mechanisms in the retina and which combine by optical (additive) mixture. *See* trichromatic color theory. The psychological primaries consist of the four unique colors red, green, yellow, and blue. *See* opponent-color theory. Artists' primaries, generally a red, a yellow, and a blue, are a small set of colors of pigments chosen to produce a broad range of other colors by physical (subtractive) mixture.

prismatic colors In writings by and about the Neo-Impressionists, colors of pigments chosen to best approximate the pure monochromatic spectral colors obtained when light is dispersed by a prism.

purity In color terminology, synonymous with saturation.

Purkinje shift The shift in the sensitivity of the eye to different colors at twilight as the less sensitive cones cease to respond and vision becomes increasingly dependent upon the more sensitive rods. With increasing darkness, the eye becomes somewhat less sensitive to the red end of the spectrum and relatively more sensitive to the blue. Named for the physiologist Jan Evangelista Purkinje (1787–1869), who first reported the phenomena.

reduction screen A screen or mask of neutral color with a small aperture in it which reduces the field of view to a small area and thereby eliminates influences of the surrounding area.

retina The light-sensitive portion of the eye on which an image is formed by the lens. It is a duplex system containing two classes of photoreceptors (rods and cones) that are interconnected by a complex network of neurons. This network feeds into the optic nerve connecting the retina of the eye with the visual cortex of the brain.

reverse contrast *See* assimilation.

rod One of the two types of photoreceptor (rods and cones), or first-order neuron, in the human retina (located extrafoveally). So named because of its long rod shape. The rods are much more sensitive than the cones and serve night vision. Rods all have the same photopigment and, acting alone, cannot mediate color vision. Cf. cone.

saturation (intensity, purity, chroma) The degree of difference of a chromatic color from an achromatic gray of the same brightness. Chromatic purity, freedom from dilution with white. One of the three dimensions (hue and brightness are the other two) that specify a given color.

serial processing The transmission and treatment of information in a sequence of channels in which the output of one stage forms the input for the next. Subtractive mixture of colors is a serial process, up to the point where the light reaches the eye. Cf. parallel processing.

simultaneous contrast The contrast of two colored areas placed side by side and viewed simultaneously. Cf. successive contrast.

spectral absorption The relative amounts of light absorbed by a substance from a spectrum of equal energy at all wavelengths.

spectrally opponent A neuron in the visual system that is ultimately excited by light falling on the eye from one part of the visible spectrum and inhibited by light from another part.

spreading effect *See* assimilation.

subjective contour A contour which has no direct physical basis but which is induced by other parts of the pattern in which it appears.

subtractive mixture of color A physical combination of substances, such as artist pigments or glass filters, each of which absorbs (subtracts) some part of the light in the visible spectrum. The remainder of the light which is transmitted determines the color of the mixture. The effects of the component pigments or filters on the common beam are serial and interdependent. In painting, yielded by superimposed or blended touches. Example: When yellow and blue are physically mixed, the result is green. Cf. additive mixture of colors; optical mixture of colors.

successive contrast The contrast of two colored areas viewed one after the other, either by moving the gaze from one to the other or by showing them in succession. Cf. simultaneous contrast.

symbolist Generally, one who uses symbols to express the invisible or intangible. Specifically, a member of a movement in France (beginning about 1880) consisting of writers and artists (including, among others, the poet Jean Moréas, the critic Félix Fénéon, the artists Puvis de Chavannes, Odilon Redon, Gustave Moreau, and Eugène Carrière) who favored the subjective over the objective in their search for general truths. In their reaction against realism they expressed their ideas symbolically and enigmatically, often in terms of the metaphysical and mysterious.

tetrachromatic theory A theory of chromatic color vision in which there are four principal psychophysiological mechanisms. *See also* opponent-color theory. Cf. trichromatic color theory.

tinge A slight shade of color.

tint A pale coloration.

tone Brightness on a gray scale from the darkest black to the brightest white, irrespective of color. Tonal value increases with brightness. *See also* value; brightness.

touch A light single stroke of paint. More generally, the distinctive manner of a painter.

trichromatic color theory A theory of chromatic color vision, advanced by Sir Thomas Young (ca. 1800) and Hermann von Helmholtz (ca. 1850), in which there are three principal psychophysiological mechanisms—namely, three different types of cones: one with its maximum absorbance in the red part of the spectrum, one in the green, and one in the blue. The trichromatic color theory offers an explanation of the optical mixture of colors and provides the rationale for the technique of pointillism. Cf. opponent-color theory; tetrachromatic theory.

unique color A hue in which no other color can be seen. Only red, yellow, green, and blue are unique. Orange is an example of a color which is not unique: both red and yellow can be seen in it.

value The lightness or darkness of a color, generally synonymous with tone. Sometimes refers to the predominant hue in a painting. *See also* brightness; tone.

Young-Helmholtz theory *See* trichromatic color theory.

Index